Photographer's Guide to the Sony DSC-RX10 III

Photographer's Guide to the Sony DSC-RX10 III

Getting the Most from Sony's Advanced Digital Camera

Alexander S. White

WHITE KNIGHT PRESS
HENRICO, VIRGINIA

Published by
White Knight Press
9704 Old Club Trace
Henrico, Virginia 23238
www.whiteknightpress.com
contact@whiteknightpress.com

ISBN: 978-1-937986-54-4 (paperback)
 978-1-937986-55-1 (ebook)
Printed in the United States of America

To my wife, Clenise

Contents

CHAPTER 4: THE SHOOTING MENU 41

CHAPTER 5: PHYSICAL CONTROLS — 99

CHAPTER 6: PLAYBACK AND PRINTING 118

CHAPTER 7: THE CUSTOM AND SETUP MENUS 130

Introduction

In 2014, I published *Photographer's Guide to the Sony DSC-RX10*, and I followed it up with a similar guide for the RX10 II in 2015. When I learned that Sony was releasing another updated version of the RX10, I decided to publish a revised guide book for the new camera. The RX10 III incorporates the excellent features of the earlier models, including the ability to capture ultra-high-definition 4K video as well as high-speed video, and also manages to incorporate a high-quality lens with a focal length range of 24mm to 600mm. The new model also adds some enhanced or new features, including a Zoom Assist function to allow a quick re-framing of a zoomed-in shot, and a Focus Hold feature that allows you to lock focus with the press of a control other than the shutter button.

With this model, Sony has produced a camera that can serve many photographers as the only equipment they will need for most purposes. From super closeup images to long telephoto shots, the RX10 III provides the features and performance to give excellent quality with great efficiency.

My goal with this book is to provide a thorough guide to the camera's features, explaining how they work and when you might want to use them. The book is aimed largely at beginning and intermediate photographers who are not satisfied with the documentation that comes with the camera and who prefer a more complete explanation of the camera's controls and menus. For those seeking more advanced information, I discuss some topics that go beyond the basics, and I include in the appendices information about additional resources. I will provide updates at my website, whiteknightpress.com, as warranted.

One note on the scope of this guide: I live in the United States, and I bought my camera here. I am not very familiar with the variations for cameras sold in Europe or elsewhere, such as different chargers. The photographic functions are generally not different, so this guide should be useful to photographers in all locations. I should note that the frame rates for HD video are different in different areas. In North America, Japan, and some other areas, the NTSC video system is generally used, whereas in Europe and elsewhere, the PAL system is in use. In this book, I discuss video frame rates in the context of the NTSC system. Also, I have stated measurements of distance and weight in both the Imperial and metric systems, for the benefit of readers in various countries around the world.

CHAPTER 1: PRELIMINARY SETUP

When you purchase your Sony RX10 III, the box should contain the camera itself, battery, charger, shoulder strap, lens cap, lens hood, micro-USB cable, and brief instruction pamphlets. Sony also lists as included items the protective cap that is inserted into the accessory shoe and the eyepiece cup that is attached to the viewfinder. There may also be a warranty card and some advertising flyers.

There is no CD with software or a user's guide; the software programs and user's guide supplied by Sony are accessible through the Internet. With cameras sold outside the United States and Canada, there should be a power cord that connects to the battery charger.

To install PlayMemories Home, the Sony software for viewing and working with images and videos, go to one of the following Internet addresses: http://www. sony.co.jp/imsoft/Win (for Windows); or http://www. sony.co.jp/imsoft/Mac (for Macintosh). You also can install Sony's Image Data Converter software, which converts the camera's Raw images so you can edit them on a computer. That software is available for download for both Windows-based computers and Macs at the locations listed above. And, you can download Capture One Express, a special Sony-oriented version of Capture One, a sophisticated Raw-processing program from a company known as Phase One.

At the same websites, you can install Sony's Remote Camera Control software, which lets you control the RX10 III from your computer when the camera is connected to the computer with its USB cable. The Sony user's guide and related documents are available at https://esupport.sony.com/US/p/model-home. pl?mdl=DSCRX10M3&LOC=3#/manualsTab.

You might want to attach the shoulder strap as soon as possible, so you can support the camera with the strap over your shoulder or around your neck.

Charging and Inserting the Battery

The Sony battery for the DSC-RX10 III is the NP-FW50. With this camera, the standard procedure is to charge the battery while it's inside the camera. To do this, you use the supplied micro-USB cable, which plugs into the camera and into the supplied Sony charger or a USB port on your computer.

There are pluses and minuses to charging the battery while it is inside the camera. On the positive side, you don't need an external charger, and the camera can charge automatically when it's connected to your computer. You also can find many portable charging devices with USB ports; many newer automobiles have USB slots where you can plug in your RX10 III to keep up its charge.

One drawback is that you cannot charge another battery outside of the camera using this system. A solution to this situation is to purchase at least one extra battery and a device to charge your batteries externally. However, with the RX10 III, unlike the original RX10 model, you can use the supplied battery charger as an AC adapter that will power the camera.

So, if your battery runs completely down, you don't have to wait until you have recharged it to start using the camera again. You can plug the charger into the camera and into an AC outlet or USB power supply, and operate the camera directly from that power source, as long as there is a battery inserted in the camera. I'll discuss batteries, chargers, and other accessories in Appendix A.

To insert the battery, open the battery compartment door on the bottom of the camera. Then look for the rectangular set of connectors on the battery, and insert the battery so those connectors are positioned close to the front of the camera as the battery goes into the compartment, as shown in Figure 1-1 and Figure 1-2.

You may have to nudge aside the blue latch that holds the battery in place, as shown in Figure 1-3, to get the battery fully inserted.

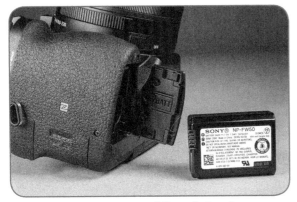

Figure 1-1. Battery Lined Up to Go into Camera

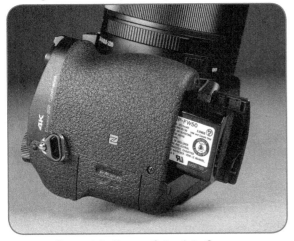

Figure 1-2. Battery Going into Camera

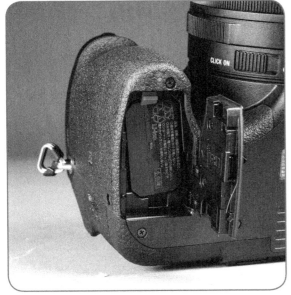

Figure 1-3. Battery Secured by Latch

With the battery inserted and secured by the latch, close the battery compartment door and slide the ridged latch on the door to the closed position. Then plug the

larger, rectangular end of the micro-USB cable into the corresponding slot on the provided AC charger, which is model number AC-UUD12 in the United States. Plug the smaller end of the cable into the micro USB port. This port, which is labeled the Multi port, is located under a small door on the lower part of the camera's left side as you hold it in shooting position, as shown in Figure 1-4.

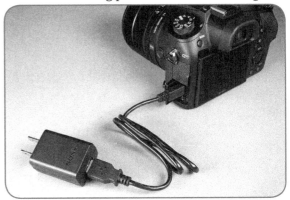

Figure 1-4. Battery Charger Connected to Camera

Plug the charger's prongs into a standard electrical outlet. A small orange lamp to the right of the camera's Multi port will light up steadily while the battery is charging; when it goes out, the battery is fully charged. The full charging cycle should take about 150 minutes. (If the charging lamp flashes, that indicates a problem with the charger or a problem with the temperature of the camera's environment.)

Choosing and Inserting a Memory Card

The RX10 III does not ship with a memory card. If you turn the camera on with no card inserted, you will see the error message "NO CARD" flashing in the upper left corner of the screen. If you ignore this message and press the shutter button to take a picture, you may be able to take one or two images, depending on the setting of the Release w/o Card option on screen 4 of the Custom menu. However, even if you can press the shutter button to capture an image, don't be fooled into thinking that the camera is storing the image in internal memory, because that is not the case.

Actually, the camera will temporarily store the image and play it back if you press the Playback button, but the image will not be permanently stored. (I did manage to save a NO CARD image by using a video capture device to capture the image from the camera's HDMI port to my computer while it was still on the screen, but that

is not a process I would want to do often.) Some other camera models have a small amount of built-in memory so you can take and store a few pictures even without a card, but the RX10 III does not have any such safety net.

To avoid the frustration of having a great camera that can't save any images, you need to purchase and insert a memory card. The RX10 III uses two basic types of memory storage cards. First, it can use all varieties of SD cards, which are quite small—about the size of a postage stamp. These cards come in several varieties; some examples are shown in Figure 1-5.

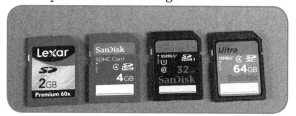

Figure 1-5. SD Cards of Various Capacities

The standard card, called simply SD, comes in capacities from 8 MB (megabytes) to 2 GB (gigabytes). A higher-capacity card, SDHC, comes in sizes from 4 GB to 32 GB. The newest, and highest-capacity card, SDXC (for extended capacity) comes in sizes of 48 GB, 64 GB, 128 GB, 256 GB, and 512 GB; this version of the card can have a capacity up to 2 terabytes (TB), theoretically, and SDXC cards generally have faster transfer speeds than the smaller-capacity cards. There also is a special variety of SD card called an Eye-Fi card, which I will discuss later in this chapter.

The RX10 III also can use micro-SD cards, which are smaller cards, often used in smartphones and other small devices. These cards operate in the same way as SD cards, but you have to use an adapter that is the size of an SD card to insert this tiny card in the RX10 III camera, as shown in Figure 1-6.

In addition to using various types of SD cards, the RX10 III, being a Sony camera, also can use Sony's proprietary storage devices, known as Memory Stick cards. These cards are similar in size and capacity to SD cards, but with a slightly different shape, as shown in Figure 1-7.

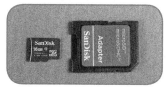

Figure 1-6. Micro-SD Card

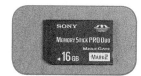

Figure 1-7. Sony Memory Stick Card

Memory Stick cards come in various types. The ones that can be used in the RX10 III are the Memory Stick PRO Duo, Memory Stick PRO-HG Duo, and Memory Stick Micro (M2). The Memory Stick Micro, like the micro-SD card, requires an adapter for use in the camera.

There is one important limitation on your choice of a memory card. If you want to record video using either of the camera's two XAVC S formats (XAVC S 4K and XAVC S HD), which provide the highest quality, you have to use an SDHC or SDXC card rated in Speed Class 10, UHS Speed Class 1, or faster. If you want to record in those formats using the highest quality of 100 megabits per second, you have to use a card rated in UHS Speed Class 3. These specifications are not just recommendations; if you try to record in a video format on a card that does not meet the requirements for that format, the camera will display an error message, as shown in Figure 1-8, and will not record the video.

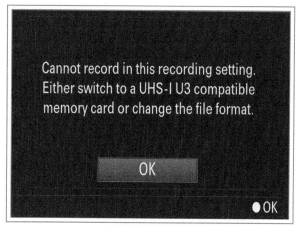

Figure 1-8. Error Message for Wrong Memory Card

The XAVC S formats are worth using if you want high-quality video, and it is a good idea to get one of the high-powered cards that can support their use. Figure 1-9 shows three cards I have tested that can handle all video formats on the RX10 III—the SanDisk Extreme Pro 32 GB card, the SanDisk Extreme 256 GB SDXC card, and the SanDisk Extreme Pro 512 GB card, all of which are rated in UHS Speed Class 3. This figure also shows two other cards that can handle all video formats except for the 100 mbps versions of the XAVC

S formats—the SanDisk Extreme Pro 64 GB SDXC card, rated in UHS Speed Class 1, and the Lexar Professional 128 GB SDXC card, rated in that same speed class.

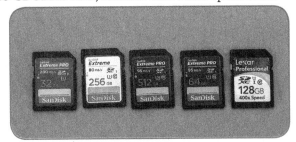

Figure 1-9. High-speed Memory Cards

Even if you don't care about using the XAVC S video formats, the factors that matter are still capacity and speed. If you're planning to record a good deal of HD (high-definition) video or a large number of Raw-format photos, you should get a large-capacity card, but don't get carried away—the largest cards have such huge capacities that you may be wasting money purchasing them.

There are several variables to take into account in computing how many images or videos you can store on a particular size of card, such as which aspect ratio you're using (16:9, 3:2, 4:3, or 1:1), picture size, and quality. Here are a few examples of what can be stored on a 64 GB SDXC card. If you're using the standard 3:2 aspect ratio, you can store about 2,850 Raw images (the highest quality), 4,150 high-quality JPEG images (Large size and Extra Fine quality), or about 9,600 of the lower-quality Standard images (Large size).

You can fit about 1 hour 15 minutes of the highest-quality XAVC S 4K or XAVC S HD video (100mbps) on a 64 GB card. That same card will hold about 22 hours of video at the lowest-quality MP4 setting of 1280 x 720 pixels, which is still HD quality. Note, though, that the camera is limited to recording no more than about 29 minutes of video in any format in any one sequence. The highest-quality MP4 format (1920 x 1080 pixels at a bit rate of 28 megabits per second) can be recorded only for 20 minutes in one sequence, because of the 4 GB file size limit. These video formats and their limitations are discussed in Chapter 8.

The other major consideration is the speed of the card. High speed is important to get good results for recording continuous bursts of images and the highest-quality video with this camera. You should try to find a card that writes data at a rate of 6 MB/second or faster

to record HD video. If you go by the class designation, a Class 4 card should be sufficient for shooting stills, though you should use a faster card if you will be using continuous shooting to capture bursts of images, as discussed in Chapter 4. A Class 6 card should suffice for recording video, except for the requirements discussed above for recording XAVC S video.

You also may want to consider getting an Eye-Fi card. This special type of device looks much like an ordinary SDHC card, but it includes a tiny transmitter that lets it send images to your computer or mobile device as soon as the images have been recorded by the camera.

I have tested an Eye-Fi mobiPRO 16 GB card, shown in Figure 1-10, and it works well with the RX10 III. Uploaded images are sent wirelessly to the Pictures/Eyefi folder on my computer.

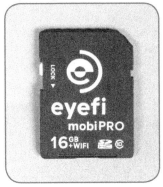

Figure 1-10. Eye-Fi mobiPRO Card

Of course, the RX10 III camera has built-in Wi-Fi capability, as discussed in Chapter 9, so you don't need to use an Eye-Fi card or the equivalent to transfer images. If you already have one or more wireless SD cards and are accustomed to that system, you should be able to use the cards in your RX10 III, but you now have other options for wireless transfer that may make more sense.

If you decide to use a Memory Stick card, be sure you have a card reader that can accept those cards, which, as noted above, are not the same shape as SD cards and require readers with compatible slots.

Once you have chosen a card, open the small door on the right side of the camera that covers the memory card compartment, and slide the card into the slot until it catches. You insert an SD card with its label pointing toward the back of the camera, as shown in Figure 1-11; insert a Memory Stick card with its label pointing toward the front of the camera, as shown in Figure

1-12. (I have placed that card at an angle so you can see where the contacts are located.)

Figure 1-11. SD Card Going Into Camera

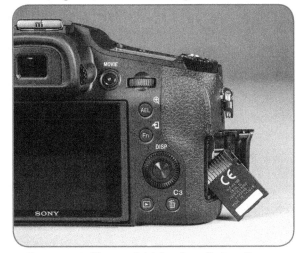
Figure 1-12. Memory Stick Ready to Go into Camera

Push the card firmly into the slot until it catches and stays in place. Once the card has been pushed in until it catches, close the compartment door and make sure it is firmly latched. To remove either type of card, push down on its edge until it releases and springs out, so you can remove it.

Although the card may work well when newly inserted in the camera, it's a good idea to format a card when first using it in the camera, so it will have the correct file structure and will have any bad areas blocked off from use. To do this, turn on the camera by pressing the power switch to the right, then press the Menu button at the upper left of the camera's back. Next, press the Right button (right edge of the Control wheel on the camera's back) multiple times until the small orange line near the top of the screen is positioned under the number 5, and the toolbox icon at the far right of the screen is highlighted, as shown in Figure 1-13.

(I will refer to the other three edges of the Control wheel as the Left, Up, and Down buttons, and to the button in the middle of the wheel as the Center button.)

Figure 1-13. Format Menu Screen

The toolbox icon indicates the Setup menu. The orange highlight bar should already be positioned on the top line of the menu, on the Format command; if not, press the Up or Down button, or turn the Control wheel, until the Format command is highlighted.

Press the Center button when the Format line is highlighted. On the next screen, seen in Figure 1-14, highlight Enter and press the Center button again to carry out the command.

Figure 1-14. Format Confirmation Screen

Setting the Date, Time, and Language

You need to make sure the date and time are set correctly before you start taking pictures, because the camera records that information (sometimes known as

"metadata") invisibly with each image and displays it later if you want. It is, of course, important to have the date (and the time of day) correctly recorded with your archives of digital images. The camera may prompt you to set these items the first time you turn it on. If not, or if you need to change the settings, follow these steps:

Turn the camera on, then press the Menu button. Press the Right button enough times to move the orange line underneath the number 4 while the Setup menu's toolbox icon is highlighted.

Figure 1-15. Screen 4 of Setup Menu

Press the Down button to move the orange highlight bar to the Date/Time Setup line on the menu screen, as shown in Figure 1-15, and press the Center button to move to the next screen, shown in Figure 1-16.

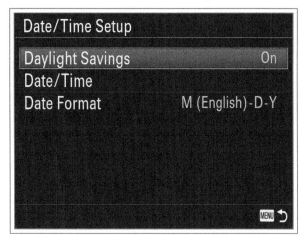

Figure 1-16. Date/Time Setup Screen

Highlight the Date/Time option, press the Center button, and then, by pressing the Left and Right buttons or by turning the Control wheel, move left and right through the month, day, year, and time settings, as shown in Figure 1-17.

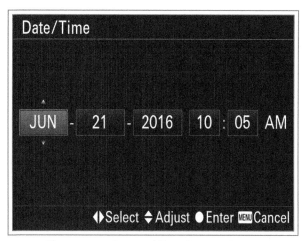

Figure 1-17. Date and Time Settings Screen

Change the values by pressing the Up and Down buttons or by turning the Control dial (the ridged dial to the right of the Movie button). When everything is set correctly, press the Center button to confirm. Then use a similar method to adjust the Daylight Savings (On or Off) and Date Format options, if necessary.

If you need to change the language the camera uses for menus and other messages, press the Menu button and navigate to the Language item, which is one line above the Date/Time Setup item, as shown in Figure 1-15. Press the Center button to select it. You then can select from the available languages on the menu, as shown in Figure 1-18.

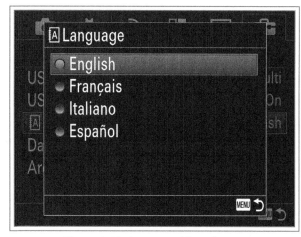

Figure 1-18. Language Menu Screen

CHAPTER 2: BASIC OPERATIONS

Now that the Sony RX10 III has the correct time and date set and a charged battery inserted along with a memory card, I'll discuss the steps to get your camera into action and to capture a usable image to your memory card.

Introduction to Main Controls

Before I discuss settings, I will introduce the camera's main controls to give a better idea of which button or dial is which. I won't discuss the controls in detail here; there is more information in Chapter 5. For now, I will include images showing the physical buttons, switches, and dials of the RX10 III. You may want to refer back to these images for a reminder about each control as you go through this book.

TOP OF CAMERA

On top of the camera are some of the most important controls and dials. The controls on the top left are shown in Figure 2-1. This view also shows the main controls on the camera's lens assembly. You use the Mode dial to select a shooting mode for stills or video. For basic shooting without making many other settings, turn the dial so the green AUTO label is next to the white marker; this will set the camera to one of its most automatic modes.

You turn the aperture ring, marked with values from 2.4 to 16, to set the camera's aperture, or opening to let in light, when the camera is in Aperture Priority or Manual exposure mode, or in Movie mode with the Movie exposure mode set to Aperture Priority or Manual Exposure. (In other modes, the camera sets the aperture automatically.) The rear lens ring is the ridged ring just beyond the aperture ring, and the front lens ring is a similar ring, in front of the rear ring. You use those two rings to control focus when manual focus is in use, and to zoom the lens in and out. You can select which ring controls focus and which controls zoom,

using the Lens Ring Setup option on screen 6 of the Custom menu.

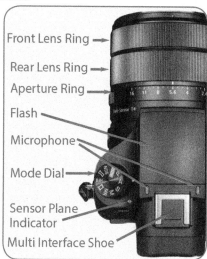

Figure 2-1. Controls on Top Left of Camera

The Multi Interface Shoe functions as a standard flash shoe to hold an external flash unit, but it also accepts certain Sony accessories that communicate with the camera through the shoe, such as microphones and a special video light, as discussed in Appendix A. The openings for the built-in microphone are located near the shoe. The built-in flash unit is normally stored inside the top of the camera; it pops up when you press the flash pop-up button. Finally, the sensor plane indicator marks the plane of the camera's digital sensor, in case you need to measure the exact distance from the sensor to your subject for a closeup shot.

The items on the top right of the camera are shown in Figure 2-2.

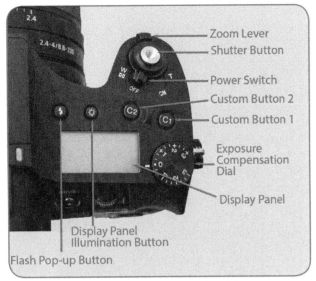

Figure 2-2. Controls on Top Right of Camera

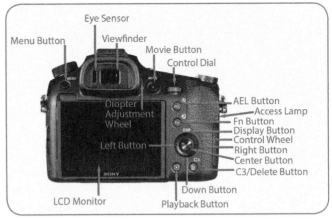

Figure 2-3. Controls on Back of Camera

The round, silver-colored shutter button is used to take pictures. Press it halfway to evaluate focus and exposure; press it all the way to take a picture. The zoom lever, surrounding the shutter button, can be used to zoom the lens in and out between its telephoto and wide-angle settings. The lever also is used to change the views of images in playback mode. The power switch turns the camera on and off.

The display panel shows information about current settings. You can press the panel illumination button, in front of the panel, to light up the display. The exposure compensation dial is used to increase or decrease the brightness of images; just turn the dial to a positive or negative value. The C1 and C2 buttons, or Custom buttons 1 and 2, each can be programmed to perform any one of several camera operations, such as adjusting ISO or Drive Mode.

BACK OF CAMERA

Figure 2-3 shows the main controls on the camera's back. The viewfinder window is where you look into the viewfinder when you want to view the scene at eye level, with your eye shaded from the sun. The diopter adjustment wheel is used to adjust the viewfinder for your vision. The eye sensor, a small slot to the left of the viewfinder, senses when your head is near, and can switch the camera between using the LCD screen and using the viewfinder.

The red Movie button starts and stops the recording of a video sequence. The Control dial, just to the right of the Movie button, is used to adjust shutter speed in Shutter Priority and Manual exposure modes, as well as in Movie mode when shutter speed can be adjusted. This dial also is used to navigate through various screens for camera settings. The Menu button calls up the camera's system of menu screens with settings for shooting and other values, such as control button functions, audio features, and others.

In shooting mode, the Function (Fn) button calls up a menu of camera functions for easy access. In playback mode, pressing this button can send an image to a smartphone or tablet. The Playback button places the camera into playback mode, so you can view your recorded images and videos. The Delete/C3 button, marked by a trash can icon, acts as the Delete button in playback mode, for erasing images. In shooting mode, this button can be programmed to carry out any one of numerous functions.

The Control wheel is a rotary dial for navigating through menu screens and other screens with camera settings. It also can be programmed through the menu system to adjust one of several particular settings. In addition, each of the wheel's four edges acts as a direction button when you press it in, for navigating through menu screens and moving items such as the focus frame.

The button in the center of the wheel (Center button) is used to confirm selections and for some miscellaneous operations. The top edge of the wheel (Up button) also serves as the Display button. You can press this button to choose the various display screens in either shooting or playback mode. In addition, the Left, Right, Center,

and Down buttons can each be programmed through the menu system to handle any one of numerous functions.

The LCD screen—which displays the scene viewed by the camera along with the camera's settings and plays back your recorded images—tilts up or down to allow you to hold the camera in a high or low position to view a scene from unusual angles.

The AEL/Zoom-in button can be used to lock the exposure of your images in shooting mode, or it can be programmed through the menu system to adjust some other setting. When the camera is in playback mode, this button zooms the image displayed on the screen or in the viewfinder. The small access lamp at the extreme right edge of the camera glows red when the camera is writing data to a memory card, indicating that you should not interrupt this activity by trying to turn the camera off or remove the memory card.

FRONT OF CAMERA

There are several items to point out on the camera's front, including the lens and its components, as shown in Figure 2-4.

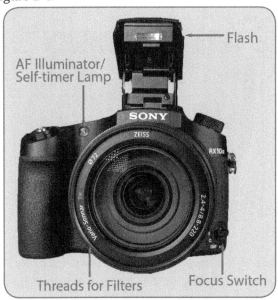

Figure 2-4. Items on Front of Camera

The AF Illuminator/Self-timer Lamp lights up to signal the operation of the self-timer and to provide illumination so the camera can use its autofocus system in dark areas. The lens itself has a 35mm equivalent focal length range of 24mm to 600mm and an aperture range of f/2.4 to f/16.0. (The actual focal length of the lens is 8.8mm to 220mm; the "35mm equivalent range"

is commonly used to state the focal length in a way that can easily be compared to lenses of other cameras.) The camera's built-in flash unit is shown here in its popped-up position, ready to be fired. The lens is threaded to accept filters with a diameter of 72mm.

The focus switch, seen in a closer view in Figure 2-5, selects a focus mode—single autofocus, continuous autofocus, direct manual focus, or manual focus.

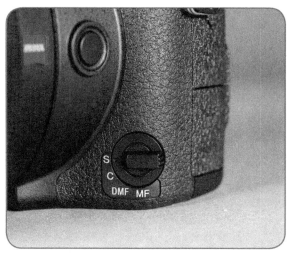

Figure 2-5. Focus Switch

LEFT SIDE OF CAMERA

On the left side of the camera are two small doors, one covering the jacks for connecting an external microphone and headphones for video recording, and one covering the Multi and HDMI ports, as seen in Figure 2-6 with the doors closed and Figure 2-7 with the doors open, showing the ports.

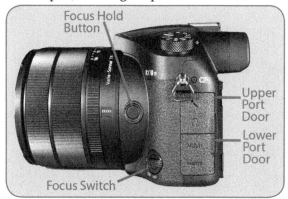

Figure 2-6. Left Side of Camera - Port Doors Closed

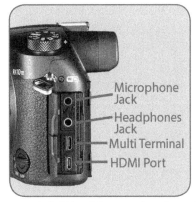

Figure 2-7. Left Side of Camera - Port Doors Open

The microphone jack accepts a standard 3.5mm stereo microphone that will record sound for video recordings. The headphones jack is where you can plug in headphones for monitoring the sound recording.

Under the lower door, the top port, called the Multi terminal, is where you connect the USB cable that is supplied with the camera to charge the battery or power the camera, to connect the RX10 III to a computer to upload images, or to connect to a printer to print images directly from the camera. The bottom port, the HDMI port, is for connecting the camera to an HDTV to view your images and videos. You also can use this port to send a "clean" HDMI signal to an external video recorder or monitor, as discussed in Chapter 8.

On the left side of the lens near the camera's body is the focus hold button. That button can be programmed to carry out any one of several functions, not necessarily involving focus. However, by default it is assigned to the Focus Hold function, which locks focus while the button is held down, as discussed in Chapter 7.

RIGHT SIDE OF CAMERA

The right side of the camera, shown in Figure 2-8, houses the memory card slot, which is concealed under a small door with a notch in it. Grab the door by the notch and pull it open to expose the card slot.

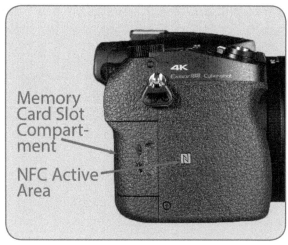

Figure 2-8. Right Side of Camera

The other item of note on this side of the camera is the NFC active area, designated by a fancy letter N. You can touch another device that uses near field communication, such as an Android smartphone or tablet, to that spot to activate a wireless connection, as discussed in Chapter 9.

BOTTOM OF CAMERA

Finally, as shown in Figure 2-9, on the bottom of the camera are the tripod socket and the battery compartment.

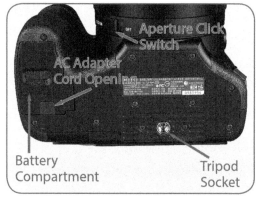

Figure 2-9. Bottom of Camera

The battery compartment door has a small flap that opens to make room for the cord from the Sony AC adapter, if you use that optional accessory, as discussed in Appendix A. In this view, you also can see the aperture click switch on the bottom of the lens. That switch lets you turn off the clicking sound of the aperture ring, so the sound is not recorded on videos.

Taking Pictures in Intelligent Auto Mode

Now I'll discuss how to use these controls to start taking pictures and videos. First, here is a set of steps for taking still photos if you want to let the camera make most decisions for you. This is a good approach for quick snapshots without fiddling with too many settings.

1. Remove the lens cap and turn the camera so the lens faces toward you. Find the focus switch at the lower right and turn the switch so the small black line points to the S indicator, for single autofocus, as shown in Figure 2-5.

2. Move the power switch on top of the camera to the On position. The LCD screen will illuminate to show that the camera has turned on. (If you see a message about creating an image database file, that means the memory card contains some images recorded by another camera. Select Enter to dismiss the message and then proceed.)

3. Find the Mode dial on top of the camera at the left, and turn it so the green AUTO label is next to the white indicator line, as shown in Figure 2-10.

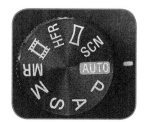

Figure 2-10. Mode Dial Auto

This sets the camera to the Intelligent Auto shooting mode. If you see the help screen that describes the mode (called the Mode Dial Guide by Sony), shown in Figure 2-11, press the Center button to dismiss it. (I'll explain how to dispense with that help screen altogether in Chapter 7.)

4. If you're indoors or in an area with low light, press the flash pop-up button, located on top of the camera to the right of the built-in flash unit, to release the flash unit and cause it to pop up. If you don't do this, the flash cannot be fired.

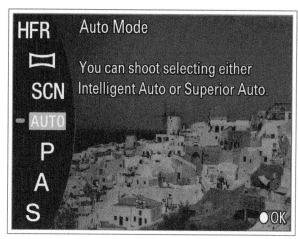

Figure 2-11. Mode Dial Guide - Auto Mode

5. Press the Menu button at the upper left of the camera's back to activate the menu system. As I discussed in Chapter 1, navigate through the menu screens by pressing the Right and Left buttons. The Shooting menu is headed by the camera icon; the Custom menu by the gear icon; the Wi-Fi menu by the Wi-Fi symbol; the Application menu by a group of black and white blocks; the Playback menu by the triangular Playback symbol; and the Setup menu by the toolbox icon. The currently active menu system has its symbol outlined by a gray line. You can tell which numbered screen of that menu system is active by looking at the small orange line (cursor) beneath the numbers.

6. When a given menu screen is selected, navigate up and down through the options on that screen by pressing the Up and Down buttons or by turning the Control wheel right or left. When the orange selection bar is on the option you want, press the Center button to select that item. Then press the Up and Down buttons or turn the Control wheel to highlight the value you want for that option, and press the Center button to confirm it. You can then continue making menu settings; when you are finished with the menu system, press the Menu button to go back to the live view, so you can take pictures.

7. Using the procedure in Step 6, make the settings shown in Table 2-1 for the Shooting menu. For menu options not listed here, any setting is acceptable for now.

Table 2-1. Suggested Settings for Shooting Menu in Intelligent
 Auto Mode

Image Size	L: 20M
Aspect Ratio	3:2
Quality	Extra Fine
Image Size (Dual Rec.)	L:17M
Quality (Dual Rec.)	Extra Fine
File Format	MP4
Record Setting	1920 x 1080 60p 28M
Dual Video REC	Off (not available)
HFR Settings	Default or As Needed
Drive Mode	Single shooting
Flash Mode	Autoflash
Red Eye Reduction	Off
Focus Area	Wide (can't be changed)
AF Illuminator	Auto
Center Lock-on AF	Off
Smile/Face Detection	Off
Auto Dual Rec	Off
Soft Skin Effect	Off
Auto Object Framing	Off
Auto Mode	Intelligent Auto
SteadyShot (Stills)	On
SteadyShot (Movies)	Standard
Color Space	sRGB
Auto Slow Shutter	On
Audio Recording	On
Audio Out Timing	Live
Wind Noise Reduction	Off
Memory	No setting needed

8. If you don't want to make all of these settings, don't worry; you are likely to get usable images even if you don't adjust most of these settings at this point. I have not included any recommendations for the Custom or Setup menus; the default settings should work well in Intelligent Auto mode. I will discuss all of the menu options later in the book.

9. Press the Menu button again to make the menu disappear, if it hasn't done so already.

10. Aim the camera to compose the picture. Locate the zoom lever on the ring that surrounds the shutter button on the top right of the camera. Push it to the left, toward the letter "W," to get a wider-angle shot (including more of the scene in the picture), or to the right, toward the letter "T," to get a telephoto,

zoomed-in shot. Or, if you prefer, grasp the ridged lens ring that controls zoom (the rear lens ring, unless the setting has been changed) and turn that ring to zoom in and out.

11. Once the picture looks good on the display, gently press the shutter button halfway and pause in that position. You should hear a beep and see one or more sets of green focus brackets on the LCD screen indicating that the subject will be in focus, as shown in Figure 2-12.

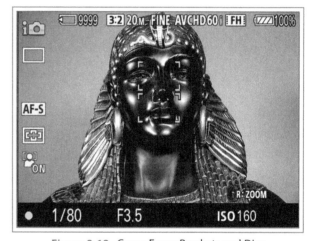

Figure 2-12. Green Focus Brackets and Disc

12. You also should see a green disc in the extreme lower left corner of the screen. If that green disc lights up steadily, the image is in focus; if it flashes, the camera was unable to focus. In that case, you can re-aim and see if the autofocus system does better from a different distance or angle.

13. After you have made sure the focus is sharp, push the shutter button all the way to take the picture.

VARIATIONS FROM FULLY AUTOMATIC

Although the RX10 III takes care of several settings when it's set to Intelligent Auto mode, this camera, unlike some other compact models, still lets you make a number of adjustments to fine-tune the shooting process.

Focus

With some compact cameras, you have few or no options for focus settings in the most automatic shooting mode. With the RX10 III, you always can control the camera's focus method, because of the physical focus switch. No matter what shooting mode is in effect, you always can turn this switch to a different setting, depending on how you want to focus the lens.

I will give a brief overview of focus options here, with further discussion in the chapters that discuss the various menu options and physical controls.

Focus Modes

There are four focus modes available with the RX10 III, as indicated by the four settings for the focus switch (S, C, DMF, and MF), as shown in Figure 2-5: single-shot autofocus, continuous autofocus, direct manual focus, and manual focus.

With the S setting, the camera starts to focus when you press the shutter button halfway down. At that point, it tries to achieve sharp focus on an object in the focus area. If it can focus sharply, it beeps and displays one or more green focus frames and a solid green disk. The focus stays locked at that distance as long as you hold the shutter button halfway down; you can then press the button the rest of the way down to take the picture.

With the C setting, when you press the shutter button halfway, the camera attempts to focus on an object in the focus area, but it then continues to adjust the focus as needed, if the camera or the subject moves. The camera does not lock the focus setting until you press the button all the way down to take the picture. The camera never displays a focus frame on the screen. The green disk appears in the lower left of the display when focus is achieved, but, as shown in Figure 2-13, it is surrounded by curving lines to indicate that the camera is continuing to adjust focus.

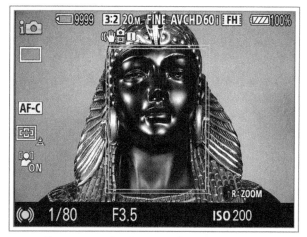

Figure 2-13. Curving Lines for Continuous AF

With the DMF setting, the camera lets you use both the autofocus capability of single autofocus and the manual focusing capability. With this combination of two focus modes, you can press the shutter button halfway to let

the camera use autofocus, and then continue to adjust focus by turning the rear or front lens ring, whichever is currently assigned to manual focus. Or, you can start to adjust focus manually in order to let the camera know approximately where the focus should be centered, and then press the shutter button halfway to let the camera fine-tune the focus on that subject.

Finally, with the MF setting, the focusing is entirely up to you. You turn the ring assigned to manual focus to bring the image into sharp focus, thereby taking full control. You might use manual focus in a dark or reflective environment where the camera would have difficulty, or in a situation where the camera might not focus on the subject that is most important to you. Another use of manual focus is for extreme closeup shots, when you need to adjust the focus distance very precisely. As I will discuss in Chapter 5 and Chapter 7, you can set the camera to provide assistance with manual focusing through several menu options.

My preference is to use the S setting for single autofocus in most situations. In tricky focusing environments, such as taking macro images or pictures of the moon, I often use manual focus with the focus-assisting aids provided by the camera. You may find that continuous autofocus is useful when you are taking pictures of subjects that are moving unpredictably, such as animals or children at play.

Other Settings

There are several other items that can be adjusted in Auto mode, but not many that will have an immediate and noticeable effect on your photography. For example, you can adjust items such as the aspect ratio (shape) of your images as well as the image size and quality. Those options are important when you want to have more control over your images, but, for general picture-taking in Intelligent Auto mode, they are not critical. I have set forth recommended settings in Table 2-1, and I will discuss details of those options in Chapter 4.

However, there are a few menu options that you might want to take advantage of when you first use the RX10 III in Intelligent Auto mode, and I will discuss those briefly now.

First, you might want to turn on face detection, so that, when the camera sees a human face, it will set its focus, exposure, and other settings to expose the

face properly. To do this, navigate to screen 6 of the Shooting menu and select the Smile/Face Detection menu option. Press the Center button and, on the next screen, select the next-to-bottom icon, depicting a face with the word On, as shown in Figure 2-14.

Figure 2-14. Face Detection On - Highlighted on Menu

With that setting, the camera will try to detect faces and set focus for them. You also can register particular faces for the camera to detect and you can set the camera to be triggered by smiles; I will discuss face registration in Chapter 7 and smile detection in Chapter 4.

You also might want to use the Soft Skin Effect option, so the camera will use processing to soften the appearance of skin tones. That option is located on screen 7 of the Shooting menu. It is effective only when face detection is turned on and a face is detected.

Another setting you might want to try for basic shooting is the Auto Mode option, the fourth item on screen 7 of the Shooting menu. Normally, this option is set to Intelligent Auto. If you select the other available setting, Superior Auto, the camera will use the same settings and functions as with Intelligent Auto mode, but it will go one step further. In appropriate conditions, the camera will use its special multiple-shot options. That is, if the environment is dark or lighted from behind (backlit), the camera may take a rapid burst of shots using a high ISO setting, and combine those shots internally to produce a composite image of higher quality than otherwise would be possible. I will discuss that option in Chapter 3.

Flash

Now I will provide more details about using the RX10 III's built-in flash unit, in case you are taking pictures

in dim lighting or need flash to soften shadows. In Chapter 4 I'll discuss the Flash Mode settings, Flash Compensation, and the prevention of "red-eye." In Appendix A, I'll discuss the use of external flash units.

The built-in flash on the RX10 III is not especially powerful, but it can provide enough illumination to let you take pictures in dark areas and to brighten up subjects that would otherwise be lost in shadows, even outdoors on a sunny day.

There is one important point to keep in mind about the built-in flash unit on the RX10 III: The flash will never pop up by itself, even if the menu settings or the ambient lighting would require use of the flash. In order for the flash to be available for use, you have to release it using the flash pop-up button, located on top of the camera to the right of the flash. In a way, this is a good system, because you can always be certain the flash will not fire by just not popping it up, when you are in a museum or other area that does not permit the use of flash. If you think you may need the flash, though, be sure to release it with this button before it is needed.

To control how the flash is used once it is popped up, you have to use the Flash Mode menu option, located on screen 3 of the Shooting menu. (You could set one of the control buttons to call up this menu option, as discussed in Chapter 7, but you still would be using the menu option.)

When you call up the Flash Mode option, using either the menu system or a button assigned to that option, you will see a vertical menu at the left of the screen, as shown in Figure 2-15.

Figure 2-15. Flash Mode Menu

That menu contains icons representing the six Flash Mode options—a lightning bolt with the universal "no" sign crossing it out, for Flash Off; a lightning bolt with the word "Auto," for Autoflash; a lightning bolt alone, for Fill-flash (meaning the flash will always fire); a lightning bolt with the word "Slow," for Slow Sync; a lightning bolt with the word "Rear," for Rear Sync; and a lightning bolt with the letters WL, for the Wireless setting.

With the camera in Intelligent Auto mode, the last three choices will appear dimmed; if you highlight one of those and press the Center button to select it, the camera will display a message saying you cannot make that selection in this shooting mode.

I discussed earlier how to set the flash unit to the Autoflash mode. If, instead of Autoflash, you choose Fill-flash, you will see the lightning bolt icon on the screen at all times (if the flash is popped up and no other icon interferes), and the flash will fire regardless of whether the camera's exposure system believes flash is needed. You can use this setting when you are certain that you want the flash to fire, such as in a dimly lighted room. This setting also can be useful in some outdoor settings, even when the sun is shining, such as when you need to reduce the shadows on your subject's face. There is an illustration of the use of Fill-flash in Figure 4-33 in Chapter 4.

When the camera is set for certain types of shooting, such as using the self-timer with multiple shots, the flash is forced off and cannot be turned on. With some other settings, such as continuous shooting, the flash will fire if you set it to do so, but the use of flash will limit the use of the other setting. In other words, instead of doing rapid continuous shooting, the camera will take multiple images but at a reduced rate, because the flash cannot recycle fast enough to fire repeatedly in rapid succession. In some situations, such as when you are using the Night Scene setting of Scene mode, the Flash Mode menu will not even appear; that option will be dimmed on the menu screen, as shown in Figure 2-16.

If you set the Mode dial to P, for Program mode, and then use the menu system to select a flash mode, you will see the same six options for Flash Mode on the menu, but this time the Autoflash option will be dimmed because that selection is available only in the more automatic modes.

Figure 2-16. Flash Mode Menu Item Dimmed for Night Scene

In addition, the Flash Off option will be dimmed; that option is available only in Auto mode and with some settings in Scene mode. Of course, if you don't want the flash to fire, you can just leave the flash unit retracted.

In summary, when using Intelligent Auto mode, if you don't want the flash to fire because you are in a museum or similar location, you can select the Flash Off mode. If you want to leave the decision whether to use flash up to the camera, you can select Autoflash mode. If you want to make sure that the flash will fire no matter what, you can select Fill-flash mode. In Chapter 4, I'll explain the other flash options—Slow Sync, Rear Sync, and Wireless—and I'll discuss other flash-related topics. For now, you have the information you need to select a flash mode when the camera is set to the Intelligent Auto shooting mode.

Drive Mode: Self-Timer and Continuous Shooting

The Drive Mode menu option provides more adjustments you may want to make when using Intelligent Auto mode. Select this menu item from screen 3 of the Shooting menu, and the camera will display a vertical menu for Drive Mode, as shown in Figure 2-17.

Figure 2-17. Drive Mode Menu

You navigate through the options on this menu by pressing the Up and Down buttons or by turning the Control wheel.

I will discuss the Drive Mode options more fully in Chapter 4. For now, you should be aware of a few of the options. (I will skip over some others.) If you select the top option, represented by a single rectangular frame, the camera is set for single shooting mode; when you press the shutter button, a single image is captured. With the second option, whose icon looks like a stack of images, the camera is set for continuous shooting, in which it takes a rapid burst of images while you hold down the shutter button.

If you choose the fourth option, whose icon is a dial with a number beside it, the camera uses the self-timer. Use the Left and Right buttons to choose two, five, or ten seconds for the timer delay and press the Center button to confirm. Then, when you press the shutter button, the shutter will be triggered after the specified number of seconds.

The ten-second delay is useful when you need to place the camera on a tripod and join a group photo; the two-second or five-second delay is useful when you want to make sure the camera is not jiggled by the action of pressing the shutter button. This option helps when you are taking a picture for which focusing is critical and you need to avoid shaking the camera, such as an extreme closeup or a time exposure. I will discuss the use of the self-timer and other Drive Mode options in more detail in Chapter 4.

Overview of Movie Recording

Now I'll discuss recording a short movie sequence with the RX10 III. Once the camera is turned on, turn the Mode dial to select the green AUTO icon, for Intelligent Auto mode. There is a special Movie mode setting marked by the movie film icon on the Mode dial, but you don't have to use that mode for shooting movies; I'll discuss the use of that option and other details about video recording in Chapter 8.

On the top line of the second screen of the Shooting menu, highlight File Format and press the Center button to go to the submenu with four choices for the format of movie recording. For now, be sure the fourth option, MP4, is highlighted, as shown in Figure 2-18; that format provides high quality for your videos without requiring a special memory card and is easy to edit or upload using a computer.

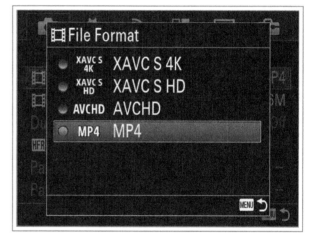

Figure 2-18. MP4 Menu Item Highlighted for File Format

(As discussed in Chapter 1, if you select XAVC S 4K or XAVC S HD for the movie format, you have to use a memory card with a speed of Class 10 or greater.) The AVCHD setting provides excellent quality but can be challenging to edit and work with using a computer.

Using the focus switch on the front of the camera, select either S for single autofocus or C for continuous autofocus. With either setting, the camera will use continuous autofocus for recording movies.

For the rest of the settings, I will provide a table like the one included earlier in this chapter for shooting still images. The settings shown in Table 2-2 are standard ones for shooting good-quality movies.

Table 2-2. Suggested Shooting Menu Settings for Movies in Intelligent Auto Mode

File Format	MP4
Record Setting	1920 x 1080 60p 28M
Dual Video REC	Off (not available)
Auto Dual Rec	Off
SteadyShot (Movies)	Standard
Auto Slow Shutter	On
Audio Recording	On
Audio Out Timing	Live
Wind Noise Reduction	Off

There are some other settings you can make for still images on the Shooting menu that will affect movie recording; I will discuss that topic in Chapter 8. For now, if you are going to be shooting a movie that shows people's faces, you may want to go to screen 6 of the Shooting menu and set the Face Detection item to On. You can leave the other items set as they were for shooting still images, as listed in Table 2-1.

After making these settings, aim the camera at your subject, and when you are ready to start recording, press and release the red Movie button at the upper right corner of the camera's back. (If you see an error message, go to screen 6 of the Custom menu, marked by a gear icon, and set the Movie Button option to Always.)

The screen will display a red REC icon in the lower left corner of the display, above a counter showing the elapsed time in the recording, as shown in Figure 2-19.

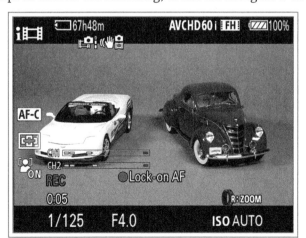

Figure 2-19. REC Icon on Shooting Screen

The camera may also display recording-level indicators to show the volume of sound being recorded for channel 1 and channel 2, depending on other menu

options. Hold the camera as steady as possible (or use a tripod), and pan it (move it side to side) smoothly if you need to. The camera will keep shooting until it reaches a recording limit, or until you press the red Movie button again to stop the recording. (The maximum time for continuous recording of any one scene is about 29 minutes in most situations.)

The camera will automatically adjust exposure as lighting conditions change. You can zoom the lens in and out as needed, but you should do so sparingly if at all, to avoid distracting the audience and to avoid recording sounds of zooming the lens on the sound track. When you are finished, press the Movie button again, and the camera will save the footage.

Those are the basics for recording video clips with the RX10 III. I'll discuss movie options in more detail in Chapter 8.

Viewing Pictures

Before I cover more advanced settings for taking still pictures and movies, as well as other matters of interest, I will discuss the basics of viewing your images in the camera.

REVIEW WHILE IN SHOOTING MODE

Each time you take a still picture, the image will show up on the LCD screen (or in the viewfinder) for a short time, if you have the Auto Review option on screen 2 of the Custom menu set to turn on this function. I'll discuss the details of that setting in Chapter 7. By default, the image will stay on the screen for two seconds after you take a new picture. If you prefer, you can set that display to last for five or ten seconds, or to be off altogether.

REVIEWING IMAGES IN PLAYBACK MODE

To review images taken previously, you enter playback mode by pressing the Playback button—the one with the small triangle icon to the lower left of the Control wheel. To view all still images and movies for a particular date, go to screen 1 of the Playback menu and set the View Mode option to Date View. If you prefer, you can set View Mode to show only stills, only MP4 movies, only AVCHD movies, only XAVC S HD movies, or only XAVC S 4K movies.

Once you choose a viewing option, you can scroll through recorded images and movies by pressing the Left and Right buttons or by turning the Control wheel or Control dial. Hold down the Left or Right button to move more quickly through the images. You can enlarge the view of any still image by moving the zoom lever on top of the camera toward the T position, and you can scroll around in the enlarged image using the four direction buttons.

If you press the zoom lever in the other direction, toward the wide-angle setting, the image will return to normal size. If you press the lever once more in that direction, you will see an index screen with a number of thumbnail images (either 9 or 25, depending on a Playback menu option). A further press brings up a folder view or a calendar screen for selecting images or videos by date, depending on the View Mode setting. You can select images from the index and date screens by pressing the Center button on a highlighted thumbnail image. I'll discuss other playback options in Chapter 6.

PLAYING MOVIES

To play movies, move through the files by the methods described above until you find the movie you want to play. You should see a triangular playback icon inside a circle, as shown in Figure 2-20.

Figure 2-20. Movie Ready for Playback.

Press the Center button to start the movie playing. Then, as seen in Figure 2-21, you will see icons at the bottom of the screen for the controls you can use, including the Center button to pause and resume play.

Figure 2-21. Basic Movie Playback Controls

Figure 2-22. More Detailed Movie Playback Controls

(If you don't see the controls, press the Display button until they appear.) You also can press the Down button to bring up a more detailed set of controls on the screen, as shown in Figure 2-22.

To change the volume, pause the movie and press the Down button to bring up the detailed controls; then navigate to the speaker icon, next to last at the right of those controls. Press the Center button to select volume, then use the Control wheel, the Control dial, or the Right and Left buttons to adjust the volume. You also can adjust the volume before a movie starts playing, by pressing the Down button to bring up the volume control. To exit from playing the movie, press the Playback button. (I'll discuss other movie playback options in Chapter 8.)

If you want to play movies on a computer or edit them with video-editing software, you can use the PlayMemories Home software that is provided through the Sony web site. You also can use any program that can deal with AVCHD and MP4 video files, such as Adobe Premiere Elements, Adobe Premiere Pro, Final Cut Express, Final Cut Pro, iMovie, or Windows Movie Maker, depending on what type of computer you have.

CHAPTER 3: SHOOTING MODES FOR STILL IMAGES

Until now, I have discussed the basics of setting up the camera for quick shots, using Intelligent Auto mode to take pictures with settings controlled mostly by the camera's automation. As with other advanced cameras, though, with the Sony RX10 III there is a large range of other options available. To explain this broad range of features, I need to discuss two subjects—shooting modes and the Shooting menu options. In this chapter, I'll discuss the shooting modes; in Chapter 4, I'll discuss the Shooting menu.

Whenever you set out to capture still images, you need to select one of the shooting modes available on the Mode dial: Intelligent Auto, Program Auto, Aperture Priority, Shutter Priority, Manual exposure, Memory Recall, Sweep Panorama, or Scene Selection. (The other two modes on the dial are for movies, which I will discuss in Chapter 8.) So far, I have discussed primarily the Intelligent Auto mode. Now I will discuss the others, after some review of the first one.

Intelligent Auto Mode

I've already discussed this shooting mode in some detail. This is a good choice if you need to take a quick shot and don't have much time to fuss with settings such as ISO, white balance, aperture, shutter speed, or focus. It's also a good mode to select when you hand the camera to someone else to take a photo of you and your companions.

For example, I used Intelligent Auto mode to grab a quick shot of the downtown skyline near the river, as seen in Figure 3-1. To set this mode, turn the Mode dial to the green AUTO label, as shown in Figure 3-2. When you select this mode, the camera makes several decisions for you and limits your options in some ways. The camera will select the shutter speed, aperture, and ISO setting, along with several other settings over which you will have no control.

Figure 3-1. Intelligent Auto Example

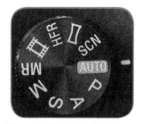

Figure 3-2. Mode Dial Auto

For example, you can't set white balance to any value other than Auto, and you can't choose a metering method or use exposure bracketing. You can, however, use quite a few features, as discussed in Chapter 2, including Flash Mode, some settings of Drive Mode, Smile/Face Detection, and others. You also can use sophisticated options such as the Raw format, which I will discuss in Chapter 4 when I discuss other Shooting menu options.

One interesting aspect of this mode is that the camera tries to figure out what sort of subject or scene you are shooting. Some of the subjects the camera will attempt to detect are Baby, Portrait, Night Portrait, Night Scene, Landscape, Backlight, Low Light, and Macro. It also will try to detect certain conditions, such as whether a tripod is in use or whether the subject is walking, and it will display appropriate icons for those situations. So, if you see different icons when you aim at various subjects in this shooting mode, that means the camera is evaluating the scene for factors such as brightness, backlighting, the

presence of human subjects, and the like, so it can use the best possible settings for the situation.

The camera will not detect the portrait-oriented scenes (Baby, Portrait, Night Portrait, etc.) unless Face Detection is turned on in screen 6 of the Shooting menu.

For Figure 3-3, the camera evaluated a scene with two human faces and appropriately used its Portrait setting. A Portrait icon is in the upper-left corner of the screen.

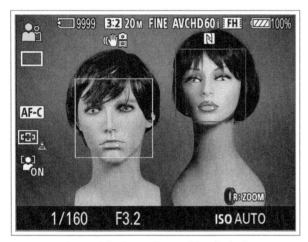

Figure 3-3. Scene Recognition Portrait

Figure 3-4 shows the use of automatic scene recognition for a subject closer to the lens. The camera interpreted the scene as a macro, or closeup shot, and switched automatically into Macro mode, indicated by the flower icon.

Figure 3-4. Scene Recognition Macro

In addition, the camera correctly detected that it was attached to a tripod, as indicated by the tripod icon to the lower right of the macro symbol.

Of course, scene recognition depends on the camera's programming, which may not interpret every scene the same way that you would. If that becomes a problem, you may want to make individual settings using one of the more advanced shooting modes, such as Program, Aperture Priority, Shutter Priority, or Manual. Or, you can use the SCN setting on the Mode dial and select a scene setting that better fits the current situation.

One more point is worth noting for this mode: The camera is programmed to avoid apertures more narrow than f/11.0 in this mode. Therefore, it will vary the shutter speed and ISO settings to avoid having to set the aperture to f/16.0 or other aperture settings above f/11.0. It also will not use a shutter speed slower than 1/4 second.

SUPERIOR AUTO MODE

With some Sony cameras, such as the RX100, RX100 II, and RX100 III, there are two Auto settings on the Mode dial—one for Intelligent Auto and one for a slightly different mode called Superior Auto. With the RX10 III, Sony has included this second automatic mode, but has not given it a separate position on the Mode dial. Instead, you have to go to screen 7 of the Shooting menu and select the Auto Mode menu option. When you select that item, you will see a screen for choosing Intelligent Auto or Superior Auto. If you select the lower icon for Superior Auto, the camera will be set to that mode, as shown in Figure 3-5.

Superior Auto mode includes all features of Intelligent Auto mode, but adds an extra function. In Superior Auto mode, as with Intelligent Auto mode, the camera uses its scene recognition capability to try to determine what subject matter or conditions are present, such as a portrait, a dimly lit scene, and the like.

For many of these scenes, the camera will function just as it does in Intelligent Auto mode. However, in a few specific situations, the camera will take a different approach: It will take a rapid burst of shots and combine them internally into a single composite image of higher quality than would be possible with a single shot. The higher quality can be achieved because the camera generally has to raise the ISO setting to a fairly high level, which introduces visual "noise" into the image.

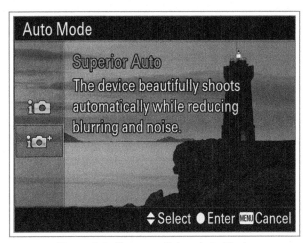

Figure 3-5. Screen to Select Auto Mode

By taking multiple shots and then combining them, the camera can average out and cancel some of the noise, thereby increasing the quality of the resulting image.

One problem with this system is that you have no control over when the camera decides to use this burst shooting technique. There are three situations in which the camera will do this: when it detects the need for settings called Anti Motion Blur, Hand-held Twilight, or Backlight Correction HDR. When the camera believes this special feature is needed, it fires a burst of shots; you will hear the rapid firing. Then, it will take longer than usual for the camera to process the multiple shots into a single composite image; you will likely see a message saying "Processing" on the screen for several seconds. When the camera is using this feature, which Sony calls "Overlay," you will see a small white icon in the upper-left corner of the display that looks like a stack of frames with a plus sign at its upper-right corner, as shown in Figure 3-6.

Figure 3-6. Overlay Icon on Display

Two of the settings the camera may use in Superior Auto mode—Anti Motion Blur and Hand-held Twilight—are available also as selections in Scene mode, discussed later in this chapter. The third—Backlight Correction HDR—is available only in Superior Auto mode, and only when the camera decides to use it. None of the multiple-shot settings will function when Quality is set to Raw or Raw & JPEG.

I have not found much advantage in using the Superior Auto setting. However, there may be cases when the burst-shooting feature will improve image quality, so it is not a bad idea to use Superior Auto mode when shooting in low light or backlit conditions. As a general rule, though, I prefer to use a mode such as Program, discussed below, and set my own values for items such as DRO, HDR, ISO, and Metering Mode.

If you want to use Superior Auto mode, there is an easier way to get access to it than selecting Auto Mode from screen 7 of the Shooting menu. Instead, use the Function Menu Settings option on screen 5 of the Custom menu, and set one of the 12 settings for the Function menu to Shoot Mode. Then, whenever you turn the Mode dial to the AUTO setting, just press the Function button, and you will see on the Function menu the icon for the current setting for Auto Mode, either Intelligent Auto or Superior Auto. At this point, move the highlight block to that icon using the direction buttons, and, when the icon is highlighted, turn the Control wheel to cycle through the choices. When your new selection (either Intelligent Auto or Superior Auto) is highlighted, just press the Function button to exit to shooting mode.

Program Mode

Choose this mode by turning the Mode dial to the P setting, as shown in Figure 3-7.

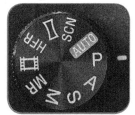

Figure 3-7. Mode Dial Program

Program mode (sometimes called Program Auto mode) lets you control many of the settings available with the RX10 III, apart from shutter speed and aperture, which

the camera chooses on its own. You still can adjust the camera's automatic exposure to a fair extent by using exposure compensation, as discussed in Chapter 5, as well as exposure bracketing, discussed in Chapter 4, and Program Shift, discussed later in this section. You don't have to make a lot of decisions if you don't want to, because the camera will make reasonable choices for you as defaults.

The camera can choose a shutter speed as long as 30 seconds or as short as 1/32000 second, depending on the setting of the Shutter Type option on screen 4 of the Custom menu. It can choose any aperture in its full range from f/2.4 to f/16.0.

The Program Shift function is available only in Program mode; it works as follows. Once you have aimed the camera at your subject, the camera displays its chosen settings for shutter speed and aperture in the lower left corner of the screen. At that point, you can turn the Control dial at the upper right of the camera's back, and the values for shutter speed and aperture will change, if possible under current conditions, to select different values for both settings while keeping the same overall exposure of the scene.

With this option, the camera "shifts" the original exposure to your choice of any of the matched pairs that appear as you turn the Control dial. For example, if the original exposure was f/2.8 at 1/30 second, you may see equivalent pairs of f/3.2 at 1/25, f/3.5 at 1/20, and f/4.0 at 1/15, among others. When Program Shift is in effect, the P icon in the upper-left corner of the screen will have an asterisk to its right, as shown in Figure 3-8.

Figure 3-8. Asterisk for Program Shift

To cancel Program Shift, turn the Control dial until the original settings are in effect or move the Mode dial to another mode, then back to Program. You also can cancel by pressing the flash pop-up button to raise the flash; Program Shift cannot function with flash in use.

When would you use Program Shift? You might want a slightly faster shutter speed to stop action better or a wider aperture to blur the background more, or you might have some other creative reason. This option lets the camera quickly evaluate the exposure, but gives you the option to tweak the shutter speed and aperture to suit your current needs.

Of course, if you need to use a specific shutter speed or aperture, you probably are better off using Aperture Priority, Shutter Priority, or Manual exposure mode. However, having Program Shift available is useful when you're taking pictures quickly using Program mode, and you want a fast way to tweak the settings somewhat.

Another important aspect of Program mode is that it expands the choices available through the Shooting menu, which controls many of the camera's settings. You will be able to make choices involving ISO sensitivity, Metering Mode, DRO/HDR, white balance, Creative Style, Picture Effect, and others that are not available in the Auto modes. I won't discuss those settings here; if you want to explore that topic, see the discussion of the Shooting menu in Chapter 4 for information about all of the different selections that are available.

Aperture Priority Mode

You select Aperture Priority shooting mode by turning the Mode dial to the A setting, as shown in Figure 3-9.

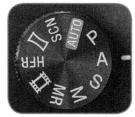

Figure 3-9. Mode Dial Aperture Priority

In this mode, you select the aperture and the camera chooses a shutter speed for proper exposure. With this mode, you can exercise control over depth of field of your shots. When you select a narrow aperture, such as f/16.0, the depth of field will be broad, with the result that more items will appear to be in sharp focus

at varying distances from the lens. On the other hand, with a wide aperture, such as f/2.4, the depth of field will be relatively shallow, and you may be able to keep only one subject in sharp focus.

In Figures 3-10 and 3-11, the settings were the same except for aperture values. I focused on the purple flower in each case. For Figure 3-10, I set the aperture of the RX10 III to f/2.4, the widest possible. With this setting, because the depth of field at this aperture was quite shallow, the trees and bushes in the background are fairly blurry. I took Figure 3-11 with the camera's aperture set to f/16.0, the narrowest possible setting, resulting in a broader depth of field, making the background appear considerably sharper.

Figure 3-10. Aperture Set to f/2.4

Figure 3-11. Aperture Set to f/16.0

These photos illustrate the effects of varying aperture by setting it wide (low numbers) to blur the background or narrow (high numbers) to enjoy a broad depth of field and keep subjects at varying distances in sharp focus. A need for shallow depth of field arises often in the case of outdoor portraits. If you can achieve a shallow depth of field by using a wide aperture, you can keep your subject in sharp focus but leave the background blurry, as in Figure 3-10. This effect is sometimes called "bokeh," a Japanese term for a pleasing blurriness of the background. In this situation, the fuzzy background can be a great asset, minimizing distraction from unwanted objects and highlighting the sharply focused portrait of your subject.

Here is the procedure for using this shooting mode. With the Mode dial at the A setting, use the aperture ring to select the aperture value. The major settings are f/2.4, f/4, f/5.6, f/8, f/11, and f/16, but you can also make intermediate settings by turning the ring to one of the white lines between the numbered values. For example, between f/2.4 and f/4, you can select f/2.8, f/3.2, or f/3.5.

When you are shooting stills in either Aperture Priority or Manual exposure mode, I recommend setting the aperture click switch to its Click On position, as shown in Figure 3-12.

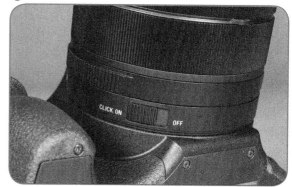

Figure 3-12. Aperture Click Switch at On Position

With that setting, the aperture ring clicks firmly into place for each available aperture setting, so you get definite feedback when the setting is made. The only reason to turn the click setting off is when you are shooting videos, because the sounds of the clicks are likely to be heard on the audio track.

When you set the aperture, as seen in Figure 3-13, the f-stop (f/4.0 in this case) will appear at the bottom of the screen next to the shutter speed. The camera will select a shutter speed that will result in a proper exposure given the aperture you have set. When the Shutter Type option on screen 4 of the Custom menu is set to Auto or Electronic, the camera can choose shutter speeds from 30 seconds to 1/32000 second.

Figure 3-13. Aperture Value on Display Screen

When Shutter Type is set to Mechanical, the range of available shutter speeds is from 30 seconds to 1/2000 second, but this range is also dependent on the aperture setting. The camera can set the mechanical shutter speed to 1/2000 second only when the aperture is set to f/8.0 or narrower. When the aperture is wider than f/8.0 (lower numbers), the fastest mechanical shutter speed available is 1/1000 second.

Although in most cases the camera will be able to select a corresponding shutter speed that results in a normal exposure, there may be times when this is not possible. For example, if you are taking pictures in a very bright location with the aperture set to f/2.4, the camera may not be able to set a shutter speed fast enough to yield a normal exposure, especially if you are using the mechanical shutter instead of the electronic shutter. In that case, the fastest possible shutter speed (1/1000 second at that aperture) will flash on the display to show that a normal exposure cannot be made using the chosen aperture. The camera will let you take the picture, but it may be too bright to be usable.

Similarly, if conditions are too dark for a good exposure at the aperture you have selected, the slowest possible shutter speed (30", meaning 30 seconds) will flash.

In situations where conditions are too bright or dark for a good exposure, the camera's display may become bright or dark, giving you notice of the problem. This will happen if the Live View Display item on screen 3 of the Custom menu is set to Setting Effect On. If that option is set to Setting Effect Off, the display will remain at normal brightness, even if the exposure settings would result in an excessively bright or dark image. I will discuss that menu option in Chapter 7.

One more note on Aperture Priority mode: Not all apertures are available at all times. In particular, the widest aperture, f/2.4, is available only when the lens is zoomed out to its wide-angle setting (zoom lever moved toward the W). At the highest zoom levels, the widest aperture available is f/4.0.

To see an illustration of this point, here is a quick test. Zoom the lens out by moving the zoom lever all the way to the left, toward the W label. Then select Aperture Priority mode and set the aperture to f/2.4. Now zoom the lens in by moving the zoom lever to the right. After the zoom is finished, the aperture will have changed to f/4.0 because that is the limit for the aperture at the full-telephoto zoom level. (The aperture will change back to f/2.4 if you zoom back to the wide-angle setting.)

Also, when you set an aperture as narrow as f/16 with this camera, lens diffraction comes into play and limits the sharpness of your images. So, unless you have a fairly strong reason to use f/16, such as a need to maximize depth of field in a brightly lighted area, you should try to use apertures no more narrow than f/11.0 if possible.

Shutter Priority Mode

In Shutter Priority mode, you choose the shutter speed you want and the camera will set the corresponding aperture to achieve a proper exposure of the image.

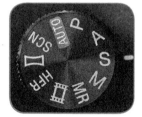

Figure 3-14. Mode Dial Shutter Priority

In this mode, designated by the S position on the Mode dial, as shown in Figure 3-14, you can set the shutter to be open for a time ranging from 30 seconds to 1/32000 of a second, if the Shutter Type menu option is set to Auto or Electronic. If that option is set to Mechanical, the fastest setting available is 1/2000 second. However, the range of settings with the mechanical shutter is also dependent on the aperture setting. You can set the mechanical shutter speed to 1/2000 second only when the aperture is set to f/8.0 or higher. When the aperture is wider than f/8.0, such as f/4.0, the fastest mechanical shutter speed that can be set is 1/1000 second.

So, if you set a mechanical shutter speed of 1/2000 second in somewhat dark conditions, the camera cannot select an aperture wider than f/8.0, which may result in an excessively dark image. If that happens, select a slower shutter speed so the camera can select an appropriate aperture for current lighting conditions. (Or, you can switch to using the electronic shutter by setting the Shutter Type option to Auto or Electronic, in which case this problem will not arise.)

If the built-in flash is in use, the fastest setting available is 1/100 second with the electronic shutter and either 1/2000 or 1/1000 second with the mechanical shutter, depending on the aperture setting. If an external flash is in use, you can set the shutter speed as high as 1/4000 second when Shutter type is set to Auto.

If you are photographing fast action, such as a baseball swing or a hurdles event at a track meet, and you want to stop the motion with a minimum of blur, you should select a fast shutter speed, such as 1/1000 of a second. For Figure 3-15 and Figure 3-16, I used different shutter speeds in photographing uncooked rice as I poured it into a clear pitcher.

Figure 3-15. Shutter Speed Set to 1/2000 Second

In Figure 3-15, I used a shutter speed setting of 1/2000 second. In this image, you can see the individual grains of rice. In Figure 3-16, with the shutter speed set to 1/20 second, the grains flow together into what looks like a continuous stream.

You select this shooting mode by turning the Mode dial to the S indicator, as shown in Figure 3-14. Then you

select the shutter speed by turning the Control dial, at the upper right of the camera's back.

Figure 3-16. Shutter Speed Set to 1/20 Second

If you turn on the Exposure Settings Guide option on screen 3 of the Custom menu, you will see a circular display of the shutter speeds as you turn the Control dial, as shown in Figure 3-17.

Figure 3-17. Shutter Speed Display with Exposure Settings Guide

Although the RX10 III uses the letter "S" to stand for Shutter Priority on the Mode dial and to designate this mode on the live view screen, it uses the notation "Tv" on the Shooting mode display in Shutter Priority mode, next to the Control dial icon. Tv stands for time value, a term often used for shutter speed. (You can see the Tv indicator in Figure 3-19, where it is shown in Manual exposure mode.)

As you cycle through various shutter speeds, the camera will select the appropriate aperture to achieve a normal exposure, if possible. As I discussed in connection

with Aperture Priority mode, if you set a shutter speed for which the camera cannot select an aperture that will yield a good exposure, the aperture reading at the bottom of the display will flash. The flashing aperture means that proper exposure at the selected shutter speed is not possible at any available aperture, according to the camera's calculations.

For example, if you set the shutter speed to 1/320 second in a fairly dark indoor environment, the aperture number (which will be f/2.4, the widest setting, if the lens is at its wide-angle setting) may flash, indicating that proper exposure is not possible. As I discussed for Aperture Priority mode, you can still take the picture if you want to, though it may not be usable. A similar situation may take place if you select a slow shutter speed (such as four seconds) in a relatively bright location. (This situation is less likely to happen in Aperture Priority mode, because of the wide range of shutter speeds the camera can use to achieve a good exposure.)

If the current settings in this mode would result in an image that is excessively dark or bright, the LCD display will grow dark or bright to show that effect, but only if a menu option is set a certain way. If you want to see how the final image would look while viewing it on the display, go to screen 3 of the Custom menu and set the Live View Display option to Setting Effect On. If the option is set to Setting Effect Off, then the display will show a normal image even in unusually bright or dark conditions. That option is discussed further in Chapter 7.

Sony has programmed the RX10 III not to use apertures more narrow than f/11 in this shooting mode; if you aim the camera at a bright subject in Shutter Priority mode, you may see the f/11 aperture setting blink, indicating that the exposure cannot be made properly under current conditions. This is apparently because Sony has determined that an aperture of f/16 is too likely to cause lens diffraction that has a negative impact on image sharpness. If you want to use an aperture setting of f/16, you will have to use Aperture Priority Mode, Manual exposure mode, or Program mode. (This limitation does not apply when you are recording videos in this mode.)

Manual Exposure Mode

One of the many features of the RX10 III that distinguish it from more ordinary compact cameras

is that it has a fully manual exposure mode, a useful tool for photographers who want to have full creative control over exposure decisions.

The technique for using this mode is similar to what I discussed for the Aperture Priority and Shutter Priority modes. To control exposure manually, set the Mode dial to the M indicator, as shown in Figure 3-18.

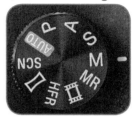

Figure 3-18. Mode Dial Manual Exposure

You now have to control both shutter speed and aperture by setting them yourself. To set the aperture, turn the aperture ring; to set the shutter speed, turn the Control dial at the upper right of the back of the camera. The values you set will appear at the bottom of the display, as shown in Figure 3-19.

As you adjust shutter speed and aperture, a third value, to the right of the aperture, also may change. That value is a positive, negative, or zero number. The meaning of the number is different depending on the current ISO setting.

Figure 3-19. Manual Exposure Mode: Aperture and Shutter Speed on Display Screen

(In Chapter 4, I'll provide more details about the ISO setting, which controls how sensitive the camera's sensor is to light. With a higher ISO value, the sensor is more sensitive and the image is exposed more quickly, so the shutter speed can be faster or the aperture more narrow, or both.)

To set the ISO value, press the Menu button to access the Shooting menu, go to the fourth screen, and highlight the ISO item. Press the Center button to bring up the ISO menu, as shown in Figure 3-20, and scroll through the selections using the Up and Down buttons or by turning the Control wheel or the Control dial.

Choose a low number like 100 to maximize image quality when there is plenty of light; use a higher number in dim light. Higher ISO settings are likely to cause visual "noise," or graininess, in your images. Generally speaking, you should try to set ISO no higher than 800 to ensure the highest image quality.

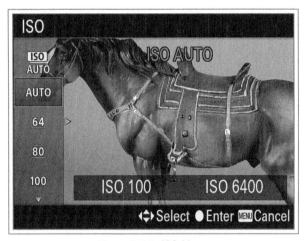

Figure 3-20. ISO Menu

If the ISO value is set to a specific number, such as 125, 200, or 1000, then, in Manual exposure mode, the icon at the bottom center of the display is a box containing the letters "M.M.," which stand for "metered manual," as shown in Figure 3-21.

Figure 3-21. M.M. on Display in Manual Exposure Mode

In this situation, the number next to the M.M. icon represents any deviation from what the camera's

metering system considers to be a normal exposure. So, even though you are setting the exposure manually, the camera will still let you know whether the selected aperture and shutter speed will produce a standard exposure.

If the aperture, shutter speed, and ISO values you have selected will result in a darker exposure than normal, the M.M. value will be negative, and vice-versa. This value can vary only by +2.0 or -2.0 EV (exposure value) units; after that, the value will flash, meaning the camera considers the exposure excessively abnormal.

Of course, you can ignore the M.M. indicator; it is there only to give you an idea of how the camera would meter the scene. You very well may want part or all of the scene to be darker or lighter than the metering would indicate to be "correct."

As with the Aperture Priority and Shutter Priority modes, the camera's display will become unusually bright or dim to indicate that current settings would result in an abnormal exposure, but only when the Live View Display menu option on screen 3 of the Custom menu is set to Setting Effect On. For example, Figure 3-22 shows the camera's display when Manual exposure settings would result in a dark image, with Setting Effect On.

Figure 3-22. Manual Exposure Settings for Dark Image

If, instead of a specific value, you have set ISO to Auto ISO, the icon at the bottom center of the screen changes. In this situation, the camera displays the exposure compensation icon, which contains a plus and minus sign, as shown in Figure 3-19. The reason for this change is that, when you use Auto ISO in Manual exposure mode, the camera can likely produce a normal exposure by adjusting the ISO. There is no need to

display the M.M. value, which shows deviation from a normal exposure.

Instead, the camera lets you adjust exposure compensation, so you can set the exposure to be darker or brighter than the camera's autoexposure system would produce.

To set exposure compensation in Manual mode, just turn the exposure compensation dial at the far right of the camera's top. Or, if you prefer, you can assign exposure compensation to the C1, C2, C3, Center, Left, Right, Down, Focus Hold, or AEL button. You make that assignment using the Custom Key (Shooting) option on screen 5 of the Custom menu, as discussed in Chapter 7. You also can use the Function menu to adjust exposure compensation, if that adjustment has been included in that menu, as discussed in Chapter 7.

With Manual exposure mode, the settings for aperture and shutter speed are independent of each other. When you change one, the other one stays unchanged until you adjust it manually. But the effect of this system is different depending on whether you have selected a specific value for ISO as opposed to Auto ISO.

If you select a numerical value for ISO, which can range from 64 to 12800 (or even higher when Multi Frame Noise Reduction is selected for the ISO setting), the camera leaves the creative decision about exposure entirely up to you, even if the resulting photograph would be washed out by excessive exposure or underexposed to the point of near-blackness.

However, if you select Auto ISO for the ISO setting, then, as discussed above, the camera will adjust the ISO to achieve a normal exposure if possible. In this case, Manual exposure mode becomes like a different shooting mode altogether. You might call this the "aperture and shutter speed priority mode," because you are able to set both aperture and shutter speed but still have the camera adjust exposure automatically by changing the ISO value.

The ability to use Auto ISO in Manual exposure mode is very useful. For example, suppose you are taking photographs of a craftsman using tools in a dimly lighted area. You may want to use a narrow aperture such as f/7.1 to achieve a broad depth of field and keep the tools and other items in focus, but you also may want to use a fast shutter speed, such as 1/250 second, to freeze

action. If you use Aperture Priority mode, the camera will choose the shutter speed; with Shutter Priority mode, the camera will choose the aperture, and with Program mode, the camera will choose both values. Only by using Manual exposure mode with Auto ISO can you choose both aperture and shutter speed and still have the camera find a good exposure setting automatically.

Even with the ability to use Auto ISO, though, there may be situations in which the camera cannot produce a normal exposure. This could happen if you have limited the scope of the Auto ISO setting by setting a narrow range between the Minimum and Maximum settings for Auto ISO. It also could happen if you have chosen extreme settings for aperture and shutter speed, such as 1/500 second at f/11.0 in dark conditions. In such situations, the ISO Auto label and the exposure compensation value at the bottom of the display will flash, indicating that a normal exposure cannot be achieved with these settings.

The range of apertures you can set in Manual mode is the same as for Aperture Priority mode: f/2.4 to f/16.0. (As with other shooting modes, the widest apertures are not available when the lens is zoomed in.)

The range of shutter speeds in Manual mode is the same as for Shutter Priority mode: 1/32000 second to 30 seconds if Shutter Type is set to Auto or Electronic and 1/2000 second to 30 seconds if Shutter Type is Mechanical. However, as with Aperture Priority and Shutter Priority modes, you can set the mechanical shutter speed to 1/2000 second only when the aperture is set to f/8.0 or higher. At wider apertures, such as f/4.0, 1/1000 second is the fastest setting available for the mechanical shutter.

If the flash is in use, the fastest setting available is 1/100 second with the electronic shutter and either 1/2000 or 1/1000 second with the mechanical shutter, depending on the aperture setting. If an external flash is in use, the fastest shutter speed available is 1/4000 second when Shutter Type is set to Auto.

There is one important addition to the range of shutter speeds in this shooting mode. In Manual exposure mode, if Shutter Type is set to Mechanical or Auto, you can set the shutter speed to the BULB setting, just beyond the 30-second mark, as shown in Figure 3-23.

With the BULB setting, you have to press and hold the shutter button to keep the shutter open. You can use this setting to take photos in dark conditions by holding the shutter open for a minute or more.

Figure 3-23. BULB Setting on Display Screen

One problem is that it is hard to avoid jiggling the camera, causing image blur, even if the camera is on a tripod. In Appendix A, I discuss using a remote control to trigger the camera. After the exposure ends, the camera will process the image for the same length of time as the exposure, to reduce the noise caused by long exposures. You will not be able to take another shot while this processing continues. (You can disable this setting with the Long Exposure Noise Reduction option on screen 6 of the Shooting menu.)

Another feature available in this mode is Manual Shift, which is similar to Program Shift, discussed earlier. To use Manual Shift, you first have to assign one of the control buttons (Custom 1, Custom 2, Custom 3, Center, AEL, or Focus Hold) to the AEL (autoexposure lock) Hold or AEL Toggle function using the Custom Key (Shooting) option on screen 5 of the Custom menu, as discussed in Chapter 7. (The Left, Right, or Down button can be assigned to AEL Toggle, but not to AEL Hold.)

Then, after making your aperture and shutter speed settings, change the aperture setting while pressing the button assigned to the AEL function. (If you selected AEL Toggle, you don't have to hold down the button; just press it and release it.)

When you do this, the camera will make new settings with equivalent exposure, if possible. For example, if the original settings were f/3.5 at 1/160 second, when you select Manual Shift and change the aperture to f/3.2, the camera will reset the shutter speed to 1/200 second,

maintaining the original exposure. In this way, you can tweak your settings to favor a particular shutter speed or aperture without affecting the overall exposure. An asterisk will appear in the lower right corner of the display while you activate the button that controls AEL.

I use Manual exposure mode often, for various purposes. One use is to take images at different exposures to combine into a composite HDR image. I will discuss that technique in Chapter 4. Figure 3-24 is an example. For this image, I took several shots at different exposure settings and combined them with Photomatix Pro software to create this HDR image.

Figure 3-24. HDR Image Created from Several Manual Exposure Shots

I also use Manual mode when using a third-party external flash, as discussed in Appendix A. In that case, the flash does not interact with the camera's autoexposure system, so I need to set the exposure manually. Manual mode also is useful for some special types of photography, such as making silhouettes.

Scene Mode

Scene mode, represented by the SCN setting on the Mode dial, as shown in Figure 3-25, is different from the other shooting modes I have discussed.

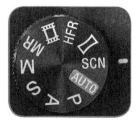

Figure 3-25. Mode Dial Scene Mode

This mode does not have a single defining feature, such as permitting control over one or more aspects of

exposure. Instead, when you select Scene mode and then choose a particular scene type within that mode, you are telling the camera what sort of environment the picture is being taken in and what type of image you are looking for, and you are letting the camera make the decisions as to what settings to use to produce that result.

One aspect of Scene mode is that with most of its settings, you cannot select many of the options that are available in Program, Aperture Priority, Shutter Priority, and Manual exposure mode, such as ISO, DRO, Creative Style, Picture Effect, Metering Mode, and White Balance. There also are some menu settings and control options that are available with certain scene settings but not others, as discussed later in this chapter.

Although some photographers may not like Scene mode because it takes some creative decisions away from them, I find it useful in various situations. You don't have to use these scene types only for their labeled purposes; you may find that some of them offer a group of settings that is well suited for shooting scenarios that you regularly encounter. I'll discuss how Scene mode works, and you can decide for yourself whether you might take advantage of it on occasion.

Select Scene mode by turning the Mode dial to the SCN indicator, as in Figure 3-25. Now, unless you want to use the setting that is already in place, you need to select from the list of nine scene options. There are several ways to do this, depending on current settings. If the Mode Dial Guide is turned on through screen 2 of the Setup menu, then, whenever you turn the Mode dial to the SCN setting and press the Center button, the Scene Selection menu, shown in Figure 3-26, will appear.

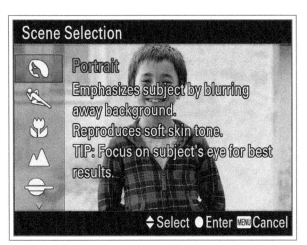

Figure 3-26. Scene Selection Menu

If the Mode Dial Guide is not in use, or if the camera is already set to Scene mode, you can go to screen 7 of the Shooting menu and call up the Scene Selection item, which produces the same menu as shown in Figure 3-26.

Once the Scene Selection menu is on the display, scroll through the nine selections on that menu using the Up and Down buttons, the Control wheel, or the Control dial. Press the Center button to select a setting and return to the shooting screen. You will then see an icon for that setting in the upper left corner of the LCD display. For example, Figure 3-27 shows the display when the Anti Motion Blur setting is selected.

Figure 3-27. Anti Motion Blur Icon on Display Screen

One helpful point about the Scene mode menu system is that each scene type has a main screen with a brief description of the setting's uses as you move the selector over it, as shown in Figure 3-26, so you are not left trying to puzzle out what each icon represents.

As you keep pushing the Up or Down button or using the Control wheel or Control dial to move the selector over the scene type icons, when you reach the bottom or top edge of the screen, the selector wraps around to the first or last icon and continues going.

As I discussed earlier for Intelligent Auto mode, there is an easier way to select the sub-modes, such as Portrait, Landscape, and the like. On screen 5 of the Custom menu, choose the Function Menu Settings option, and assign the Shoot Mode option to one of the 12 slots for the Function menu. Then, whenever the Mode dial is set to Scene, you can press the Function button to bring up the Function menu with the icon for the current Scene mode setting displayed, as shown in Figure 3-28.

Highlight that icon by moving to it with the direction buttons and turn the Control wheel to scroll through the available settings (Portrait, Landscape, Sunset, etc.). When your choice is highlighted, press the Function button to return to the shooting screen.

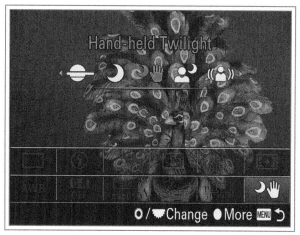

Figure 3-28. Function Menu with Shoot Mode Selected

There is one more, even easier way to switch among the various scene types: Turn the Control dial while the shooting screen is displayed in Scene mode, and the camera will cycle through the scene selections. The scene-type icon will change, in the upper left of the display.

Those are the methods for selecting a scene type. But you need to know something about each option to decide whether it's one you would want to use. In general, each scene setting carries with it a variety of values, including things like flash options, Drive Mode settings, sensitivity to various colors, and others.

Some settings are designed for certain types of shooting rather than particular subjects such as sunsets or portraits. For example, the Anti Motion Blur and Hand-held Twilight settings are designed for difficult shooting environments, such as dimly lighted areas.

With that introduction, I will discuss the main features of each of the nine choices, with a sample image for each of the settings.

PORTRAIT

The Portrait setting is designed to produce flesh tones with a softening effect, as shown in Figure 3-29. You should be fairly close to the subject and set the zoom to some degree of telephoto, such as 80mm or higher, so as to blur the background if possible; the camera

will try to use a wide aperture to assist in this blurring. You may want to pop up the flash and use the Fill-flash setting to reduce shadows. If you want to improve the lighting, consider using off-camera flash with a softbox, as discussed in Appendix A.

Figure 3-29. Portrait Example

If you are shooting a portrait in front of a busy background, such as a house, try to position the subject's head in front of a plain area, such as a light-colored wall, so the head will be seen clearly.

You can use the self-timer, but you cannot use bracketing or continuous shooting.

SPORTS ACTION

The Sports Action setting is for use when lighting is good and you need to freeze the action of your subjects, such as athletes, children at play, pets, or other subjects in motion. Depending on conditions, the camera may set a high ISO value so it can use a fast shutter speed to stop action. The camera sets itself for continuous shooting, so you can hold down the shutter button and capture a burst of images. In that way, you increase your chances of capturing the action at a perfect moment. You can switch to the fastest level of continuous shooting if you want, but you cannot set Drive Mode to single shooting and you cannot use the self-timer or any form of bracketing. You can use flash if you wish.

In Figure 3-30, taken in the evening as the light was fading, the camera set itself to f/2.8 with an ISO setting of 1250, and a shutter speed of 1/125 second to freeze the action. Using the standard continuous shooting setting, I took a burst of several shots to catch this one of a bicyclist riding on a pedestrian bridge over the river.

Figure 3-30. Sports Action Example

Figure 3-31. Macro Example

MACRO

With the Macro setting, the RX10 III sets itself to take closeups. Though you can focus at close range in other shooting modes, it is convenient to use this setting with its options that are suited for taking extreme closeups of flowers, insects, or other small objects.

When you select the Macro option, the camera will let you use the self-timer, but you cannot turn on continuous shooting or exposure bracketing. You can use the flash if you pop it up.

With the RX10 III, there is no special setting for macro focus; in any focus mode, the camera can focus as close as about 1.2 inch (3 cm) when the lens is zoomed out to its wide-angle setting. When the lens is zoomed in all the way to its telephoto setting, it can focus as close as about 28 inches (72 cm).

Even when the camera is set to the Macro setting in Scene mode, you can use the manual focus option. This can be an excellent approach when using Macro because you can fine-tune the focus, which becomes critical and hard to measure precisely when you are photographing insects or other objects in extreme closeups. To use manual focus, turn the focus switch on the front of the camera, below the lens, to the MF position. Then use the front lens ring or rear lens ring (whichever is assigned to this function) to adjust focus. You also can use the direct manual focus option; I will discuss focus options further in Chapter 4.

In Figure 3-31, I used the Macro setting to take a picture of a telegraph key in its museum display case. I focused as close to the subject as I could, using the single-autofocus mode.

LANDSCAPE

Landscape is a Scene mode setting that I use often. It is convenient to turn the Mode dial to the SCN position and pull up the Landscape setting when I'm taking pictures at a scenic location. The camera lets you use Fill-flash in case you want to shoot an image of a person close to the camera in front of a building or other attraction, and it boosts the brightness and intensity of colors somewhat. You cannot use continuous shooting or exposure bracketing, but you can use the self-timer. Figure 3-32 is an example taken using this setting to capture a view of an old building on the corner in a picturesque part of town.

Figure 3-32. Landscape Example

SUNSET

This setting is designed to capture the reddish hues of the sky as the sun rises or sets. You can use Fill-flash if you want to, so you can take a portrait of a person with the sunset or sunrise in the background. You cannot use continuous shooting or exposure bracketing, but you can use the self-timer. The main feature of this setting is that the camera boosts the intensity of the reddish colors in the scene.

Of course, as I noted earlier, you don't have to limit the use of this, or any Scene mode setting, to the subject its name implies. For example, if you are photographing red and orange leaves of trees that are changing colors in autumn, you might want to try the Sunset option to create an enhanced view of the brightly colored foliage. In Figure 3-33, I used this setting for a view of the night sky at sunset, with a pair of flags shown in silhouette.

Figure 3-33. Sunset Example

NIGHT SCENE

The Night Scene option is designed to preserve the natural look of a nocturnal setting. The camera disables the flash; if the scene is dark, you should use a tripod, if possible, to avoid motion blur during the long exposure that may be needed. You can use the self-timer, but not continuous shooting or exposure bracketing. This setting is good for outdoor scenes after dark when flash would not help. The camera does not raise the ISO or use multiple shots, as it does with some other modes used in dim lighting, such as Hand-held Twilight.

Figure 3-34. Night Scene Example

In Figure 3-34, I used the Night Scene setting to photograph a family enjoying a park just at sunset. The camera used a relatively long shutter speed of 1/6

second with an aperture of f/4.0 and preserved image quality by using a low ISO setting of 100.

HAND-HELD TWILIGHT

This Scene mode setting gives you an option for taking pictures in low light without flash or tripod. In dim lighting, blurring of the image can happen when the camera uses a slow shutter speed to expose the image properly, because it is hard to hold the camera steady for an exposure longer than about 1/30 second.

To counter the effects of blurring, with Hand-held Twilight the camera raises the ISO to a higher-than-normal level so it can use a fast shutter speed and still admit enough light to expose the image properly. Because higher ISO settings result in increased noise, the RX10 III takes a burst of four shots and combines them through internal processing into a single composite image with reduced noise.

Hand-held Twilight is useful for a landscape or other static subject at night when you cannot use a tripod or flash. If you can use a tripod, you might be better off using the Night Scene setting, discussed above. Or, if you don't mind using flash, you could just use Intelligent Auto, Program, or one of the more ordinary shooting modes. Hand-held Twilight is a very useful option when it's needed, but it will not yield the same overall quality as a shot at a lower ISO with the camera on a steady support.

With Hand-held Twilight, the flash is forced off. You can use the self-timer, but not continuous shooting or bracketing. If Quality is set to Raw, the camera will change it to Fine temporarily. You can set Quality to Extra Fine if you want to, though.

Figure 3-35. Hand-held Twilight Example

In Figure 3-35, I used this setting for a hand-held shot of a couple walking through a park just before sunset. The camera shot this image at f/4.0 and set the ISO to 800, with a shutter speed of 1/100 second, fast enough to hand-hold the camera without noticeable motion blur. As I noted above, this setting is excellent for hand-held shots of motionless or slow-moving subjects in dim light. If there is brisk motion involved, you may do better with the Anti Motion Blur setting, discussed later in this section.

NIGHT PORTRAIT

This night-oriented setting is for taking a portrait when you are willing to use flash. With Night Portrait, the camera takes only one shot and it activates the flash in Slow Sync mode. I will discuss the Slow Sync setting and provide an example in Chapter 4. Basically, with this Flash Mode setting, the camera uses a slow shutter speed, so that as the flash illuminates the portrait subject in the foreground, there is enough time for the natural light to illuminate the background also. You cannot use the Flash Off setting for Flash Mode, though you can leave the flash unit retracted, and the camera will still let you take the picture.

You can use the self-timer, but not continuous shooting or exposure bracketing. Because of the slow shutter speed, you should use a tripod if possible to avoid motion blur.

Figure 3-36. Night Portrait Example

In Figure 3-36, the camera used a shutter speed of 1/4 second, an exposure long enough to allow the lights in the background to show up clearly, but short enough that I probably could have hand-held the camera without undue motion blur, though I used a tripod in this case. With this setting, you should advise the subject not to move during the relatively long exposure.

ANTI MOTION BLUR

Like other night-oriented options, this setting is not meant for a particular subject, but for dim lighting, using a technique similar to that used by the Hand-held Twilight setting, discussed above. Just as with Hand-held Twilight, with Anti Motion Blur the camera raises the ISO to a higher-than-normal level and combines a burst of four shots into a single composite image with reduced noise. In addition, the camera counteracts blur from motion of the subject to a fair extent, by analyzing the shots and rejecting those with motion blur as much as possible. For Figure 3-37, I used this setting for a shot of another family at the park, not long after sunset.

Figure 3-37. Anti Motion Blur Example

Because it was quite dark, the camera used an ISO setting of 6400 with a shutter speed of 1/80 second. The Anti Motion Blur setting is likely to use a higher ISO setting than Hand-held Twilight to maximize the camera's ability to capture the scene in dim light. Anti Motion Blur is useful as the light is fading if you don't want to use flash.

You should not expect good results if you use this setting with fast-moving subjects, because the camera will not be able to eliminate the motion blur. With slower-moving subjects, though, the RX10 III can do a good job of minimizing blur. With this setting, you can use the self-timer, but not continuous shooting or

exposure bracketing. As with Hand-held Twilight, if Quality is set to Raw, the camera will change it to Fine while this setting is in use.

Sweep Panorama Mode

The next setting on the Mode dial is designed for the shooting of panoramic images. The RX10 III, like many other Sony cameras, has an excellent ability to automate the capture of panoramas. If you follow the fairly simple steps involved, the camera will stitch together a series of images internally and produce a high-quality final result with a dramatic, wide (or tall) view of a scenic vista or other subject that lends itself to panoramic depiction.

It is significant that Sony has given this shooting mode its own spot on the Mode dial, indicating the importance of this type of photography nowadays. Because of this placement on the dial, you can quickly set the camera to take panoramas. Just turn the Mode dial to select the icon that looks like a long, squeezed rectangle, as shown in Figure 3-38.

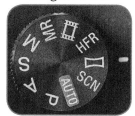

Figure 3-38. Mode Dial Sweep Panorama

You will immediately see a message telling you to press the shutter button and move the camera in the direction of the arrow that appears on the screen. (If the Mode Dial Guide option is turned on, you will have to press the Center button to dismiss the screen that describes Sweep Panorama mode before this message appears.) At that point, you can follow the directions and likely get excellent results. However, the camera allows you to make a number of choices for your panoramic images using the Shooting menu. Press the Menu button, and you will go to the menu screen that is currently active.

Navigate to the Shooting menu, which limits you to fewer choices than in most other shooting modes because several options are not appropriate for panoramas. For example, the Image Size, Aspect Ratio, and Quality settings are dimmed and unavailable. Also, options such as Drive Mode, Flash Mode, and Focus

Area are of no use in this situation and cannot be selected. In addition, you will not be able to zoom the lens in; it will be fixed at its wide-angle position. (If the lens was zoomed in previously, it will zoom back out automatically when you switch the Mode dial to the Sweep Panorama selection.)

You will, however, see two options on screen 2 of the Shooting menu that are not available for selection in any other shooting mode: Panorama Size and Panorama Direction, as shown in Figure 3-39.

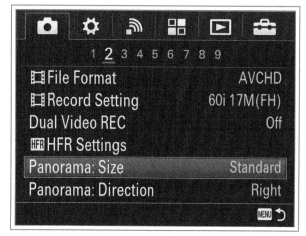

Figure 3-39. Panorama Size and Direction Menu Options

If you select Panorama Size, you will see two options, Standard and Wide.

With Standard, a horizontal panorama will have a size of 8192 by 1856 pixels, which is a resolution of about 15 megapixels (MP). If you choose Wide, a horizontal panorama will have a size of 12416 by 1856 pixels, resulting in a resolution of about 23 MP. (This figure is larger than the camera's maximum resolution of 20 MP because with the panorama settings, the camera is taking multiple images and stitching them together.)

A vertical panorama at the Standard setting is 3872 by 2160 pixels, or about 8.3 MP; a vertical panorama at the Wide setting is 5536 by 2160 pixels, or about 12 MP.

The Panorama Direction option lets you choose Right, Left, Up, or Down for the direction in which you will sweep the camera to create the panorama.

There is a convenient shortcut for choosing the direction for your panorama. Just turn the Control dial while the panorama shooting screen is displayed, and the direction arrow will change to a different position.

You can cycle through all four positions with quick turns of this dial.

Also, you can use the Direction setting with various orientations of the camera to get different results than usual. For example, if you set the direction to Up and then hold the camera sideways while you sweep it to the right, you will create a horizontal panorama that has 2160 pixels in its vertical dimension rather than the standard 1856.

Those are the main settings for panoramas. There are other options you can select on the Shooting menu, including Metering Mode, White Balance, Creative Style, and SteadyShot. I will discuss all of these menu options in Chapter 4. You can set the focus mode using the focus mode switch, though you cannot select continuous autofocus. In my opinion, the best options for these settings for shooting panoramas are the ones shown in Table 3-1, at least as a starting point.

Table 3-1. **Suggested Settings for Panoramas**

Focus Mode	Single-shot AF
Metering Mode	Multi
White Balance	Auto White Balance
Creative Style	Standard
SteadyShot	On, or use tripod

One other setting you can make when shooting panoramas is exposure compensation, using the exposure compensation dial. I will discuss that function in Chapter 5. This feature can be quite useful for panoramas because the camera will not change the exposure if the camera is pointed at areas with varying brightness. So, for example, if you start sweeping from a dark area on the left, the camera will set the exposure for that area. If you then sweep the camera to the right over a bright area, that part of the panorama will be overexposed and possibly washed out in excessive brightness. To correct for this effect, you can reduce the exposure using exposure compensation. In this way, the initial dark area will be underexposed, but the brighter area should be properly exposed. Of course, you have to decide what part of the panorama is the one you most want to have properly exposed.

Another way to deal with this issue is to point the camera at the bright area before starting the shot and press the shutter button halfway to lock the exposure, then go back to the dark area at the left and start

sweeping the camera. In that way, the exposure will be locked at the proper level for the bright area.

Once you have made all of the settings you want for your panorama, follow the directions on the screen. Press and release the shutter button and start moving the camera at a steady rate in the direction you have chosen. I tend to shoot my panoramas moving the camera from left to right, but you may have a different preference. You will hear a steady clicking as the camera takes multiple shots during the sweep of the panorama. A white box and arrow will move across the screen; your task is to finish the camera's sweep at the same moment that the box and arrow finish their travel across the scene. If you move the camera too quickly or too slowly, the panorama will not succeed; if that happens, try again.

Generally speaking, panoramas work best when the scene does not contain moving objects such as cars or pedestrians because when items are in motion, the multiple shots are likely to capture images of the same object more than once in different positions.

It is advisable to use a tripod if possible, so you can keep the camera steady in a single plane as it moves. If you don't have a tripod available, you might try using the electronic level that Sony provides with the RX10 III. You have to activate the level using the Display Button option on screen 2 of the Custom menu, as discussed in Chapter 7. Then press the Display button until the screen with the electronic level appears. Make sure the outer tips of the level stay green as much as possible, and the resulting panorama should benefit from the level shooting.

In addition to exposure, as discussed above, focus and white balance are fixed as soon as the first image is taken for the panorama.

When a panoramic shot is played back in the camera, it is initially displayed at a small size so the whole image can fit on the display screen. You can then press the Center button to make the panorama scroll across the display at a larger size, using the full height of the screen.

Figure 3-40 is a sample panorama, shot from left to right using the Standard setting, hand-held.

Figure 3-40. Sample Panorama, James River, Richmond, Virginia

Memory Recall Mode

There is one more shooting mode left to discuss, apart from Movie mode and HFR mode, which I will discuss in Chapter 8. This last mode, called Memory Recall, is a powerful tool that gives you expanded options for your photography.

When you turn the Mode dial to the MR position (shown in Figure 3-41) and then select one of the seven groups of settings that can be stored there, you are, in effect, selecting a custom-made shooting mode that you create with your own favorite settings.

Figure 3-41. Mode Dial Memory Recall

You can set up the camera just as you want it—with stored values for items such as shooting mode, shutter speed, aperture, zoom amount, white balance, ISO, and other settings—and later recall all of those values instantly just by turning the Mode dial to the MR position and selecting one of the seven stored memory registers on the Memory Recall screen, depending on which one you used to store the settings. With the RX10 III, unlike some other camera models, you can store settings for any shooting mode, including the Intelligent Auto and Scene modes.

Here is how this works. First, set up the camera with all of the settings you want to recall. For example, suppose you are going to do street photography. You may want to use a fast shutter speed, say 1/250 second, in black and white, at ISO 800, using continuous shooting with

autofocus, Large and Extra Fine JPEG images, and shooting in the 4:3 aspect ratio.

The first step is to make all of these settings. Set the Mode dial to Shutter Priority and use the Control dial to set a shutter speed of 1/250 second. Then press the Menu button to call up the Shooting menu and, on screen 1, select L for the image size, 4:3 for Aspect Ratio, and Extra Fine for Quality. Then move to screen 3 and choose continuous shooting for Drive Mode. On screen 4, set ISO to 800, then on screen 5 set the white balance to Daylight. Next, scroll down 2 positions to the Creative Style option and select the B/W setting, for black and white. You also may want to push the zoom lever all the way to the left for wide-angle shooting. You can set any other available Shooting menu options as you wish, but the ones listed above are the ones I will consider for now.

Once these settings are made, navigate to the Memory item, shown in Figure 3-42, which is the final item on the last screen of the Shooting menu.

Figure 3-42. Memory Option Highlighted on Menu

After you press the Center button, you will see a screen like the one in Figure 3-43, showing icons and values for all of the settings currently in effect.

The word Memory appears at the upper left of the screen, and the indicators 1, 2, 3, M1, M2, M3, and M4 at the upper right. In the example shown here, the number 1 is highlighted. Now press the Center button, and you will have selected register 1 to store all of the settings you just made. Registers 1, 2, and 3 are stored in the camera's internal memory. Registers M1, M2, M3, and M4 are stored on the memory card that is currently inserted in the camera.

Figure 3-43. Screen Showing Memory Settings

Note the short gray bar at the right side of the Memory screen shown in Figure 3-43. That bar indicates that you can scroll down through other screens to see additional settings that are in effect, such as ISO Auto Maximum and Minimum, AF Illuminator, Center Lock-on AF, SteadyShot, and several others. Use the Up and Down buttons to scroll through those screens.

Next, to check how this worked, try making some very different settings, such as setting the camera for Manual exposure with a shutter speed of one second, Creative Style set to Vivid, continuous shooting turned off, the zoom lever moved all the way to the right for telephoto, and Quality set to Raw. Then turn the Mode dial back to the MR position and press the Center button while the number 1 is highlighted for Register 1. You will see that all of the custom settings you made have instantly returned, including the zoom position, shutter speed, and everything else. You can then continue shooting with those settings.

This is a wonderful feature, and it is more powerful than similar options on some other cameras, which can save menu settings but not values such as shutter speed and zoom position, or can save settings only for the less-automatic shooting modes, but not the Scene and Auto modes. What is also quite amazing is that if you now switch back to Manual exposure mode, the camera will restore the settings that you had in that mode before you turned to the MR mode. (The position of the zoom lens will not revert to where it was, though.)

You can store settings from the Shooting menu, as well as the shutter speed and optical zoom settings. So, for example, you could set up one of the seven memory registers to recall Scene mode using the Macro setting, with the lens zoomed back to its wide-angle position. In that way, you could be ready for closeup shooting on a moment's notice.

Note that you can recall the M1, M2, M3, or M4 settings only if the memory card that has those settings saved is inserted in the camera. On the positive side, this means that you can build up an inventory of different groups of settings, and store them in groups of four on different memory cards. If those cards are clearly labeled or indexed, you can select a card with the four settings you need for a particular shooting session.

There are some important settings you cannot save to a Memory Recall slot: focus mode, aperture, and exposure compensation, all of which are controlled by physical dials or controls. Presumably, Sony decided it would be confusing to let you store these settings, which could mean the actual setting could conflict with the position of the control that adjusts it. So, if you call up a group of settings using Memory Recall mode, you need to remember to make any other settings that require the use of a physical control. For example, you would need to turn the focus switch to the C position for continuous autofocus, in order to have the camera adjust its focus between shots. In addition, a Program Shift setting cannot be stored.

Overall, though, this feature is powerful and useful. With a twist of the Mode dial and the press of a button, you can call up a complete group of settings tailored for a particular type of shooting. It is worth your while to experiment with this feature and develop various groups of settings that work well for your shooting needs.

CHAPTER 4: THE SHOOTING MENU

Much of the power of the Sony RX10 III comes from options on the Shooting menu, which offers many ways to control the appearance of images and how you capture them. Depending on your preferences, you may not have to use this menu too much. You may prefer to use the camera's physical controls, with which you can make many settings, or you may use the Scene or Auto mode options, which choose many settings for you. However, it's nice to have this degree of control if you want it, and it is useful to understand the choices you can make. In addition, with the RX10 III, more than with many other cameras, you can control a fair number of settings on the Shooting menu even when the camera is in a Scene or Auto mode. Therefore, it is worth exploring this powerful menu.

The Shooting menu is easy to use once you have played with it a bit. The available options will change depending on the setting of the Mode dial. For example, if the camera is set to Intelligent Auto mode, the Shooting menu options are limited because that mode is for a user who wants the camera to make many decisions without input. If the camera is in Sweep Panorama mode, the Shooting menu options are limited because of the specialized nature of that mode. For this discussion, I'm assuming you have the camera set to Program mode, because with that mode you have access to most of the options on the Shooting menu.

Turn the Mode dial on top of the camera to P, which represents Program mode, as shown in Figure 4-1.

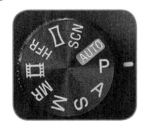

Figure 4-1. Mode Dial Program

Enter the menu system by pressing the Menu button and move through the screens of the menu system by pressing the Right or Left button on the Control wheel. With each press of one of those buttons, the small orange line (cursor) at the top of the screen moves underneath a number that represents a menu screen.

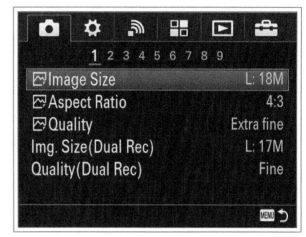

Figure 4-2. First Screen of Shooting Menu

When the menu system first appears, the cursor should sit beneath the number 1 while the camera icon, which represents the Shooting menu, is highlighted in the group of icons at the top of the screen, as shown in Figure 4-2. If a different screen is displayed, press the Right and Left buttons or turn the Control dial to navigate to that first screen. As you keep pressing the Right button or turn the Control dial to the right, the cursor will move through all nine numbered screens of the Shooting menu.

As you move through the menu screens on the RX10 III, after the Shooting menu comes the Custom menu, marked by a gear icon, then the Wi-Fi menu, headed by a wireless network icon. The last three menus are the Application menu, designated by a set of black and white blocks; the Playback menu, marked by a triangle icon; and, finally, the Setup menu, marked by a toolbox icon.

To navigate quickly through these six menu systems, you can press the Up button or turn the Control wheel to move the highlight block into the line of icons at the top of the screen. When one of those icons is highlighted, you can use the Left and Right buttons or the Control dial to move directly from one menu system to another without going through the various screens of each menu.

For example, in Figure 4-3, the Wi-Fi menu icon is highlighted. From there, you can press the Left button

twice or turn the Control dial to the left to move the highlight to the camera icon for the Shooting menu at the far left, as shown in Figure 4-4.

Then you can press the Down button or turn the Control wheel to move the highlight into the list of items on screen 1 of the Shooting menu, as shown in Figure 4-2.

Figure 4-3. Wi-Fi Menu Icon Highlighted at Top of Menu

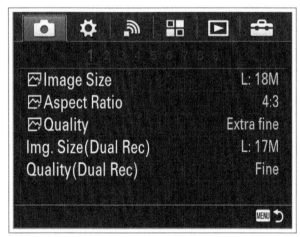

Figure 4-4. Camera Icon for Shooting Menu Highlighted

When a menu item on a menu screen is highlighted, you can press the Left and Right buttons or turn the Control dial to move quickly through the numbered screens of the various menus.

In this chapter, I will discuss only the Shooting menu; I will discuss the other five menus in Chapter 6 (Playback), Chapter 7 (Custom and Setup), and Chapter 9 (Wi-Fi and Application).

The Shooting menu has many options on nine numbered screens. In most cases, each option (such as Image Size) occupies one line, with its name on the left and current

setting (such as L: 18M) on the right. Some items on the menu screens are dimmed and have only a dash at the right side, such as the Auto Mode, Scene Selection, and High Frame Rate options in Figure 4-5, for example.

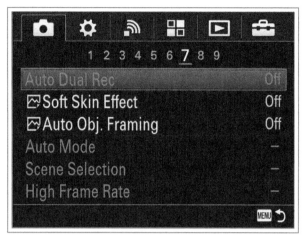

Figure 4-5. Several Items Dimmed on Shooting Menu

This means those options are not available for selection in the current context. In this case, the camera is set to Program mode and Record Setting on screen 2 of the menu is set to 30p 100M. The Auto Mode option is available only in Auto mode; the Scene Selection option is available only in Scene mode; and the High Frame Rate option is available only with the Mode dial set to HFR. Therefore, those three menu items are dimmed. In addition, the Auto Dual Recording option is dimmed because it is not compatible with the Record Setting at 30p 100M.

Some items are preceded by an icon that indicates whether they are used for still images, movies, or high frame rate (HFR) movies. For example, Figure 4-6 shows screen 8 of the Shooting menu, on which the first SteadyShot item and the Color Space item are for still images, while the second SteadyShot item and the Auto Slow Shutter item are for movies, as indicated by the still-image and movie icons preceding those options.

To follow the discussion below of the options on the Shooting menu, leave the shooting mode set to Program, which gives you access to most of the options on that menu. (I'll also discuss the options that are available in other modes as I come to them.) I'll start at the top of screen 1 and discuss each option on the way down the list for each of the nine screens of this menu.

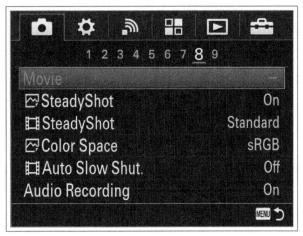

Figure 4-6. Screen 8 of Shooting Menu, Showing Icons for Options Related to Still Images and Movies

Image Size

This first option on the Shooting menu is related to the next two entries on the menu, Aspect Ratio and Quality, to control the overall appearance and "quality" of your images, in a broad sense. The Image Size setting controls the size in pixels of a still image recorded by the camera. The Sony RX10 III has a relatively large digital sensor for a compact camera, and that sensor has a high maximum resolution, or pixel count. The sensor is capable of recording a still image with 5472 pixels, or individual points of light, in the horizontal direction and 3648 pixels vertically. When you multiply those two numbers together, the result is about 20 million pixels, often referred to as megapixels, MP, or M.

The resolution of still images is important mainly when it comes time to enlarge or print your images. If you need to produce large prints (say, 8 by 10 inches or 20 by 25 cm), then you should select a high-resolution setting for Image Size. You also should choose the largest Image Size setting if you may need to crop out a small portion of the image and enlarge it for closer viewing.

For example, if you are shooting photos of wildlife and the animal or bird you are interested in is in the distance, you may need to enlarge the image digitally to see that subject in detail. In that case, also, you should choose the highest setting (L) for Image Size.

The available settings for Image Size are L, M, S, and VGA, for Large, Medium, Small, and VGA, as shown in Figure 4-7, although, as discussed below, VGA is available only when Aspect Ratio is set to 4:3.

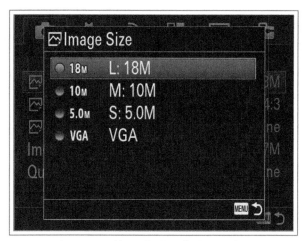

Figure 4-7. Menu Options for Image Size

When you select one of the first three options, the camera displays a setting such as L: 18M, meaning Large: 18 megapixels. The number of megapixels changes depending on the Aspect Ratio setting, discussed below. This is because when the shape of the image changes, the number of horizontal pixels or the number of vertical pixels changes also to form the new shape.

For example, if the Aspect Ratio setting is 3:2, the maximum number of pixels is used because 3:2 is the aspect ratio of the camera's sensor. However, if you set Aspect Ratio to 16:9, the number of horizontal pixels (5472) stays the same, but the number of vertical pixels is reduced from 3648 to 3080 to form the 16:9 ratio of horizontal to vertical pixels. When you multiply those two numbers (5472 and 3080) together, the result is about 17 million pixels, which the camera states as 17M, as in Figure 4-8.

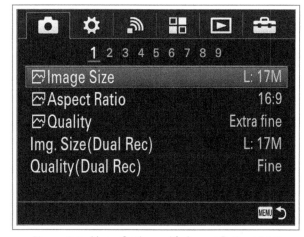

Figure 4-8. Menu Options with Aspect Ratio at 16:9

The VGA option, the smallest size possible, is available only if Aspect Ratio is set to 4:3. Otherwise, this choice does not even appear on the menu option for

Image Size. VGA stands for video graphics array, the designation used for older-style computer screens, which have a 4:3 aspect ratio. The pixel count for this setting is very low—just 640 by 480 pixels, yielding a resolution of 0.3 M, much less than one megapixel. This very small size is suitable if you need to send images by e-mail or need to store a great many images on a memory card.

One of the few reasons to choose an Image Size smaller than L is if you are running out of space on your memory card and need to keep taking pictures in an important situation. Table 4-1 shows approximately how many images can be stored on a 64 GB memory card for various settings.

Table 4-1. **Number of Images that Fit on a 64 GB Card (Image Size vs. Quality at 3:2 Aspect Ratio)**

	Large	Medium	Small
Raw & JPEG	1900	2300	2500
Raw	2900	-----	-----
Extra Fine	4300	6700	9999+
Fine	5700	9999+	9999+
Standard	9900	9999+	9999+

As you can see, if you are using a 64 GB memory card, which is a fairly common size nowadays, you can fit about 1900 images on the card even at the maximum settings of 3:2 for Aspect Ratio, Large for Image Size, and Raw & JPEG for Quality. If you limit the image quality to Fine, with no Raw images, you can fit about 5700 images on the card. If you reduce the Image Size setting to Small, you can store more than 10,000 images. I am unlikely ever to need more than about 300 or 400 images in any one session. And, of course, I can use a larger memory card or multiple memory cards.

If space on your memory card is not a consideration, then I recommend you use the L setting at all times. You never know when you might need the larger-sized image, so you might as well use the L setting and be safe. Your situation might be different, of course. If you were taking photos purely for a business purpose, such as making photo identification cards, you might want to use the Small setting to store the maximum number of images on a memory card and reduce expense. For general photography, I rarely use any setting other than L for Image Size. (One exception could be when I want to increase the range of the optical zoom lens without

losing image quality; see the discussion of Smart Zoom and related topics in Chapter 7.)

When Quality, discussed later in this chapter, is set to Raw, the Image Size option is dimmed and unavailable for selection because you cannot select an image size for Raw images; they are always at the maximum size, as is shown above in Table 4-1.

Aspect Ratio

This second option on the Shooting menu lets you choose the shape of your still images. The choices are the default of 3:2, as well as 4:3, 16:9, and 1:1, as shown in Figure 4-9. These numbers represent the ratio of the units of width to the units of height. For example, with the 16:9 setting, the image is 16 units wide for every 9 units of height.

Figure 4-9. Aspect Ratio Menu Options Screen

The aspect ratio that uses all pixels on the image sensor is 3:2; with any other aspect ratio, some pixels are cropped out. So, if you want to record every possible pixel, you should use the 3:2 setting. If you shoot using the 3:2 aspect ratio, you can always alter the shape of the image later in editing software such as Photoshop by cropping away parts of the image. However, if you want to compose your images in a certain shape and don't plan to do post-processing in software, the aspect ratio settings of this menu item can help you frame your images in the camera using the appropriate aspect ratio on the display.

The RX10 III provides more options in this area than many other cameras do. For each of the aspect ratios discussed below, I am including an image I took using

that setting in the same location at the same time, to give an idea of what the different aspect ratios look like.

Figure 4-10. Aspect Ratio 3:2

The default 3:2 setting, used for Figure 4-10, includes the maximum number of pixels, and is the ratio used by traditional 35mm film. This aspect ratio can be used without cropping to make prints in the common U.S. size of 6 inches by 4 inches (15 cm by 10 cm).

Figure 4-11. Aspect Ratio 4:3

The 4:3 setting, shown in Figure 4-11, is in the shape of a traditional (non-widescreen) computer screen, so if you want to view your images on that sort of display, this may be your preferred setting.

As I noted earlier in discussing Image Size, if you want to use the VGA setting for Image Size, the camera must be set to the 4:3 aspect ratio. With this setting, some pixels are lost at the left and right sides of the image.

The 16:9 setting, illustrated in Figure 4-12, is the "widescreen" option, like that found on many modern HD television sets.

You might use this setting when you plan to show your images on an HDTV set. Or, it might be suitable for a particular composition in which the subject matter is

stretched out in a horizontal arrangement. With this setting, some pixels are cropped out at the top and bottom, though none are lost at the left or right.

Figure 4-12. Aspect Ratio 16:9

Figure 4-13. Aspect Ratio 1:1

The 1:1 ratio, illustrated in Figure 4-13, produces a square shape, which some photographers prefer because of its symmetry and because the neutrality of the shape leaves open many possibilities for composition. With the 1:1 setting, the camera crops pixels from the left and right sides of the image.

The Aspect Ratio setting is available in all shooting modes except Sweep Panorama. However, although you can set Aspect Ratio when the camera is in Movie mode or HFR mode (Mode dial turned to movie-film icon or HFR), that setting will have no effect until you switch to a mode for taking still images, such as Program mode. When the Mode dial is set to the Movie position, you cannot take still images other than during movie recording. The aspect ratio of a still image taken while recording a movie is determined by the File Format and Record Settings menu options, not by the Aspect Ratio option. With the Mode dial at the HFR position, you cannot take still images at all.

Quality

The Quality setting, below Aspect Ratio, is one of the most important Shooting menu options for still images. The choices are Raw, Raw & JPEG, Extra Fine, Fine, and Standard, as shown in Figure 4-14.

The term "quality" in this context concerns the way in which digital images are processed. In particular, JPEG (non-Raw) images are digitally "compressed" to reduce their size without losing too much information or detail from the picture. However, the more an image is compressed, the greater the loss of detail and clarity in the image.

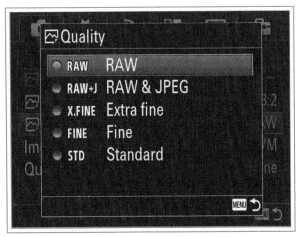

Figure 4-14. Quality Menu Options Screen

Raw files, which are in a class by themselves, are the least compressed of all and have the greatest level of quality, though they come with some complications, as discussed below. All other (non-Raw) formats for still images used by the RX10 III (as with most similar cameras) are classified as JPEG, which is an acronym for Joint Photographic Experts Group, an industry group that created the JPEG standard. The JPEG files, in turn, come in three varieties on the RX10 III: Extra Fine, Fine, and Standard. The Extra Fine setting provides the least compression. Images captured with the Fine or Standard setting undergo increasingly more compression, resulting in smaller files with somewhat reduced quality.

Here are some guidelines for using these settings. First, you need to choose between Raw and JPEG images. Raw files are larger than other files, so they take up more space on your memory card, and on your computer, than JPEG files. But Raw files offer advantages over JPEG files. When you shoot in the Raw format, the camera records as much information as it

can about the image and preserves that information in the file it saves to the memory card. When you open the Raw file later on your computer, your software can process that information in various ways. For example, you can change the exposure or white balance of the image when you edit it on the computer, just as if you had changed your settings while shooting. In effect, the Raw format gives you what almost amounts to a chance to travel back in time to improve some of the settings that you didn't get quite right when you pressed the shutter button.

For example, Figure 4-15 is an image I took with the RX10 III using the Raw format, with the exposure purposely set too dark and the white balance set to Incandescent, even though I took the picture outdoors during daylight hours.

Figure 4-15. Raw Image Taken with Wrong Settings

Figure 4-16 shows the same image after I opened it in Adobe Camera Raw software and adjusted the settings to correct the exposure and white balance. The result was an image that looked just as it would have if I had used the correct settings when I shot it.

Figure 4-16. Raw Image with Settings Corrected in Software

Raw is not a cure-all; you cannot fix bad focus or excessive exposure problems. But you can improve some exposure-related issues and white balance with Raw-processing software. You can use Sony's Image Data Converter software to view or edit Raw files, and you also can use other programs, such as Adobe Camera Raw, that have been updated to handle Raw files from this camera. Another option is Capture One Express, which is available from Sony to purchasers of this camera.

Using Raw can have disadvantages, also. The files take up a lot of storage space; Raw images taken with the RX10 III are about 20 MB in size, while Large JPEG images I have taken are between about 4 and 12 MB, depending on the settings used. Also, Raw files have to be processed on a computer; you can't take a Raw image and immediately share it through social media or print it; you first have to use software to convert it to JPEG, TIFF, or some other standard format for manipulating digital photographs. If you are pressed for time, you may not want to take that extra step. Finally, some features of the RX10 III are not available when you are using the Raw format, such as the Auto HDR, Picture Effect, Soft Skin Effect, and Digital Zoom options.

If you're undecided as to whether to use Raw or JPEG, you have the option of selecting Raw & JPEG, the second choice for the Quality menu item. With that setting, the camera records both a Raw and a JPEG image when you press the shutter button.

The advantage with that approach is that you have a Raw image with maximum quality and the ability to do extensive post-processing, and you also have a JPEG image that you can use for viewing, sharing, printing, and the like. Of course, this setting consumes storage space more quickly than saving your images in just Raw or JPEG format, and it can take the camera longer to store the images, so there may be a slowdown in the rate of continuous shooting, if you are using that option. You also cannot use some menu options that conflict with the Raw setting.

When you choose Raw & JPEG, you can select an Image Size setting that will apply only to the JPEG image; the Raw image, as noted earlier, is always at the maximum size. You cannot select a Quality setting for the JPEG image with the Raw & JPEG selection; the JPEG image will be fixed at the Fine setting.

The best bet for preserving the quality of your images and your options for post-processing and fixing exposure mistakes later is to choose Raw files. However, if you want to use features such as Sweep Panorama mode, some Scene mode types such as Anti Motion Blur, the Picture Effect menu option, and others, which are not available with Raw files, then choose JPEG. If you do choose JPEG, I strongly recommend that you choose the Large size and Extra Fine quality, unless you have an urgent need to conserve storage space on your memory card or on your computer. If you want Raw quality and are not concerned about storage space or speed of shooting, choose Raw & JPEG. However, you will still not be able to use Picture Effect and some other options.

Image Size (Dual Recording)

This next option on the Shooting menu sets the size of still images that are captured during video recording. When you have started recording a video, you can press the shutter button at any time to capture a still image. You also can use the Auto Dual Recording option, on screen 7 of the Shooting menu, to set the camera to capture still images automatically during video recording. There are some limitations on these capabilities, which are discussed in Chapter 8.

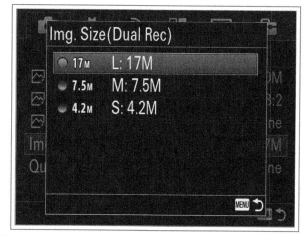

Figure 4-17. Image Size (Dual Recording) Menu Options Screen

Choices for Image Size, seen in Figure 4-17, are L:17M, M:7.5M, and S:4.2M, for Large, Medium, and Small.

Quality (Dual Recording)

Like the previous option, this one affects still images that are captured while a video is being recorded. The options available for this setting are Extra Fine, Fine, and Standard. The Raw setting is not available.

The next settings to be discussed are on Screen 2 of the Shooting menu, shown in Figure 4-18.

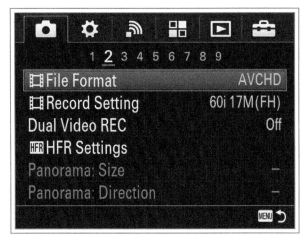

Figure 4-18. Screen 2 of Shooting Menu

File Format

This first option on screen 2 of the Shooting menu is preceded by a movie-film icon, meaning it applies only for movies. I will discuss this option in Chapter 8. For now, you should know that XAVC S (either 4K or HD) gives the highest quality but is available only if you are using an SDHC or SDXC card rated in Speed Class 10 or UHS Speed Class 1 (UHS Speed Class 3 for some settings). The AVCHD option yields very high quality and MP4 gives somewhat lower quality but can be easier to edit. Your choice for this setting depends on the type of video you are recording, as discussed in Chapter 8.

Record Setting

This next option on screen 2 of the Shooting menu is related to the File Format option, discussed above. The available options for Record Setting will change, depending on what you select for File Format. I will discuss the details of this option in Chapter 8. For now, if you want the highest quality for MP4 video, choose the top option, 1920 x 1080 60p 28M. These options will be different if you choose XAVC S 4K, XAVC S HD, or AVCHD for File Format. They also will be different if you have set the NTSC/PAL selector, on screen 3 of the Setup menu, to PAL, the TV system used in much of Europe and some other locations. For example, the top option for MP4 in that case is 1920 x 1080 50p 28M. In this book, I will discuss the video options that are applicable for the NTSC system, as used in the United States, Japan, and elsewhere.

Dual Video Recording

This option is somewhat like a video version of the Raw & JPEG setting for still images. When it is turned on and File Format is set to XAVC S 4K, XAVC S HD, or AVCHD, the camera also records the video in the MP4 format, giving you a second video file that is easier to edit and share. I recommend leaving this option turned off unless you have a specific reason to use it. I will discuss it further in Chapter 8. There are some limitations on this setting, which I will also discuss in Chapter 8.

HFR Settings

This menu option controls the settings for HFR, or high frame rate video recording, when the Mode dial is set to the HFR position. I will discuss this option and other aspects of HFR recording in Chapter 8.

Panorama Size and Panorama Direction

The last two commands on this screen of the menu are available only when the Mode dial is at Sweep Panorama mode. I discussed these settings in Chapter 3, in connection with that mode. You should not need the Panorama Direction menu option often, because you can always set the panorama direction by turning the Control dial when the camera is in Sweep Panorama mode. You do need the Panorama Size option in order to set the size of the Panorama to Standard or Wide.

Screen 3 of the Shooting menu is shown in Figure 4-19.

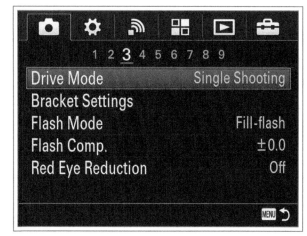

Figure 4-19. Screen 3 of Shooting Menu

Drive Mode

This first option on screen 3 of the menu gives access to features of the RX10 III for shooting bursts of images, bracketing exposures, and using the self-timer.

Figure 4-20. Drive Mode Menu

When you highlight this option and press the Center button, a menu appears at the left of the screen as shown in Figure 4-20, with nine choices represented by icons: Single Shooting, Continuous Shooting, Speed Priority Continuous Shooting, Self-timer, Self-timer (Continuous), Continuous Exposure Bracketing, Single Exposure Bracketing, White Balance Bracketing, and DRO Bracketing. (You have to scroll down to see the last five choices.)

Details for the Drive Mode settings are discussed below.

SINGLE SHOOTING

This is the normal mode for shooting still images. Select this top choice on the Drive Mode menu to turn off all continuous shooting. In some cases, having one of the continuous-shooting options selected will make it impossible to make other settings, such as Soft Skin Effect or Long Exposure Noise Reduction. If you find you cannot make a certain setting, try selecting single shooting to see if that removes the conflict and fixes the problem.

As noted in Chapter 3, this option is not available with the Sports Action setting of Scene mode.

CONTINUOUS SHOOTING

Continuous shooting, sometimes called burst shooting, is useful in many contexts, from shooting

an action sequence at a sporting event to taking a series of shots of a person in order to capture changing facial expressions. I often use this setting for street photography to increase my chances of catching an interesting scene.

Figure 4-21. Continuous Shooting Icon Highlighted

The Continuous Shooting option is the first of two types of burst shooting available with the RX10 III. With this setting, whose icon is highlighted in Figure 4-21, the camera shoots continuously as you hold down the shutter button.

If the focus mode switch is set to single autofocus, the camera will not adjust its focus during the burst of shots. But, if you set the focus mode switch to C for continuous autofocus, the camera will adjust focus for each shot. As you can imagine, this focusing may not be exact because of motion by the subject, the camera, or both, but the camera will try to re-focus while the burst continues.

If you want the camera to adjust its exposure during the series of continuous shots, you need to go to screen 4 of the Custom menu and check the setting of the AEL w/ Shutter menu item. If that item is set to On, the camera will lock exposure when you press the shutter button, and exposure will be locked throughout the burst as it was set for the first image, even if lighting changes dramatically.

However, if you set AEL w/Shutter to Off, then the camera will adjust its exposure as needed during the burst of shots. If you set AEL w/Shutter to Auto, then the camera will adjust exposure during continuous shooting if the focus switch is set to continuous autofocus. If it is set to single autofocus, then the

camera will keep the exposure locked. (Of course, if you want the camera to adjust exposure automatically, you have to use an exposure mode in which the camera normally controls exposure. If you use Manual mode with a fixed ISO value, the exposure will not change.)

Depending on conditions such as image size and quality, lighting, settings for autofocus and autoexposure lock, and the speed of the memory card, the rate of burst shooting can vary considerably. With optimal conditions, such as shooting Extra Fine and Large images with a shutter speed of 1/200 second using single autofocus, the camera can shoot at about 6 frames per second (fps) using this setting until the memory buffer fills up after about 60 shots. Then the rate slows to about 1.5 fps. When shooting with Quality set to Raw & JPEG, I found that the shooting speed remained about the same, but it slowed down after about 30 shots.

Although you can turn on the flash when the Continuous Shooting option is selected, and the camera will actually take a series of shots with flash as you hold down the shutter button, the time between shots may be several seconds because the flash cannot recycle quickly enough to take a rapid series of shots.

The speed of this first continuous-shooting mode is not as great as that of the Speed Priority option, discussed below. However, being able to take a stream of shots with focus adjusted for each one can be worth the reduction in speed when you need to focus on moving subjects or subjects at varying distances.

SPEED PRIORITY CONTINUOUS SHOOTING

Figure 4-22. Speed Priority Continuous Shooting Icon Highlighted

To shoot a series of images at the fastest rate possible, choose the Speed Priority Continuous Shooting option, highlighted in Figure 4-22.

With this setting, the camera captures images at a rate up to about 14 fps in ideal conditions. The trade-off for speed is that the camera will not adjust focus between shots, even if you set the focus mode to continuous autofocus. As with the standard Continuous Shooting setting, with Speed Priority the camera will adjust exposure for each shot if the AEL w/Shutter menu option is set to Off. If that option is set to On, the camera will lock exposure with the first shot and will not adjust it for the remaining shots. With the Auto setting, it will adjust exposure if continuous AF is turned on, though, as noted, the camera will not adjust focus between shots.

As with normal continuous shooting, various factors including the Quality setting affect the shooting rate of the Speed Priority setting. When I used my fastest memory card to take Extra Fine JPEG images at a shutter speed of 1/400 second, the camera shot a burst of 45 images at about 13.5 fps. When I took Raw & JPEG shots, the camera took an initial burst of about 28 shots at a rate of 8 fps, then slowed to a pace of about 1 fps. As with the standard Continuous Shooting option, using the flash slows down the shooting drastically. Also, using slower memory cards has a noticeable impact on the speed of continuous shooting.

After taking a burst of shots, it can take the camera a while to save them to the memory card. You can't use the menu system or play back existing shots until the data has been saved, although you can take additional shots. There is an access lamp that lights up in red while the camera is writing to the card, at the far right edge of the camera's back. While that light is illuminated, be sure not to remove the battery or the memory card.

For Figure 4-23, I used continuous shooting to take a series of images of a very lively spaniel, and ended up with this shot that caught her in mid-leap.

Neither normal-speed nor higher-speed continuous shooting is available in Sweep Panorama mode, in Scene Selection mode (except for the Sports Action setting), with certain Picture Effect settings, with Auto HDR turned on, with ISO set to Multi Frame Noise Reduction, or when the Smile Shutter is turned on.

Figure 4-23. Image from Series of Continuous Shots

SELF-TIMER

The next icon down on the menu of Drive Mode options represents the self-timer, as shown in Figure 4-24. The self-timer is useful when you need to be the photographer and also appear in a group photograph. You can place the RX10 III on a tripod, set the timer for five or ten seconds, and insert yourself into the group before the shutter clicks. The self-timer also is helpful when you don't want to cause blur by jiggling the camera as you press the shutter button.

Figure 4-24. Self-timer Menu Options Screen

For example, when you're taking a macro shot very close to the subject, focusing can be critical, and any bump to the camera could cause motion blur. Using the self-timer gives the camera a chance to settle down

after the shutter button is pressed, before the image is recorded.

The self-timer option presents you with three choices: ten seconds, five seconds, and two seconds. When the self-timer icon is highlighted, press the Left or Right button or turn the Control dial to highlight one of these options, and press the Center button to select it. After you make this selection, the self-timer icon will appear in the upper left corner of the display with the chosen number of seconds (10, 5, or 2) displayed next to the icon, as shown in Figure 4-25. (If you don't see the icon, press the Display button until the screen with the various shooting icons appears.)

Once the self-timer is set, when you press the shutter button, the timer will count down for the specified number of seconds and then take the picture. The reddish lamp on the front of the camera will blink, and the camera will beep during the countdown.

Figure 4-25. Self-timer Icon on Shooting Screen

The self-timer is not available in Sweep Panorama mode, with the Sports Action setting of Scene mode, or for recording a movie with the Movie button, and you cannot select continuous autofocus when the self-timer is turned on.

SELF-TIMER (CONTINUOUS)

The next item down on the Drive Mode menu, shown in Figure 4-26, is another variation on the self-timer. With this option, the camera lets you set the timer to take multiple shots after the countdown ends. You can choose any of the three time intervals, and you can set the camera to take either three or five shots after the delay. When you highlight this option, you will see a horizontal triangle indicating that, by pressing the

Left and Right buttons or turning the Control dial, you can select one of six combinations of the number of shots and the timer interval. For example, the option designated as C3/2S sets the camera to take three shots after the timer counts down for two seconds; C5/10S sets it for five shots after a ten-second delay.

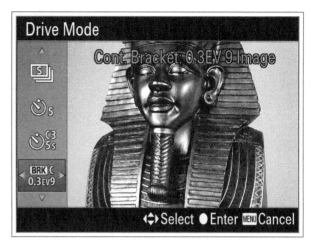

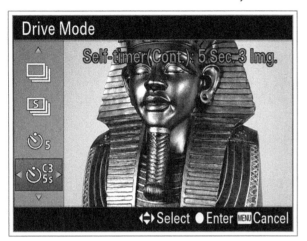

Figure 4-26. Self-timer (Continuous) Icon Highlighted

Figure 4-27. Continuous Exposure Bracketing Icon Highlighted

This option is useful for group photos; when a series of shots is taken, you increase your chances of getting at least one shot in which everyone is looking at the camera and smiling. You can choose any settings you want for Image Size and Quality, including Raw & JPEG, and you will still get three or five rapidly fired shots, though the speed of the shooting will decrease slightly at the highest Quality settings. You cannot use the continuous autofocus setting for the focus switch with this option.

CONTINUOUS EXPOSURE BRACKETING

This next option on the Drive Mode menu, shown in Figure 4-27, sets the camera to take three, five, or nine images with one press of the shutter button but with a different exposure level for each image, giving you a greater chance of having one image that is properly exposed.

When you highlight this option, you will see a horizontal triangle meaning that you can use the Left and Right buttons or the Control dial to select one of 13 combinations of the difference in exposure value and the number of images in the bracket. The first nine choices include exposure value (EV) intervals of 0.3, 0.7, or 1.0, each with a bracket of three, five or nine exposures. The other four choices are for EV intervals of 2.0 or 3.0 EV, each with a bracket of three or five exposures.

The decimal numbers represent the difference in EV among the multiple exposures (three, five, or nine) that the camera will take. (With the larger EV intervals of 2.0 or 3.0 EV, the available numbers of shots are three or five; there is no option for choosing nine shots, because the overall exposure range would be too great, given the larger EV interval.)

For example, if you select 0.7 EV as the interval for three exposures, the camera will take three shots— one at the metered exposure level; one at a level 0.7 EV (or f-stop) below that, resulting in a darker image; and one at a level 0.7 EV above that, resulting in a brighter image. If you want the maximum exposure difference among the shots, select 3.0 EV as the interval for the three or five shots.

Once you have set this option as you want it and composed your scene, press and hold the shutter button and the camera will take the three, five, or nine shots in rapid succession while you hold down the button.

If you set this option for three exposures, the first one will be at the metered value, the second one underexposed by the selected interval, and the third one overexposed to the same extent. If you set it for five exposures, the first three shots will have the values noted above, the fourth will have the most negative EV, and the fifth will have the most positive EV. With nine exposures, the pattern will be similar, with the final two exposures having the most negative and positive EV settings, respectively. (You can change this order using the Bracket Settings menu option, discussed later in this chapter.)

You can use exposure compensation, in which case the camera will use the image with exposure compensation as the base level, and then take exposures that deviate under and over the exposure of the image with exposure compensation.

If you pop up the flash and set it to fire, using the Fill-flash setting for example, the flash will fire for each of the bracketed shots and the exposure will be varied, but you have to press the shutter button for each shot, after the flash has recycled. (The orange dot to the right of the flash icon on the screen shows when the flash is ready to fire again.) With this approach, the camera will vary the output of the flash unit rather than the exposure value of the images themselves.

When using Manual exposure mode with ISO set to Auto, the camera adjusts the ISO setting to achieve the different exposure levels for the multiple images. If ISO is set to a specific value, the camera varies the shutter speeds for the multiple shots.

SINGLE EXPOSURE BRACKETING

The next option is similar to the previous one, except that, with this selection, you have to press the shutter button for each shot; the camera will not take multiple shots while you hold down the shutter button. You have the same 13 choices for combinations of EV intervals and numbers of exposures. You might want to choose this option when you need to pause between shots for some reason, such as if you are using a model who needs to have some costume or makeup adjustments for each exposure. It also could be useful if you want to look at the resulting image after each shot to see if you need to make further adjustments to your settings.

Apart from using individual shutter presses, this option works the same as continuous exposure bracketing. For example, you can use flash and you can change the order of the exposures using the Bracket Settings menu option.

None of the bracketing options—exposure, white balance, or DRO—is available in the Auto, Scene, or Sweep Panorama shooting mode.

WHITE BALANCE BRACKETING

The next option on the Drive Mode menu, White Balance Bracketing, whose icon is highlighted in Figure

4-28, is similar to Continuous Exposure Bracketing, except that only three images can be taken and the value that is varied for the three shots is white balance rather than exposure.

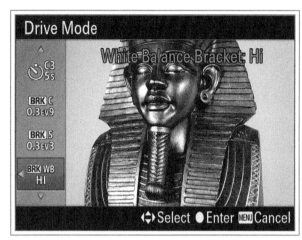

Figure 4-28. White Balance Bracket Icon Highlighted

Using the Left and Right buttons or the Control dial, select either Lo or Hi for the amount of deviation from the normal white balance setting. Then, when you press the shutter button (you don't have to hold it down), the camera will take a series of three shots—one at the normal setting; the next one with a lower color temperature, resulting in a "cooler," more bluish image; and the last one with a higher color temperature, resulting in a "warmer," more reddish image. When you use this form of bracketing, unlike exposure bracketing, you will hear only one shutter sound because the camera takes just one image, with one quick shutter press, and then electronically creates the other two exposures with the different white balance values.

You can change the order of the exposures using the Bracket Settings menu option, discussed later in this chapter.

DRO BRACKETING

This final option on the Drive Mode menu, whose icon is shown in Figure 4-29, sets the RX10 III to take a series of three shots at different settings of the DRO (dynamic range optimizer) option. I'll discuss DRO later in this chapter. Essentially, DRO alters the RX10 III's image processing to even out the contrast between shadowed and bright areas. It can be difficult to decide how much DRO processing to use, and this option gives you a way to experiment with several different settings

before you decide on the amount of DRO for your final image.

Figure 4-29. DRO Bracket Icon Highlighted

As with White Balance Bracketing, you can select Hi or Lo for the DRO interval. Also, as with White Balance Bracketing, you only need to press the shutter button once, briefly; the camera will record the three different exposures electronically. The order of these exposures is not affected by the Bracket Order menu option.

Bracket Settings

The second option on this menu screen includes two settings for how bracketed exposures are taken. When you select Bracket Settings, you will see two sub-options: Self-timer During Bracket, and Bracket Order, as shown in Figure 4-30.

Figure 4-30. Bracket Settings Menu Options Screen

The Self-timer During Bracket option lets you use the self-timer with bracket shooting. Without this option you could not use bracketing and the self-timer at

the same time, because they are selected by different options on the Drive Mode menu.

With this menu item you can have the self-timer set for two, five, or ten seconds before the first bracket shot is triggered, or you can leave the self-timer turned off. This setting turns on the self-timer for any type of bracket shooting you choose—exposure, white balance, or DRO.

The second sub-option, Bracket Order, lets you alter the sequence of the bracketed shots. As shown in Figure 4-31, there are two choices.

Figure 4-31. Bracket Order Menu Options Screen

The first one is the default setting, with which the first shot is at the normal setting, the next is more negative (or with lower color temperature), the one after that is more positive (or with higher color temperature), and so on, ending with the most negative setting and, finally, the most positive setting. If you choose the second option, the images are shot in a strictly ascending series, moving from the most negative setting to the most positive setting.

The Bracket Order option affects the order for exposure bracketing and white balance bracketing, but not for DRO bracketing.

Flash Mode

In Chapter 2, I discussed the RX10 III's built-in flash, which is controlled with the Flash Mode menu item. There are six choices for that setting—Flash Off, Autoflash, Fill-flash, Slow Sync, Rear Sync, and Wireless—the first four of which are shown in Figure 4-32. Slow Sync is dimmed on this screen, because that setting is not available for selection in the shooting mode

illustrated here. There is no shooting mode in which all six options are available. Here is a brief summary of the options I discussed in Chapter 2, followed by a discussion of the ones I did not discuss there.

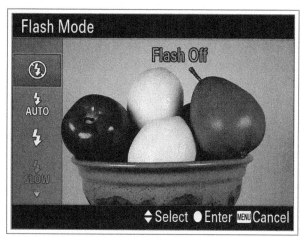

Figure 4-32. Flash Mode Menu

FLASH OFF

To make sure the flash will not fire, choose Flash Off. This is a good choice when you are in a museum or other place where you don't want the flash to fire, or if you know you will not be using flash. It also can be helpful to avoid depleting a battery that is running low. This option is available in Auto mode and with the Portrait, Sports Action, Macro, Landscape, and Sunset settings of Scene mode. Of course, with the RX10 III you also have the option of just not raising the flash with the flash pop-up button, which will have the same effect as using this Flash Mode option.

AUTOFLASH

With Autoflash, you leave it up to the camera to decide whether to fire the flash. The camera will analyze the lighting and other aspects of the scene and decide whether to use flash without further input from you. This selection is available only in Auto mode, and with the Portrait and Macro settings of Scene mode.

FILL-FLASH

With Fill-flash, you are making a decision to use flash no matter what the lighting conditions are. If you choose this option, the flash will fire every time you press the shutter button, if the flash is popped up. This is the setting to use when the sun is shining and you need to soften shadows on a subject's face, or when you need to correct the lighting when a subject is backlit.

For example, for Figure 4-33, I took two shots of a mannequin outdoors on a sunny day: one without flash (left image) and one using Fill-flash (right image). In the image on the right, for which flash was used, the harsh shadows are largely eliminated, providing more even lighting for the face. With this option, the camera uses what could be called "Front Sync," as opposed to Rear Sync, the next-to-last option on the Flash Mode menu, discussed later in this section.

Figure 4-33. Fill-flash Example

Fill-flash is available with all shooting modes except Movie, HFR, and Sweep Panorama, and these Scene mode settings: Night Scene, Hand-held Twilight, Night Portrait, and Anti Motion Blur.

SLOW SYNC

Slow Sync is one of the settings I did not discuss in detail in Chapter 2. This option is designed for use when you are taking a flash photograph of a subject at night or in dim lighting, when there is some natural light in the background.

With this setting, the camera uses a relatively slow shutter speed so the ambient (natural) lighting will have time to register on the image. In other words, if you're in a fairly dark environment and fire the flash normally, it will likely light up the subject (such as a person), but because the exposure time is short, the surrounding scene may be black. If you use the Slow Sync setting, the slower shutter speed allows the surrounding scene to be visible also.

I took the two images in Figure 4-34 with identical lighting and camera settings, except that I took the top image with the flash set to Fill-flash and shutter speed at 1/60 second, and I took the bottom image with the flash set to Slow Sync, resulting in a longer shutter speed of 1/4 second.

In the top image, the flash illuminated the mannequin head in the foreground, but the background is dark. In the bottom image, the room behind the mannequin is illuminated by ambient light because of the slower shutter speed.

When you use Slow Sync, you should use a tripod because the camera may choose a slow shutter speed, such as three seconds or longer. Note that you can choose Slow Sync even in Shutter Priority mode. If you do so, you should select a slow shutter speed because the point is to use a slow shutter speed to light the background with ambient light. With Shutter Priority mode you can choose the shutter speed, but it would not make sense to select a relatively fast one, such as, say, 1/30 second. The same considerations apply for Manual exposure mode, in which you also can select Slow Sync.

Figure 4-34. Slow Sync Example

Slow Sync is available only in the Program, Aperture Priority, Shutter Priority, and Manual exposure modes. With the Night Portrait setting of Scene mode, Slow Sync is set by the camera and cannot be changed.

REAR SYNC

The next setting for Flash Mode is Rear Sync. You should not need this option unless you encounter the special situation it is designed for. If you don't activate this setting (that is, if you select any other flash mode in which the flash fires), the camera uses the unnamed default setting, which could be called "Front Sync." In that case, the flash fires very soon after the shutter opens to expose the image. If you choose the Rear Sync

setting instead, the flash fires later—just before the shutter closes.

Rear Sync helps avoid a strange-looking result in some situations. This issue arises, for example, with a relatively long exposure, say one-half second, of a subject with lights, such as a car or motorcycle at night, moving across your field of view. With normal (Front) sync, the flash will fire early in the process, freezing the vehicle in a clear image. However, as the shutter remains open while the vehicle keeps going, the camera will capture the moving lights in a stream extending in front of the vehicle. If, instead, you use Rear Sync, the initial part of the exposure will capture the lights in a trail that appears behind the vehicle, while the vehicle itself is not frozen by the flash until later in the exposure. With Rear Sync in this particular situation, if the lights in question are taillights that look more natural behind the vehicle, the final image is likely to look more natural than with the Front Sync (default) setting.

The images in Figure 4-35 illustrate this concept using a flashlight. I took both pictures using the built-in flash, with a shutter speed of 1/2 second. For each shot, I waved the flashlight from right to left. In the top image, using the normal (Fill-flash) setting, the flash fired quickly, making a clear image of the flashlight at the right of the image, and the light beam continued on to the left during the long exposure to make a light trail in front of the flashlight's path of movement.

Figure 4-35. Rear Sync Example

In the bottom image, using Rear Sync, the flash did not fire until the flashlight had traveled all the way to the left, and the trail of light from its beam appeared behind the flashlight's path of motion. If you are trying to convey a sense of natural movement, the Rear Sync

setting, as seen here, is likely to give you better results than the default setting.

A good general rule is to use Rear Sync only when you have a definite need for it. Using this option makes it harder to compose and set up the shot, because you have to anticipate where the main subject will be when the flash finally fires late in the exposure process. But, in the relatively rare situations when it is useful, Rear Sync can make a dramatic difference. Rear Sync is available in the more advanced shooting modes: Program, Aperture Priority, Shutter Priority, and Manual exposure.

WIRELESS

The last setting on the Flash Mode menu, Wireless, gives you a powerful tool for controlling an off-camera flash unit using Sony's special wireless protocol. In order to take advantage of this setting, you need to have at least two flash units that are compatible with the Sony wireless system—one attached to the camera's accessory shoe and another one (or multiple units) positioned off the camera.

The flash on the camera acts as the controller. The built-in flash on the RX10 III camera cannot act as a wireless controller using this protocol, so you need to use an external unit. One option for this purpose is the Sony HVL-F20M, a small and relatively inexpensive unit. I discuss it in Appendix A. One negative point about this unit is that it cannot act as a remote unit using the Sony wireless protocol, only as the controller. That is not much of a problem, though; you can just dedicate this unit as your controller and use other, larger units as the remote flash units. Another option I have used as a controller is the Sony HVL-F32M, which I discuss below.

One remote unit I have used is the Sony HVL-F43M, also discussed in Appendix A. This full-sized flash has features such as a rotating head and a built-in video light. For wireless purposes, it can serve as either the controller or the remote unit for the Sony protocol.

I will describe how to set up a shot using the Sony wireless flash protocol in Aperture Priority mode using the HVL-F32M flash as the controller and the HVL-F43M flash as the remote unit; the procedure would be similar with other compatible Sony flash units.

1. Attach the HVL-F43M to the RX10 III, turn the camera and flash on, and set the camera to Aperture Priority mode, which is one of the modes that permit the use of Wireless for Flash Mode. On the Shooting menu, set the Flash Mode to Wireless and press the shutter button halfway. Make sure the flash's display shows that it is now set to Wireless mode, on Channel 1. If necessary, press the Mode button and the -/RMT button on the flash to set the flash to RMT (remote) mode.

2. Remove the HVL-F43M flash from the camera and set it up aiming at your subject, on a light stand, on its own plastic stand, or handheld by the subject or other person. The red AF Illuminator light on the flash unit should now be flashing, indicating that the remote unit is ready to receive a signal from the controller unit.

3. Attach the HVL-F32M to the RX10 III and turn the flash on. On the RX10 III, set up your shot using Aperture Priority mode.

4. On the camera, select Flash Mode from the Shooting menu and set the mode to Wireless (WL). Make sure the camera is aimed at the subject, and that the flash from the HVL-F32M can be seen by the remote flash. (The line of sight can be indirect, from bouncing off of a wall or ceiling.) If necessary, press the Mode button and the +/CTRL button on the F32M flash unit to set that unit to CTRL (controller) mode. To test the setup, press the AEL button on the camera to fire a test flash, which should trigger the remote flash.

5. When the shot is set up as you want it, press the shutter button to take the picture.

The flash unit on the camera sends a coded signal to the remote flash telling it to fire a pre-flash. The camera then evaluates that pre-flash and sets the remote flash to fire the flash at the proper intensity for the actual exposure. You will see the pre-flash, followed fairly quickly by the actual flash for the exposure.

Figure 4-36 shows a setup using this system, with the remote flash aimed at the subject and the controller flash on the camera.

Figure 4-36. Setup of Equipment for Wireless Flash Shot

Figure 4-37 shows an image taken with a setup similar to this one, using flash from the HVL-F43M.

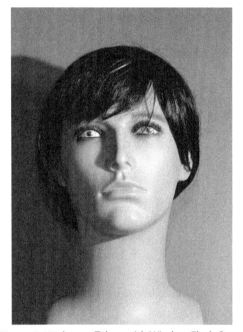

Figure 4-37. Image Taken with Wireless Flash Setup

This image was taken with the single remote flash shown here. I used Aperture Priority mode, and the camera exposed the image for 1/50 second at f/8.0 with ISO set to 200.

There are other Sony flash units that work with the wireless flash protocol, including the HVL-F60M. You can use multiple external flash units if you want.

Here is one more note about using flash: The built-in flash unit can synchronize with the shutter at any speed up to 1/2000 second when Shutter Type is set to Auto or Mechanical. The fastest shutter speed is 1/4000 second when an external flash is used and Shutter Type is set to Auto. However, when Shutter Type is set to Electronic, the fastest shutter speed at which the flash

can synchronize is 1/100 second, with either the built-in unit or an external flash.

Flash Compensation

This menu item lets you control the output of the camera's built-in flash unit, or of an external unit if a compatible one is attached to the flash shoe. This function works similarly to exposure compensation, which is available by turning the exposure compensation dial in the more advanced shooting modes. (Exposure compensation is discussed in Chapter 5.) The difference between the two options is that flash compensation varies only the brightness of the light emitted by the flash, while exposure compensation varies the overall exposure of a given shot, whether or not flash is used. (You can control whether the exposure compensation dial adjusts flash output as well as exposure settings by using the Custom menu's Exposure Compensation Setting option, as discussed in Chapter 7.)

Flash compensation is useful when you don't want the subject overwhelmed with light from the flash. I sometimes use this setting when I am shooting a portrait outdoors with the Fill-flash setting to reduce shadows on the subject. With a bit of negative flash compensation, I can keep the flash from overexposing the image or casting a harsh light on the subject's face.

To use this option, highlight it on the menu screen and press the Center button. On the next screen, shown in Figure 4-38, press the Left and Right buttons or turn the Control dial or the Control wheel to set the amount of positive or negative compensation you want.

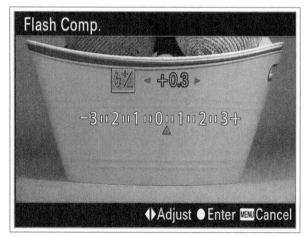

Figure 4-38. Flash Compensation Adjustment Screen

When the flash is popped up, an icon in the upper right shows the amount of flash compensation in effect, even if it is zero, as shown in Figure 4-39. Be careful to set the value back to zero when you are done with the setting, because any setting you make will stay in place even after the camera has been powered off and back on again.

The Flash Compensation option is not available in the Auto, Scene, or Sweep Panorama modes.

Figure 4-39. Flash Compensation Icon on Shooting Screen

Red Eye Reduction

This final option on screen 3 of the Shooting menu is designed to combat "red-eye"—the eerie red glow in human eyes that appears in images when on-camera flash lights up the blood vessels on the retinas. This menu item can be set to either On or Off. If it is turned on, then, whenever the flash is used, it fires a few times before the actual flash that illuminates the image. The pre-flashes cause the subject's pupils to narrow, reducing the ability of the later, full flash to enter the pupils, bounce off the retinas, and produce the unwanted red glow in the eyes.

I prefer to leave this option turned off and deal with any red-eye effects using editing software. However, if you will be taking flash photos at a party, you may want to use this menu option to minimize the occurrence of red-eye effects in the first place.

Figure 4-40 shows screen 4 of the Shooting menu.

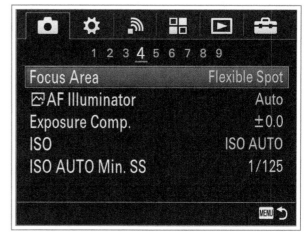
Figure 4-40. Screen 4 of Shooting Menu

Focus Area

The first option on this menu screen, Focus Area, lets you choose the area the camera focuses on when using autofocus or DMF, as selected with the focus switch. The two autofocus modes are single and continuous. Direct manual focus, or DMF, is a mode that lets you use both manual focus and autofocus. The Focus Area option sets the focus area for all three of those focus modes.

The choices for Focus Area are Wide, Center, Flexible Spot, Expand Flexible Spot, and Lock-on AF. Figure 4-41 shows the first four of these, from top to bottom; you have to scroll down to see the last option, Lock-on AF.

Figure 4-41. Focus Area Menu Options Screen

The ways these selections operate vary somewhat depending on whether you select single autofocus, continuous autofocus, or DMF for the focus mode using the focus switch. If you select DMF, you can use autofocus in the same way as with single autofocus, so DMF is the same as single autofocus with respect

to Focus Area. I will discuss the following options assuming at first that you are using single autofocus or DMF as your focus mode.

WIDE

With Wide, the RX10 III uses multiple focus zones and tries to detect one or more items within the scene to focus on based on their locations. When it has achieved sharp focus on one or more subjects, the camera displays a green frame indicating each focus point. You may see one or several green frames, depending on how many objects are detected at the same distance. An example with multiple objects is shown in Figure 4-42.

Figure 4-42. Wide Setting for Focus Area in Use

If the camera has difficulty picking out a subject to focus on, it will display a large, dotted frame around the whole image, as shown in Figure 4-43. The camera also uses this type of frame when it is using Clear Image Zoom or Digital Zoom, as discussed in Chapter 7.

Figure 4-43. Large, Dotted Frame for General Focus Area

When you are using single autofocus, the Wide option is excellent for shots of landscapes, buildings, and the like. In continuous autofocus mode, the RX10 III does not display any focus frame with the Wide setting. The camera tries to focus on the subjects that appear to be the main ones. I don't recommend using Wide for Focus Area with continuous autofocus unless you are focusing on a single, clearly defined subject, so the camera will be able to maintain focus on the proper area.

CENTER

If you select Center for the Focus Area setting, the camera places a black focus frame in the center of the display, as shown in Figure 4-44, and focuses on whatever it finds within that frame.

Figure 4-44. Center Setting for Focus Area in Use

When you press the shutter button halfway, if the camera can focus it will beep and the frame will turn green. This option is useful for an object in the center of the scene.

Even if you need to focus on an off-center object, you can use this setting. To focus on an object at the right, center that object in the focus frame and press the shutter button halfway to lock focus. Keeping the button pressed halfway, move the camera so the object is on the right, and press the button to take the picture.

If you turn on continuous autofocus with the Center setting, the camera still will display a black focus frame. When you press the shutter button halfway, the frame will turn green when focus is sharp. As the camera or subject moves, the camera will continue to re-focus as you hold the shutter button halfway down. You can use this technique to carry out your own focus tracking, by

moving the camera to keep the center frame targeted on a moving subject.

FLEXIBLE SPOT

The Flexible Spot option gives you more control over the focus area, with a frame you can move around the screen and resize. After you highlight this option on the Shooting menu, press the Right or Left button or turn the Control dial to select the size of the Flexible Spot focus frame: L, M, or S, for Large, Medium, or Small.

After choosing a size, press the Center button and you will see a screen like that in Figure 4-45, with a gray focus frame of that size with arrows pointing to the four edges of the display.

Figure 4-45. Movable Frame for Flexible Spot Focus Area Option

Use the four direction buttons to move the frame around the display. You also can turn the Control wheel to change the size of the frame, no matter what size you initially selected from the menu. When the frame is located and sized as you want it, press the Center button to fix it in place. The camera will display a black frame of the chosen size in the chosen location. When you press the shutter button halfway to focus, the focus frame will turn green when focus is sharp.

This frame operates the same way as the frame for the Center option, except for the ability to change the location and size. To return the frame quickly to the center of the screen, press the Custom 3/Delete button while the frame is activated for moving, and it will move back to the center of the display.

This option is useful for focusing on a particular point, such as an object at the far right, without having to move the camera to place a focus frame over that object.

This might help if you are using a tripod, for example, and need to set up the shot with precision, focusing on an off-center subject. If the subject is small, using the smallest focus frame can make the process even easier.

If you use continuous autofocus, the Flexible Spot option works the same way as the Center option, discussed above, but with the added ability to change the size and location of the frame.

One problem with the Flexible Spot menu option is that it can be cumbersome to move the frame again once you have fixed it in place. One way to do this is to select the Focus Area menu option and repeat all of the steps discussed above. There are a couple of quicker ways to move the frame, though.

The easiest way to do this is to go to screen 5 of the Custom menu and select the Custom Key (Shooting) option. On the next screen, select the Custom 1, Custom 2, Custom 3, Center, Focus Hold, or AEL Button, and assign the Focus Standard setting to that button. Then, whenever Flexible Spot is in effect, just press the assigned button when the shooting screen is displayed, and the screen for moving the focus frame will appear. You can quickly use the direction buttons to move the frame where you want it, and you can turn the Control wheel to resize it. You can press the Custom 3 (Delete) button to center it on the display.

Another option for moving the focus frame is to assign Focus Area to a control button using the Custom Key (Shooting) menu option. Then, when you press the assigned button, the camera displays the Focus Area menu, from which you can choose the size and location of the Flexible Spot frame. Or, you can assign Focus Area to the Function menu, which is called up by pressing the Function button. I will discuss that menu in Chapter 7.

My preference is to assign the Focus Standard setting to the Center button. Then, to move the focus frame, I just press that button and it is an easy matter to adjust the frame's location and size. I will discuss the Custom Key (Shooting) options further in Chapter 7.

EXPAND FLEXIBLE SPOT

This next option is a variation on the previous one, Flexible Spot. It operates in the same way, except that the frame size is small and it cannot be resized. You can

move it around the display with the direction buttons and the Control wheel. When you use this frame to fix the focus for your shot, the camera will first try to focus on a subject within the frame. If it cannot find a focus point in that small area, it will expand its scope and try to focus on a subject within the area immediately surrounding the frame. That area is outlined by four small brackets outside the corners of the focus frame, as shown in Figure 4-46.

Figure 4-46. Focus Frame for Expand Flexible Spot

This option can be of use when you want to focus on a small area, but you don't want the focusing to fail if focus can't be achieved in that exact spot.

LOCK-ON AF

The final option for Focus Area is Lock-on AF, which sets up the camera to track a moving object. This option is available for selection only when the focus mode is set to Continuous AF with the focus switch. When you highlight this option on the menu, as shown in Figure 4-47, the camera gives you six choices for the Lock-on focus frame: Wide, Center, Flexible Spot Small, Flexible Spot Medium, Flexible Spot Large, or Expand Flexible Spot. These frames correspond to the other choices for Focus Area, discussed above, and they also include the Lock-on frame's ability to "lock on" to a subject and track it as it moves.

After choosing one of these six frames, aim the camera at the subject, place the focus frame over it, and press the shutter button halfway. The camera will make an attempt to keep the subject within a double-bordered green frame as the subject moves, as shown in Figure 4-48. When you are ready to take the picture, press the shutter button all the way. If the autofocus system worked as expected, the image should be in focus.

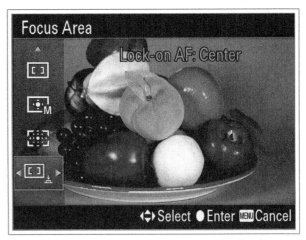

Figure 4-47. Lock-on AF Option Highlighted

Figure 4-48. Double-bordered Green Frame for Lock-on AF

When you are deciding which of the six sub-options to choose for Lock-on AF, consider the subject that you want the camera to lock onto, and choose accordingly. For example, if the subject is an automobile that is not too far away, you can probably choose Wide. If the subject is a person some distance away, you may want to choose Flexible Spot Small or Medium. Note that this choice affects only how the camera selects the subject to lock onto. Once it has locked onto that subject, the camera will display a double green focus frame that should expand to cover the area of that subject. So, even if you started with the Flexible Spot Small setting, if the camera locks onto a nearby face, the frame should expand to cover the whole area of the face, even if that face is larger than the initial focus frame.

The Lock-on AF option will not give good results if the subject moves too rapidly or erratically, or moves completely out of the frame. But, for subjects that are moving moderately in stable patterns, the Lock-on AF system is worth trying.

If this feature does not produce the results you want, you can consider using the Center Lock-on AF option, found on screen six of the Shooting menu, discussed later in this chapter.

AF Illuminator

The AF Illuminator item lets you disable the reddish lamp on the front of the camera for autofocusing. By default, this option is set to Auto, which means that when you are shooting a still image in a dim area, the camera will turn on the lamp briefly if needed to light the subject and assist the autofocus mechanism in gauging the distance to the subject. If you want to make sure the light never comes on for that purpose— to avoid causing distractions in a museum or other sensitive area, or to avoid alerting a subject of candid photography—set this option to Off. In that case, the lamp will never light up for focusing assistance, though it will still illuminate if the self-timer is activated.

Exposure Compensation

This next option on the Shooting menu gives you an alternative way to adjust exposure compensation. As I will discuss in Chapter 5, the primary way to adjust this option is by turning the exposure compensation dial at the right of the camera's top. You also can use the Custom Key (Shooting) menu option to assign one of the control buttons to adjust exposure compensation, or you can use the Function menu for that purpose, as discussed in Chapter 7. This menu option is yet another way to adjust this value.

Figure 4-49. Exposure Compensation Adjustment Scale

When you use the Exposure Compensation menu option, there is no difference from the procedure when you use a control button (as opposed to the exposure compensation dial) to make the adjustment. Once the EV (exposure value) scale appears on the display, as shown in Figure 4-49, use the Left and Right buttons, the Control wheel, or the Control dial to set the amount of positive or negative compensation, to make the image brighter or darker than it would be otherwise. Exposure compensation can be adjusted up to 3.0 EV in a positive or negative amount for still images, but only up to 2.0 EV in either direction for movies.

When you adjust exposure compensation using this menu option or a control button, as opposed to the exposure compensation dial, the value you set will be retained in memory after the camera is powered off and back on again, if the Reset EV Compensation option on screen 4 of the Custom menu is set to Maintain. If that option is set to Reset, any value you set with the Exposure Compensation menu option (or a control button) will be reset to zero when the camera is powered off. I will discuss the Reset EV Compensation menu option in Chapter 7.

Also, note that the setting of the exposure compensation dial takes priority over any setting using the exposure compensation menu option or a control button. Therefore, an EV setting using this menu option or a control button will take effect only when the exposure compensation dial is at the zero point.

ISO

ISO is a measure of the sensor's sensitivity to light. When ISO is set to higher values, the camera's sensor needs less light to capture an image and the camera can use faster shutter speeds and narrower apertures. The problem with higher values is that their use produces visual "noise" that can reduce the clarity and detail in your images, adding a grainy, textured appearance.

In practical terms, shoot with low ISO settings (around 100) when possible; shoot with high ISO settings (800 or higher) when necessary to allow a fast shutter speed to stop action and avoid motion blur, or when desired to achieve a creative effect with graininess.

With that background, here is how to set ISO on this camera. As is discussed in Chapters 5 and 7, with the

RX10 III you can get quick access to certain important settings, such as ISO, using the Function menu, the Quick Navi system, or, if you want, assigning the setting to a control button or the Control wheel using the Custom Key (Shooting) option on screen 5 of the Custom menu. However, you can also set ISO from the Shooting menu, and you can get access to some additional ISO settings only from this menu. So, it's important to understand how to use this menu item.

Figure 4-50. ISO Menu

ISO is the fourth item on screen 4 of the Shooting menu. After you highlight it, press the Center button to bring up the vertical ISO menu at the left of the screen, as seen in Figure 4-50.

Scroll through the options by turning the Control wheel or by pressing the Up and Down buttons to select a value ranging from one of the top two options—Multi Frame Noise Reduction and Auto ISO—through 64, 80, 100, 125, 160, 200, and other specific values, to a maximum of 12800 at the bottom of the scale. (If you want to use an ISO value higher than 12800, you need to use the Multi Frame Noise Reduction feature, discussed below.) You can scroll through the menu more quickly, skipping over two values at a time, by using the Control dial.

If you choose Auto ISO (the second option on the menu, highlighted in Figure 4-50), the camera will select a numerical value automatically depending on the lighting conditions and other camera settings. You can select both the minimum and maximum levels for Auto ISO. In other words, you can set the camera to choose the ISO value automatically within a defined range such as, say, ISO 200 to ISO 1600. In that way, you can be assured that the camera will not select a value outside

that range, but you will still leave some flexibility for the setting.

To set minimum and maximum values, while the orange highlight is on the Auto ISO option, press the Right button to move the highlight to the right side of the screen, where there are two rectangles that are labeled (when highlighted) ISO Auto Minimum and ISO Auto Maximum, as shown in Figure 4-51.

Figure 4-51. Screen for Setting ISO Minimum and Maximum

Move the highlight to each of these blocks in turn using the Right button and change the value as you wish, by pressing the Up and Down buttons or turning the Control wheel or the Control dial. You can set both the minimum and the maximum to values from 100 to 12800. When both values have been set, press the Center button to move to the shooting screen.

Once the minimum and maximum values are set, the camera will keep the ISO level within the range you have specified whenever you select Auto ISO or the Auto setting for Multi Frame Noise Reduction, discussed below. Of course, you can always set a specific ISO value at any other level by selecting it from the ISO menu.

MULTI FRAME NOISE REDUCTION

The top item on the ISO menu, whose icon includes the ISO label and a stack of frames, as shown in Figure 4-52, is a special setting called Multi Frame Noise Reduction (MFNR). With this option, the camera uses the ISO value you select and also uses a different type of image capture to enhance the quality of the shot.

With this option, you can set an ISO value as high as 25600, twice as high as the maximum value on the standard ISO menu. When you use MFNR, the camera

takes multiple shots in a rapid burst and creates a composite image with reduced noise. The camera also attempts to select frames with minimal motion blur.

Figure 4-52. Multi Frame Noise Reduction Icon Highlighted

After you have selected MFNR, use the Right button to move the highlight to the right side of the screen, on the selection block for the ISO setting to be used, as shown in Figure 4-53.

Use the Up and Down buttons or turn the Control wheel or the Control dial to select a value, which can be Auto or a specific value from 100 all the way up to 25600. If you choose Auto, the camera will select an ISO value within the limits set for ISO Auto Minimum and Maximum, and it will take multiple shots using that value. You cannot use the flash when MFNR is in effect. Also, you cannot use Raw quality, DRO, HDR, Picture Profile, Picture Effect, or continuous shooting with this setting.

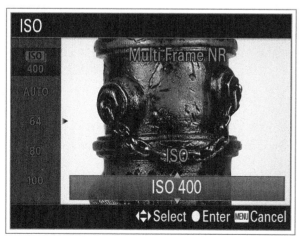

Figure 4-53. Selection Block for MFNR Setting

The MFNR setting is the only way to set the RX10 III to an ISO above 12800. If you are faced with the prospect

of taking pictures in an unusually dark environment, consider using this specialized setting, which really is more akin to a shooting mode than to an ISO setting.

For Figure 4-54, I used this setting to capture a view of an antique sewing machine in a dimly lighted museum. The RX10 III set the ISO to 6400 and used a shutter speed of 1/40 second at f/3.2.

Figure 4-54. Multi Frame Noise Reduction Example

Here are some more notes on ISO. As I discussed in Chapter 3, with the RX10 III, unlike many other cameras, you can select Auto ISO in Manual exposure mode. In that way, you can set both the shutter speed and aperture, and still have the camera set the exposure automatically by varying the ISO level. In the Auto, Scene, and Sweep Panorama modes, Auto ISO is automatically set, and you cannot adjust the ISO setting. The available ISO settings for movie recording are different from those for stills; I will discuss that point in Chapter 8.

Also, note that the settings for ISO 64 and 80 are surrounded by lines on the menu, as shown in Figure 4-50. The lines indicate that those two settings are not "native" to the RX10 III's sensor, whose base ISO is 100. So, although using the two lower settings reduces the sensor's sensitivity to light and darkens the exposure, it does not improve dynamic range or reduce noise in your images significantly.

My recommendation is to use Auto ISO for general snapshots when the main consideration is to have a properly exposed image. When you know you will need a fast shutter speed, select a high ISO setting as necessary. When you need to use a wide aperture to blur the background or a slow shutter speed to smooth out the appearance of flowing water, use a low ISO setting. When you are shooting in unusually dark conditions, consider using the MFNR setting with a high setting for ISO, even as high as 25600 in extreme cases.

ISO Auto Minimum Shutter Speed

The final option on screen 4 of the Shooting menu lets you set a minimum shutter speed, or shutter speed range, for the camera to use when ISO is set to ISO Auto. This option is available for selection only when the shooting mode is set to Program or Aperture Priority, the only two advanced shooting modes in which the camera chooses the shutter speed. The purpose of this setting is to give you a way to ensure that the camera uses a shutter speed fast enough to stop the action for the scene you are shooting.

For example, if you are shooting images of children at play with the camera set to Program mode and ISO Auto in effect with a range from 200 minimum to 1600 maximum, the camera ordinarily may choose a relatively low ISO setting in order to maintain high image quality and low noise. However, using that setting may result in the use of a fairly slow shutter speed, such as 1/30 second, in order to provide enough light for the exposure. With the ISO Auto Minimum Shutter Speed setting, you can set the minimum shutter speed you want the camera to use, such as, say, 1/125 second, to avoid motion blur. You also can specify a more general range of shutter speeds, using several categories, as discussed below.

To use this option, make sure the shooting mode is set to Program or Aperture Priority and that ISO is set to Auto ISO, or to Multi Frame Noise Reduction, with Auto ISO in effect for that setting. Then, highlight this option and press the Center button. You will see the menu shown in Figure 4-55, which includes numerous options as you scroll down through several screens.

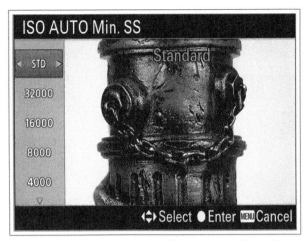

Figure 4-55. ISO Auto Minimum Shutter Speed Menu Option

All but one of the options are specific shutter speeds, ranging from 1/32000 second to 30 seconds. If you select one of those values, the camera will try to use a shutter speed at least that fast for each shot while maintaining the minimum ISO setting. Once the camera has found it necessary to lower the shutter speed to the minimum value, it will start raising the ISO level as needed. If the camera has set the ISO value to the upper range specified for Maximum ISO and still cannot expose the image properly at the ISO Auto Minimum Shutter Speed, the camera will set a shutter speed slower than the minimum value, in order to achieve a proper exposure.

For example, in the situation discussed above, using ISO Auto with a range from 200 to 1600, if there is plenty of light, the camera may select shutter speeds such as 1/250 second or 1/500 second. It will maintain the ISO at 200 if possible, and it will never select a shutter speed slower than 1/125 second. If the lighting conditions become such that the camera needs to lower the shutter speed all the way to the minimum setting of 1/125 second, the camera will raise the ISO as needed. If the light becomes too dim, the camera may set the ISO to the top of its Auto ISO range at 1600 but still find it impossible to get a good exposure using 1/125 second for the shutter speed. In that case, the camera will use a slower setting, such as 1/60 second or 1/30 second, as needed.

The item at the top of the menu for this option lists settings that are not specific shutter speeds: Standard, Fast, Faster, Slower, and Slow. You can use one of these if you don't need to specify a particular shutter speed but just want to set general guidance for the camera to use. If you choose Standard, the camera tries to maintain a normal shutter speed based on

its programming, taking into account the current focal length of the lens. So, if the lens is at its 24mm wide-angle setting, the camera will try to maintain a shutter speed faster than 1/24 second. If it is zoomed in to 200mm, it will try to use a speed faster than 1/200 second. If you choose Fast or Faster, the camera attempts to maintain a faster shutter speed than with Standard; Slow or Slower has the opposite effect.

Screen 5 of the Shooting menu is shown in Figure 4-56.

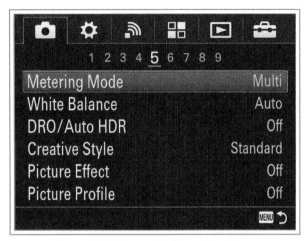

Figure 4-56. Screen 5 of Shooting Menu

Metering Mode

This option lets you choose among the three patterns of exposure metering offered by the RX10 III—Multi, Center, and Spot—as shown in Figure 4-57.

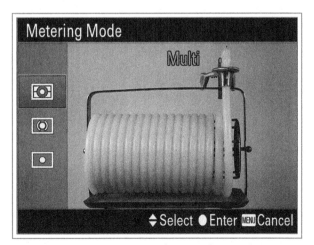

Figure 4-57. Metering Mode Menu Options Screen

This choice tells the camera's automatic exposure system what part of the scene to consider when setting the exposure. With Multi, the camera uses the entire scene that is visible on the display. With Center, the camera still measures all of the light from the scene, but it gives additional weight to the center portion of the image on the theory that your main subject is in or near the center. Finally, with Spot, the camera evaluates only the light that is found within the spot metering zone.

In Spot mode, the camera places a small circle in the center of the screen indicating the metered area, as seen in Figure 4-58.

Figure 4-58. Spot Metering Circle on Shooting Screen

With the Spot setting, you can see the effects of the exposure system clearly by selecting Program exposure mode and aiming the small circle at various points, some bright and some dark, and seeing how sharply the brightness of the scene on the camera's display changes. If you try the same experiment using Multi or Center mode, you will see more subtle and gradual changes.

If you choose Spot metering, the circle you will see is different from the rectangular frames the camera uses to indicate the Center or Flexible Spot Focus Area mode settings. If you make either of those Focus Area settings at the same time as the Spot metering setting, you will see both a spot-metering circle and an autofocus frame in the center of the LCD screen, as in Figure 4-59, which shows the screen with the Spot metering and Center Focus Area settings in effect.

Be aware of which one of these settings is in effect, if a circle or a frame is visible in the center of the screen. Remember that the circle is for Spot metering, and the rectangular bracket is for Center or Flexible Spot autofocus (or an equivalent Lock-on AF setting).

Figure 4-59. Spot Metering and Center Focus Area in Use

In Auto mode and all varieties of Scene mode, the only metering method available is Multi. That method also is the only one available when Clear Image Zoom or Digital Zoom is in use. (The conflict arises only when the lens is actually zoomed beyond the limit of optical zoom; at that point, the camera will change the metering method to Multi, and will change it back when the lens is zoomed back within the optical zoom limit.)

The Multi setting is best for scenes with relatively even contrast, such as landscapes, and for action shots, when the location of the main subject may move through different parts of the frame. The Center setting is good for sunrise and sunset scenes, and other situations with a large, central subject that exhibits considerable contrast with the rest of the scene. The Spot setting is good for portraits, macro shots, and other images in which there is a relatively small part of the scene where exposure is critical. Spot metering also is useful when lighting is intense in one portion of a scene, such as when a concert performer is lit by a spotlight.

White Balance

The White Balance menu option is needed because cameras record colors of objects differently according to the color temperature of the light illuminating those objects. Color temperature is a value expressed in Kelvin (K) units. A light source with a lower K rating produces a "warmer," or more reddish light. A source with a higher rating produces a "cooler," or more bluish light. Candlelight is rated about 1,800 K, indoor tungsten light (ordinary light bulb) is rated about 3,000 K, outdoor sunlight and electronic flash are rated about 5,500 K, and outdoor shade is rated about 7,000 K. If the camera

is using a white balance setting that is not designed for the light source that illuminates the scene, the colors of the recorded image are likely to be inaccurate.

The RX10 III, like most cameras, has an Auto White Balance setting that chooses the proper color correction for any given light source. The Auto White Balance setting works well, and it will produce good results in many situations, especially if you are taking snapshots whose colors are not critical.

If you need more precision in the white balance of your shots, the RX10 III has settings for common light sources, as well as options for setting white balance by color temperature and for setting a custom white balance based on the existing light source.

Once you have highlighted this menu option, press the Center button to bring up the vertical menu at the left of the screen, as shown in Figure 4-60.

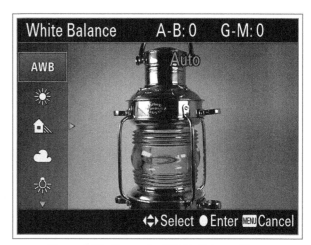

Figure 4-60. Screen 1 of White Balance Menu

Press the Up and Down buttons or turn the Control wheel or Control dial to scroll through the choices on the first screen: Auto White Balance (AWB), Daylight (sun icon), Shade (house icon), Cloudy (cloud icon), and Incandescent (round light bulb icon).

The second screen, seen in Figure 4-61, includes Fluorescent Warm White (bulb icon with -1), Fluorescent Cool White (same, with 0), Fluorescent Day White (same, with +1), Fluorescent Daylight (same, with +2), and Flash (WB with lightning icon).

Figure 4-61. Screen 2 of White Balance Menu

The choices on the third screen, shown in Figure 4-62, are Color Temperature/Filter (K and filter icon) and three numbered Custom choices. Below the three Custom icons is an icon with the word "SET," which represents the option for setting a Custom value.

Figure 4-62. Screen 3 of White Balance Menu

To select a setting, highlight it and press the Center button. Most of the settings describe a light source in common use. There are four settings for fluorescent bulbs, so you should be able to find a good setting for any fluorescent light, though you may need to experiment to find the best setting for a given bulb. For settings such as Daylight, Shade, Cloudy, and Incandescent, select the setting that matches the dominant light in your location. If you are indoors and using only incandescent lights, this decision will be easy. If you have a variety of lights turned on and sunlight coming in the windows, you may want to use either the Color Temperature/Filter setting or the Custom option.

The Color Temperature/Filter option lets you set the camera's white balance according to the color temperature of the light source. One way to determine that value is with a device like the Sekonic Prodigi color meter shown in Figure 4-63.

Figure 4-63. Sekonic Prodigi Color Meter

That meter works well when you need extra accuracy in your white balance settings. If you don't want to use a meter, you can still use the Color Temperature/Filter option, but you will have to do some guesswork or use your own sense of color. For example, if you are shooting under lighting that is largely incandescent, you can use the value of 3,000 K as a starting point, because, as noted earlier in this discussion, that is an approximate value for the color temperature of that light source. Then you can try setting the color temperature figure higher or lower, and watch the camera's display to see how natural the colors look.

As you lower the color temperature setting, the image will become more "cool," or bluish; as you raise it, the image will appear more "warm," or reddish. Once you find the best setting, leave it in place and take your shots. (The Live View Display option on screen 3 of the Custom menu must be set to Setting Effect On for these changes to appear on the display, as discussed in Chapter 7.)

To make this setting, after you highlight the icon for Color Temperature/Filter, press the Right button to move the orange highlight to the right side of the camera's screen so that it highlights the color temperature value bar, as shown in Figure 4-64.

Figure 4-64. Screen for Setting Color Temperature

Raise or lower that number by pressing the Up and Down buttons or by turning the Control wheel or Control dial, and press the Center button to select that value.

If you don't want to use color temperatures, you can set a Custom White Balance. This process can be confusing, because the Custom setting has several icons on the White Balance menu. The first three Custom icons, just below the Color Temperature/Filter icon, are used to set the camera to one of three currently stored Custom White Balance settings. The fourth icon, with the word "SET", is the one to use to measure and store a new reading for one of the Custom settings using the camera's special procedure for setting that value. Before you can use any of the three upper Custom icons, you need to use the lowest Custom icon to set the Custom White Balance value as you want it.

Figure 4-65. Screen for Setting Custom White Balance

To set and store a Custom White Balance, highlight the SET icon at the bottom of the White Balance menu. Press the Center button to select this option, and the

camera will display a message saying "Press the [Center] button to capture data of central area of screen," as shown in Figure 4-65. Aim the camera at a gray or white surface, lit by the light source you are measuring, that fills the circle on the screen. Press the Center button, and the camera will set the white balance.

The lower area of the screen will show the measured color temperature along with letters and numbers indicating variations along two color axes. If there is some variation, you will see an indication such as G-M: G1, meaning one unit of variation toward green along the green-magenta axis, as shown in Figure 4-66.

Figure 4-66. Screen Showing Results for Custom White Balance

Press the Right and Left buttons or turn the Control wheel or Control dial to select register 1, 2, or 3. Press the Center button to store the new setting to that register, replacing the existing setting. To use the Custom White Balance setting you saved, select the 1, 2, or 3 Custom icon on the White Balance menu, depending on the slot you used to save the setting. You can change any of the Custom settings whenever you want to, if you are shooting under different lighting conditions.

There is one more way to adjust the white balance setting by taking advantage of the two color axes discussed above. If you want to tweak the white balance setting to the nth degree, when you have highlighted your desired setting (whether a preset or the Custom setting), press the Right button, and you will see a screen for fine adjustments, as shown in Figure 4-67. This screen has a pair of axes that intersect at a zero point marked by an orange dot. The axes are labeled G, B, M, and A for green, blue, magenta, and amber.

Figure 4-67. Screen for Adjusting White Balance Axes

You can now use all four direction buttons to move the orange dot along any of the axes to adjust these 4 values until you have the color balance exactly how you want it. You also can use the Control wheel to adjust the G-M axis and the Control dial to adjust the B-A axis. Press the Center button to confirm the setting.

Be careful to undo any adjustments using these axes when they are no longer needed; otherwise, the adjustments will alter the colors of all of your images that are shot with this white balance setting in a shooting mode for which white balance can be adjusted, even after the camera has been powered off and then back on.

Some final notes about white balance: First, if you shoot using Raw quality, you can always correct the white balance after the fact in your Raw software. So, if you are using Raw, you don't have to worry so much about what setting you are using for white balance. Still, it's a good idea always to check the setting before shooting to avoid getting caught with incorrect white balance when you are not using the Raw format.

Second, before you decide to use the "correct" white balance in every situation, consider whether that is the best course of action to get the results you want. For example, I know of one photographer who generally keeps his camera set for Daylight white balance even when shooting indoors because he likes the "warmer" appearance that comes from using that setting. I don't necessarily recommend that approach, but it's not a bad idea to give some thought to straying from a strict approach to white balance, at least on occasion.

The white balance setting is fixed to Auto White Balance in the Auto and Scene modes.

Before I leave this topic, I am including a chart in Figure 4-68 that shows how white balance settings affect images taken by the RX10 III. I took the photos in the chart under daylight-balanced light using each available white balance setting, as indicated on the chart.

Most of the settings yielded acceptable results. The only ones that clearly look incorrect for this light source are the Incandescent and Fluorescent Warm White settings. The other settings produced variations that might be appropriate, depending on how you plan to use the images.

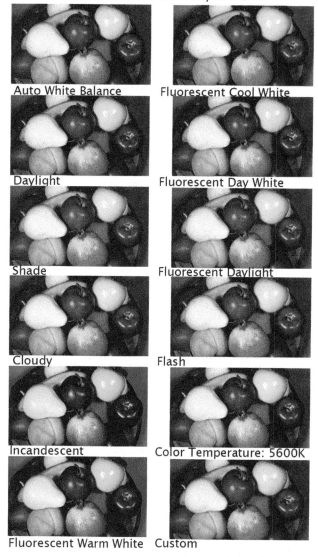

Figure 4-68. White Balance Comparison Chart

DRO/Auto HDR

The next option on the Shooting menu lets you control the dynamic range of your shots using the DRO/HDR processing of the RX10 III. These settings can help correct problems with excessive contrast in your images. Such issues arise because digital cameras cannot easily process a wide range of dark and light areas in the same image—that is, their "dynamic range" is limited. So, if you are taking a picture in an area that is partly lit by bright sunlight and partly in deep shade, the resulting image is likely to have some dark areas in which details are lost in the shadows, or some areas in which highlights, or bright areas, are excessively bright, or "blown out," so, again, the details of the image are lost.

One way to deal with this situation is to use high dynamic range (HDR) techniques, in which multiple photographs of the same scene with different exposures are combined into a composite image that has clear details throughout the entire scene. The RX10 III can take HDR shots on its own, or you can take separate exposures yourself and combine them in software on a computer into a composite HDR image. I will discuss those HDR techniques later in this chapter.

The RX10 III's DRO (dynamic range optimizer) setting gives you another way to deal with the problem of uneven lighting, with special processing in the camera that can boost details in dark areas and reduce overexposure in bright areas at the same time, resulting in a single image with better-balanced exposure than would be possible otherwise. To do this, the DRO setting uses digital processing to reduce highlight blowout and pull details out of the shadows.

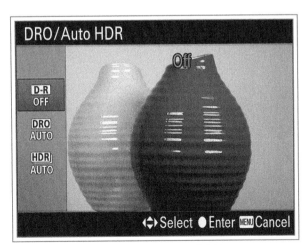
Figure 4-69. DRO/Auto HDR Menu

To use the DRO feature, press the Menu button and highlight this option, then press the Center button to bring the DRO/Auto HDR menu up on the camera's display, as shown in Figure 4-69. Scroll through the options on that menu using the Up and Down buttons or by turning the Control wheel.

With D-R Off, no special processing is used. With the second choice, press the Right and Left buttons or turn the Control dial to move through the DRO choices: Auto, or Level 1 through Level 5. With the Auto setting, the camera analyzes the scene to pick an appropriate amount of DRO processing. Otherwise, you can pick the level; the higher the number, the greater the processing to even out contrast between light and dark areas.

Figures 4-70 through 4-72 are examples of the various levels of DRO processing, ranging from Off to Level 5.

Figure 4-70. DRO Off

Figure 4-71. DRO Level 3

As you can see, the greater the level of DRO used, the more evenly the RX10 III processed lighting in the scene, primarily by enhancing details in the shadowy areas.

There is some risk of increasing visual noise in the dark areas with this sort of processing, but the RX10 III does

not seem to do badly in this respect; I have not seen increased noise levels in images processed with the DRO feature.

Figure 4-72. DRO Level 5

The final option for this item, HDR, involves in-camera HDR processing. With traditional HDR processing, the photographer takes two or more shots of a scene with contrasting lighting, some underexposed and others overexposed, and merges them using Photoshop or HDR software to blend differently exposed portions from all of the images. The end result is a composite HDR image with clear details throughout all parts of the image.

Because of the popularity of HDR, many makers have incorporated some degree of HDR processing into their cameras in an attempt to help the cameras even out areas of excessive brightness and darkness to preserve details. With the RX10 III, as with many modern cameras, Sony has provided an automatic method for taking multiple shots that the camera combines internally to achieve one HDR composite image. To use this feature, highlight the bottom option on the DRO/ Auto HDR menu, as shown in Figure 4-73.

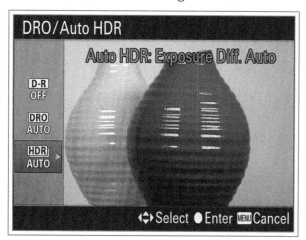

Figure 4-73. Auto HDR Icon Highlighted

Press the Right and Left buttons or turn the Control dial to scroll through the various options for the HDR setting until you have highlighted the one you want, then press the Center button to select that option and exit to the shooting screen. The available options are Auto HDR and HDR with EV settings from 1.0 through 6.0.

If you select Auto HDR, the camera will analyze the scene and the lighting conditions and select a level of exposure difference on its own. If you select a specific level from 1.0 to 6.0, the camera will use that level as the overall difference among the three shots it takes.

For example, if you select 1.0 EV for the exposure difference, the camera will take three shots, each 0.5 EV level (f-stop) different in exposure from the next— one shot at the metered EV level, one shot at 0.5 EV lower, and one shot at 0.5 EV higher. If you choose the maximum exposure difference of 6.0 EV, then the shots will be 3.0 EV apart in their brightness levels.

When you press the shutter button, the camera will take three shots in a quick burst; you should either use a tripod or hold the camera very steady. When it has finished processing the shots, the camera will save the composite image as well as the single image that was taken at the metered exposure.

For Figure 4-74 through Figure 4-77, I took shots of an old copper pitcher on a sunny day when the subject was partly in bright light and partly in shade, to illustrate the effectiveness of the HDR settings.

Figure 4-74. HDR Off

For Figure 4-74, HDR was turned off; for Figure 4-75, it was set at 3.0EV; for Figure 4-76, HDR was set to its highest value, 6.0EV. The image using HDR at 6.0EV gave the best results in terms of pulling details out of the shadows.

Figure 4-75. HDR Set to 3.0 EV

Figure 4-76. HDR Set to 6.0 EV

For comparison, I took several shots of the subject using a range of exposure levels in Manual exposure mode. I merged those images together in Photomatix Pro software and tweaked the result until I got what seemed to be the optimal dynamic range.

Figure 4-77. HDR Composite from Photomatix Pro Software

In my opinion, the HDR image done in software, shown in Figure 4-77, did a better job of evening out the contrast than the Auto HDR images processed in the camera. However, these images were taken under fairly extreme conditions. The in-camera HDR option is an excellent option for subjects that are partly shaded

and partly in sunlight, when you don't have the time or inclination to take multiple pictures and combine them later with HDR software into a composite image.

My recommendation is to leave the DRO Auto setting turned on for general shooting, especially if you don't plan to do post-processing. If the contrast in lighting for a given scene is extreme, then try at least some shots using the Auto HDR feature.

If you are planning to do post-processing, you may want to use the Raw Quality setting so you can work with the shots later using software to achieve evenly exposed final images. You also could use Manual exposure mode or exposure bracketing to take shots at different exposures and merge them with Photoshop, Photomatix, or other HDR software. The RX10 III provides high levels of dynamic range in its Raw files, particularly if you shoot with low ISO settings. Therefore, you very well may be able to bring details out of the shadows and reduce overexposure in highlighted areas using your Raw processing software.

Note that the Auto HDR setting cannot be used if you are using the Raw format for your images. The other DRO settings do work with Raw images, but they will have no effect on the Raw images unless you process them with Sony's Image Data Converter software or some other software that has been programmed to recognize the DRO settings embedded in the Raw files.

You cannot adjust DRO and Auto HDR settings in the Auto, Scene, and Sweep Panorama modes. With the Sunset, Night Scene, Night Portrait, Hand-held Twilight, and Anti Motion Blur settings, DRO/Auto HDR is turned off. With other scene types, DRO is turned on. DRO/HDR cannot be used when Multi Frame NR, Picture Effect, or Picture Profile is active. You can use flash with these settings, but it will fire only for the first HDR shot, and it defeats the purpose of the settings to use flash, so you probably should not do so.

Creative Style

The Creative Style setting provides options for altering the appearance of your images with in-camera adjustments to their contrast, saturation (color intensity), and sharpness. Using these settings, you can add or subtract intensity of color or make subtle changes to the look of your images, as well as

shooting in monochrome. Of course, if you plan to edit your images on a computer using software such as Photoshop, you can duplicate these effects readily at that stage. But, if you don't want to spend time processing your images in that way, having the ability to alter the look of your shots using this menu option can add a good deal to the enjoyment of your photos.

To use this feature, highlight Creative Style on screen 5 of the Shooting menu and press the Center button to go to the next screen, as shown in Figure 4-78.

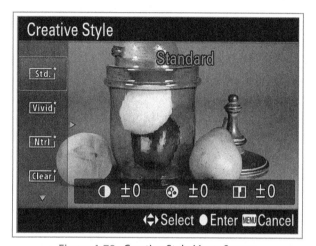

Figure 4-78. Creative Style Menu Screen

Using the Up and Down buttons or turning the Control wheel, scroll through the 13 main settings: Standard, Vivid, Neutral, Clear, Deep, Light, Portrait, Landscape, Sunset, Night Scene, Autumn Leaves, Black and White, and Sepia. If you want to choose one of these settings with no further adjustment, just press the Center button when your chosen option is highlighted.

If you use an option other than Standard, you may see a change on the display in shooting mode. For example, if you choose Sepia or Black and White, the screen will have that coloration. This effect will be visible, though, only if the Live View Display option on screen 3 of the Custom menu is set to Setting Effect On. If that menu option is set to Setting Effect Off, the display will not show any change from the Creative Style setting. You will still see an icon showing which setting is in effect, in the lower right of the screen. For example, Figure 4-79 shows the display when the Sepia setting is active but Setting Effect is off. (The VIEW indicator on the display indicates that Setting Effect is turned off.)

Figure 4-79. Display with Sepia on and Setting Effect Off

Adjusting Contrast, Saturation, and Sharpness

To fine-tune contrast, saturation, or sharpness for a Creative Style setting, move the highlight bar to the setting, such as Portrait, and press the Right button or turn the Control dial to put a new bar on the right of the screen. You will see a label above a line of icons at the bottom of the screen, as shown in Figure 4-80.

As you move the highlight over each icon with the Left and Right buttons or the Control dial, the label will change to show which value is active and ready to be adjusted. When the chosen value (contrast, saturation, or sharpness) is highlighted, use the Up and Down buttons or turn the Control wheel to adjust the value upward or downward by up to three units. When the Black and White or Sepia setting is active, there are only two adjustments available—contrast and sharpness. Saturation is not available because it adjusts the intensity of colors and there are no colors to adjust for those two settings.

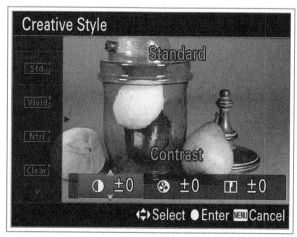

Figure 4-80. Screen to Adjust Contrast, Saturation, Sharpness

By varying the amounts of these three parameters, you can achieve a considerable range of different appearances for your images. For example, by increasing saturation, you can add punch and make colors stand out. By adding contrast and/or sharpness, you can impose a "harder" appearance on your images, making them look grittier and more realistic. Figure 4-81 is a composite image in which the left shot was taken with the Standard setting with all three parameters adjusted to their minimums, and the right shot was taken with the same setting, but with the contrast, sharpness, and saturation all adjusted to their maximum levels of +3 units. As you can see, the right image is noticeably brighter, with a crisper look than the left one.

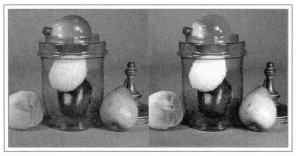

Figure 4-81. Comparison of Minimum and Maximum Creative Style Adjustments

If you want to save the adjusted settings for future use, you can create and save six different custom versions, using any of the 13 basic settings with whatever adjustments you want. To do this, scroll down on the Creative Style menu to the numbered items, starting just below the Sepia item, as shown in Figure 4-82.

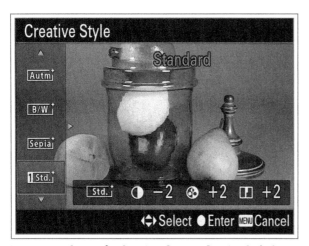

Figure 4-82. Screen for Creating Custom Creative Style Setting

There are six numbered icons, of which only the first one is visible on the screen shown here. They all work in the same way. Highlight a numbered icon, then,

using the Right button or the Control dial, move the highlight to the right side of the screen, on the name of the setting (Vivid, Neutral, Deep, etc.). Use the Control wheel or the Up and Down buttons to select any one of the 13 basic Creative Style settings. Then, scroll to the right and adjust contrast, saturation, and sharpness as you want them. When all the adjustments are made, press the Center button to accept them. Then, whenever you want to recall that customized setting for use, call up the Creative Style menu and scroll to the numbered icon for the style you adjusted.

The Creative Style option works with all shooting modes except Auto mode and Scene mode. You can use it with the Raw format, but the results will vary depending on the Raw-conversion software you use. For example, I just shot a Raw image in Program mode using the Black and White setting. The image showed up in black and white on the camera's screen. However, when I opened the image in Capture One Express for Sony, the image was in color; that software ignored the information in the image's data about the Creative Style setting. The same thing happened with Adobe Camera Raw and Photoshop.

When I opened the image using Sony's Image Data Converter software, though, the image appeared in black and white, because Sony's software recognized the Creative Style information. So, if you want to use this menu option with Raw files, be aware that not all software will use that data when processing the images.

The Creative Style menu option cannot be used when the Picture Effect or Picture Profile option is in use.

Figures 4-83 and 4-84 include comparison photos showing each Creative Style setting as applied to the same subject under the same lighting conditions to illustrate the different effects you can achieve with each variation. General descriptions of these effects are provided after the comparison charts.

Creative Styles Chart - Part 1

Creative Styles Chart - Part 2

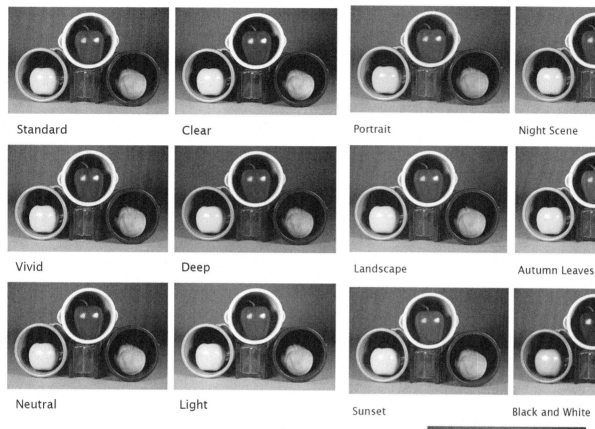

Standard Clear Portrait Night Scene

Vivid Deep Landscape Autumn Leaves

Neutral Light Sunset Black and White

Figure 4-83. Creative Style Comparison Chart 1

Sepia

Figure 4-84. Creative Style Comparison Chart 2

STANDARD

The Standard setting uses what Sony considers to be appropriate processing to give a pleasing overall appearance for everyday photographs, with some enhancements to make color photographs appear bright and sharp. This option is intended to be a good default setting for general purposes.

VIVID

The Vivid setting increases the saturation, or intensity, of all colors in the image. As you can see from the samples, it calls attention to the scene, though it does not produce very dramatic effects. The Vivid setting

might work well if you want to emphasize the colors in images taken at a birthday party or at a carnival.

NEUTRAL

With the Neutral setting, the RX10 III leaves images with reduced saturation and sharpness, so you can process them to your own taste using software.

CLEAR

Clear, according to Sony, emphasizes the highlighted areas in the image, giving them added intensity. Some users feel this setting yields images with more intensity than the Vivid setting.

DEEP

Sony says that this setting is intended to show the "solid presence" of the subject. In effect, it emphasizes the shadow tones and lowers the overall brightness of the image.

LIGHT

This setting is the opposite of Deep; it emphasizes the highlight tones and results in a brighter, lighter appearance.

PORTRAIT

The main feature of the Portrait setting is a reduction in the saturation and sharpness of colors to soften the appearance of skin tones. You might want to use this setting to take portraits that are flattering rather than harsh and realistic. Because this setting provides midrange values for the colors and contrast, some photographers find this to be their favored Creative Style setting for general photography.

LANDSCAPE

With the Landscape setting, the RX10 III increases all three values—contrast, saturation, and sharpness—to make the features of a landscape, such as trees and mountains, stand out with clear, sharp outlines. It is similar to Portrait in its processing of colors, but the sharper outlines and contrast might be too strong for portraits.

SUNSET

With the Sunset option, the camera increases the saturation to emphasize the red hues of the sunset. In my opinion, this setting produces more changes in color images than any of the others.

NIGHT SCENE

Night Scene lowers contrast in an attempt to soften the harsh effect that may result from shots taken in dark surroundings, without affecting the saturation or hues of the colors.

AUTUMN LEAVES

This setting, designed for enhancing shots of fall foliage, increases the intensity of existing red and yellow tones in the image, but does not alter the color balance or introduce new reddish shades, as the Sunset setting does.

B/W

This setting removes all color, converting the scene to black and white. Some photographers use this setting to achieve a realistic look for their street photography.

SEPIA

This second monochrome setting also removes the color from the image, but adds a sepia tone that gives an old-fashioned appearance to the shot.

The RX10 III also has settings for Portrait, Landscape, Sunset, and Night Scene in Scene mode, discussed in Chapter 3. However, the similar settings of the Creative Style option are available in the more advanced shooting modes, including Program, Aperture Priority, Shutter Priority, and Manual exposure, so you have access to settings such as ISO, Metering Mode, and others. And, as noted above, you can tweak Creative Style settings by fine-tuning contrast, saturation, and sharpness.

I don't often use the Creative Style settings, because I prefer to shoot with the Raw format and process my images in software such as Photoshop. I occasionally use the Sunset setting to enhance an evening view. The Creative Style settings are of value to a photographer who needs to take numerous photographs with a certain appearance and process them quickly. For

example, a wedding or sports photographer may not have time to process images in software; he or she may need to capture hundreds of images in a particular visual style and have them ready for a client or a publication without delay. For this type of application, the Creative Style settings are invaluable. The settings also are useful for any photographer who wants to maintain a consistent appearance of his or her images and is not satisfied with how the JPEG files look when captured with the factory-standard settings.

Picture Effect

The Picture Effect menu option includes a rich array of settings for shooting images with in-camera special effects. The Sony RX10 III gives you a variety of ways to add creative touches to your shots, and the Picture Effect settings are probably my favorites.

The Picture Effect settings do not work with Raw images. If you set a Picture Effect option and then select Raw (or Raw & JPEG) for Quality, the Picture Effect setting will be canceled. However, with a Picture Effect setting turned on, you still have control over many of the most important settings, including Image Size, White Balance, ISO, and even, in most cases, Drive Mode. So, unlike the situation with the Scene mode settings, when you select a Picture Effect option, you are still free to control the means of taking your images as well as other aspects of their appearance.

To use these effects, select the Picture Effect menu option as seen in Figure 4-85, and scroll through the choices at the left using the Control wheel or the Up and Down buttons.

Some selections have no other options, and some have sub-settings that you can make by pressing the Left and Right buttons or by turning the Control dial.

I will discuss each option in turn. In Figures 4-86 and 4-87, I provide charts with example images taken with each effect, all showing the same scene, for the purpose of comparison. Despite the fact that some settings are intended for other types of scenes, I believe the charts are useful to show how the various settings affect the same scene. After the charts, I will discuss each of the settings and provide a more individualized example image for each one.

Picture Effect Chart - Part 1

Off

Posterization

Toy Camera - Normal

Retro Photo

Pop Color

Soft High-key

Partial Color - Red

Figure 4-86. Picture Effect Comparison Chart 1

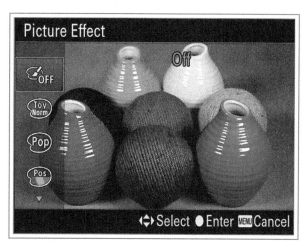

Figure 4-85. Picture Effect Menu

Picture Effect Chart - Part 2

High Contrast Monochrome

Rich-tone Monochrome

Soft Focus - High

Miniature

HDR Painting - Mid

Watercolor

Illustration - Mid

Figure 4-87. Picture Effect Chart 2

Following are details about each of the settings.

OFF

The top setting on the Picture Effect menu is used to cancel all Picture Effect settings. When you are engaged in ordinary picture-taking or video shooting, you should make sure the Off setting is selected so that no unwanted special effects interfere with your images.

TOY CAMERA

The Toy Camera option is an alternative to using one of the "toy" film cameras such as the Holga, Diana, or Lomo, which are popular with hobbyists and artists who use them to take photos with grainy, low-resolution appearances. With all of the Toy Camera settings, the RX10 III processes the image so it looks

as if it were taken by a camera with a cheap lens: The image is dark at the corners and somewhat blurry.

The several sub-settings for Toy Camera, reached by pressing the Right and Left buttons or turning the Control dial, act as follows:

Normal: No additional processing.

Cool: Adjusts color to the "cool" side, resulting in a bluish tint.

Warm: Uses a "warm" white balance, giving a reddish hue.

Green: Adds a green tint, similar to dialing in an adjustment on the green axis for white balance.

Magenta: Similar to the Green setting, but adjustment is along the magenta axis.

I took Figure 4-88 with the Toy Camera option using its Normal setting. This setting seemed appropriate to add a vignetting effect to a view of a historic trolley car in a museum.

Figure 4-88. Toy Camera Example

POP COLOR

This setting, according to Sony, is meant to give a "pop art" feel through emphasis on bright colors. As you can see in Figure 4-89, which shows a view of colorful storefronts on a city street, what you get with this setting is another way to add "punch" and intensity, along with added brightness, to your color images.

Figure 4-89. Pop Color Example

POSTERIZATION

This is a dramatic effect. Using the Right and Left buttons or the Control dial, you can choose to apply this effect in color or in black and white. In either case, the camera places extra emphasis on colors (or dark and light areas if you select black and white) and uses a high-contrast, pastel-like look. It is somewhat like an exotic type of HDR processing. The number of different colors (or shades of gray) used in the image is decreased to make it look as if the image were created from just a few poster paints; the result has an unrealistic but dramatic effect, as you can see in Figure 4-90, with its view of a yellow building that is transformed through this effect into a strange-looking shape.

Figure 4-90. Posterization Example

Remember that with all Picture Effect settings, you can adjust other settings, including white balance, exposure compensation, and others. With Posterization, you might use exposure compensation, which can change the appearance of this effect dramatically. I have found the results with this setting often are improved by using negative exposure compensation to avoid excessive brightness, as I did with this image. I recommend using

Posterization to achieve a striking effect, perhaps for a distinctive-looking poster or greeting card.

RETRO PHOTO

With this setting, the RX10 III uses sepia tint and reduced contrast to mimic the appearance of an aging photo. This effect is not as pronounced as the sepia effects I have seen on other cameras; with the RX10 III, a good deal of the image's original color still shows up, but there is subtle softening of the image with the sepia coloration.

Figure 4-91. Retro Photo Example

In Figure 4-91 I used this effect for a shot of an old bank building, to give it an air of days gone by.

SOFT HIGH-KEY

"High key" is a technique that uses bright lighting throughout a scene for an overall look with light colors and few shadows. With the RX10 III, Sony has added softness to give the image a light appearance without the harshness that might otherwise result from the unusually bright exposure. In Figure 4-92 I used this setting for a photo of a Conestoga wagon in a history museum. This setting was useful in adding brightness to a subject that would have looked excessively dark without some such lightening.

Figure 4-92. Soft High-key Example

PARTIAL COLOR

The Partial Color effect lets you choose a single color to retain in an image; the camera reduces the saturation of all other colors to monochrome, so that only objects of that single hue remain in color in the image. I really enjoy this setting, which can be used to isolate a particular object with dramatic effect. In Figure 4-93, I used this setting to emphasize the color of another item in the history museum, this time a bright red gasoline pump.

Figure 4-93. Partial Color Example

The choices for the color to be retained are red, green, blue, and yellow; use the Left and Right buttons or the Control dial to select one of those colors. When you aim the camera at your subject, you will see on the display

what objects will show up in color, if the Live View Display menu option is set to Setting Effect On.

There is no direct way to adjust the color tolerance of this setting, so you cannot, for example, set the camera to accept a broad range of reds to be retained in the image. However, if you change the white balance setting, the camera will perceive colors differently.

So, if there is a particular object that you want to depict in color, but the camera does not "see" it as red, green, blue, or yellow, you can try selecting a different white balance setting and see if the color will be retained. You also can fine-tune the white balance using the color axes to add or subtract these hues if you want to bring a particular object within the range of the color that will be retained.

By choosing a color that does not appear in the scene at all, you can take a straight monochrome photograph.

HIGH CONTRAST MONOCHROME

This setting lets you take black and white photographs with a stark, high-contrast appearance. You might want to consider this setting for street photography or any other situation in which you are not looking for a soft or flattering appearance.

I used this setting for Figure 4-94, an image of supporting beams under a railroad bridge over the river. I felt that this setting was appropriate for emphasizing the geometric structure of the subject.

Figure 4-94. High Contrast Monochrome Example

SOFT FOCUS

The Soft Focus effect is another setting that is variable; you can select either Low, Mid, or High by pressing the Right and Left buttons or turning the Control

dial to scroll through those options. This effect is straightforward; the camera blurs the focus to achieve a dreamlike aura. This is the first of several Picture Effect settings that cannot be previewed on the screen; you have to take the picture and then play it back to see the results of the Soft Focus setting. (As an alternative to using this setting, you can move the focus switch to the manual focus position and defocus the image to your own taste to achieve a similar effect.)

Figure 4-95. Soft Focus Example

For Figure 4-95, I used this option for an image of a lone woman walking along a wooded path at dusk. I find that this effect is often good for adding a feeling of peacefulness to a scene.

HDR Painting

The HDR Painting setting is similar to the HDR setting of the DRO/Auto HDR menu option. With this option, the camera takes a burst of three shots at different exposure settings and combines them internally into a single image to achieve even exposure over a range of areas with differing brightness. Unlike the more standard HDR setting, this one does not let you select the specific exposure differential for the three shots, but it lets you choose Lo, Mid, or Hi for the intensity of the effect. Also, it adds stylized processing to give the final image a painterly appearance.

I often have good results with this setting when I shoot from an indoor area through a window on a sunny day, especially when there is a variety of colorful items outside. For Figure 4-96, though, I chose a view of a historic house. With this sort of subject, with its straightforward, plain lines, the effect does not create excessive or confusing patterns.

Figure 4-96. HDR Painting Example

Because the camera takes multiple images with this option, you can't preview the results on the screen before taking the picture. Using a tripod is advisable to avoid blur from camera motion while the three shots are being taken.

Rich-Tone Monochrome

The Rich-tone Monochrome setting can be considered as a black and white version of the HDR Painting setting. With this option, like that one, the RX10 III takes a triple burst of shots at different exposures and combines them digitally into a single composite photo with a broader dynamic range than would otherwise be possible. Unlike the color setting, though, this one does not let you select the intensity of the effect. I used it in Figure 4-97 for a view of turbulent river waters near a bridge. This setting is good for producing traditional, postcard-like views of scenic subjects.

Figure 4-97. Rich-tone Monochrome Example

Miniature Effect

With the Miniature Effect option, the camera adds blurring at one or more sides or the top or bottom of an image to simulate the look of a photograph of a tabletop model or miniature. Such images often appear hazy in one or more areas, either because of the narrow depth of field of these closeup photos, or because of the use of a tilt-and-shift lens, which causes blurring at the edges.

For this feature to work well, you need an appropriate subject. I have found that this effect looks interesting when applied to something like a street scene or a train, which might actually be reproduced in a tabletop model. For example, if you are able to get a high vantage point above a road intersection or a railroad, you may be able to use this processing to make it look as if you had photographed a high-quality tabletop display.

After highlighting this option on the Shooting menu, press the Right and Left buttons or turn the Control dial to choose either Top, Middle (Horizontal), Bottom, Right, Middle (Vertical), Left, or Auto for the configuration of the effect. If you choose a specific area, that area will remain sharp.

For example, if you choose Top, then, after you take the picture, the top area (roughly one-third) will remain sharp, and the rest of the image below that area will appear blurred. If you choose Auto, then the camera will select the area to remain sharp based on the area that was focused on by the autofocus system and by the camera's sensing how you are holding the camera.

Figure 4-98. Miniature Effect Example

You will not see how the effect will alter the image while viewing the scene, though the camera will place gray areas on the parts of the image that will ultimately be blurred to give an idea of how the final product

will look. In Figure 4-98, I used this setting with the Bottom option for an image of a car parked in front of a colorful house.

This effect can provide a lot of fun if you experiment with it; it can take some work to find the right subject and the best arrangement of sharp and blurry areas to achieve a satisfying result.

Watercolor

The Watercolor effect blurs the colors of an image to make it look as if it were painted with watercolors that are bleeding together. You need to choose a subject that lends itself to this sort of distortion. For example, I have found that the faces of dolls and other figures can be pleasantly altered to have an impressionistic appearance. I have also had some pleasing results with plants and trees. In Figure 4-99, I tried a different subject, and used this option for a view from a bridge down on the very active waters of the river after a period of heavy rains.

Figure 4-99. Watercolor Example

Illustration

This final option for the Picture Effect setting is one of my favorites. This effect finds edges of objects in the scene and adds contrast to them, making the image seem like a pen-and-ink illustration that has been colored in. You can set the intensity of the effect to Low, Mid, or High using the Right and Left buttons or the Control dial. If you choose a subject with edges that can be outlined and a repeating pattern, you can achieve a pleasing result. This is another effect whose final result you cannot judge while viewing the live scene; you need to see the recorded image to know what the actual effect will look like.

As you can see in Figure 4-100, taken with Illustration set to Mid, this effect can transform an ordinary view into a stylized image while leaving the scene recognizable. The images produced with this effect may be more suited as decorative items than as depictions of actual objects or locations, but their appearance can be very striking and unusual. This setting often produces good results when people are included in the scene, especially if they are wearing clothes with bright colors.

Figure 4-100. Illustration Example

Here are some more notes about the Picture Effect settings. Several of the options are not available for shooting movies. Those settings are Soft Focus, HDR Painting, Rich-tone Monochrome, Miniature Effect, Watercolor, and Illustration. If one of those effects is turned on when you press the Movie button, the camera will turn off the effect while the movie is being recorded, and turn it back on after the recording has ended. You also cannot use continuous shooting or any type of bracketing with any of those six effects.

Picture Profile

The Picture Profile option, the final item on the fifth screen of the Shooting menu, provides powerful tools for adjusting the appearance of your files, particularly your video footage. This option is similar in some ways to the Creative Style option, which provides a separate set of preset adjustments that affect image processing, as discussed earlier in this chapter. Like Creative Style, the Picture Profile option includes several presets from which you can easily choose the one that best suits your current needs and instantly apply it to all of the videos and images you record using that setting. You also can make adjustments to several parameters within any of the Picture Profile settings, just as you can with the

Creative Style settings, and you can save the adjusted settings for future use.

However, apart from those similarities, the Picture Profile option is considerably different from the Creative Style feature. Creative Style is straightforward in the adjustments it provides, both in its 13 preset options (Standard, Vivid, Neutral, etc.) and in the adjustments you can make to those settings (contrast, saturation, and sharpness). It is easy to understand what is being adjusted for the presets and to see the resulting differences in the appearance of your images and videos.

The Picture Profile option does not provide such easily categorized adjustments. These adjustments are technical ones that are intended for use by professional videographers, to produce footage that is ready for post-processing, or that matches footage from other cameras using the same profile.

In this section, I will explain how to apply a Picture Profile setting and how to adjust one, and I will discuss parameters that can be tweaked for each profile. I will not try to give a detailed explanation of all possible adjustments for the various settings involved, such as gamma, knee, and detail.

To use this setting, highlight Picture Profile on the menu screen and press the Center button to display the vertical menu of settings, as shown in Figure 4-101.

Figure 4-101. Picture Profile Menu

Use the Control wheel, Control dial, or Up and Down buttons to scroll through the eight settings, including PP Off and PP1 through PP7.

If you don't need or want to bother with setting a profile, just leave this item set to PP Off and you

won't have to deal with it further. To use one of the seven preset profiles, scroll to that setting and press the Center button to choose it. That profile will then be displayed in an icon in the lower left corner of the detailed shooting screen, as shown in Figure 4-102.

Figure 4-102. Picture Profile Icon on Shooting Screen

The basic characteristics of the seven preset profiles that come with the camera are as follows:

PP1 Uses the standard gamma curve for movies.

PP2 Uses the standard gamma curve for still images.

PP3 Uses ITU709 gamma curve for natural color tone. The ITU709 standard is the normal set of specifications for HD television. This is a good profile to use for shooting that won't need extensive post-processing. This is also good for matching footage with that of other cameras.

PP4 Uses the ITU709 standard for color tone. Should not need much post-processing for color tone.

PP5 Uses Cine1 gamma curve to reduce contrast in dark areas and modify bright areas to produce a "relaxed" color effect. Good for sunny days and conditions with high contrast.

PP6 Uses Cine2 gamma curve, optimized for editing with up to 100% video signal; generally similar to Cine1, for use with less need for post-processing to avoid clipping highlights.

PP7 Uses S-Log2 gamma curve, designed to yield the greatest dynamic range, for footage that will be adjusted with post-processing software.

You should be able to get good results for general footage with any of the first four Picture Profile settings. On a particularly bright day or in contrasty conditions, you might try PP5, which uses the Cine1 gamma, designed to compress the dynamic range to avoid clipping highlights, or PP6, which uses the Cine2 gamma, which compresses the range even more.

If you will be doing post-processing to correct the color of your footage, you may want to use PP7, which uses the S-Log2 gamma curve setting. With this option, your footage will look dull and somewhat dark as shot, but its dynamic range will be considerably greater than normal, so you will have excellent options for producing good-looking footage with your post-processing software. However, because of the way this setting expands dynamic range, it requires the use of an ISO setting of 800 or greater. So, if you use PP7 or any profile that includes S-Log2 gamma, the camera will not set the ISO any lower than 800, and will reset a lower ISO value to 800.

The chart in Figure 4-103 shows the effects of the seven preset Picture Profile settings, as well as the same image with no Picture Profile in place, to give a general idea of how these settings affect an image. As you can see, PP7, which uses S-Log2 gamma, produces a dark image on the camera's display. When you are using that setting, you can activate the Gamma Display Assist feature, which sets the display to a higher level of contrast, so you can compose your shot accurately. That feature is found on screen 1 of the Setup menu. You also can assign it to a control button using the Custom Key (Shooting) option on screen 5 of the Custom menu, as discussed in Chapter 7.

If you are serious about video production, you may not be content with any of the seven pre-packaged Picture Profile settings. You can readily modify any of them in the camera. I don't recommend that you do this unless you are experienced and knowledgeable about video production, but the option for extensive tweaking is available. I will discuss the mechanics of how to adjust the various parameters for the Picture Profile settings, but I will not engage in a technical discussion of when and why to adjust them. (Appendix C has links to resources with further information.)

Picture Profiles Comparison

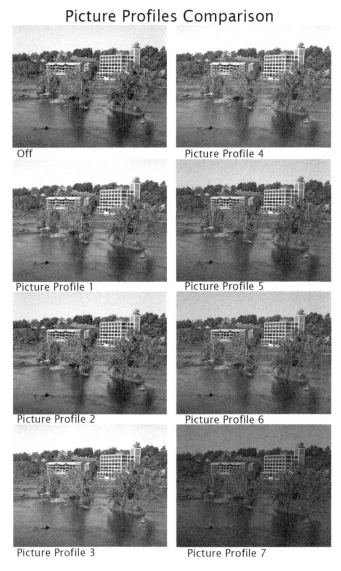

Figure 4-103. Picture Profile Comparison Chart

When you have highlighted a parameter to adjust, such as gamma, press the Right button to bring up the adjustment screen, as shown in Figure 4-105.

Figure 4-104. Picture Profile Parameters Screen

Figure 4-105. Picture Profile Parameter Adjustment Screen

To adjust a Picture Profile setting, first highlight the Picture Profile menu option and press the Center button to display the menu of Picture Profile options, as shown in Figure 4-101. Scroll to the one you want to adjust and press the Right button. You will then see a screen like that in Figure 4-104, listing the first six parameters that can be adjusted: black level, gamma, black gamma, knee, color mode, and saturation.

Turn the Control wheel or Control dial or press the Up and Down buttons to scroll through this list and on to the remaining parameters: color phase, color depth, and detail. The last two options, copy and reset, are for copying the settings or restoring the default settings.

Use the Control wheel, the Control dial, or the Up and Down buttons to choose the value to set, and press the Center button to set the value and return to the previous screen. Continue scrolling through the parameters to set each as you want it. Once you have made the adjustments, the Picture Profile number you adjusted will retain those changes, even if the camera is turned off and back on. If you want to copy the settings from one Picture Profile slot to another, use the copy item near the bottom of the list of parameters. Use the reset option to restore the Picture Profile setting to its default values.

Following are general descriptions of the nine parameters that you can adjust for each Picture Profile setting:

Black Level. Default 0; adjustment from -15 to +15. Adjusting in the negative direction strengthens the black color in the image; adjusting in the positive direction fades or weakens it.

Gamma. No default. Choices are Movie, Still, Cine1, Cine2, ITU709, ITU709 (800%), or S-Log2. The gamma curve is an adjustment to the video signal to account for the difference between recorded video and the output characteristics of various display devices, such as cathode ray tubes, HDTVs, etc. The first two choices are self-explanatory. Cine1 has the signal compressed to avoid clipping of highlights; Cine2 is compressed further for the same purpose. The ITU709 setting is a standard one for HDTV. The ITU709 (800%) option provides greater dynamic range than ITU709. It applies standard contrast and color levels to the video signal and turns off the knee circuit. It can be used as the finished product for video production. You may need to use this standard or S-Log2 when recording to certain external recorders, such as Odyssey7 models from Convergent Design. Finally, the S-Log 2 standard, which provides the greatest possible dynamic range, produces a flat, somewhat dark signal. This standard is for use only when you are going to be correcting the appearance of the video file with post-processing software.

Black Gamma. Range default is Middle; can be set to Wide or Narrow. Level default is 0; can be set from -7 to +7. Increasing Level brightens the image and decreasing Level darkens it. Adjusting Range determines whether the Level adjustment affects only blacks (Narrow) or a wider range of grays.

Knee. The knee adjustment sets a curve for compressing the signal in the brightest parts of the video image to avoid clipping or washing out of highlights. The Mode can be set to Auto or Manual. If you select Auto, then you need to use the Auto Set option to choose the Max Point and Sensitivity. If you choose Manual, you need to use the Manual Set option to set the Point and Slope.

Color Mode. No default. Can be set to Movie, Still, Cinema, Pro, ITU709 Matrix, Black & White, or S-Gamut. Movie is designed for use with the Movie setting for Gamma; Still for the Still setting; Cinema for the Cine1 setting; Pro for the gamma curve of Sony professional video cameras; ITU709 Matrix for use with the ITU709 gamma curve; Black & White for shooting in monochrome; and S-Gamut for shooting with the S-Log2 gamma curve. If you select the Black & White setting, the video will be shot in black and white.

Saturation. Default 0. Can be set from -32 to +32. This adjustment is similar to the saturation adjustment available with the Creative Style menu option. A negative setting lowers the intensity of colors, reducing them almost completely to black and white at the -32 level, while a positive value increases their intensity.

Color Phase. Default 0. Can be set from -7 to +7. Adjusting in the negative or positive direction makes the colors shift their hues. You can use this setting to match the color output of the RX10 III to that of another camera you are using for video production.

Color Depth. Default 0. Can be set from -7 to +7 for each of six colors: red, green, blue, cyan, magenta, and yellow. A higher number makes the color darker and richer; a lower number makes it brighter and paler.

Detail. There are two main settings: Level and Adjust. Level has a default of 0 and can be adjusted from -7 to +7. This setting affects the sharpness of edges in the image. A lower number softens the image and a higher number gives it sharper contrast. The other main setting, Adjust, has several settings, starting with Mode, which can be set to Auto or Manual. If you set Mode to Auto, you can ignore the other settings. If you set it to Manual, you can adjust V/H Balance, B/W Balance, Limit, Crispening (misspelled on the camera's menu), and Hi-Light Detail. Sony's user's guide recommends changing only the Level setting, at least at first, but the guide provides details on the other settings. You can see those details at Sony's website, http://helpguide.sony.net/di/pp/v1/en/contents/ TP0000909112.html. If you are planning to use software to process your video, you may want to reduce Level to -7 so you can determine the proper amount of sharpening on your own.

The good news about the Picture Profile setting is that you do not need to worry about it if you don't want to. If you are shooting primarily still images or videos for your own use, you don't have to select any Picture Profile setting. However, if you are using the RX10 III for professional video production, perhaps as a second camera, you may need to set the Picture Profile so the camera's output will match that of your other cameras.

Picture Profile cannot be used when DRO/HDR, Creative Style, or Picture Effect is in use. Picture Profile settings affect Raw files, but the black level, black gamma, knee, and color depth settings are not reflected in Raw images.

If you want to explore Picture Profile in greater detail, check out the resources listed in Appendix C.

Screen 6 of the Shooting menu is shown in Figure 4-106.

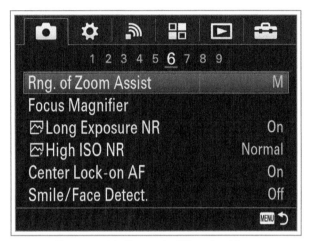

Figure 4-106. Screen 6 of Shooting Menu

Range of Zoom Assist

This first item on screen 6 of the Shooting menu lets you adjust the setting of the range in which the Zoom Assist feature operates. Zoom Assist lets you quickly zoom the lens back out from a telephoto position to give an overview of the scene. It is available for use only if you have assigned it to one of the control buttons, such as Custom button 1, 2, or 3, the Center button, or the Focus Hold button.

When Zoom Assist is assigned to a button, you press that button when you are viewing a subject using a long focal length, such as 500mm or 600mm. When you press and hold the button, the camera will immediately zoom the lens out so you can see a wider view of the scene, with a frame that shows the area that was visible at the telephoto focal length, as shown in Figure 4-107.

With this view, you can locate the subject you want to concentrate on. For example, if you were trying to photograph a bird or the moon, and had lost your view of it, this temporary wide-angle view should help you locate it. Then release the button assigned to

Zoom Assist, and the lens will return to its zoomed-in, telephoto position so you can take your shot.

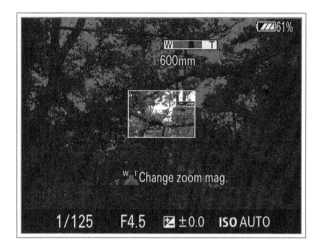

Figure 4-107. Shooting Screen While Zoom Assist Button Pressed

While the Zoom Assist view is on the display, you can use the zoom lever to adjust the amount of zoom. If you do that, when you release the Zoom Assist button, the lens will return to the new zoom amount as adjusted by the zoom lever.

Finally, you can adjust the amount by which the camera pulls back out from the zoomed-in position when you press the Zoom Assist button. That is the function of the Range of Zoom Assist menu option. The choices are S, M, or L, for small, medium, or large. If you want the lens to zoom back to a large degree so you can see a wide-angle view of the scene, choose L. For lesser amounts of pulling back, choose M or S.

Focus Magnifier

The Focus Magnifier option gives you a way to enlarge a small portion of the display so you can check the focus of that area. It is useful primarily when using manual focus or direct manual focus (DMF), but it can be used when the focus switch is at either of the autofocus positions (S or C), also. This option works somewhat differently when recording movies, as discussed later in this section.

When you select this menu option, the camera places an orange frame on the display, as seen in Figure 4-108.

Figure 4-108. Focus Magnifier Frame on Shooting Screen

You can move the frame to any position on the display using the direction buttons, the Control wheel, or the Control dial. When the frame is over the area where you want to check focus, press the Center button. The camera will then enlarge the area within the frame to 5.3 times normal, as shown in Figure 4-109. (The enlargement factor is different when shooting movies; see discussion below.)

Figure 4-109. Focus Magnifier at 5.3x Enlargement

An inset square will show the position of the Focus Magnifier frame. You can move the frame around the display while the display is enlarged and recall the frame to the center of the display by pressing the Custom 3 button. Press the Center button again, and the focus area will be magnified to 10.7 times normal. A final press will restore the display to normal size. Once you press the shutter button halfway, the magnifier frame will disappear. You can then call it up again using this menu option if you want to.

This option can be a bit confusing because it acts in a similar way to another option, which is activated from screen 1 of the Custom menu, called MF Assist. As I will discuss in Chapters 5 and 7, when you turn on MF Assist with manual focus in effect, the focus area is enlarged to 5.3 times normal as soon as you start turning the assigned focus ring to adjust the focus. Then, once the focus area is enlarged with that option, pressing the Center button will magnify the focus area to 10.7 times normal. You can toggle between the 5.3 and 10.7 magnifications using the Center button, and exit to the shooting screen by half-pressing the shutter button.

In other words, if the MF Assist menu option is active, the Center button always acts to magnify the focus area once you have started to adjust focus in manual focus mode. If you select the Focus Magnifier menu option, the difference is that pressing the Center button will magnify the display before you start focusing.

The advantage of using the Focus Magnifier menu option is that you can select the position of the enlarged focus area before you start adjusting focus. If you use the MF Assist option, the camera will enlarge the display as soon as you start turning the lens ring to adjust focus, and you will not be able to choose the location of the enlarged focus area until the display is already enlarged.

The MF Assist option works well for me, because it operates as soon as I start adjusting focus. However, if you prefer to be able to adjust the location of the frame for the enlarged focus area before starting to adjust focus, the Focus Magnifier option is useful. In addition, as noted earlier, you can use Focus Magnifier even with autofocus, although you cannot adjust autofocus with the frame on the display, because the frame disappears when you half-press the shutter button. (It also disappears if you use another button to autofocus with the AF/MF Control Hold function, which is discussed in Chapter 5.)

The Focus Magnifier feature is easier to use if you assign it to one of the control buttons. For example, you can use the Custom Key (Shooting) option on screen 5 of the Custom menu to assign Focus Magnifier to the Left button. Then, you can just press that button to bring the enlargement frame up on the display. You can quickly adjust the position of the frame, press the Center button once or twice to enlarge that area, and

then adjust the focus (if using manual focus or DMF) and take the picture.

You can adjust the length of time the screen stays enlarged with this feature by using the Focus Magnification Time option on screen 1 of the Custom menu. I prefer to set the time to No Limit so the magnification lasts as long as I need it. I will discuss that menu option in Chapter 7. You also can set the option to use an initial magnification factor of 1.0x or 5.3x using the Initial Focus Magnification item on screen 1 of the Custom menu.

As noted above, Focus Magnifier works slightly differently for movies than for still images. If you assign this option to a control button, you can call it up while recording a movie to check the focus of the area within the frame. The only magnification factor when shooting movies is 4.0x, rather than 5.3x and 10.7x, the factors when shooting still images.

Long Exposure Noise Reduction

This option uses processing to reduce the "noise" that affects images during exposures of 1/3 second or longer. This option is turned on by default. When it is turned on, the camera processes your shot for a time equal to the time of the exposure. So, if your exposure is for two seconds, the camera will process the shot for an additional two seconds, creating a delay before you can shoot again.

In some cases, this processing may remove details from your image. In addition, in certain situations you may prefer to leave the noise in the image because the graininess can be pleasing in some cases. Or, you may prefer to remove the noise using post-processing software. If you want to turn off this option, use this menu item to do so.

This option is not available for adjustment when the camera is set for continuous shooting, Multi Frame Noise Reduction, exposure bracketing, or in the Auto, Sweep Panorama, or Scene modes. The camera will select a setting for Long Exposure Noise Reduction in those cases. For example, the camera will turn this option off with the Sports Action, Hand-held Twilight, and Anti Motion Blur Scene mode settings, but turn it on with the Portrait and Macro settings.

I recommend you make this setting based on the type of shooting you are doing. If you're taking casual shots or don't want to do post-processing, I suggest you leave this option turned on. But, if you are shooting with Raw quality and want to do processing with software, I recommend turning it off.

High ISO Noise Reduction

This next menu entry has three settings: Normal, Low, or Off; the default is Normal. This option removes noise caused by the use of a high ISO level. One problem with this sort of noise reduction is that it takes time to process your images after they are captured. You may want to set this option to Low or Off to minimize the delay before you can take another picture. If Quality is set to Raw, this option will be unavailable on the menu because this processing is not available for Raw images. It also is not available in the Auto, Scene, or Sweep Panorama modes.

Center Lock-on AF

This menu option is similar to the Lock-on AF option discussed earlier in this chapter, but there are differences. Lock-on AF is a setting that is available for Focus Area on screen 4 of the Shooting menu. That option is available only with continuous autofocus. When it is activated, the camera places a frame of the chosen type on the display. When you center your subject in that frame and half-press the shutter button, the camera will try to keep the subject in focus as it moves.

The option being discussed here, Center Lock-on AF, is a separate menu option. It is not available when the Lock-on AF option has been selected for Focus Area. However, unlike the other option, Center Lock-on AF is available with both single autofocus and continuous autofocus. In order to make use of this feature, apart from turning on the menu option, you also have to assign one of the control buttons to the Focus Standard option, using the Custom Key (Shooting) option on screen 5 of the Custom menu. I usually assign either the Focus Hold button or the Center button to that function.

To use Center Lock-on AF, select this menu option and turn it on. The camera will display a message showing that you can press the Center button to lock on to the subject. At that point, press the Center button. The

camera will display a double-bordered frame that will move around the display and expand as needed to keep the subject inside the frame and in focus. You can half-press the shutter button to turn the focus frame green and lock focus at the current focus distance. When you are ready to take the picture, press the shutter button. To cancel the tracking, press the button assigned to Focus Standard. To start tracking again, from the shooting screen press the button assigned to Focus Standard to reactivate the feature.

This option can be more convenient to use than the Lock-on AF option, because you can use it with either single or continuous autofocus and you don't have to select a particular type of focus frame. You can just press the button assigned to Focus Standard and the tracking function will start.

There is one area of potential confusion with this feature: Although you can assign the Center button to the Focus Standard option, you do not have to use that button for that option. In fact, the Focus Hold button may be more convenient, and other buttons can be assigned as well. However, no matter which button is assigned to Focus Standard, you still have to use the Center button to initiate the tracking of the subject. So, you may have to press the Focus Hold button to activate the Center Lock-on AF feature, and then press the Center button to start the tracking. You can then press the Focus Hold button to cancel tracking.

This option does not work with Sweep Panorama mode or with the Hand-held Twilight or Anti Motion Blur settings of Scene mode. It also does not operate when Digital Zoom or Clear Image Zoom is in use, in Movie mode with SteadyShot (movies) set to Intelligent Active, or when Record Setting is set to one of the 120p options (100p for PAL systems).

Smile/Face Detection

This last option on screen 6 of the Shooting menu gives you access to two functions with fairly different features. There are four separate entries on the vertical menu that pops up when this menu item is selected, as shown in Figure 4-110.

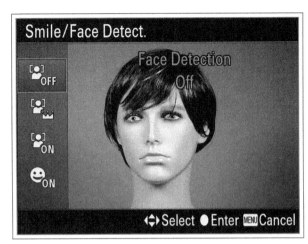

Figure 4-110. Smile/Face Detection Menu

You can select the top setting, Off, which leaves all options turned off, or you can select one of the other three, which operate as follows:

FACE DETECTION ON (REGISTERED FACES)

This option is designated on the menu screen by an icon of a person's head and a crown. When you select this choice, the camera searches for faces that you have previously registered using the Face Registration option on screen 5 of the Custom menu, as discussed in Chapter 7. If it detects a registered face, it should consider that face to have priority, in which case it will place a white frame on the face and adjust the Focus Area, Flash Mode, exposure compensation, white balance, and Red Eye Reduction values automatically to produce optimum exposure for that particular face. If there are multiple faces, some of which are registered, the camera should place a white frame over the one with the highest priority and purple frames over registered faces with lower priorities.

I do not often use this feature. It could be useful if you are taking pictures of children in a group setting and you want to make sure your own child is in focus and has his or her face properly exposed. I tried this feature out by registering one face and then aiming the camera at that face along with an unregistered face. In some cases, the camera picked the registered one as the priority face, but at other times it chose the unregistered one. Other users have reported good results with this feature, though, so, if it would be useful to you, by all means explore it further.

FACE DETECTION ON

This setting is similar to the previous one, except that it does not involve registered faces. As shown in Figure 4-111, the camera will detect any human faces, up to eight in total, and select one as the main face to concentrate its settings on.

Before you press the shutter button, the camera will display white or gray frames around any faces it finds. When you press the shutter button halfway to lock focus and exposure, the frame over the face the camera has selected as the main face will turn green. The camera may place multiple green frames if there are multiple faces at the same distance from the camera. If the camera is not recognizing faces well, you can adjust the sensitivity of the Smile Shutter, discussed below; that adjustment may improve the camera's ability to detect faces in general.

Figure 4-111. Face Detection in Use

Face Detection does not work when some other settings are in use. For example, it does not work with the Landscape, Night Scene, or Sunset scene settings, when Picture Effect is set to Posterization, when Digital Zoom or Clear Image Zoom is in use, when the Sweep Panorama mode is in use, or when using the Focus Magnifier option. It also does not function when recording a video with Record Setting set to 120p (100p if the PAL system is in use).

SMILE SHUTTER

The final option for this menu item is the Smile Shutter, which is a sort of self-timer that is activated when the subject smiles.

After highlighting this option, use the Left and Right buttons or the Control dial to choose the level of smile

that is needed to trigger the camera—Slight Smile, Normal Smile, or Big Smile. Then press the Center button to exit back to the shooting screen, and aim the camera at the subject or subjects. (You can, of course, put the camera on a tripod and aim it at yourself, if you want.)

As shown in Figure 4-112, the camera will show a meter at the left of the screen with a pointer to indicate how large a smile is needed to trigger a shot.

Figure 4-112. Smile Meter at Left of Shooting Screen

As soon as the camera detects a big enough smile from any person, the shutter will fire. If a person smiles again, the camera will be triggered again, with no limit on the number of shots that can be taken. In effect, this feature acts as a limited kind of remote control with one specific function. I consider this option to be something of a novelty, which can be entertaining but is not necessary for everyday photography.

The next options to discuss are on Screen 7 of the Shooting menu, shown in Figure 4-113.

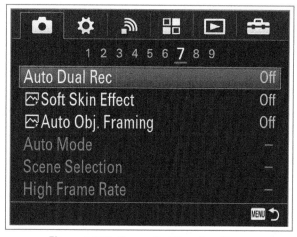

Figure 4-113. Screen 7 of Shooting Menu

Auto Dual Recording

This menu option lets you set the camera to capture still images automatically during a video recording, when the camera detects what it considers to be "impressive compositions, including people." If this feature is turned on, when a video sequence is being recorded, the camera may, from time to time, snap a still image during the recording, if the camera believes a particular scene with human faces is worthy of a still photo.

When you highlight the icon for turning this option on, you can press the Left and Right buttons or turn the Control dial to select a shooting frequency of Low, Standard, or High. This setting controls how often the camera is likely to capture a still image. When the camera does take a still photo, the word CAPTURE appears in green letters at the top of the display screen.

The size and quality of the still images captured with this feature are controlled by the Image Size (Dual Rec) and Quality (Dual Rec) items on screen 1 of the Shooting menu. The choices for Image Size are L:17M, M:7.5M, and S:4.2M. The options for Quality are Extra Fine, Fine, and Standard. If you are going to use this feature, I recommend using the L:17M and Extra Fine settings, for the best results. I also recommend using the High setting for frequency, unless you find the camera takes too many still images with that option.

I cannot imagine many situations in which I would want to use this feature, because it provides you with very little control over what the camera does. If you want to capture still images while recording video, you can press the shutter button to do so at any time you choose. However, if you have placed the camera unattended on a tripod to record an event, such as a family gathering or a wedding, it might be useful to use this feature to set the camera to take some still photos if it detects a good composition with family members or guests.

Soft Skin Effect

This menu option softens skin tones in the faces of your subjects for still images. The option is dimmed and unavailable in some situations, such as when one of the continuous shooting options or the Raw setting for Quality is selected. After you select it and turn it on, you can use the Right and Left buttons or the Control dial to set the level at Lo, Mid, or Hi, from the screen shown

in Figure 4-114. However, even if you turn the Soft Skin Effect option on, it will not produce any changes in your images unless you also have Face Detection turned on in the menu system and the RX10 III has detected a face.

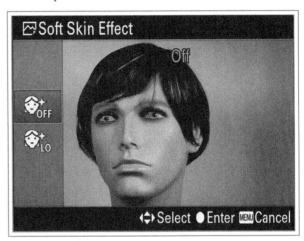

Figure 4-114. Soft Skin Effect Menu Screen

When it works, this setting reduces sharpness and contrast in areas that the camera perceives as skin tones. It can do a good job of smoothing out wrinkles. Figure 4-115 shows the results of a test I made. The image on the left was taken with the effect turned off; the image on the right had the setting at its Hi level.

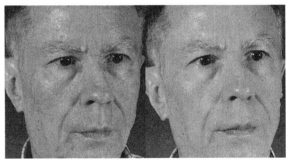

Figure 4-115. Soft Skin Effect Example

This can be a useful option for doing some basic retouching of your JPEG portraits in the camera.

Auto Object Framing

This menu option provides a somewhat unusual function: It rearranges the composition of your shot based on the camera's electronic judgment. To activate it, set it to Auto on the menu. Then, when you compose your image, the camera will place a green frame around what it believes to be the subject if it finds that the image can benefit by being trimmed to fit the subject better. For this feature to work with faces, you need to have Face Detection turned on with the Smile/Face

Detection menu option discussed above. Besides faces, Sony says that the feature will work with macro shots and objects tracked with Lock-on AF.

When you take a picture of the face or other subject, the camera may, if it finds it possible, crop the image and produce a new version of the image with the frame trimmed and resized to emphasize the subject in a more pleasing way.

Figure 4-116. Original Image Before Cropping

Figure 4-117. Image After Auto Object Framing

An example is shown in Figure 4-116 and Figure 4-117, which show the uncropped and cropped versions, respectively, of a mannequin head I photographed with Face Detection activated.

The camera's cropping looks appropriate, but I would rather do the cropping myself in Photoshop or just compose the image in this way to begin with.

The camera saves both versions, so there is no harm in using this feature. It could be useful if you are pressed for time or are unable to get into position to take the shot you want. If you need a more nicely cropped version of the image quickly for a slide show, perhaps, this could be a good way to fill that need.

This feature is available for selection only if the camera is set for autofocus with Quality set to Extra Fine, Fine, or Standard. This option does not work with Raw images or when the lens is zoomed beyond the full optical zoom range.

Auto Mode

This option is available for selection only when the Mode dial is set to the AUTO position. This menu item lets you choose either Intelligent Auto or Superior Auto for the shooting mode, as discussed in Chapter 3. If the Mode Dial Guide option is turned on through screen 2 of the Setup menu, the screen for choosing between these two modes is automatically displayed whenever you turn the Mode dial to the AUTO position and press the Center button when the Mode Dial Guide appears. If that option is not turned on or the Mode dial is already at the AUTO position, you can use the Auto Mode option to choose one or the other of the Auto modes.

Scene Selection

As discussed in Chapter 3, this option is used only when the camera is set to Scene mode. You use this menu item to select one of the settings in that shooting mode, including Portrait, Anti Motion Blur, Sunset, Night Scene, and others. Note that you also can use the Control dial to change scene types when the shooting screen is displayed. In addition, the Scene Selection menu screen appears automatically when you turn the Mode dial to the SCN position and press the Center button, if the Mode Dial Guide option on screen 2 of the Setup menu is turned on.

High Frame Rate

This last option on screen 7 of the Shooting menu is another mode-specific item. It is available for selection only when the Mode dial is set to the HFR position, for high frame rate movie recording. This option lets you choose one of the four exposure modes for recording

super-slow-motion movies: Program Auto, Aperture Priority, Shutter Priority, or Manual Exposure. I will discuss those modes, as well as other aspects of HFR recording, in Chapter 8.

The options on screen 8 of the Shooting menu are shown in Figure 4-118.

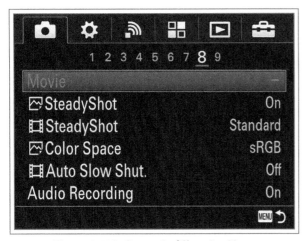

Figure 4-118. Screen 8 of Shooting Menu

Movie

This first menu item on this screen is available for selection only when the Mode dial is set to Movie mode (the position marked by a movie-film icon). Like the High Frame Rate option discussed above, it lets you select one of the four available exposure settings for recording movies in that mode. The Movie mode is for recording movies at normal speeds, as opposed to the high frame rates used for slow-motion movies recorded in the HFR mode. I will discuss this option in Chapter 8.

SteadyShot (Still Images)

SteadyShot is Sony's optical image stabilization system, which compensates for small movements of the camera to avoid motion blur, especially during exposures of longer than about 1/30 second. This setting is turned on by default, and I recommend leaving it on at all times, except when the camera is on a tripod. In that case, SteadyShot is not needed, and there is some chance it can "fool" the camera and cause it to try to correct for motion that does not exist, resulting in image blur.

SteadyShot (Movies)

This next option is a separate SteadyShot setting, for movies only. This menu item has a movie film icon in front of its name, whereas the previous one, for still images, has a mountain-landscape icon in front of its name. I will discuss this video-oriented SteadyShot option in Chapter 8.

Color Space

With this option, you can choose to record your still images using the sRGB "color space," the more common choice and the default, or the Adobe RGB color space. The sRGB color space has fewer colors than Adobe RGB; therefore, it is more suitable for producing images for the web and other forms of digital display than for printing. If your images are likely to be printed commercially in a book or magazine or it is critical that you be able to match a great many different color variations, you might want to consider using the Adobe RGB color space. I always leave the color space set to sRGB, and I recommend that you do so as well unless you have a specific need to use Adobe RGB, such as a requirement from a printing company that you are using to print your images.

If you are shooting your images with the Raw format, you don't need to worry so much about color space, because you can set it later using your Raw-processing software.

Auto Slow Shutter

This menu item is preceded by a movie film icon, indicating that it is used only for recording movies. This option lets the camera automatically set a slower shutter speed than normal when shooting a movie, in order to compensate for dim lighting. I will discuss this option in Chapter 8.

Audio Recording

The Audio Recording item on the Shooting menu can be set either on or off. If you are certain you won't need the sound recorded by the camera, then you can turn this option off. I never turn it off, because I can always turn down the volume of the recorded sound when playing the video. Or, if I am editing the video

on a computer, I can delete the sound and replace it as needed—but there is no way to recapture the original audio after the fact if this option was turned off during the recording.

The items on screen 9 of the Shooting menu are shown in Figure 4-119.

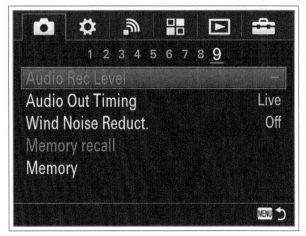

Figure 4-119. Screen 9 of Shooting Menu

Audio Recording Level

This option is available for selection only when the Mode dial is set to Movie mode. If you record movies by pressing the Movie button in any other shooting mode, the camera will set the level for recording sound, and you cannot control it. If the Mode dial is set to Movie mode, then you can control the sound level using this menu option. I will discuss its use in Chapter 8.

Audio Out Timing

This is another option that applies only when recording movies. I will discuss it in Chapter 8.

Wind Noise Reduction

This option also is one that applies only to movies. I will discuss it in Chapter 8.

Memory Recall

The Memory Recall option is used only when the Mode dial is set to MR. Using this option, you can recall the camera settings that you stored to one of the seven slots for this mode, as discussed in Chapter 3.

When the Mode dial is first turned to MR, this option's main screen appears on the camera's display with one of the seven indicators at the upper right highlighted, as shown in Figure 4-120. (If the Mode Dial Guide option is turned on through screen 2 of the Setup menu, the Mode Dial Guide screen will appear first; you then have to press the Center button to make this screen appear.)

Figure 4-120. Memory Recall Selection Screen

If the Mode dial is already at MR and you want to change to another memory register, you can use this menu option. Once the Memory Recall screen is displayed, either by turning the Mode dial to MR or by using this menu option, use the direction buttons or the Control wheel or Control dial to select register 1, 2, 3, M1, M2, M3, or M4 at the upper right of the screen. The settings for registers 1, 2, and 3 are stored in the camera's internal memory; the settings for registers M1 through M4 are stored on a memory card. Of course, you have to make sure the appropriate memory card is in the camera if you want to use M1 through M4.

When the register whose saved settings you want to recall for use is highlighted, press the Center button, and the new group of settings that were stored to that register will take effect.

Memory

The final option on the Shooting menu, Memory, was discussed in Chapter 3 in connection with the Memory Recall shooting mode. Once you have set up the RX10 III with the settings you want to store to a register of the MR mode, select the Memory option and choose one of the seven numbered registers, as shown in Figure 4-121.

Figure 4-121. Memory Settings Screen

Press the Center button, and all of the current settings will be stored to that register for the Memory Recall mode. You can recall those settings at any time by turning the Mode dial to the MR position (or selecting the Memory Recall menu option if the Mode dial is already at that position) and selecting register 1, 2, or 3, or M1, M2, M3, or M4. As noted above, the contents of the first three registers are stored to the camera's internal memory, while the contents of M1 through M4 are stored to a memory card in the camera.

With either the Memory Recall or Memory option, you can scroll to additional screens using the Down button to see other settings currently in effect.

CHAPTER 5: PHYSICAL CONTROLS

The Sony RX10 III, like other compact cameras, does not have as many physical controls as an advanced DSLR camera. But the RX10 III has more controls than most compact cameras, and the ones it has provide many options for customization. You can assign the most-used functions to buttons and dials to a greater extent than with many other cameras in this class.

In this chapter, I'll discuss each of the camera's physical controls and how they can be used to best advantage, starting with the controls on the right side of the top of the camera, shown in Figure 5-1.

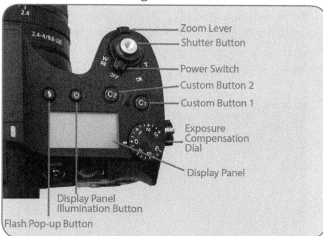

Figure 5-1. Controls on Right Side of Camera Top

Shutter Button

The shutter button is the single most important control on the camera. When you press it halfway, the camera evaluates exposure and focus (unless you're using manual exposure or manual focus). Once you are satisfied with the settings, press the button all the way to take the picture. When the camera is set for continuous shooting, you hold this button down while the camera fires repeatedly. You also can press this button halfway to exit from playback mode, menu

screens, and help screens to get the camera set to take its next picture. You can half-press this button to wake the camera up after it has powered down because of the Power Save Start Time option on the Setup menu.

When you are recording movies, you can, in most cases, press this button to capture a still image. When the Mode dial is set to Movie mode, pressing the shutter button has no effect unless a movie is being recorded. When the Mode dial is set to the HFR position, pressing the shutter button has no effect in any situation.

One somewhat unusual feature with the RX10 III is that the shutter button is threaded, so you can screw in a standard, mechanical cable release that can trip the shutter or lock it down for a long time exposure. I will discuss cable releases in Appendix A. You also can screw in a "soft release"—a button that provides a softer, smoother surface for your finger to press.

Zoom Lever

The zoom lever is a small ring with a short handle surrounding the shutter button. Its primary function is to change the focal length of the lens between its wide-angle setting of 24mm and its telephoto setting of 600mm. If you have the camera set for Clear Image Zoom or Digital Zoom, the lever will take the zoom to higher levels, as discussed in Chapter 7.

In addition to using this lever, you can use the front lens ring or the rear lens ring to zoom the lens, depending on a menu setting, as discussed later in this chapter and in Chapter 7.

In playback mode, moving the zoom lever to the right enlarges the current image, and moving the lever to the left reduces the size of enlarged images and produces index screens with multiple images. Those operations are discussed in Chapter 6.

Power Switch

This switch behind the shutter button is used to turn the camera on and off.

Flash Pop-up Button

This small button to the right of the RX10 III's built-in flash, marked with a lightning bolt, has just one

function—to release the flash and let it pop up. The flash on this camera will not operate until you use this button to pop it up out of the camera's housing. If you think you may have a need for the flash, be sure to press this button to pop it up. On the other hand, if you definitely do not want the flash to fire, such as when you are in a museum or other setting where flash is not permitted, just don't press this button, and the flash will not pop up. When you have finished with the flash, press it gently back into the camera until it clicks into place.

Custom Button 1

This small button labeled C1, for Custom 1, is a powerful control. By default, with the factory settings, this button is programmed to bring up the ISO menu so you can quickly change the ISO sensitivity for your shooting session. However, Sony has made this button available for you to assign to another function.

Using the Custom Key (Shooting) option on screen 5 of the Custom menu, you can assign any one of numerous settings to this button, including Drive Mode, Flash Mode, and many others. I will discuss all of the options in Chapter 7, where I discuss the Custom menu. Because of the convenient location of this button, in easy range of the index finger of your right hand, it is a good idea to choose an often-used option to be operated by the Custom 1 button.

In addition, Custom Button 1 is one of the four buttons on the camera that also can be assigned a function to be used when the camera is in playback mode using the Custom Key (Playback) menu option. I will discuss that option in Chapter 7.

Custom Button 2

The C2 button, near the C1 button, operates in a similar way. Like its companion, it can be assigned to one of many functions for use in shooting mode using the Custom Key (Shooting) menu option, and one of several functions to be used in playback mode.

Exposure Compensation Dial

Another convenient control on the RX10 III is this dial, which gives you a straightforward way to control exposure compensation. Rather than having to use a menu screen, you just turn this dial to one of the clearly marked values for positive or negative exposure compensation.

Figure 5-2. Image in Need of Exposure Compensation

Here is an example of the use of this dial to adjust exposure. In Figure 5-2, I photographed a lemon using the Program shooting mode. The lemon was bright, but the background was black. The camera's autoexposure system measured the light from the overall scene, and because of that dark background, it increased the exposure, making the lemon appear too bright.

I turned the dial to apply -1.7 EV (exposure value) of negative exposure compensation. The changed value appears in numbers at the lower right of the screen, to the left of the ISO value, as shown in Figure 5-3.

Figure 5-3. Display Showing Exposure Compensation Adjustment

With a negative value, the image will be darker than it otherwise would; with a positive value, it will be brighter. The camera's display will change to show the effect of the adjustment, if you have set the camera to show the effect. To see the effect as you adjust exposure compensation, go to screen 3 of the Custom menu,

select Live View Display, and choose Setting Effect On. If you choose the other possibility, Setting Effect Off, you will not see the effect of exposure compensation on the shooting screen, though it will appear in the final image. In this case, with exposure compensation adjusted downward by 1.7 EV units, the lemon became darker and was no longer overexposed, as shown in the final image, Figure 5-4.

Figure 5-4. Image After Exposure Compensation Adjustment

You might consider using exposure compensation on a routine basis. Some photographers generally leave exposure compensation set at a particular amount, such as negative 0.7 EV. You could do this if you find your images often look slightly overexposed or if you see that highlights are clipping in many cases. (You can tell if highlights are clipping by checking the playback histogram, as discussed in Chapter 6. If the histogram chart is bunched to the right, with no space between the graph and the right side of the chart, the highlights are clipping, or reaching the maximum value.) It is difficult to recover details from images whose highlights have clipped, so it can be a safety measure to underexpose your images slightly to avoid that situation.

If you don't plan to leave a permanent exposure compensation setting in place, you should return the setting to the zero point when you are finished with it, so you won't inadvertently change the exposure of later images that don't need the adjustment. (The exposure compensation setting will remain in place even after the camera has been turned off and back on again.)

In Manual exposure mode, exposure compensation has no effect unless ISO is set to Auto ISO. Exposure compensation is not available in Intelligent Auto or Scene mode. In Movie mode and HFR mode, exposure compensation can be adjusted only up to 2.0 EV positive or negative, instead of the 3.0 EV available for still images. You can control whether this dial adjusts flash output as well as exposure settings by using the Exposure Compensation Setting option on screen 4 of the Custom menu, as discussed in Chapter 7.

There are other ways to adjust exposure compensation if for some reason you don't want to use the exposure compensation dial. You can assign exposure compensation to one of the control buttons (C1, C2, C3, Left, Right, Center, Down, Focus Hold, or AEL) using the Custom Key (Shooting) option on screen 5 of the Custom menu. In addition, you can use the Exposure Compensation item on screen 4 of the Shooting menu. Note, though, that you cannot adjust exposure compensation using any of those methods unless the exposure compensation dial is at its zero point. In other words, any setting on the exposure compensation dial takes precedence, and prevents any other adjustment of exposure compensation.

Also, if you adjust exposure compensation using one of the methods that does not use the dial, you can use the Reset EV Compensation option on screen 4 of the Custom menu to determine whether that setting will remain in effect after the camera is powered off and back on. I will discuss that menu option in Chapter 7.

Display Panel and Display Panel Illumination Button

The screen to the left of the exposure compensation dial displays information for several settings, including shutter speed, aperture, white balance, exposure compensation, Drive Mode, number of images remaining, ISO (as it is being set), and others. To illuminate the display, press and release the button labeled with a light bulb, to the left of the panel. The panel will stay lighted until you press the button again to turn the light off.

The items on the left side of the camera's top are shown in Figure 5-5. This image also includes the aperture ring and the two lens rings, which I will discuss later, after discussing the controls on top of the camera and the items on its front.

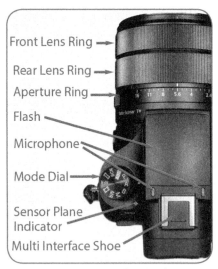

Figure 5-5. Controls on Left Side of Camera Top

Mode Dial

The Mode dial, at the far left side of the camera's top, has just one function—to set the shooting mode for capturing still images or videos. I discussed those modes in Chapter 3. To take a quick still picture, turn this dial to the green AUTO label and fire away. To take a quick video sequence, turn the dial to that position and then press the red Movie button, to the right of the viewfinder at the top of the camera's back. You can record a normal-speed movie with the Mode dial set to any position except HFR, which is used only for super-slow-motion movies. There is a Movie mode on this dial, marked by a movie film icon, but you do not have to select that icon to record movies.

Note, though, that screen 6 of the Custom menu has an option called Movie Button that can lock out the use of the Movie button unless the camera is set to Movie mode or HFR mode. If the Mode dial is set to Auto, Program, or any setting other than Movie or HFR mode, the Movie button will not work if that menu option is set to Movie Mode Only.

If the Mode dial is set to Movie mode, the camera will not take still images. In that mode, you can only record videos. You can, however, capture still images while recording videos in that mode, with some restrictions. I will discuss that process in Chapter 8. If the Mode dial is set to HFR, you cannot record still images at any time. I will discuss the HFR feature in Chapter 8 also.

Built-in Flash

The camera's built-in flash unit is normally retracted and hidden in the center of the camera's top. The camera cannot use it until you pop it up manually using the flash pop-up button located to the right of the flash. If you want the flash to be stowed away again, you need to press it gently back down into the camera until it clicks into place.

Multi Interface Shoe

The shoe on top of the RX10 III comes with a protective cap; slide that cap out, and the shoe is ready to accept several accessories. The most obvious accessory for this shoe is an external flash. I will discuss some available flash units in Appendix A, where I discuss accessories.

This shoe has special circuitry built into it so it can accept certain other accessories that are designed to interact with the camera. Sony makes microphones that can work with the shoe, including model ECM-XYST1M and model ECM-W1M. Sony also offers an accessory kit, model XLR-K2M, that lets you use professional-level, balanced microphones with XLR connections, and a video light, model HVL-LBPC, that can be controlled through this shoe. I will discuss those items in Appendix A. Sony undoubtedly will release other accessories that can take advantage of this interface as time goes by.

Microphone

The two openings for the camera's built-in stereo microphone are located on either side of the Multi Interface Shoe. This microphone provides excellent quality for everyday video recording. However, if you need greater quality, there are several options available for using higher-quality external microphones, as discussed in Appendix A.

Sensor Plane Indicator

This small symbol located to the right rear of the Mode dial shows the position of the digital sensor within the RX10 III. This indicator is provided in case you need to measure the exact distance from the sensor plane to your subject for macro photography.

Next, I will discuss the items on the front of the camera, as seen in Figure 5-6.

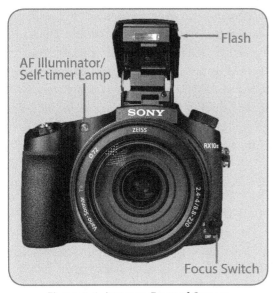

Figure 5-6. Items on Front of Camera

Focus Switch

The focus switch, one of the most important controls on the camera, is located at the extreme bottom of the camera's front, to the right of the lens as you face the camera. This small control is difficult to see in the general view of the camera's front, so I am including a detailed view of it in Figure 5-7.

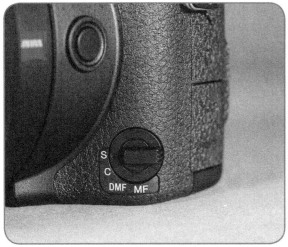

Figure 5-7. Focus Switch

Whenever you set out to take photographs or videos with the RX10 III, you need to make sure this switch is turned to the proper position to set the focus mode you intend to use. The switch has four positions for focus mode: S, for single-shot autofocus; C, for continuous autofocus; DMF, for direct manual focus; and MF, for manual focus. I will discuss these settings below.

SINGLE-SHOT AF

With this option, which is available only for shooting still images, the camera does its best to focus automatically on the scene the camera is aimed at, using the focus area that is selected using the Focus Area option on screen 4 of the Shooting menu. I discussed that option in Chapter 4. With the single-shot AF setting, the focus is locked in when you press the shutter button halfway down.

At that point, you will see one or more green focus brackets on the screen indicating the point or points where the camera achieved sharp focus, as shown in Figure 5-8, and you will hear a beep (unless beeps are turned off through the Audio Signals item on screen 1 of the Setup menu). In addition, a green disc in the lower left corner of the display will light up steadily, indicating that focus is confirmed. If focus cannot be achieved, the green disc will blink and no focus brackets will appear on the screen.

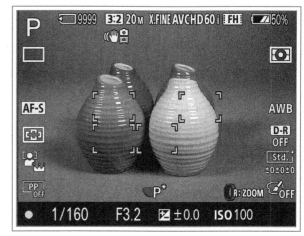

Figure 5-8. Green Focus Frames Indicating Good Focus

Once you have pressed the shutter button halfway to lock focus (and exposure), you can use the locked focus on a different subject at the same distance as the one the camera originally locked focus on. For example, if you focus on a person at a distance of 15 feet (4.6 m), and then you decide to include another person or object in the scene, once you have locked the focus on the first person by pressing the shutter button halfway, you can move the camera to include the other person or object in the scene as long as you keep the camera at about the same distance from the subject. The focus will remain locked at that distance until you press the shutter button the rest of the way down to take the picture.

CONTINUOUS AF

The second option for focus mode, continuous AF, is designated by the C setting for the focus switch. With this option, the RX10 III focuses continuously from the time you half-press the shutter button until you press the button all the way to take the picture. The difference with this mode is that the camera does not lock focus when you press the shutter button halfway. Instead, the camera continues to adjust focus if the subject or camera moves. You will not hear a beep or see any focus brackets to confirm focus. Instead, the green focus indicator in the lower left corner of the display will change its appearance to show the focus status.

If the indicator appears as a green disc surrounded by curved lines, as in Figure 5-9, that means focus is sharp but is subject to adjustment if needed.

Figure 5-9. Green Disc with Curves for Continuous AF

If only the curved lines appear, that means the camera is still trying to achieve focus. If the green disc flashes, that means the camera is having trouble focusing.

This focusing mode is useful when you are shooting a moving subject. With this option, you can get the RX10 III to fix its focus on the subject, but you don't have to let up the shutter button to refocus; instead, you can keep holding the button halfway until you take the picture; in this way, you may save some time, rather than having to keep starting the focus and exposure process over by pressing the shutter button halfway again.

Continuous AF is the only autofocus method available for shooting movies. When you are recording a movie in any shooting mode, if the focus switch is set to any position other than MF, the camera will use continuous autofocus and will constantly adjust its focus as needed.

Before I finish with autofocus modes, I will mention one menu item that has an important impact on the focusing of the RX10 III for still images. That option, called Pre-AF, is on screen 3 of the Custom menu. When you turn Pre-AF on with an autofocus mode (single-shot or continuous) in effect, the camera will constantly attempt to bring the image into focus without any action on your part. That is, when you just aim the camera at the subject, without touching the shutter button, the camera will continue to adjust its focus.

The camera will take into account the Focus Area setting (Wide, Center, Flexible Spot, etc.) as well as settings such as Face Detection, and attempt to focus on any object that appears to qualify as the main subject. With this option turned on, the camera should be ready to make its final focus adjustments more quickly when you press the shutter button to lock focus or to capture an image. I will discuss this option again in Chapter 7.

DIRECT MANUAL FOCUS

The third option for focus mode is DMF, which stands for direct manual focus. This feature lets you use a combination of autofocus and manual focus. One area in which DMF is useful is when you are shooting an extreme closeup of a small object, in which case focusing can be critical and hard to achieve. After you choose DMF, start the focusing process by pressing the shutter button halfway. The camera will make its best attempt to focus sharply using the autofocus mechanism. Then you can use the camera's manual focusing mechanism (turning the front or rear lens ring, as discussed below in this chapter) to fine-tune the focus, concentrating on the parts of the subject that you want to be most sharply focused.

Another time DMF is useful is when you are shooting a scene with objects at varying distances, and you want to focus on one of the more distant ones. You can start out using manual focus to get an approximate focus on the object you want to focus on, thereby letting the camera know the location of the main subject. Then you can press the shutter button halfway to let the camera take over and use autofocus to improve the sharpness of the focus.

When DMF is activated, you can turn on the Peaking Level feature on screen 2 of the Custom menu, as discussed below, and it will assist you with autofocus

operations using DMF as well as with manual focus. In addition, the MF Assist feature will enlarge the screen to help you with manual focusing, if you have turned it on through screen 1 of the Custom menu. However, with DMF, you have to keep the shutter button pressed halfway down while turning the lens ring for MF Assist to function. (With manual focus, you can just turn the ring without half-pressing the shutter button.)

MANUAL FOCUS

The final position on the focus switch is MF, for manual focus. As I discussed for DMF, there are times when you may achieve sharper or more precise focus by adjusting it manually. Those situations include shooting extreme closeups, when focus is critical; shooting a group of objects at differing distances, when the camera will not know which one to focus on; and shooting through a barrier such as glass or a wire fence, which may interfere with focusing.

Also, manual focus gives you the freedom to use a soft focus effect purposely. As I discussed in Chapter 4, the RX10 III has a Picture Effect setting called "Soft Focus," which adds a pleasing blurriness to images. If you would rather achieve this effect on your own by controlling focus directly, you can set the camera for manual focus and defocus your subject in precisely the way you want.

Using manual focus with the RX10 III is a pleasure. All you have to do is turn the ring that is currently assigned to manual focus. As I will discuss later in this chapter, the RX10 III has two ridged rings in front of the aperture ring—the front lens ring and rear lens ring. Using the Lens Ring Setup option on screen 6 of the Custom menu, you can assign either the front or the rear lens ring to manual focus; the other ring is then assigned to zooming the lens. Focusing with the lens ring is intuitive, and it is similar to the way most lenses were focused before autofocus existed.

There are several menu options available to help with manual focusing. I discussed one in Chapter 4 and I will discuss the others in Chapter 7, but I will briefly describe these aids here because you very well may need them when focusing manually.

First, the Focus Magnifier menu item, on screen 6 of the Shooting menu, puts an orange frame on the display, as shown in Figure 5-10.

Figure 5-10. Focus Magnifier Frame

Move this frame using the direction buttons, Control wheel, or Control dial. Press the Center button to enlarge the view within the frame to 5.3 times; press again to double the magnification, and a final time to return it to normal size. (You can alter the initial magnification setting using the Initial Focus Magnification item on screen 1 of the Custom menu.) You can focus with the assigned lens ring while the display is enlarged. If DMF is in use, you can half-press the shutter button for autofocus, but the display will not stay enlarged; it will return to normal if you press the shutter button.

The next manual focus aid, MF Assist, is the second option on screen 1 of the Custom menu. When MF Assist is on, whenever you turn the focusing ring to adjust focus in manual focus mode, the image on the display is automatically magnified 5.3 times, as shown in Figure 5-11, so you can more clearly check the focus.

Figure 5-11. MF Assist Screen at 5.3x Magnification

Photographer's Guide to the Sony DSC-RX10 III

Once the magnified image is displayed, if you press the Center button, the image is magnified to 10.7 times normal. Press the Center button again to return to the 5.3-times view. You can control how long the magnified display stays on the screen using the Focus Magnification Time option, directly below MF Assist on screen 1 of the Custom menu. I prefer to set the time to No Limit, so the magnification does not disappear just as I am getting the focus adjusted. With No Limit, the magnification stays on the screen until you dismiss it by pressing the shutter button halfway.

If you don't want the camera to enlarge the image as soon as you start focusing, you can use the Focus Magnifier option, discussed above, instead of MF Assist. Or, you can use both the MF Assist and Focus Magnifier options, though I see no need to do so. In most cases, my preference is to use only the MF Assist option, which is sufficient for my needs.

The RX10 III provides another manual focusing aid, Peaking Level, on screen 2 of the Custom menu. Peaking Level can be left off, or it can be set to Low, Mid, or High. When it is turned on, then, when you are using manual focus, the camera places bright pixels around the areas of the image it judges to be in focus, as shown in Figure 5-12 (no Peaking) and Figure 5-13 (Peaking set to Mid).

Figure 5-12. Peaking Level Off

Besides setting the intensity of this display, as discussed above, you can set the color the camera uses—either white, red, or yellow—using the Peaking Color option on the Custom menu. I have found this feature especially useful when focusing in dark conditions, because the Peaking color is illuminated and contrasts nicely with the dark display. Also, as noted

above, Peaking Level works with both the autofocus and manual focus aspects of the DMF option. I will discuss Peaking Level further in Chapter 7.

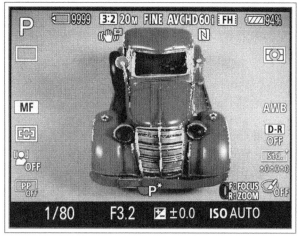

Figure 5-13. Peaking Level Mid

Finally, there is another way to customize the use of manual focus with the RX10 III. On screen 5 of the Custom menu, using the Custom Key (Shooting) option, you can assign the Center, AEL, Focus Hold, or Custom 1, 2, or 3 button to control any one of a long list of functions. One of those functions, AF/MF Control Hold, is useful if you may need to switch between autofocus and manual focus frequently. When this function is assigned to a button, you can press that button whenever you want to switch instantly between these two focus modes. (The Left, Right, and Down buttons also can be programmed, but they cannot be assigned to the AF/MF Control Hold option.)

Also, when the focus switch is at the MF position and you use the assigned button to switch from manual focus to autofocus using AF/MF Control Hold, the camera instantly focuses on the subject before it. This option, sometimes called "back button focus," because you can focus using a button on the back of the camera, is more convenient than reaching down to find the focus switch and turning it to the new position, and it may be worthwhile assigning a button to this use.

The RX10 III has a strong array of aids for manual focus. With some compact cameras, manual focus is hard to use because you have to turn a very small dial or the magnification options are not helpful. I find that with the RX10 III, I prefer using manual focus rather than autofocus in some situations, because it is so powerful and easy to use.

AF Illuminator/Self-Timer Lamp

The lamp on the front of the camera next to the lens has two uses. Its reddish light blinks to signal use of the self-timer and it turns on in dark conditions to assist with autofocusing for still images. You can control the lamp's autofocus function with the AF Illuminator item on screen 4 of the Shooting menu, as discussed in Chapter 4. If you set that menu item to Auto, the lamp will light as needed for autofocus; if you set it to Off, the lamp will never light for that purpose, though it will still illuminate for the self-timer.

Aperture Ring and Aperture Click Switch

The aperture ring, located next to the camera's body and labeled with numbers from 2.4 to 16, has a single purpose. You use this ring to set the aperture when the camera is in Aperture Priority or Manual exposure mode for still shooting or video recording, or in Movie mode or HFR mode with the movie or HFR exposure mode set to Aperture Priority or Manual Exposure. In other shooting modes, the ring has no function.

To set the aperture, turn the ring so the selected f-stop, such as f/2.4 or f/5.6, is aligned with the white indicator line on the lens. The ring is labeled with the major settings, and it has unlabeled white lines that indicate the intermediate settings of one-third of an f-stop. For example, between the labeled settings of f/4 and f/5.6 are unlabeled lines for the settings of f/4.5 and f/5.0.

There are a couple of other points to note about this ring. First, because it is a physical control on a camera with many electronic features, including automatic exposure, there will be times when the reading on the ring does not agree with the actual aperture setting. For example, when the camera is in Program mode, Shutter Priority mode, or Intelligent Auto mode, the camera will set the aperture, regardless of the position of the aperture ring.

The other point is that you can change the behavior of the ring with the aperture click switch. This small switch is hard to see; it is located near the camera's body on the lower left of the lens as you face the camera, as shown in Figure 5-14. When the switch is set to the On position, the ring moves with a reassuring click and stops cleanly at each setting on the aperture scale. I

usually leave this switch turned on when I'm using the camera for shooting still images.

Figure 5-14. Aperture Click Switch at On Position

When shooting videos, though, it's a good idea to turn the clicks off using this switch, if there's any chance you'll be turning the ring during the video recording. The reason for doing this is to avoid recording the sounds of the clicks on the audio track. With the switch turned off, the ring will rotate smoothly and quietly, with no defined stops for the various settings. This makes it harder to pick a specific aperture value, but, for shooting videos, you're probably more likely to want the smooth, silent motion of the ring, and you may not be so concerned with selecting a particular f-stop.

Front and Rear Lens Rings

The other large rings around the lens, beyond the aperture ring, are the front and rear lens rings, which are covered with smooth ridges. One of these rings is assigned to control manual focus when that option is active, and the other one is used to zoom the lens in and out throughout its optical focal length range of 24mm to 600mm.

By default, the front lens ring controls focus and the rear lens ring controls zoom. However, you can easily reverse those assignments using the Lens Ring Setup option on screen 6 of the Custom menu, discussed in Chapter 7. The top menu option selects the default setup. If you select the bottom option, the front ring will control zoom and the rear ring will control manual focus.

You also can select the direction in which each ring rotates to increase or decrease its setting, using the Focus Ring Rotate and Zoom Ring Rotate options on screen 6 of the Custom menu. In addition, you can select the speed of zooming and whether or not the ring assigned to zoom the lens does its zooming

continuously or in a series of predefined steps, using the Zoom Function on Ring option on that same Custom menu screen.

There are several important controls on the back of the RX10 III, as seen in Figure 5-15.

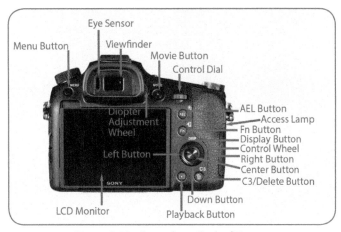

Figure 5-15. Controls on Back of Camera

Playback Button

This button to the lower left of the Control wheel, marked with a small triangle, is used to put the camera into playback mode, which allows you to view your images and videos on the LCD screen or in the viewfinder. When the camera is in playback mode, pressing this button will switch the camera to shooting mode. When the camera has powered down because of the Power Save Start Time menu option, you can press this button to wake the camera up into playback mode.

Movie Button

The red button to the right of the viewfinder has just one function—to start and stop the recording of movie sequences. As I noted in discussing the Mode dial earlier in this chapter, you can control how the Movie button operates. If you want to be able to start recording a movie in any shooting mode (in HFR mode, the button initiates a somewhat different procedure), go to the Custom menu and select the Movie Button option on screen 6. If you set that menu option to Always (the default setting), then the Movie button will operate in any shooting mode. If you set that option to Movie Mode Only, then the Movie button will not operate unless the camera is set to Movie mode or HFR mode using the Mode dial. (Movie mode is the mode marked by the movie film icon.)

This is a fairly important decision to make, and it depends on your preferences and likely uses of the camera. If you want to be able to start recording a video at any time without delay, you should leave the Movie Button option set to Always. The reason you might not want to do this is if you believe you may press the Movie button by mistake. I have done that often myself, particularly with a smaller Sony model, the DSC-RX100, which does not have the option to limit the use of the Movie button to Movie mode. When you press the button by mistake, you have to press it again to stop the recording, and then wait for the camera to finish processing the movie before you can use any other controls. And, of course, the camera will have an unwanted file cluttering the memory card.

With the RX10 III, I never press the Movie button by mistake, because the button does not come within range of my thumb unless I want to press it. So, with this camera I leave the option set to Always, to avoid missing video opportunities. But you should consider whether you want to use that menu option as a precaution against unwanted footage.

There are differences in how the camera operates for video recording in different shooting modes. I will discuss movie-making in detail in Chapter 8.

Menu Button

The Menu button, at the upper left of the camera's back, has a straightforward function. Press it to enter the menu system and press it again to exit to the mode the camera was in previously (shooting or playback). The button also cancels out of sub-menus, taking you to the previous menu screen. You can press the Menu button to wake the camera up into the menu system when it has powered down from the Power Save Start Time option.

Function Button

The button marked Fn, for Function, has several roles, depending on whether the camera is in shooting mode or playback mode.

FUNCTION MENU

When the camera is set to shooting mode, the Function button gives you quick access to menu options. When you press the button the camera displays the Function

menu, from which you can select a setting for immediate adjustment. Using the Function Menu Settings option on screen 5 of the Custom menu (discussed in Chapter 7), you can assign up to 12 functions to this menu, from among 34 possibilities. The items that can be assigned include settings such as ISO, Drive Mode, White Balance, Flash Mode, Focus Area, and Picture Effect. You also can choose Not Set, which leaves a blank slot on the Function menu.

Once you have assigned up to 12 options to this button, it is ready for action. To use an option, press the button when the camera is in shooting mode, and a menu will appear along the bottom of the display in two rows with six choices each, as shown in Figure 5-16.

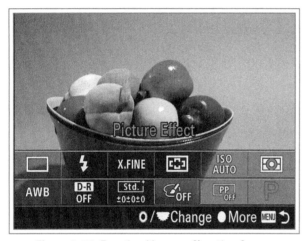

Figure 5-16. Function Menu on Shooting Screen

Use the direction buttons to move the highlight block at the bottom of the display over the item you want to select. With that setting highlighted, turn the Control wheel to cycle through the possible settings. As you do so, a circular menu will appear near the top of the display, showing the range of settings. When the one you want to select is highlighted, press the Function button to select it and exit back to the shooting screen. If there are sub-settings, use the Control dial to scroll through those before exiting the menu.

For example, if you have moved the orange highlight block to the Quality item, turn the Control wheel until the setting you want to make appears, as shown in Figure 5-17, where Fine is selected. Then, press the Function button to confirm the setting and exit from the Function menu screen. Or, if you want to make multiple settings from the Function menu options, after changing one setting you can press the Center button to go back to the Function menu and make more

settings before you press the Function button to exit to the shooting screen.

Figure 5-17. Fine Selected for Quality on Function Menu

To take an example with a sub-setting, call up the Function menu and scroll to Focus Area, then use the Control wheel to select the Flexible Spot setting. At that point, an additional line of icons will appear below the main options, with choices for the size of the focus frame, as seen in Figure 5-18.

Figure 5-18. Selection Window for Flexible Spot on Function Menu

Use the Control dial to scroll through the choices and select small, medium, or large. With your selection highlighted, press the Function button to confirm it and exit to the shooting screen. (Or, press the Center button to make more choices from the Function menu.)

Note that there may be some items at the bottom of the screen whose icons are dimmed because the item is unavailable for selection in the current context. If you move the orange highlight block to one of those items and then try to change the setting, the camera will display an error message.

Also, the selections I discussed above may not be available because they have not been assigned to the Function menu. If that is the case, you can use the Function Menu Settings menu option to assign them if you want to follow the examples.

The Function menu system on the RX10 III is well thought out and convenient. I strongly recommend that you experiment and develop a group of 12 items to assign to this button and make use of this speedy way to change important settings.

QUICK NAVI SYSTEM

In shooting mode, the Function button also gives you access to the Quick Navi system for changing settings rapidly. This system is similar to the Function menu system I just discussed, but there are significant differences.

The Quick Navi system comes into play only in one situation—when you have called up the special display screen shown in Figure 5-19, which Sony calls the "For Viewfinder" display.

Figure 5-19. For Viewfinder Display Screen

This is the only shooting-mode display screen that does not include the live view. It is called "For Viewfinder" because the idea is that you will select this display when using the viewfinder, so you can see the live view through the viewfinder and see details of your settings on this display, which appears only on the LCD screen.

The For Viewfinder display is summoned by pressing the Display button, but only if you have selected it for inclusion in the cycle of display screens. You select it using the Display Button option on screen 2 of the Custom menu. From that option, select the sub-option

for Monitor, then check the box for the For Viewfinder item on the next screen, as shown in Figure 5-20.

Figure 5-20. For Viewfinder Selected for Monitor Display

As seen in Figure 5-19, the For Viewfinder screen displays a lot of information at the right, including Drive Mode, White Balance, Focus Area, DRO, Picture Effect, Picture Profile, and several others.

Normally, these items are displayed only for your information; you cannot adjust them. But, if you press the Function button, an orange highlight appears at the right, as shown in Figure 5-21. You can then use the direction buttons to navigate through the settings.

You also can move the orange highlight block to the left, to the settings for options such as ISO, SteadyShot, exposure compensation, and Image Size. When you have highlighted a setting to adjust, turn the Control wheel to scroll through the available values and make the adjustment quickly. When you adjust certain settings, such as Aspect Ratio, a secondary window opens in the top part of the display, as shown in Figure 5-22, showing the various options available for the setting.

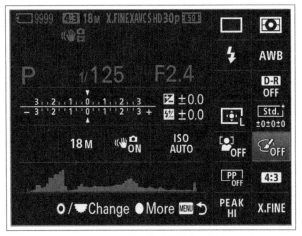

Figure 5-21. Quick Navi Display Activated

For sub-settings, make the main setting with the Control wheel and the sub-setting with the Control dial. For example, move the highlight to Picture Effect, turn the Control wheel to highlight Partial Color, and turn the Control dial to highlight Yellow, as shown in Figure 5-23. Or, if you prefer, you can press the Center button when the main setting is highlighted to get access to a menu with the sub-options for that setting.

After changing a setting, you can move to other settings using the direction buttons. Once you have made all your changes, press the Function button again to exit to the static For Viewfinder display, which will now show the new settings in place.

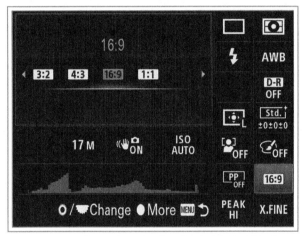

Figure 5-22. Secondary Window for Quick Navi Display

The Quick Navi system can streamline your ability to change settings once you get used to it. I recommend you devote some time to practicing with it, if speed is important to you.

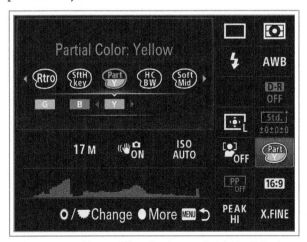

Figure 5-23. Picture Effect Setting on Quick Navi Display

DIAL/WHEEL LOCK

The Function button also can carry out one other operation in shooting mode, depending on how a Custom menu option is set. The last item on screen 6 of that menu is the Dial/Wheel Lock option. If that option is set to Lock, then, when you press and hold the Function button for several seconds when the shooting screen is displayed, the shooting-related operations of the Control wheel and Control dial are locked. The wheel and dial will still operate to navigate through menu screens and menu settings, but they will not set items such as ISO and shutter speed. I will discuss that menu option in Chapter 7.

SEND TO SMARTPHONE

When the camera is in playback mode, pressing the Function button brings up a screen allowing you to send the current image or multiple images to a smartphone or tablet, if that function is available. I will discuss this option in Chapter 9, where I discuss the camera's Wi-Fi functions.

Custom 3/Delete Button

The button marked C3, to the right of the Playback button, has a trash can icon on it, indicating that it serves as the Delete button as well as the Custom 3 button. It functions just like the Custom 1 and Custom 2 buttons, discussed earlier. Using the Custom Key (Shooting) option on screen 5 of the Custom menu, you can assign any one of numerous functions to the button. That function will be activated if you press the button when the camera is in shooting mode, if the context permits.

In playback mode, when an image or video is displayed, this button acts as the Delete button, as indicated by the trash can icon. If you press the button, the camera displays the message shown in Figure 5-24, prompting you to select Delete or Cancel. If you highlight Delete and press the Center button, the camera will delete the image or video that was displayed. If you choose Cancel, the camera will return to the playback mode screen.

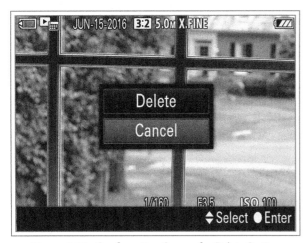

Figure 5-24. Confirmation Screen for Delete Button

Finally, this button has one specialized function that is not obvious. When you have activated a movable focus frame such as the Flexible Spot focus frame, and have moved that frame to a new position on the camera's display, you can press the C3/Delete button to return the focus frame immediately to the center of the display.

Control Wheel and Its Buttons

Several important controls are within the perimeter of the Control wheel, the ridged wheel with a large button in its center. The four edges of the wheel (Up, Down, Left, and Right) function as buttons. That is, if you press the wheel's rim at any of those four points, you are, in effect, pressing a button.

On the RX10 III only one of these buttons is labeled—the top button, which serves as the Display button as well as the Up button for navigating through various screens. The other three buttons act as the Left, Right, and Down buttons for moving through screens. However, one of the powerful features of the RX10 III is your ability to program each of those three buttons, as well as some other controls, with any one of numerous functions. Using this ability, you can set up the RX10 III with a set of custom controls that matches your preferences for adjusting settings quickly. I will discuss the programming options for each control in Chapter 7. I will describe the basic uses of each button or dial below.

Control Wheel

In many cases, to choose a menu item or a setting, you can turn this wheel, which is centrally located on the camera's back. In some cases, you have the choice of using this wheel or pressing the direction buttons.

In others, you can turn this wheel or the Control dial, located at the upper right of the camera's back.

When you are viewing a menu screen, you can navigate up and down through the lists of options by turning the wheel. When you are adjusting items using the Function menu or the Quick Navi menu, you can change the value for the highlighted setting by turning the Control wheel. When you are using manual focus and you have the Focus Magnifier or MF Assist option turned on, you can turn the Control wheel to choose the area of the scene that is being magnified.

In playback mode, you can turn the Control wheel to navigate from one image to the next on the LCD screen. Also, when a video is being played on the screen and has been paused, you can turn the Control wheel to move the video either forward or in reverse. While a movie is playing, you can use the wheel to fast-forward or fast-reverse the footage.

Finally, with the Custom Key (Shooting) option on screen 5 of the Custom menu, you can assign a function to each of several camera controls, including the Control wheel. Using that menu option, you can assign any one of four functions to the Control wheel: ISO, White Balance, Creative Style, or Picture Effect. I will discuss that option in Chapter 7, in connection with the Custom menu.

Center Button

The large button in the center of the Control wheel has many uses. On menu screens that have additional options, such as the Image Size screen, this button takes you to the next screen to view the other options. It also acts as a selection button when you choose certain options. For example, after you select Flash Mode from screen 3 of the Shooting menu and then navigate to your desired option, you can press the Center button to confirm your selection and exit from the menu screen back to the shooting screen.

When the camera is set to manual focus and the MF Assist option is turned on, once you turn the front or rear lens ring to start focusing, pressing the Center button roughly doubles the magnification of the display: from 5.3 times to 10.7 times. Pressing the button again toggles the display back to the 5.3 times magnification level. When the Focus Magnifier menu option is turned on, pressing the Center button

magnifies the screen when the orange magnifier frame is on the display.

The Center button also has several other possible uses, depending on how it is set up in the menu system. The Custom Key (Shooting) option on Screen 5 of the Custom menu has a sub-option for assigning a function to the Center Button. If you choose Focus Standard for that sub-option, you can set the Center button to have a preset group of focus-related functions.

If you select the Focus Standard option, the Center button is used to activate the tracking frame for the Center Lock-on AF feature, assuming you have turned on that menu option. When the object you want to track with autofocus is in the center of the display, press the Center button and the camera will try to keep that object in focus. Press the button again to cancel the tracking.

If Focus Area is set to a movable setting such as Flexible Spot, pressing the Center button activates the screen to adjust the location of the focus frame.

If you prefer not to use the Focus Standard option, you can use the Center Button option of the Custom Key (Shooting) menu item to set this button to carry out any one of numerous functions. I will discuss those functions in Chapter 7, in connection with the Custom menu.

In playback mode, you press the Center button to start playing a video whose first frame is displayed on the camera's screen. Once the video is playing, press the Center button to pause the playback and then to toggle between play and pause. When a panoramic image is displayed, press the Center button to make it scroll on the screen at a larger size using the full expanse of the display screen. When you have enlarged an image using the zoom lever, you can return it immediately to its normal size by pressing the Center button. When you are selecting images for deletion or protection using the appropriate Playback menu option, you use the Center button to mark or unmark an image for that purpose.

DIRECTION BUTTONS

Each of the four edges of the Control wheel—Up, Down, Left, and Right—is also a "button" you can press to get access to a setting or operation, if the button has had one assigned to it. This is not immediately obvious,

and sometimes it can be tricky to press in exactly the right spot, but these four buttons are important to your control of the camera. You use them to navigate through menus and through screens for settings, whether moving left and right or up and down.

You also can use them in playback mode to move through your images and, when you have enlarged an image using the zoom lever, to scroll around within the magnified image.

In addition to these navigational duties, the direction buttons have miscellaneous functions in connection with various settings. For example, when a movie is being played, pressing the Down button opens up the control panel for controlling playback of the movie. When a movie is displayed on the screen ready to be played, pressing the Down button brings up the camera's volume control screen. And, as with the Center button, the Right, Left, and Down buttons can be assigned to carry out other functions through the Custom menu, as discussed in Chapter 7.

Finally, one of the direction buttons, the Up button, comes pre-assigned as the Display button, as discussed below.

Up Button: Display

The Up button, marked "DISP," is used to switch among the displays of information on the camera's screen and in the viewfinder, in both shooting and playback modes. As discussed in Chapter 7, you can change the contents of the shooting mode screens using the Display Button option on screen 2 of the Custom menu. The display screens that are available in playback mode are discussed in Chapter 6. Because it is dedicated to display duties, the Up button cannot be programmed to perform any other functions.

Left Button

One of the excellent features of the RX10 III is that three buttons—the Left, Right, and Down buttons—have no dedicated functions assigned to them. With many cameras, these three buttons have icons next to them on the camera's back, designating them to handle functions such as flash mode, exposure compensation, drive mode, and the like. I prefer the system with the RX10 III, which lets you choose the assignments for these three buttons according to your own preferences.

The Left button can be assigned to carry out any one of a number of functions, using the Custom Key (Shooting) option on screen 5 of the Custom menu. I will discuss those options in Chapter 7.

Right Button

The Right button can be assigned any one of many functions, the same as for the Left button.

Down Button

The Down button also has the same options as the Left button for having a function assigned to it.

AEL Button

The AEL button, located above the Function button, is set by default to the AEL Hold option. With that setting, you can press and hold this button to lock the exposure as metered by the camera using the current metering method. I will discuss that option in Chapter 7, where I discuss all of the settings that can be assigned to this and the other control buttons.

This button also has another specific assignment for use with the Wireless setting for Flash Mode. When you have the camera set up with a control flash unit and a remote flash unit, you can press the AEL button to fire a test flash that will verify that the flash units are communicating properly with the camera.

When the camera is set to playback mode, the AEL button serves to enlarge a still image that is displayed on the camera's screen, as indicated by the magnifying glass icon with a plus sign next to the button on the camera's back. This function remains assigned to the button for playback mode, even if you change the button's assignment for shooting mode.

Control Dial

The Control dial is the small dial that sticks out from the camera's back, directly to the right of the red Movie button. The most important function of this dial is to set the camera's shutter speed when you are using either Shutter Priority or Manual exposure mode for still photos, or when you are using Movie mode or HFR mode and have the Movie or HFR exposure mode set to Shutter Priority or Manual Exposure.

This dial also is used for selecting sub-options in some cases. For example, when you choose Picture Effect from the shooting menu or the Function menu, some settings, such as Toy Camera, have sub-settings that can be selected by turning the Control dial. In Program mode, turning the dial activates Program Shift, which causes the camera to pick a new pair of shutter speed and aperture settings to match the current exposure. In Sweep Panorama mode, turning this dial changes the panorama direction. In Scene mode, turning the dial changes the scene setting, such as Portrait, Landscape, and the others.

When the Control dial is set to control a particular setting, the camera displays an icon for the dial next to a label or icon for that setting. For example, in Figure 5-25, the display shows that the dial controls shutter speed (indicated by Tv, which stands for time value).

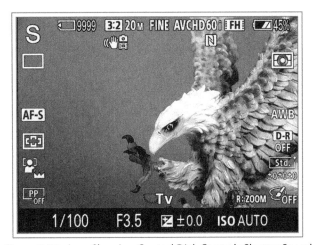

Figure 5-25. Icon Showing Control Dial Controls Shutter Speed

In playback mode, you can turn the Control dial to navigate through the images and videos stored on the camera's memory card. The dial will move to another image at the same enlargement factor when an image has been enlarged using the zoom lever or the AEL button. The dial also will move through movies slowly when paused or rapidly when they are playing.

Viewfinder and Eye Sensor

The eye sensor is a small window in the viewfinder eyepiece to the left of the main viewfinder window. When your eye approaches this small slot and blocks the light that reaches it, the camera automatically switches from using the LCD screen to using the viewfinder, if the menu option is set for that behavior.

To enable this automatic switching, go to screen 4 of the Custom menu, select the Finder/Monitor item, and choose Auto. If you don't want the automatic switching, choose Viewfinder or Monitor, to keep either one of those viewing options as the permanent setting.

Diopter Adjustment Wheel

The diopter adjustment wheel is a small, ridged wheel on the right side of the viewfinder eyepiece. You can turn this wheel to adjust the viewfinder according to your vision. If you wear eyeglasses, you may find that you can adjust the setting of the viewfinder so that you can see clearly through it without your glasses.

Tilting LCD Screen

The tilting LCD screen is not really a "control," but it does allow some physical adjustment. This screen, even without its tilting ability, is a notable feature of the camera. It has a diagonal span of 3 inches (7.5 cm) and provides a resolution of 1.2 million dots using Sony's "WhiteMagic" technology, which adds a white sub-pixel to the normal red, green, and blue ones, giving a very clear and sharp view of your images before and after you capture them.

The screen can tilt downward as much as 42 degrees, as shown in Figure 5-26. When the LCD is tilted in this way, you can hold the camera high above your head and view the scene as if you were an arm's length taller or were standing on a small ladder. If you attach the camera to a monopod or other support and hold it up in the air, you can extend the camera's height even farther and still view the screen quite well. You can activate the self-timer before raising the camera up in the air.

Figure 5-26. LCD Screen Tilted Down for Overhead Shots

You also can use a smartphone or tablet connected to the camera by Wi-Fi to trigger the camera by remote control while it is raised overhead, as discussed in Chapter 9, or you can use one of Sony's remote controls, as discussed in Appendix A.

On the other hand, if you need to take images from a vantage point near ground level, you can rotate the screen so it tilts upward toward your eyes, as shown in Figure 5-27, and hold the camera down as far as you need to get a mole's-eye view of the world. The screen can tilt upward as much as 107 degrees.

Figure 5-27. LCD Screen Tilted Upward for Low-angle Shots

It can be helpful to shoot upward like this when your subject is in an area with a busy, distracting background. You can hold the camera down low and shoot with the sky as your background to reduce or eliminate the distractions. (Similarly, you may be able to shoot from a high angle to frame your subject against the ground or floor to have a less-cluttered background.)

The tilting display also can be useful for street photography: you can fold the screen upward and look down at the camera while taking photos of people on the street without drawing undue attention to yourself.

Access Lamp

At the far right edge of the camera's back is a small lamp that lights up red when the camera is writing data to the memory card, as shown in Figure 5-28. The lamp may stay lighted for a considerable time when you are taking a burst of continuous shots. It is important not to remove the memory card or the battery while that lamp is illuminated.

Figure 5-28. Access Lamp at Right of Camera's Back

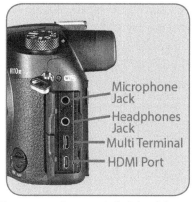

Figure 5-30. Ports on Left Side of Camera

Ports for Audio, HDMI, and Other Connections

Next, I will discuss the jacks and ports that are located on the left side of the camera. Figure 5-29 shows this side of the camera with the protective doors closed. When those doors are opened, the jacks and ports are readily accessible, as seen in Figure 5-30.

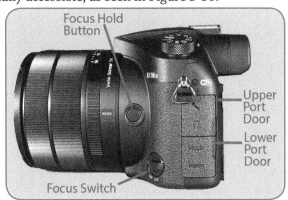

Figure 5-29. Left Side of Camera with Port Doors Closed

The top jack is for an external microphone with a 3.5mm stereo plug. I will discuss external microphones in Appendix A. The second jack is for headphones, also using a standard 3.5mm plug, so you can monitor the audio being recorded by the camera. The audio being played back for a video also is output through this jack, so you can listen to it through headphones or route it to external speakers for better sound.

The third item is the Multi terminal. This is where you plug in the USB cable for charging the battery, powering the camera with the AC adapter, uploading images and videos to your computer, or connecting the camera directly to a printer to print images. You also can plug in other accessories that are compatible with this special terminal, including various Sony remote controls, which I discuss in Appendix A.

The last item in this area is the HDMI port, where you plug in an optional micro-HDMI cable to connect the camera to an HDTV for viewing images and videos. You also can view the shooting display from the camera through this connection, so you can connect the camera to an HDTV to act as a monitor for your shooting of still images or videos. I will discuss this process in Chapter 9. In addition, you can use this port to output a "clean" HDMI video signal for video production. For example, you can output the video signal to an external video recorder. I discuss that process in Chapter 8.

Focus Hold Button

The other item on the left side of the camera is the Focus Hold button, located on the lens housing near the camera, as seen in Figure 5-29. This button, like the C1, C2, C3, Center, Left, Right, Down, and AEL buttons, can be programmed to handle any one of many functions through the Custom Key (Shooting) option on screen 5 of the Custom menu. By default, though, logically enough, it is assigned to the Focus Hold option.

If you leave this button assigned to the Focus Hold option, once you have used autofocus to achieve sharp focus, press and hold this button, and the focus will stay at that position until you release the button. You can then move the camera, keeping the focus distance

where it was set. Then, you can take your finger off of the shutter button. At that point, you can recompose your shot and the camera will meter the scene when you half-press the shutter button, while still maintaining the focus that is being held. In this way, you can take multiple shots while holding the same focus with the Focus Hold button, but metering the scene each time using the shutter button.

You also can use this function to create a nice pull-focus effect when recording a movie. For example, you can set Focus Area to Center or Flexible Spot, focus on a subject close to the camera, and hold down the button assigned to Focus Hold to hold the focus on that subject. Then start recording the movie with the focus frame on a distant subject. When you are ready, release the button, and the focus will be instantly pulled to the subject in the foreground.

If you don't have a need for the Focus Hold option, or if you prefer to assign it to another button, you can assign any one of many other features to the Focus Hold button. I will list those features in Chapter 7, in connection with the Custom Key (Shooting) menu option.

Right Side of Camera

The right side of the camera, shown in Figure 5-31, is where the memory card slot is located, under a protective door. As discussed in Chapter 1, you need to insert either an SD card or a Sony Memory Stick into this slot in order to store your images and videos.

To the right of the memory card area is a decorative letter N, which marks the NFC active area for the RX10 III. This is where you touch the camera against the similar area on a compatible Android smartphone or tablet that uses the near field communication protocol. As discussed in Chapter 9, when the two devices are touched together at their NFC active areas, they should automatically connect through a Wi-Fi connection. Once the connection is established, they can share images and the phone or tablet can control the camera remotely in some ways.

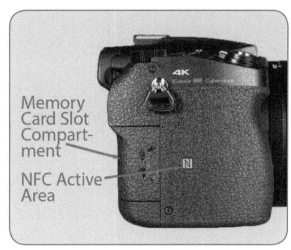

Figure 5-31. Right Side of Camera

Bottom of Camera

The final items are on the bottom of the RX10 III, seen in Figure 5-32.

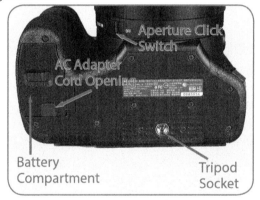

Figure 5-32. Bottom of Camera

The major items here are the tripod socket and the battery compartment. The battery compartment door has a small flap located at its edge. That flap is provided so you can insert an AC adapter into the battery compartment and run its cord through the flap, so the compartment's door can be latched securely shut. I will discuss the AC adapter in Appendix A. In this view, you also can see the aperture click switch, which I discussed earlier in connection with the aperture ring.

Chapter 6: Playback and Printing

You may not spend a lot of time viewing your images and videos in the camera, but even if you don't, it's useful to know how the various in-camera playback functions work. You may need to examine an image closely in the camera to check focus, composition, and other aspects, or you may want to share images with friends and family. So it's worth taking a good look at the various playback functions of the Sony RX10 III. I'll also discuss options for printing images in this chapter.

Normal Playback

First, you should be aware of the Auto Review option on screen 2 of the Custom menu. This setting determines whether and for how long the image stays on the screen for review when you take a new picture. If your major interest for viewing images in the camera is to check them right after they are taken, this setting is all you need to be concerned with. As discussed in Chapter 7, you can leave Auto Review turned off or set it to two, five, or ten seconds.

To control how your images are viewed later on, you need to work with the options that are available in playback mode. For plain review of images, the process is simple. Once you press the Playback button (marked with a triangle icon), the camera is in playback mode, and you will see the most recent image or video saved to the camera's memory card. To move back through older items, press the Left button or turn the Control wheel or Control dial to the left. To see more recent ones, use the Right button or turn the Control wheel or Control dial to the right. To speed through the images, hold down the Left or Right button.

Index View and Enlarging Images

In normal playback mode, you can press the zoom lever on top of the camera to view an index screen of your images and videos or to enlarge a single image. When you are viewing an individual image, press the zoom lever once to the left, and you will see a screen showing either 9 or 25 images, one of which is outlined by an orange frame, as shown in Figure 6-1.

Figure 6-1. One Image Highlighted on Index Screen

(You can choose whether this screen shows 9 or 25 images using the Image Index option on the Playback menu, discussed later in this chapter.)

You can press the Center button to bring up the outlined image on the screen, or you can move through the images on the index screen by pressing the Left and Right buttons or by turning the Control wheel. If you move the orange highlight to the far left of the display, as seen in Figure 6-2, you can use the Up and Down buttons to move through the images a screen at a time.

Figure 6-2. Navigation Bar Highlighted at Left of Index Screen

At any time when you are viewing the index screen, you can turn the Control dial to move through the images a screen at a time.

On the 9-image or 25-image index screen, one more press of the zoom lever to the left brings up another screen. For example, if View Mode, discussed later in this chapter, is set to Date View, this next screen will be a calendar display, as shown in Figure 6-3.

Figure 6-3. Calendar Display Screen

On that screen, you can move the orange frame to any date and press the Center button to bring up a view with images and videos from that date. If you move the orange highlight to the narrow strip to the left of the calendar, as seen in Figure 6-4, you can move through the items by months with the Up and Down buttons.

Figure 6-4. Bar for Navigating by Month Highlighted

If you move the highlight to the far left, as in Figure 6-5, you can use the Up and Down buttons to move through the six icons. You can choose the date view, still-images view, MP4 videos view, AVCHD videos view, XAVC S HD videos view, or XAVC S 4K videos view. I will discuss

those options later in this chapter, in connection with the View Mode item on the Playback menu.

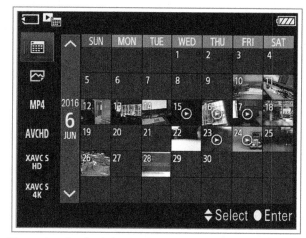

Figure 6-5. Bar for Selecting Image or Video View Highlighted

When you are viewing a single still image, a press of the zoom lever to the right or a press of the AEL button enlarges the image, with the enlargement centered on the point where the camera used autofocus, if it did so. If the camera did not use autofocus, the camera will zoom in on the center of the image. (You can change this behavior with the Enlarge Initial Position menu option, discussed later in this chapter.)You will see a display in the lower left corner of the image showing a thumbnail with an inset orange frame that represents the portion of the image that is now filling the screen in enlarged view, as shown in Figure 6-6. This feature is very useful for quickly checking the focus of the image.

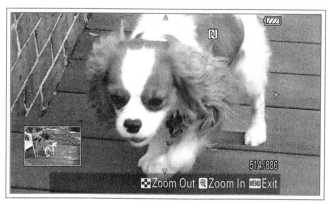

Figure 6-6. Enlarged Image in Playback Mode

If you press the zoom lever to the right repeatedly or keep pressing the AEL button, the image will be enlarged to increasing levels. While it is magnified, you can scroll in it with the four direction buttons; you will see the orange frame move around within the thumbnail image. To reduce the image size again, press

the zoom lever to the left as many times as necessary or press the Center button to revert immediately to normal size. You can press the Custom 3/Delete button to bring up the Delete screen for that image while it is enlarged. You also can zoom the image in and out using the Control wheel. To move to other images while the display is magnified, turn the Control dial.

Playback Display Screens

When you are viewing an image in single-image display mode, pressing the Display button (Up button) repeatedly cycles through three playback screens: (1) the full image with no information; (2) the full image with basic information, including date and time it was taken, image number, Aspect Ratio, aperture, shutter speed, ISO, and Image Size and Quality, as shown in Figure 6-7; and (3) a reduced-size image with detailed recording information, including aperture, shutter speed, ISO, shooting mode, white balance, focal length, DRO setting, and other data, plus a histogram, as shown in Figure 6-8.

Figure 6-7. Playback Display with Basic Information

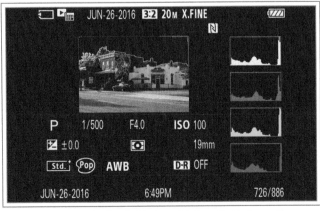

Figure 6-8. Playback Display with Detailed Information

A histogram is a graph showing distribution of dark and bright areas in the image. Dark blacks are represented by peaks on the left and bright whites by peaks on the right, with continuous gradations in between. With the RX10 III, the graph's top box gives information about the overall brightness of the image. The three lower boxes contain information about the brightness of the basic colors that make up the image: red, green, and blue.

If a histogram has brightness values bunched at the left side, there is an excessive amount of black and dark areas (high points on the left side of the histogram) and very few bright and white areas (no high points on the right). If the graph runs into the left side of the chart, it means the shadow areas are "clipped"; that is, the image is so dark that some details have been lost in the dark areas. The histogram in Figure 6-9 illustrates this degree of underexposure.

Figure 6-9. Histogram for Underexposed Image

A histogram with its high points bunched on the right means the image is too bright, as shown in Figure 6-10.

Figure 6-10. Histogram for Overexposed Image

If the lines of the graph run into the right side of the chart, that means the highlights are clipped and the image has lost some details in the bright areas.

Figure 6-11. Histogram for Normally Exposed Image

A histogram for a normally exposed image has high points arranged evenly in the middle. That pattern, illustrated by Figure 6-11, indicates a good balance of light, dark, and medium tones.

When the playback histogram is on the screen, any areas containing highlights that are excessively bright will flash to indicate possible overexposure, alerting you that you might need to take another shot with the exposure adjusted to avoid that situation.

The histogram is an approximation and should not be relied on too heavily. It can give you helpful feedback as to how evenly exposed your image is. There may be times when it is appropriate to have a histogram skewed to the left or right for intentionally "low-key" (dark) or "high-key" (brightly lit) scenes.

If you want to see the histogram when the camera is in shooting mode, you can turn on that option using the Display Button option on screen 2 of the Custom menu, as discussed in Chapter 7.

Deleting Images with the Delete Button

As I mentioned in Chapter 5, you can delete individual images by pressing the Delete button, also known as the Custom 3 or C3 button, at the bottom right of the camera's back. If you press this button when a still image or a video is displayed, whether individually or

highlighted on an index screen, the camera will display the Delete/Cancel box shown in Figure 6-12.

Figure 6-12. Confirmation Screen for Delete Button

Highlight your choice and press the Center button to confirm. You can delete only single images or videos in this way. If you want to delete multiple items, you need to use the Delete option on the Playback menu, discussed next in this chapter.

Playback Menu

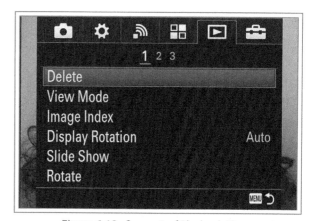

Figure 6-13. Screen 1 of Playback Menu

The other options that are available for controlling playback on the RX10 III appear as items on the Playback menu, whose first screen is shown in Figure 6-13.

You get access to this menu by pressing the Menu button and navigating to the menu marked by a triangle icon. Following is information about each item on this menu.

DELETE

The Delete command lets you erase multiple images and videos from your memory card in one operation. (If you just want to delete one or two items, it's usually easier to display each one on the screen, then press the Delete button and confirm the erasure.) When you select the Delete command, the menu offers you various choices, as shown in Figure 6-14.

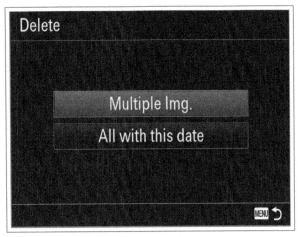

Figure 6-14. Delete Menu Options Screen

These choices may include Multiple Images, All in this Folder, or All with this Date, depending on the current view that has been selected with the View Mode option, discussed below.

If you choose Multiple Images, the camera will display the still images or videos with a check box at the left side of each item, as shown in Figure 6-15.

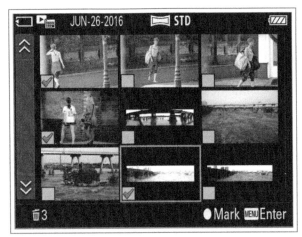

Figure 6-15. Screen to Select Images for Deletion

The images and videos may be shown individually or on an index screen, depending on whether you started from an individual image or an index screen. You can change between full-screen and index views using the zoom lever, even after choosing the Delete option.

Scroll through the images and videos with the Control wheel, the Control dial, or the Left and Right buttons. When you reach an item you want to delete, press the Center button to place a check mark in the box for that item. To unmark an image or video, press the Center button again. Continue with this process until you have marked all items you want to delete. Then, press the Menu button to move to the next screen, where the camera will prompt you to highlight OK or Cancel, and press the Center button to confirm. If you select OK, all of the marked items will be deleted. If you want to cancel before you have marked any items, press the Playback button to return to normal playback mode.

If, instead of Multiple Images, you choose All in this Folder or All with this Date, the camera will display a screen asking you to confirm deletion of all of those files.

If any images have a key icon displayed at the top, those images are protected, and cannot be deleted using this option unless you first unprotect them, as discussed later in this chapter.

VIEW MODE

This second option on the Playback menu lets you choose which images or videos are currently viewed in playback mode. The options are Date View, Folder View (Still), Folder View (MP4), AVCHD View, XAVC S HD View, and XAVC S 4K View, as shown in Figure 6-16.

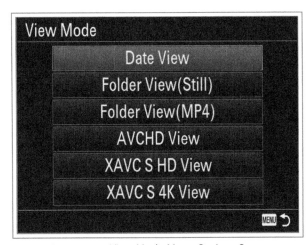

Figure 6-16. View Mode Menu Options Screen

If you select Date View, the camera will display the same calendar screen shown earlier in Figure 6-3. You

can navigate through that screen using the Control wheel or the direction buttons. Highlight a date and press the Center button; the camera will then display all images and videos from that date. When the calendar screen is displayed, you can move to other months using the Control dial.

If you select Folder View (Still), the camera will display the screen shown in Figure 6-17, which displays the folders available for selection.

Figure 6-17. Folder View (Still) Screen

Highlight the folder you want (there may be only one) and press the Center button; the camera will display all still images in that folder. You can navigate through the index screens for those images and select the image or images you want to view.

If you select Folder View (MP4), the process is the same, except that the camera will display only the MP4 videos from the folder you select, if there are any such videos.

If you select AVCHD View, the camera will display a calendar screen with thumbnail images indicating which dates have AVCHD files associated with them. You can then highlight any date with a thumbnail image and press the Center button to move to an AVCHD video from that date.

If you select XAVC S HD View or XAVC S 4K View, the camera will display a calendar screen showing the dates on which videos in the selected format were recorded.

My preference is to use the Date View option, because then I can view both images and videos from any date. However, if I want to locate a particular video, it can be

quicker to choose one of the video views so I can limit my search to videos only.

You can select a view option from an index screen without using the Playback menu. After moving the zoom lever to the left to call up the calendar display or the folder display, you can move the highlight to the extreme left of the screen to the line of six icons that represent these six view modes, and select one of the modes from that display by highlighting its icon and pressing the Center button.

IMAGE INDEX

This menu option, shown in Figure 6-18, gives you the choice of having the camera include either 9 images or 25 images when it displays an index screen.

When you make this selection, the camera displays the index screen you chose, and it will display that screen whenever you call up the index screen using the zoom lever, as discussed earlier.

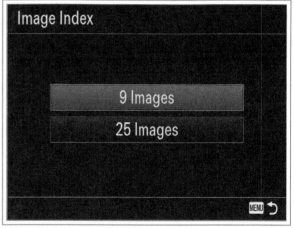

Figure 6-18. Image Index Menu Options Screen

Whether you choose the 9-image screen or the 25-image screen depends on your personal preference as well as some other factors, including how many images you have altogether and how easy it is to distinguish one from another by looking at the small thumbnail images.

The thumbnails on the 9-image screen are considerably larger than those on the 25-image screen, and it may make sense to choose the 9-image screen unless you have so many images that it would be burdensome to scroll through them 9 at a time.

DISPLAY ROTATION

This next item on the Playback menu controls whether images shot with the camera held vertically appear that way when you play them back on the camera's screen. By default, this option is set to Auto, meaning images taken vertically are automatically rotated so that the vertical shot appears in portrait orientation on the horizontal display, as shown in Figure 6-19. What is unusual about this setting is that, if you tilt the camera sideways so one side is up, a vertical image will rotate to fill the screen. In this way, you get the best of both worlds: Vertical images display in proper orientation (but smaller than normal) within the horizontal display, and, when you tilt the camera, they display at full size.

Figure 6-20. Vertical Image Displayed Without Rotation

SLIDE SHOW

This feature lets you play your still images and videos in sequence at an interval you specify. This menu option will be dimmed and unavailable if the View Mode option on the Playback menu is set to Folder View (MP4), AVCHD View, or either of the two XAVC S View settings. If that is the case, use the View Mode menu option to select either Date View or Folder View (Still). If you select Date View, the Slide Show option will display all of your movies, in all four formats, along with your still images. Each movie will play in full before the show advances to the next item, unless you interrupt it with one of the controls. If you select Folder View (Still), the Slide Show option will display only the still images from the folder you selected.

Figure 6-19. Vertical Image Displayed on Horizontal Screen

If you change the setting to Manual, a vertical image will appear vertically on the horizontal screen, in the same way as shown in Figure 6-19. The difference with this setting from Auto is that, if you tilt the camera, the image will not change its orientation.

If you set this option to Off, then a vertical image will display in landscape orientation on the display, as shown in Figure 6-20, so you would have to tilt the camera to see it in its proper orientation.

With all of these settings, you can use the Rotate option on the Playback menu, discussed later in this chapter, to rotate an image manually to a different orientation.

When you select the Slide Show option and press the Center button, the next screen has two options you can set: Repeat and Interval, as seen in Figure 6-21. If Repeat is turned on, the show will keep repeating; otherwise, it will play only once.

Figure 6-21. Slide Show Menu Options Screen

The camera will not power off automatically in this mode, so be sure to stop the show when you are done with it. The Interval setting, which controls how long each still image stays on the screen, can be set to one, three, five, ten, or 30 seconds. (The Interval setting does not apply to movies, each of which plays to its end.)

With the options set, navigate to the Enter box at the bottom of the screen using the Control wheel, the Control dial, or the Down button, and press the Center button to start the show. You can move forward or back through the images (and videos, if included) using the Right and Left buttons. Hold the buttons down to move quickly through the images and videos.

You can stop the show by pressing the Menu button or the Playback button. There is no way to pause the show and resume it. When a movie is playing as part of the show, you can control its volume by pressing the Down button and then adjusting the sound with the Left and Right buttons or with the Control wheel or Control dial. Each movie plays fully before the next movie or image is displayed, but you can skip to the next movie or image using the Right button.

The Slide Show option does not provide settings such as transitions, effects, or music. You cannot select which images to play; this option just lets you play all of your still images from the selected folder, if you are using Folder View, or all still images and videos starting from the selected date, if you are using Date View.

ROTATE

The Rotate menu option gives you a way to rotate an image. Select this menu item, and you will see a screen like that in Figure 6-22, prompting you to press the Center button to rotate the image.

Figure 6-22. Screen for Rotating an Image

Each time you press the button, the image will rotate 90 degrees counter-clockwise. You can use this option for images taken vertically, when Display Rotation option, discussed above, is off. This option will be dimmed if View Mode is set to a view for videos only.

The next options on the Playback menu are on its second screen, shown in Figure 6-23.

Figure 6-23. Screen 2 of Playback Menu

ENLARGE IMAGE

This option does the same image magnification discussed earlier, which you can also do with the zoom lever or AEL button. When you select this option, the enlarged image will appear on the screen; you can use the zoom lever or the AEL button to change the enlargement factor. Once the image is enlarged, you also can use the Control wheel to increase or decrease the magnification and you can press the Center button or the Menu button to return the image to normal size. You can use the Control dial to move to other images at the current magnification level.

ENLARGE INITIAL MAGNIFICATION

This option lets you choose either Standard Magnification or Previous Magnification, as shown in Figure 6-24. With the Standard Magnification option, when you press the AEL button or use the zoom lever to magnify an image, the camera uses the standard magnification factor. If you choose Previous Magnification, the camera will use whatever magnification level was used for any image. So, if you like to zoom your images in with three presses of the zoom lever, you can choose Previous Magnification for this option, and, once you have enlarged one image

to that degree, other images will be enlarged to that degree when you first press the AEL button or turn the zoom lever to enlarge them.

Figure 6-24. Enlarge Initial Magnification Menu Options Screen

ENLARGE INITIAL POSITION

This option lets you choose whether, when an image is enlarged, the camera centers it on the point where focus was achieved (if any), or on the center of the image. The menu options screen is shown in Figure 6-25.

Figure 6-25. Enlarge Initial Position Menu Options Screen

If you want to check focus, it can be convenient to have the enlarged image automatically centered on the focus point when it is enlarged in playback mode. For that option, choose Focused Position from this menu screen.

PROTECT

With the Protect feature, you can "lock" selected images or videos so they cannot be erased with the normal erase functions, including using the Delete button and using the Delete option on the Playback menu, discussed above. However, if you format the memory

card using the Format command, all data on the card will be erased, including protected images.

Figure 6-26. Protect Menu Options Screen

To protect images or videos using this menu item, the procedure is similar to the one for deleting images, discussed earlier. When you select this option, the camera will display a screen like that shown in Figure 6-26, with the choices to select multiple images; all from the same date as the current image; all from the current folder, depending on the current setting for View Mode; or to cancel protection for all images with this date or from this folder.

If you select Multiple Images, the camera will present you with either index screens or individual images. As with the Delete option, you can scroll through your images and videos and mark any item's check box for protection by pressing the Center button. When you have finished marking them, press the Menu button and the camera will display a confirmation screen. If you select OK to confirm, the marked items will be protected. Any image that is protected will have a key icon in the upper right corner to the left of the battery icon, as shown in Figure 6-27.

Figure 6-27. Protected Image with Key Icon

The key icon will be visible when the image is viewed with the detailed information screen or the basic information screen, but it will not appear in the image-only view.

To unprotect all images or videos in one operation, select the appropriate Cancel option from the Protect item on the Playback menu. That option will prompt you to Cancel All with this Date or to Cancel All in this Folder, depending on the View Mode setting.

MOTION INTERVAL ADJUSTMENT

This menu option lets you vary the length of the interval between frames when the camera creates a Motion Shot effect in playing back a movie. The adjustment screen for this option is shown in Figure 6-28.

Figure 6-28. Motion Interval Adjustment Screen

The default value is four; you can set the interval to any value from one to seven. The higher the number, the greater the spacing between images in the motion shot. I will discuss this option in Chapter 8, where I discuss movie playback features.

SPECIFY PRINTING

This final option on screen 2 of the Playback menu lets you use the DPOF (Digital Print Order Format) function, a standard printing protocol that is built into the camera. The DPOF system lets you mark various images on your memory card to be added to a print list, which can then be sent to your own printer. Or, you can take the memory card to a commercial printing company to print out the selected images.

To add images to the DPOF print list, select the Specify Printing option from the Playback menu. On the next screen, shown in Figure 6-29, select Multiple Images.

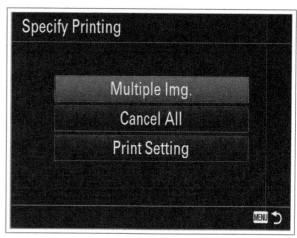

Figure 6-29. Specify Printing Menu Options Screen

The camera will display the first image with a check box at the left, or an index screen with an orange frame around the currently selected image and a check box in the lower-left corner of each image thumbnail, as shown in Figure 6-30.

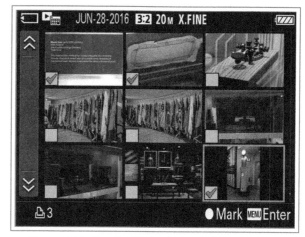

Figure 6-30. Specify Printing Image Selection Screen

You can display individual images, or show index screens using the zoom lever. There will be a small printer icon in the lower left of the display with a zero beside it at first, meaning no copies of any images have been set for printing yet. Use the Control wheel or direction buttons to move through the images. Use the Control dial to move through index screens a screen at a time.

When an image you want to have printed is displayed, press the Center button to mark it for printing or to unmark it. You can then keep browsing through your images and adding (or subtracting) them from the print list. As you add images to the print list, the DPOF counter in the lower left corner of the display will show the total number of images selected for printing.

When you have finished selecting images to be printed, press the Menu button to move to a screen where you can confirm your choices by selecting OK.

You also can turn the Date Imprint option on or off to specify whether or not the pictures will be printed with the dates they were taken. To do this, go to the first screen of the Specify Printing menu option and select Print Setting. On the next screen, shown in Figure 6-31, the camera will let you select Enter, to specify that the date should be printed on each image.

Figure 6-31. Specify Printing Date Imprint Selection Screen

You can take the memory card with the DPOF list to a service that prints photos using this system, or you can connect the camera to a PictBridge-compatible printer to print the images. If you want to cancel a DPOF order, select the Specify Printing menu item, and select the Cancel All option on the next screen.

The final screen of the Playback menu is shown in Figure 6-32.

Figure 6-32. Screen 3 of Playback Menu

PHOTO CAPTURE

This only option on the last screen of the Playback menu gives you a set of tools for saving one or more still frames from a movie that was recorded with the camera. To use this option, first find the movie that you want to save a still image from. You can use the View Mode option discussed earlier in this chapter to find movies of various formats, to help narrow the search.

When you have the chosen movie displayed on the screen in playback mode, select the Photo Capture menu option, and the camera will display the movie again, but this time with a circular area with several icons at the right side of the display that represent the camera's direction buttons and Center button, as shown in Figure 6-33.

Figure 6-33. Movie Playback Screen with Photo Capture Controls

The top icon represents slow playback; the right one is for single-frame forward; the left one is for single-frame reverse; the center one is for play; and the bottom one is for photo capture.

Using the four direction buttons and the Center button according to that scheme, play the movie to the exact frame you want to save, and then press the Down button to capture the frame to a still image. The camera will display a Processing message briefly, and then will save a still image to the memory card. The image will have the same resolution as the movie from which it was saved. For example, if you save a frame from a 4K movie, it will have a resolution of 3840 x 2160 pixels, or about 8 megapixels.

If you want, you can start the Photo Capture process without using the menu system. To do that, start a movie playing, and press the Center button to pause it. Then press the Down button, and you will see a control

panel at the bottom of the screen, as shown in Figure 6-34.

Figure 6-34. Movie Playback Controls Showing Photo Capture Icon

The Photo Capture icon is the third one from the right. Use the direction buttons to navigate to that icon and select it, to start using the Photo Capture feature. Figure 6-35 is a frame that was saved from a 4K video using this feature.

Figure 6-35. Sample Image Saved with Photo Capture Feature

Chapter 7: The Custom and Setup Menus

In earlier chapters, I discussed the options available in the Shooting and Playback menu systems. The Sony RX10 III has two other menu systems that help you set up the camera and customize its operation: Custom and Setup. In this chapter, I will discuss all of the options on those menus. I'll discuss menu options for Movie mode in Chapter 8 and I'll discuss the options on the Wi-Fi and Application menus in Chapter 9.

Custom Menu

The Custom menu gives you control over numerous items that affect the ways you use the camera to take pictures and videos, but that do not change the basic photographic settings such as white balance, ISO, focus modes, and matters of that nature. The items to be adjusted on this menu are more in the categories of control and display options, although several of them are important for your daily image-making operations. Details about the options on the six screens of this menu follow. The first screen of the menu is seen in Figure 7-1.

Figure 7-1. Screen 1 of Custom Menu

Zebra

This first Custom menu option gives you a tool for gauging the exposure of an image or video. When you turn this menu option on, you can select a value from 70 to 100 IRE in five-unit increments, or 100+ for values greater than 100. The IRE units are a measure of relative brightness or exposure, with 0 representing black and 100 representing white.

You also can save and later use two custom values, as discussed below. Figure 7-2 shows the screen for selecting values up to 85.

Figure 7-2. Zebra Value Selection Screen

When you turn this option on to any level, you very likely will see, in some parts of the display, the black-and-white "zebra" stripes that give this feature its name.

Zebra stripes originally were created as a feature for professional video cameras, so the videographer could see whether the scene would be properly exposed. This tool often is used in the context of taping an interview, when proper exposure of a human face is the main concern.

There are various approaches to using these stripes. Some videographers like to set the zebra function to 90 IRE and adjust the exposure so the stripes barely appear in the brightest parts of the image. Another recommendation is to set the option to 75 IRE for a scene with Caucasian skin, and expose so that the stripes barely appear in the area of the skin.

In Figure 7-3, I set IRE to 75 and exposed to have the stripes appear clearly on the mannequin's face and neck.

As the brightness of the lighting increases for a subject, there may be no stripes at first, then they will gradually appear until they cover the subject, then they will seem to disappear, because the exposure is so bright that the subject is surrounded by an outline of "marching ants" rather than having stripes in its interior.

Figure 7-3. Zebra Example at IRE 75

If you want to save customized values for Zebra, you can save settings to the C1 and C2 slots. A standard way to use these two values is to set C1 to a value for exposure confirmation and C2 to a value for flare confirmation.

To set C1 for exposure confirmation, scroll down to the C1 block and press the Right button. You will see a screen like that in Figure 7-4, with the Std+Range block highlighted in orange. (Press the Up or Down button if necessary to bring that label into the block.)

Figure 7-4. Screen to Set Zebra C1 Block for Exposure Confirmation

With the Std+Range block highlighted, press the Right button to move to the next block, and use the Up and

Down buttons or the Control dial to set a value, which can be from zero to 109, in one-unit increments. Then press the Right button to move to the next block and select a range, which can be from ±1 to ±10.

For example, you might set the first block to 77 and the second block to ±5, so the Zebra pattern would appear when the brightness of the scene was within five units of 77, plus or minus. You could then set Zebra to C1 to confirm that the scene's exposure was within that range.

To set the C2 value for flare confirmation, scroll down to that block and press the Right button. Make sure the highlighted block contains the Lower Limit label, as shown in Figure 7-5.

Figure 7-5. Screen to Set Zebra C2 Block for Flare Confirmation

Then press the Right button to move to the second block and select a setting from 50+ to 100+ in one-unit increments. That value represents the brightness level that you don't want to exceed. You can then set Zebra to the C2 block and check the scene to make sure the lighting stays within that limit, to avoid flare. The Zebra pattern will appear if that limit is exceeded.

Zebra is a feature to consider, especially for video recording, but the RX10 III has an excellent metering system, including both live and playback histograms, so you can manage without this option if you don't want to deal with its learning curve.

MF ASSIST

The MF Assist option is useful when manual focus or DMF is in use. When MF Assist is turned on in manual focus mode, the RX10 III enlarges the image on the display screen to 5.3 times normal size as soon as you start turning the focusing ring (the front or rear lens

ring, depending on which is assigned to adjust focus), as shown in Figure 7-6. To increase magnification to 10.7 times, press the Center button; press that button again to return to the 5.3 enlargement factor. Press the shutter button halfway down to return the image to normal size. This feature is helpful in judging whether a particular area is in sharp focus. If you turn this option off, you can use another focusing aid, such as Focus Magnifier, discussed in Chapter 4, or Peaking, discussed later in this chapter.

Figure 7-6. MF Assist Screen at 5.3x Magnification

Or, you can use this option and Peaking at the same time, to provide even more assistance.

When DMF is in effect, you have to keep the shutter button pressed halfway down while turning the focusing ring to use the MF Assist enlargement feature.

I find MF Assist helpful, especially when I set the camera to leave the enlarged screen in place indefinitely using the Focus Magnification Time option, discussed immediately below. However, the Focus Magnifier option also is helpful, and may be preferable in one way because the screen does not become magnified until you select the area to be magnified using the orange frame and press the Center button to magnify the screen. (You can change that behavior with the Initial Focus Magnification menu option, discussed below.)

In some cases, where a subject (like the moon) does not have clear edges or other features to focus on, enlarging the view may not be that much help. In those situations, Peaking may be more useful. Or, you may find that using Peaking in conjunction with MF Assist is the most useful approach of all. You should experiment with the various options to find what works best for you.

FOCUS MAGNIFICATION TIME

This option lets you select how long the display stays magnified when you use either the MF Assist option, discussed directly above, or the Focus Magnifier option, discussed in Chapter 4. The choices are two or five seconds or No Limit, as shown in Figure 7-7. The default option is two seconds. With No Limit, the image will stay magnified until you press the shutter button all the way to take the picture, or press it halfway to dismiss the enlarged view. My preference is to use the No Limit option, so I can take my time in adjusting manual focus precisely.

Figure 7-7. Focus Magnification Time Menu Options Screen

Note, though, that with the No Limit option, whenever you turn the focusing ring to adjust manual focus with MF Assist in effect, the image will be enlarged, and you may want to be able to keep adjusting focus with a view of the unenlarged subject. If that is the case, select one of the options with a time limit, or turn off MF Assist and use the Focus Magnifier option instead.

INITIAL FOCUS MAGNIFICATION

This menu option lets you select either 1.0x or 5.3x as the initial magnification factor for the Focus Magnifier frame when it first appears on the screen. The Focus Magnifier option was discussed in Chapter 4; it is found on screen 6 of the Shooting menu, and it can be assigned to one of the camera's control buttons through the Custom Key (Shooting) option on screen 5 of the Custom menu.

If you select the default of 1.0x for this menu option, the Focus Magnifier frame will appear on the display with no magnification until you press the Center

button. The area within the frame is then magnified to 5.3 times, and a second press magnifies it to 10.7 times; a third press removes the frame from the display. If you select 5.3x for this option, the frame will appear with the 5.3x magnification already in effect.

Note: If you use the In-Camera Guide help system, which can be assigned to a control button using the Custom Key (Shooting) option, and press that button when this menu item is highlighted, you will see that the help system says that this option controls the initial magnification for the Focus Magnifier option and for the MF Assist option. However, this option controls the initial magnification only for the Focus Magnifier option. The MF Assist screen always displays initially at the 5.3x magnification, regardless of the setting for this option.

GRID LINE

With this option, you can select one of four settings for a grid to be superimposed on the shooting screen. By default, there is no grid. If you choose one of the grid options, the lines will appear in your chosen configuration whenever the camera is showing the live view in shooting mode, whether the detailed display screen is selected or not. Of course, the grid does not appear when the For Viewfinder display, with its black screen full of shooting information, is displayed. The four options are seen in Figure 7-8.

Figure 7-8. Grid Line Menu Options Screen

Here are descriptions of these choices, other than Off, which leaves the screen with no grid.

Rule of Thirds Grid

This arrangement has two vertical lines and two horizontal lines, dividing the screen into nine blocks, as shown in Figure 7-9.

Figure 7-9. Rule of Thirds Grid Example

This grid follows a rule of composition that calls for locating an important subject at an intersection of these lines, which will place the subject one-third of the way from the edge of the image. This arrangement can add interest and asymmetry to an image.

Square Grid

With this setting, the grid has five vertical lines and three horizontal lines, dividing the display into 24 blocks, as seen in Figure 7-10. In this way, you can still use the Rule of Thirds, but you have additional lines available for lining up items, such as the horizon or the edge of a building, that need to be straight.

Figure 7-10. Square Grid Example

Diagonal Plus Square Grid

The last option gives you a square grid of four blocks in each direction and adds two diagonal lines, as shown in Figure 7-11.

Figure 7-11. Diagonal Plus Square Grid Example

The idea is that placing a subject or, more likely, a string of subjects along one of the diagonals can add interest to the image by drawing the viewer's eye into the image along the diagonal line.

MARKER DISPLAY

This option, which can be turned either on or off, determines whether or not various informative guidelines, called "markers," are displayed on the camera's screen for movie recording. There are four special markers available, which outline the aspect ratio and other areas on the screen. Any or all of them can be selected for use with the Marker Settings menu option, directly after this one on the Custom menu. If you turn Marker Display on, then any of the four markers that you have selected will be displayed on the shooting screen while a movie is being recorded in any mode. The markers also will be displayed while the Mode dial is set to the Movie mode position or the HFR position, even before recording starts.

If this option is turned on, the selected markers will display on the camera's display screen, but they will not be recorded with the movie.

Screen 2 of the Custom menu is shown in Figure 7-12.

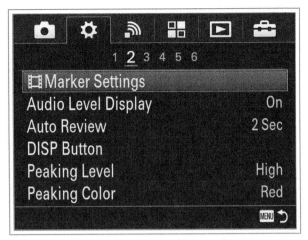

Figure 7-12. Screen 2 of Custom Menu

MARKER SETTINGS

This menu option works together with the Marker Display option, discussed above. This option lets you activate any or all of the four available markers—Center, Aspect, Safety Zone, and Guideframe.

If you turn on the Center marker, it places a cross in the center of the display, as illustrated in Figure 7-13. If you are shooting video in a busy or hectic environment, this marker may help you keep the main subject centered in the display so you don't cut it off.

Figure 7-13. Center Marker in Use

The Aspect marker can be off or set to any one of seven settings: 4:3, 13:9, 14:9, 15:9, 1.66:1, 1.85:1, or 2.35:1. Figure 7-14 shows the display with the 2.35:1 setting.

Figure 7-14. Aspect Marker 2.35:1 in Use

This setting places vertical white lines at the sides of the frame or horizontal white lines at the top and bottom of the frame, to outline the shape of the movie frame for the chosen aspect ratio. These lines are useful if you plan to alter the aspect ratio of your footage in post-production, to show what parts of the image will be cut off and help you frame your shots accordingly.

The Safety Zone marker can be off, or set to outline either 80% or 90% of the area of the display. The purpose of this marker's guidelines is to provide a margin for safety, because the average consumer television set does not display the entire broadcast signal provided to it. If you set these lines to mark a safety zone, you can make sure that your important subjects are included in the area that definitely will be displayed on most television sets. Figure 7-15 shows the display with the 80% safety zone activated.

Figure 7-15. Safety Zone Marker 80% in Use

Finally, the Guideframe option, if turned on, displays a grid that is similar to the Rule of Thirds grid available

with the Grid Line option, discussed earlier in this chapter. That option uses thin, black lines, which may be hard to see when you are shooting video under difficult conditions. The bold, white lines of the Guideframe setting should be more useful for video shooting. You cannot use both options at the same time; Grid Line is not available when Marker Display is turned on. Figure 7-16 shows the Guideframe option in use.

Figure 7-16. Guideframe Marker in Use

AUDIO LEVEL DISPLAY

This option controls whether audio level meters appear during movie recording in any shooting mode and before recording a video when the camera is set to Movie mode. The meters have green indicators that move farther to the right to indicate increases in the volume of audio, as shown in Figure 7-17.

Figure 7-17. Audio Level Meters on Display

The meters appear on detailed information screens; if this option is on and you don't see the meters when recording a video, press the Display button to call up

one of the other screens. Also, check to see if the Audio Recording option on screen 8 of the Shooting menu is on; if that option is off, the meters will not be displayed. I generally leave this option turned on; seeing the movement of the audio levels on the meters reassures me that the audio is being recorded successfully.

Auto Review

The Auto Review option, shown in Figure 7-18, sets the length of time that an image appears on the display screen immediately after you take a still picture.

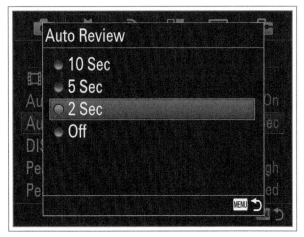

Figure 7-18. Auto Review Menu Options Screen

The default is two seconds, but you can set the time to five or ten seconds, or you can turn the function off. If you turn it off, the camera will return to shooting mode as soon as it has saved a new image to the memory card. When this option is in use, you can always return to the live view by pressing the shutter button halfway. The Auto Review option does not apply to movies; the camera does not display the beginning frame of a movie that was just recorded until you press the Playback button.

While the new image is being displayed, you can use the various functions of playback mode, such as enlarging the image, bringing up index screens, moving to other images, or pressing the Delete button to delete the image. If you start one of these actions before the camera has reverted to shooting mode, the camera will stay in playback mode.

Display Button

This option lets you choose what screens appear in shooting mode as you press the Display button. There are sub-options for the monitor (LCD) and viewfinder,

as seen in Figure 7-19. You can make different choices for the LCD and viewfinder, so pressing the Display button when you are using the monitor may bring up different screens than when you are using the viewfinder. After you decide to choose screens for the monitor or the viewfinder, you will see a screen like that shown in Figure 7-20.

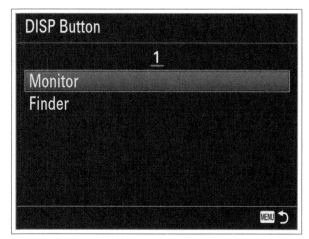

Figure 7-19. Display Button Main Options Screen

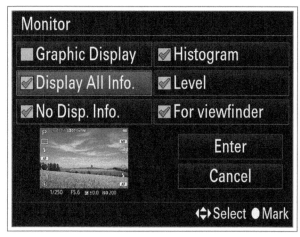

Figure 7-20. Display Button Screen for Monitor

This screen shows the six display screens you can select for the monitor. The selection screen for the viewfinder is identical to this one, except that the sixth choice, For Viewfinder, is not available as a choice to appear in the viewfinder. That display screen is designed to appear on the monitor to provide shooting information when you are viewing the live view through the viewfinder.

Five of the six display screens available for the monitor are shown in Figure 7-21 through Figure 7-25. The screen displaying just the image with no information is not shown here.

Figure 7-21 shows the version of the screen with the Graphic Display in the lower-right corner; that display is supposed to illustrate the use of faster shutter speeds to stop action and the use of wider apertures to blur backgrounds. I find it distracting and not especially helpful, but if it is useful to you, by all means select it.

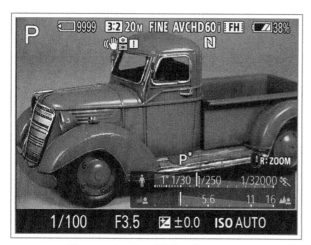

Figure 7-21. Graphic Display Screen

I find the Display All Information screen, shown in Figure 7-22, to be cluttered, but it has useful information.

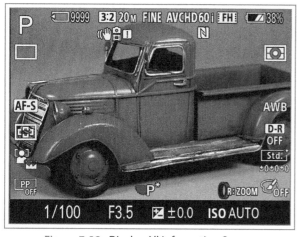

Figure 7-22. Display All Information Screen

You can always move away from this screen by pressing the Display button (if there is at least one other display screen available), and I like to have it available for times when I need to see what settings are in effect.

The third option, displaying only the image, isn't shown here. This display is good for focusing and composing your shot. I always include it in the cycle of screens.

The fourth screen, shown in Figure 7-23, displays the histogram. This shooting-mode histogram, unlike

the one displayed in playback mode, shows only basic exposure information with no color data. However, it gives you an idea of whether your image will be well exposed, letting you adjust exposure compensation and other settings as appropriate while watching the live histogram on the screen. If you can make the histogram display look like a triangular mountain centered in the box, you are likely to have a good result.

Figure 7-23. Histogram Screen

You should try to keep the body of the histogram away from the right and left edges of the graph, in most cases. If the histogram runs into the left edge, that means shadow areas are clipping and details in those areas are being lost. If it hits the right edge, you are losing details in highlights. If you have to choose, it is best to keep the graph away from the right edge because it is harder to recover details from clipped highlights than from clipped shadows.

Figure 7-24. Level Screen

The fifth available display screen, shown in Figure 7-24, includes the RX10 III's level, which is a useful tool for leveling the camera both side-to-side and front-to-back.

Watch the small orange lines on the screen; when the outer two ones have turned green, the camera is level side-to-side; when the inner two lines are green, the camera is level front-to-back.

The sixth choice, shown in Figure 7-25, which is available only for the monitor, is called For Viewfinder.

Figure 7-25. For Viewfinder Screen

This option is the only one that does not include the live view in shooting mode. Instead, it displays a black screen with detailed information about the camera's settings, so you can check your settings after (or before) you look at the live view in the viewfinder. In addition, as I discussed in Chapter 5, this screen includes the Quick Navi system. When you press the Function button, the settings on the screen become active. You can navigate through the settings using the direction buttons and adjust them using the Control wheel and the Control dial.

Once you select the Display Button option and choose whether to select screens for the monitor or viewfinder, you can scroll through the six (monitor) or five (viewfinder) choices using the Control wheel, Control dial, or direction buttons. When a screen you want to have displayed is highlighted, press the Center button to put an orange check mark in the box to the left of the screen's label, as seen in Figure 7-20.

You can also press that button to unmark a box. The camera will let you uncheck all six of the items (or all five for the viewfinder), but if you do that, you will see

an error message as you try to exit the menu screen. You have to check at least one box so that some screen will display when the camera is in shooting mode.

After you select from one to six screens for the monitor and from one to five for the viewfinder, highlight the Enter block and press the Center button. Then, whenever the camera is in shooting mode, the selected screens will be displayed; you cycle through them by pressing the Display button (Up button). If you have selected only one screen, pressing the Display button will have no effect in shooting mode when the live view is displayed.

Even if you select only the one screen that includes no information, the camera will still always display the shutter speed, aperture, exposure compensation, and ISO; all of those values are displayed in the black strip below the area where the image is displayed.

PEAKING LEVEL

The Peaking Level option, shown in Figure 7-26, controls the use of the Peaking display to assist with manual focus.

Figure 7-26. Peaking Level Menu Options Screen

By default, this option is turned off. You can turn the feature on with a level of Low, Mid, or High. When it is on and you are using manual focus, the camera places an outline with the selected intensity around any areas of the image that are in focus and therefore have edges the camera can distinguish.

Figure 7-27 illustrates this feature with a composite image in which Peaking Level is turned off for the left image and set to Mid for the right image.

Figure 7-27. Peaking Level Example

The idea is that these lines provide a more definite indication that the focus is sharp than just relying on your judgment of sharpness. When I first used a camera with this feature, I found it distracting and not as useful as options such as MF Assist and Focus Magnifier that enlarge the screen for a clearer view when using manual focus. However, after further experience, I have come to appreciate the usefulness of the Peaking feature for some situations.

For example, as discussed in Chapter 9, I took some shots of the moon with the RX10 III using manual focus mode. The image on the camera's screen was unsteady because of the high magnification, and the moon did not have any features with edges that I could see clearly in the enlarged view. When I turned on Peaking with the red color selected, I found it much easier to focus; the camera displayed a broad band of red around the edge of the moon when focus was sharp.

Some photographers set Creative Style to black and white while focusing so the Peaking color will stand out, and some like to set Peaking Level to Low so the color is not overwhelming, letting them see when the color just starts to appear. Some like to turn on MF Assist to enlarge the screen when using Peaking. You should experiment to find what approach works best for you.

For an excellent demonstration of how Peaking works, see this YouTube video posted by a participant in the Sony Cyber-shot Talk forum at dpreview.com at http://youtu.be/jMAlMQev7Kw.

Note that Peaking also works with DMF, even if you are using the autofocus function of that setting.

PEAKING COLOR

This option lets you choose red, yellow, or white for the color of the lines that the Peaking Level feature

places around the edges of in-focus areas of the image. The default color is white. It is useful to be able to change the color depending on the colors present in your image. The Peaking Level feature is likely to be most useful when the color you choose for the effect contrasts with the main colors in your subject. As noted above, I found that the red color worked very well for shots of the moon; yellow or white may work well with darker subjects.

Screen 3 of the Custom menu is shown in Figure 7-28.

Figure 7-28. Screen 3 of Custom Menu

EXPOSURE SETTINGS GUIDE

The first option on screen 3 of the Custom menu places a circular display on the screen to simulate one or two rotating wheels showing the settings for aperture, shutter speed, or both. The display varies according to the shooting mode.

In Program mode, the wheels display aperture and shutter speed when you activate Program Shift. In Shutter Priority and Manual exposure modes, and in Movie mode or HFR mode when the exposure mode is set to Shutter Priority or Manual Exposure, a single wheel displays shutter speed as you adjust it using the Control dial. Figure 7-29 shows the display when shutter speed is being adjusted. In Aperture Priority and other shooting modes, this menu option has no effect.

I find this display distracting so I leave it turned off, but it might be useful to see this large display to let you know what value is being set, in some circumstances.

Figure 7-29. Exposure Settings Guide in Use

LIVE VIEW DISPLAY

This menu option can be important for getting results that match your expectations. It lets you choose whether or not the camera displays the effects that certain settings will have on your final image, while you are composing the image.

When you select this option, you will see two sub-options on the next screen: Setting Effect On and Setting Effect Off, as shown in Figure 7-30.

Figure 7-30. Live View Display Menu Options Screen

If you select Setting Effect On, then, when you are using Program, Aperture Priority, Shutter Priority, or Manual exposure mode, the camera's display in shooting mode will show the effects of exposure compensation, white balance, Creative Style, and Picture Effect, with some limitations. In addition, it will show the effects of exposure changes in Manual exposure mode and other advanced modes, to some extent.

In some cases, it may be helpful to see what effect a particular setting will have on the final image, and in other cases that feature might be distracting or might even make it difficult to take the shot.

For example, when you are setting white balance, it can be helpful to see how the various options will alter the appearance of your final images. If you have selected Setting Effect On, then, as you scroll through the white balance menu options, you will instantly see the effect of each setting, such as Daylight, Cloudy, Shade, and Incandescent. That change in the display is not distracting; it is actually very informative.

However, if you are using the Picture Effect option and experimenting with a setting such as Posterization, which drastically alters the appearance of your images, you might find it difficult to compose the image with Setting Effect On selected.

There is one particular use for the Live View Display menu option that I find practically indispensable. On occasion, I use the RX10 III to trigger external, non-Sony flash units, with the camera set to Manual exposure mode. For some of these shots, I use settings such as f/16.0, 1/200 second, and ISO 80. This shot will be exposed properly with the flash units I am using, but, with Setting Effect On selected, the camera's screen is completely dark as I compose the shot. That is because the camera's programming does not account for the fact that flash units will be fired.

If I use the Setting Effect Off setting, then the camera displays the scene using the available ambient light, ignoring the settings I have made. In this way, I can see the scene on the camera's display in order to compose the shot properly.

The Setting Effect On option, though, can be useful when using Aperture Priority, Shutter Priority, or Manual exposure mode when you are shooting in unusually dark or bright conditions, because the camera's display screen will change its brightness to alert you that a normal exposure may not be possible with the current settings. (You should see the aperture, shutter speed, M.M., or exposure compensation value flashing to alert you to this situation, also.)

With the Picture Effect setting, some of the options will not change the appearance of the display, even with Setting Effect On activated. Those options are

Soft Focus, HDR Painting, Rich-tone Monochrome, Miniature, Watercolor, and Illustration. You can see the effects of those settings in playback mode, after you have captured an image using one of the settings.

When Setting Effect Off is selected, the camera will display a VIEW icon on the screen, as shown in Figure 7-31, to remind you that the camera's display is not showing the effects of all your settings.

Figure 7-31. VIEW Icon on Display for Setting Effect Off

My recommendation is to leave this option at Setting Effect On unless you are faced with a situation in which it is difficult to compose a shot, either because the display is too dark or light, or because a setting such as Picture Effect interferes with your ability to view the subject clearly.

In the Intelligent Auto, Scene, Sweep Panorama, HFR, and Movie modes, this option is forced to Setting Effect On and cannot be changed.

PRE-AF

The Pre-AF setting affects the way the RX10 III uses autofocus for capturing still images. When this option is turned on and the focus switch is set to the S or C position, for single-shot or continuous autofocus, the camera continuously tries to focus on a subject, even before you press the shutter button halfway. With this setting, the camera's battery is depleted more quickly than normal, but the final focusing operation may be speeded up because the camera can reach an approximate focus adjustment before you press the shutter button to evaluate focus and take the picture.

If this setting is turned off, then the camera makes no attempt to use its autofocus mechanism until you press the shutter button halfway to check focus.

I usually leave this setting off to avoid running the battery down too soon. But, if I were taking pictures of moving subjects, I might activate this setting to speed up the focusing process.

When the camera is recording movies, it always uses the equivalent of the Pre-AF setting; this menu option has no effect for movie recording.

ZOOM SPEED

This option, which can be set to Normal or Fast, controls how quickly the lens zooms in or out when you move the zoom lever. It also controls the speed of the lens when you are using an optional Sony remote control, as discussed in Appendix A. The setting for this item depends on your preference. You may prefer the smoother zooming of the Normal setting, especially if you want to set a specific, intermediate focal length for your shots. But, if you like to change focal lengths quickly to zoom all the way in or out, the Fast setting will save some time.

To increase the speed of zooming using the front or rear lens ring, use the Zoom Function on Ring option on screen 6 of the Custom menu, discussed later in this chapter, and set the value to Quick instead of Standard.

ZOOM SETTING

The last option on screen 3 of the Custom menu, Zoom Setting, provides two ways to give the RX10 III extra zoom range, using features called Clear Image Zoom and Digital Zoom. To explain these features in context, I will discuss all three zoom methods that the camera offers—optical zoom, Clear Image Zoom, and Digital Zoom. (I will also discuss a fourth feature related to these, called Smart Zoom.)

Optical zoom is the camera's "natural" zoom capability—moving the lens elements so they magnify the image, just as binoculars do. You can call optical zoom a "real" zoom because it increases the amount of information that the lens gathers. The optical zoom of the RX10 III operates within a range from 24mm at the wide-angle setting to the fully zoomed-in telephoto setting of 600mm.

To complicate matters a bit, I should point out that the actual optical zoom range of the RX10 III's lens is 8.8mm to 220mm; you can see those numbers on the end of the lens. But the numbers that are almost always used to describe the zoom range of a compact camera's lens are the "35mm-equivalent" figures, which translate the actual zoom range into what the range would be if this were a lens on a camera that uses 35mm film. This translation is done because so many photographers are familiar with the zoom ranges and focal lengths of lenses for traditional 35mm cameras, on which a 50mm lens is considered "normal." I use the 35mm-equivalent figures throughout this book.

The Digital Zoom feature on the RX10 III magnifies the image electronically without any special processing to improve the quality. This type of zoom does not really increase the information gathered by the lens; rather, it just increases the apparent size of the image by enlarging the pixels within the area captured by the lens. On some cameras, the amount of digital zoom can be very large, such as 50 times normal, but such a large figure should be considered as a marketing ploy to lure customers, rather than as a feature of real value to the photographer.

The other option on the RX10 III, Clear Image Zoom, is a special type of digital zoom developed by Sony. With this feature, the RX10 III does not just magnify the area of the image; rather, the camera uses an algorithm based on analysis of the image to add pixels through interpolation, so the pixels are not just multiplied. The enlargement is performed in a way that produces a smoother, more realistic enlargement than the Digital Zoom feature. Therefore, with Clear Image Zoom, the camera achieves greater quality than with Digital Zoom, though not as much as with the "pure" optical zoom.

Finally, there is another way the RX10 III can have a zoom range greater than the normal range of 24mm to 600mm, with no reduction in image quality. The standard range of 24mm to 600mm is available when Image Size is set to Large. However, if Image Size is set to Medium or Small, then the camera needs only a portion of the pixels on the image sensor to create the image at the reduced size. It can use the "extra" pixels to enlarge the view of the scene. This process, which Sony calls Smart Zoom in its documentation, is similar to what you can do using editing software such as Photoshop. If the final image does not need to be at the Large size, you can crop out some pixels from the center

(or other area) of the image and enlarge them, thereby retaining the same final image size with a magnified view of the scene.

So, with Smart Zoom, if you set Image Size to M or S, the camera can zoom to a greater range than with Image Size set to L and still retain the full quality of the optical zoom. You will, of course, end up with lower-resolution images, but that may not be a problem if you are going to post them on a website or share them via e-mail.

In short, optical zoom provides the best quality for magnifying the scene; Clear Image Zoom gives excellent quality; and Digital Zoom produces magnification accompanied by deterioration of the image. Smart Zoom lets you get greater zoom range with no image deterioration, but at the expense of resolution.

Here is how to use these settings. I will assume for now that you are leaving Image Size set to L, because that is the best setting for excellent results in printing and editing your images.

When you select the Zoom Setting menu option and press the Center button, the camera displays the screen shown in Figure 7-32, giving you the choice of Optical Zoom Only; On: Clear Image Zoom; or On: Digital Zoom. If you turn on Digital Zoom, Clear Image Zoom will automatically be activated also. Optical Zoom is always available, no matter what settings are used.

Figure 7-32. Zoom Setting Menu Options Screen

If you turn on only Clear Image Zoom, you will have greater zoom range than normal, as discussed above, with minimal quality loss. If you also turn on Digital Zoom, you will get even greater zoom range, but quality will suffer as the lens is zoomed past the Clear Image

Zoom range. When these various settings are in effect, you will see different indications on the camera's display.

In Figure 7-33, Image Size is set to L with Clear Image Zoom and Digital Zoom turned off. The zoom indicator at the top of the screen goes only as far as 600mm.

In Figure 7-34, Clear Image Zoom is turned on. The lens can be zoomed to two times the normal range; here, it is zoomed to 1.3 times normal..

There is a small vertical line in the center of the zoom scale marking the point where the zoom changes from optical-only to expanded (either Clear Image Zoom or Digital Zoom, depending on the settings). The magnifying glass icon with the "C" beneath the scale means Clear Image Zoom is turned on. Also, once the lens zooms past the optical zoom range, the sound of the zoom mechanism stops, so you can tell by listening when the camera has entered the range of Clear Image Zoom and Digital Zoom.

Figure 7-33. Zoom Scale for Optical Zoom Only

Figure 7-34. Zoom Scale for Clear Image Zoom

In Figure 7-35, both Clear Image Zoom and Digital Zoom are turned on, and the zoom indicator goes up to four times normal. The magnifying glass icon beneath the scale has a "D" beside it, indicating that Digital Zoom is now in effect.

With an Image Size setting smaller than Large, the zoom scale will use an S to show that the camera is using Smart Zoom, as the zoom range extends beyond the standard optical zoom range.

Figure 7-35. Zoom Scale for Digital Zoom

For example, in Figure 7-36, with Image Size set to Small, the lens is zoomed in to 1.8 times the optical range, and the zoom indicator displays an S to indicate that Smart Zoom is in effect.

With smaller image sizes, the ranges of Clear Image Zoom and Digital Zoom also are expanded.

Figure 7-36. Zoom Scale for Smart Zoom

For example, as shown in Figure 7-37, with Image Size set to Small and Digital Zoom turned on, the lens can be zoomed in to 8.0 times the normal optical range.

Figure 7-37. Zoom Scale for Smart Zoom and Digital Zoom

Table 7-1 shows the zoom ranges available when Image Size is set to Large, Medium, and Small, with settings of Optical Zoom, Clear Image Zoom, and Digital Zoom. In all cases, Aspect Ratio is set to 3:2; with other Aspect Ratio settings, results would be different.

Table 7-1. **Zoom Ranges at Various Image Sizes**

	Large	Medium	Small
Optical Zoom (with no deterioration)	600mm	840mm	1200mm
Clear Image Zoom (with minimal deterioration)	1200mm	1680mm	2400mm
Digital Zoom (with significant deterioration)	2400mm	3360mm	4800mm

To summarize the situation with zoom, when Image Size is set to Large, you can zoom up to 600mm with no deterioration using optical zoom; you can zoom to 1200mm with minimal deterioration using Clear Image Zoom; and you can zoom to 2400mm using Digital Zoom but with significant deterioration.

My preference is to limit the camera to optical zoom and avoid any deterioration. However, many photographers have found that Clear Image Zoom yields surprisingly good results, and it is worth using when you cannot get close to your subject. I do not like to use Digital Zoom to take a picture. However, it can be useful to zoom in to meter a specific area of a distant subject, or to check the composition of your shot before zooming back out and taking the shot using Clear Image Zoom or optical zoom.

Clear Image Zoom and Digital Zoom are not available in several situations, including with Raw images, when the Smile Shutter is turned on, and in Sweep Panorama mode. They also are unavailable when the Smart Teleconverter option has been assigned to a control button. The Smart Teleconverter option, discussed later in this chapter, is itself a form of Digital Zoom.

When the lens is zoomed in to the range of Clear Image Zoom or Digital Zoom and autofocus is in use, the Focus Area menu option is disabled and the camera uses a broad focus frame, which is represented by a dotted area like that seen in Figure 7-34.

Screen 4 of the Custom menu is shown in Figure 7-38.

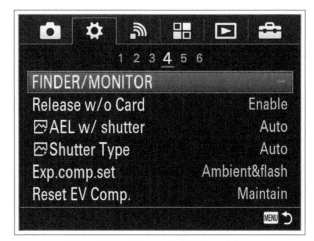

Figure 7-38. Screen 4 of Custom Menu

FINDER/MONITOR

This first option on screen 4 of the Custom menu, shown in Figure 7-39, lets you choose whether to view shooting and playback displays on the RX10 III's LCD screen or in the viewfinder.

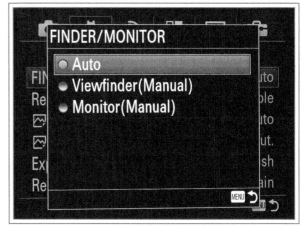

Figure 7-39. Finder/Monitor Menu Options Screen

The viewfinder provides the same information as the LCD screen, but its display is viewed inside an eye-level window that is shaded from daylight, giving you a clear view of the shooting, playback, and menu screens.

By default, this menu option is set to Auto, which means the camera switches to the viewfinder automatically when you move your head near the eye sensor to the left of the viewfinder. The camera turns on the viewfinder display and blacks out the LCD.

If you prefer to use either the viewfinder or the LCD screen at all times, set this menu option to Viewfinder (Manual) or Monitor (Manual), according to your preference. With either of those settings, the camera will not switch to the other method of viewing unless you go back to this menu option and change the setting.

For me, the Auto option works well, and I have not found a reason to use the other settings. But if you will be using the LCD while working with your head (or another object) very close to the camera's viewfinder, you might want to use the Monitor (Manual) option so the screen does not blank out unexpectedly.

RELEASE WITHOUT CARD

This option can be set to either Enable or Disable. If it is set to Enable, you can operate the camera's shutter release button even if there is no memory card inserted in the camera. In that case, the camera will display a NO CARD warning message, but it will let you operate the shutter and an image will be saved temporarily. This setting is useful if the camera is on display in a retail store, so customers can operate the controls and see how a saved image would look, without having to have an expensive memory card left in the camera. As I noted in Chapter 1, there is no easy way to save an image taken when this setting is active, although in an emergency you may be able to send the image through the HDMI port to a video capture device.

If you select Disable for this item, the NO CARD warning is still displayed. In addition, if you try to press the shutter button, the camera will display a warning message advising that the shutter cannot be operated with no memory card inserted, as shown in figure 7-40. This setting is the safest one to use, because it protects you against operating the camera when there is no card inserted to save images or videos.

Figure 7-40. Warning Message for Release without Card

AEL WITH SHUTTER

This menu item, whose options screen is shown in Figure 7-41, controls how the shutter button handles autoexposure lock. There are three possible settings for this feature: Auto, On, and Off.

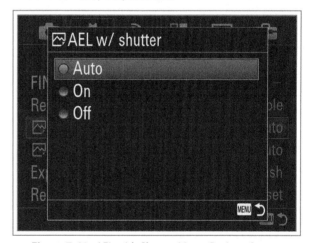

Figure 7-41. AEL with Shutter Menu Options Screen

With the default option, Auto, pressing the shutter button halfway locks exposure when the focus switch is set to S for single-shot autofocus or DMF for direct manual focus. When the focus switch is set to C for continuous focus or MF for manual focus, pressing the shutter button halfway does not lock exposure.

If AEL with Shutter is set to On, then pressing the shutter button halfway locks exposure in all situations, regardless of what focus mode is in place. So, for example, if the focus switch is set to the C position for continuous autofocus, pressing the shutter button halfway locks exposure, though the focus mechanism will continue adjusting focus.

If this menu option is set to Off, then pressing the shutter button halfway never locks exposure, in any focus mode. You may want to use this setting when you need to press the shutter button halfway to lock focus and then move the camera to change the composition somewhat. You might want the camera to re-evaluate the exposure, even though you have already locked the focus.

Another important use for the Off setting is when you are using the continuous shooting settings of Drive Mode. As I discussed in Chapter 4, if you want the camera to adjust its exposure for each shot in a continuous burst, you need to set AEL with Shutter to Off, or set it to Auto with the focus switch set to continuous AF. Otherwise, the camera will lock exposure with the first shot, and will not adjust it if the lighting changes during the burst.

Of course, you may not want to use the Off or Auto setting in that scenario, because it can slow down the burst of shots, and, depending on the situation, it may not be likely that the lighting will change during a brief burst of shots. But this option is available for those times when you want the camera to keep evaluating and adjusting exposure while you take a burst of shots.

SHUTTER TYPE

This next option lets you determine whether the RX10 III uses its mechanical shutter or its electronic shutter for still images. One of the distinctive features of this camera is that it is equipped with both types of shutter, giving you flexibility for various scenarios.

With the mechanical shutter, the camera can use shutter speeds from 1/2000 second to 30 seconds, plus the BULB setting, with which you can hold the shutter open as long as you need to. In addition, the camera can synchronize its flash with the mechanical shutter at any setting, including 1/2000 second. When an external flash is used, the fastest shutter speed is 1/4000, if Shutter Type is set to Auto.

However, as noted in Chapter 3, the range of settings for the mechanical shutter varies with the aperture setting. The fastest setting available for the mechanical shutter is 1/1000 second when the aperture is set to a value wider than f/8.0 (lower f-numbers).

With the electronic shutter, the camera can use shutter speeds from 1/32000 second to 30 seconds, but with no

BULB setting, and it can synchronize with its flash only at speeds of 1/100 second or slower. These settings are not dependent on the aperture setting.

There are several considerations for choosing mechanical or electronic for the shutter type. First, if you need a super-fast shutter speed such as 1/20000 second, you need to use the electronic shutter. You might want a speed in that range if you are taking photos in very bright conditions but still want to use a fairly wide aperture to blur the background. You also might want to use a very fast shutter speed in order to maximize the rate of continuous shooting, or to ensure that you get sharp images of fast action at a sporting event.

Also, you can use the electronic shutter when you want to minimize the sounds made by the camera, such as if you are shooting in a museum or other place where sounds should be kept to a minimum. The mechanical shutter makes a sound that cannot be disabled; you can disable the sound of the electronic shutter using the Audio Signals option on screen 1 of the Setup menu. However, the sound of the mechanical shutter is quite faint, and I have not found the shutter sound to be a major factor in choosing a shutter type.

You might use the mechanical shutter if you need the BULB setting for exposures longer than 30 seconds, or if you need to synchronize the flash with a shutter speed faster than 1/100 second. You also might use the mechanical shutter to avoid distortion that can take place in some cases from use of the electronic shutter, such as when shooting under fluorescent lighting.

Figure 7-42. Shutter Type Menu Options Screen

This option has three choices, shown in Figure 7-42: Auto, Mechanical Shutter, or Electronic Shutter. With

Auto, the camera decides which shutter type to use based on current conditions, including what shutter speed is called for by the exposure reading. With Mechanical Shutter or Electronic Shutter, the specified shutter type is always used, with two exceptions. Even if Shutter Type is set to Electronic Shutter, the mechanical shutter will be used when you press the Center button to save a custom white balance, or you press the shutter button to register a new face with the Face Registration option. When Shutter Type is set to Electronic Shutter, Long Exposure Noise Reduction is not available. I usually leave this setting at Auto, unless there is a particular need for the Mechanical or Electronic setting.

EXPOSURE COMPENSATION SETTING

This next option has two possible settings, as shown in Figure 7-43: Ambient & Flash, or Ambient Only.

Figure 7-43. Exposure Compensation Setting Menu Options Screen

With Ambient & Flash, the default setting, when you adjust exposure compensation, the camera will adjust not only its exposure settings, but also the intensity of the flash. If you choose Ambient Only, then adjusting exposure compensation will control only the exposure settings, and not the flash.

To give the RX10 III maximum flexibility in adjusting exposure compensation, leave the setting at Ambient & Flash. However, results can be different using the Ambient Only setting, so you may want to experiment with both options to see which one you prefer in a given situation. Remember, also, that the camera has a separate adjustment for Flash Compensation on the shooting menu, and you can set that value separately if you need to adjust the output of the flash. I recommend

using the Ambient & Flash setting unless you have a particular reason for using the Ambient Only option.

RESET EV COMPENSATION

This option controls how the camera handles exposure compensation values that are set using the Shooting menu or a control button, as opposed to the exposure compensation dial. The two choices for this menu option are Reset or Maintain. If you choose Reset, then, when you have set exposure compensation using the menu or a control button, that value will be reset to zero when the camera is turned off and then back on. If you choose Maintain, then the exposure compensation value you set will be retained in memory and will remain in effect after the camera is turned off and back on.

There is one complication to be aware of, though. This menu option takes effect only if the exposure compensation dial remains set at its zero point. If that dial is set to any other value, then the value on the dial controls the exposure compensation, and this option will have no effect.

I have not found a use for this option myself; if I want to adjust exposure compensation, I use the exposure compensation dial. It might be useful to assign exposure compensation to one of the control buttons, and then set this option to Reset. With that setup, any exposure compensation set with the control button will be reset to zero after the camera is powered off, so you do not have to worry about resetting the value yourself. In that way, you can make a temporary adjustment to exposure compensation and not worry about remembering to reset it to zero later.

Screen 5 of the Custom menu is shown in Figure 7-44.

Figure 7-44. Screen 5 of Custom Menu

FACE REGISTRATION

This first option on screen 5 of the Custom menu lets you register human faces so the RX10 III can give those faces priority when it uses face detection. You can register up to eight faces and assign each one a priority from one to eight, with one being the highest. Then, when you set the Shooting menu option for Smile/Face Detection to On (Registered Faces), the camera will try to detect the registered faces first in the order you have assigned them. This feature could be useful if, for example, you take pictures at school functions and you want to make sure the camera focuses on your own children rather than on other kids.

To use this setting, select this menu option, and on the next screen, shown in Figure 7-45, select New Registration. Press the Center button, and the camera will place a square on the screen. Compose a shot with the face to be registered in that frame, as shown in Figure 7-46, and press the shutter button to take a picture of the face. If the process succeeds, the camera will display the face with the message "Register face?" Highlight the Enter bar on that screen and press the Center button to complete the registration process.

Figure 7-45. Screen to Select New Registration for Face

Later, you can use the Order Exchanging option to change the priorities of the registered faces, and you can delete registered faces using other menu options.

Figure 7-46. Screen for Registering a Face

WRITE DATE

This setting can be used to embed the current date in orange type in the lower-right corner of your still images as you record them, as shown in Figure 7-47.

Figure 7-47. Write Date Option in Use

This embedding is permanent, which means the information will appear as part of your image and cannot be deleted, other than through cropping or other editing procedures. You should not use this function unless you are certain that you want the date recorded on your images, perhaps for pictures that are part of a scientific research project.

You can always add the date in other ways after the fact in editing software if you want to, because the camera records the date and time internally with each image (if the date and time have been set accurately), so think twice before using this function. This option is not available when Quality is set to Raw or Raw & JPEG, with panoramas, bracketing, continuous shooting, or in Movie or HFR mode.

VIDEO LIGHT MODE

This menu option is of use only when the camera has a compatible video light attached to the Multi Interface Shoe. An example is the Sony HVL-LBPC, which is discussed in Appendix A. This menu item offers four choices, as shown in Figure 7-48: Power Link, REC Link, REC Link & STBY, and Auto.

With Power Link, the light turns on or off when the camera is powered on or off. With REC Link, the light turns on or off when the camera starts or stops video recording. With REC Link & STBY, the light turns on when the camera starts and dims when the camera stops recording. With this setting, the light does not dim all that much, so I did not find it as useful as other settings. Finally, with Auto, the light turns on when the environment becomes dark. However, it does not turn off if the camera is then brought into a brighter area; once it turns on it stays on until some other control turns it off.

These options worked as described when I tested them with the Sony HVL-LBPC light. If you are recording events that develop quickly, it could be quite useful to have the light turn on as soon as you power on the camera or press the red Movie button to start recording, depending on your preference.

Figure 7-48. Video Light Mode Menu Options Screen

FUNCTION MENU SETTINGS

As I discussed in Chapter 5, when you press the Function button in shooting mode, the camera displays up to 12 options in blocks at the bottom of the display.

Move through those options with the direction buttons. Adjust the main settings with the Control wheel and secondary settings with the Control dial. Use the Function Menu Settings menu item to assign options to the 12 blocks of the Function menu. When you select this menu option, the camera displays the screen shown in Figure 7-49, showing the assignments for the upper 6 blocks of the Function menu.

When you press the Center button on any one of those lines, you will see a screen like that in Figure 7-50, listing the options that can be assigned to that block.

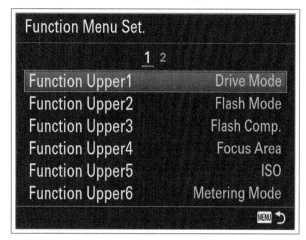

Figure 7-49. Function Menu Settings Menu Options Screen

Figure 7-50. Screen for Selecting Option for Function Menu Slot

For each block, the options that can be assigned are:

- Drive Mode
- Self-timer During Bracket
- Flash Mode
- Flash Compensation
- Focus Area
- Exposure compensation

- ISO
- ISO Auto Minimum Shutter Speed
- Metering Mode
- White Balance
- DRO/Auto HDR
- Creative Style
- Shoot Mode
- Picture Effect
- Picture Profile
- Frame Rate (HFR)
- Center Lock-on AF
- Smile/Face Detection
- Auto Dual Recording
- Soft Skin Effect
- Auto Object Framing
- Image Size
- Aspect Ratio
- Quality
- SteadyShot (Still Images)
- SteadyShot (Movies)
- Audio Recording Level
- Zebra
- Grid Line
- Marker Display
- Audio Level Display
- Peaking Level
- Peaking Color
- Gamma Display Assist
- Not Set

Press the Center button when the option you want to assign to a given block is displayed, and the camera will place an orange dot on that line to indicate that that feature is assigned to that block.

I recommend you assign a function to each of the 12 blocks and experiment to find the best setup. Remember that you can use the Control wheel and the Custom 1, Custom 2, Custom 3, AEL, Focus Hold, Center, Left, Right, and Down buttons for your most important settings, such as, perhaps, ISO, AEL Toggle, Drive Mode, White Balance, and Focus Area, so you can reserve these 12 blocks for other options.

CUSTOM KEY (SHOOTING)

I described this menu option in Chapter 5, in discussing controls that can have settings assigned to them for instant recall in shooting mode. Now I will discuss the details of the settings that can be assigned.

When you select the Custom Key (Shooting) menu option, you will see the screen shown in Figure 7-51. That screen shows the first six controls that can be assigned; the other four controls are listed on the second screen of this menu option.

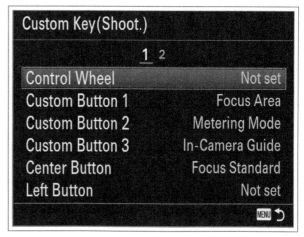

Figure 7-51. Custom Key (Shooting) Menu Options Screen

Navigate to the line for a control and press the Center Button. You will see a screen listing all the options that can be assigned to that control. In most cases, these assignments are self-explanatory. When you assign an option, such as ISO, to a button, pressing the button calls up the menu screen for ISO, which lets you set the ISO just as if you had selected ISO from the Shooting menu. However, there are differences for some controls, and there are some items that can be assigned through

this option that are not available through any menu. I will discuss these details below, as I provide information about each of the items for this menu option.

Control Wheel

The first control on the Custom Key (Shooting) menu screen is the Control wheel. This control is a special case, because, of course, it is not a button but a wheel. The options that can be assigned to the wheel are ISO, White Balance, Creative Style, Picture Effect, or Not Set, as shown in Figure 7-52.

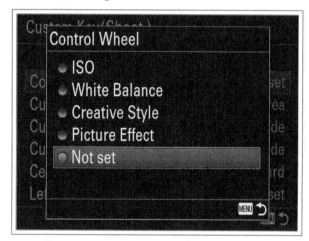

Figure 7-52. Options Screen for Control Wheel

This feature is powerful because, when you assign a setting such as ISO to this wheel, you can use the wheel to instantly adjust the setting. For example, if you choose ISO, then, when the camera is in shooting mode, all you have to do is turn the Control wheel and the ISO setting will change. You can then immediately press the shutter button to take a picture with the new setting.

However, you cannot get access to all aspects of these settings by turning the wheel. For example, if you assign ISO to the wheel, you can select a numerical ISO value or Auto ISO, but you cannot set the Minimum and Maximum settings for Auto ISO, and you cannot assign a numerical ISO value or Auto for the Multi Frame Noise Reduction setting.

Similarly, if you assign white balance to the Control wheel, you can select a white balance setting, including Custom or Color Temperature, but you cannot set a new custom white balance or choose a new Color Temperature setting, and you cannot fine-tune the white balance setting using the color axes. For those options, you need to use the white balance menu option. Likewise, with Creative Style assigned to the

wheel, you cannot adjust the contrast, sharpness, and saturation parameters of a selected setting.

However, if you choose Picture Effect, you can select any of the settings or sub-settings, because the Control wheel will cycle through all of the options, including, for example, the sub-settings for Toy Color, including Normal, Cool, Warm, Green, and Magenta.

Figure 7-53. Icon Showing Control Wheel Controls ISO

When the Control wheel has been assigned to a function through this menu item, the camera places a gray icon representing the wheel in the bottom right of the screen next to an icon or label indicating what setting is currently assigned to the wheel. For example, Figure 7-53 shows the screen as it appears when ISO has been assigned to the Control wheel.

Assigning one of these few shooting-related functions to the Control wheel does not interfere with any other operations of the wheel, because turning the wheel ordinarily does not have any effect unless a menu screen or a special screen like the MF Assist enlarged screen is displayed.

Custom Button 1

If you select Custom Button 1 from the Custom Key (Shooting) menu screen, the camera will display a screen like that shown in Figure 7-54, which lists the first six options that can be assigned to the Custom 1 button.

Figure 7-54. First Screen of Options for Custom Button 1

The complete list, which is much longer than that single screen, includes all of the following choices, any one of which can be assigned to this button:

- Focus Standard

- Drive Mode

- Self-timer During Bracket

- Flash Mode

- Flash Compensation

- Focus Area

- Exposure Compensation

- ISO

- ISO Auto Minimum Shutter Speed

- Metering Mode

- White Balance

- DRO/Auto HDR

- Creative Style

- Picture Effect

- Picture Profile

- Frame Rate (HFR)

- Smile/Face Detection

- Auto Dual Recording

- Soft Skin Effect

- Auto Object Framing

- SteadyShot (Still Images)

- SteadyShot (Movies)

- Audio Recording Level

- Image Size

- Aspect Ratio

- Quality

- In-Camera Guide

- Memory

- AEL Hold

- AEL Toggle

- Spot AEL Hold

- Spot AEL Toggle

- AF/MF Control Hold

- AF/MF Control Toggle

- Center Lock-on AF

- Eye AF

- Focus Hold

- Bright Monitoring

- Smart Teleconverter

- Zoom Assist

- Focus Magnifier

- Deactivate Monitor

- MOVIE

- Zebra

- Grid Line

- Marker Display Select

- Audio Level Display

- Peaking Level

- Peaking Color

- Finder/Monitor Select
- Send to Smartphone
- Download Application
- Application List
- Monitor Brightness
- Gamma Display Assist
- TC/UB Display Switch
- Not Set

Scroll through this list and press the Center button to make your selection. The dot next to the chosen option will turn orange to mark the choice.

Many of these options are self-explanatory because, when the button has the option assigned, pressing the button simply calls up the menu screen for that option, if the option is available in the current shooting mode. For example, if the Custom 1 button is assigned to Drive Mode, then, when you press the button, the camera displays the Drive Mode menu, just as if you had used the Menu button to get access to that option. I will not discuss those options here; see Chapter 4 for discussion of the Shooting menu, Chapter 7 for discussion of the Custom and Setup menus, and Chapter 9 for discussion of the Wi-Fi and Application menus.

In a few cases, the assigned button switches between menu options without first calling up a menu screen. For example, this is the case with the Marker Display Select, Finder/Monitor Select, and TC/UB Display Switch options.

There are some other selections for the Custom 1 button (and the other buttons) that do not call up a menu screen or switch between menu items. Instead, they perform a function that does not come from any menu option. I will discuss those selections below.

Focus Standard

The Focus Standard option can be assigned to any one of several buttons. That button can then be used to perform several focus-related functions in various situations when autofocus is in use. When Focus Area is set to Flexible Spot, Expand Flexible Spot, or Lock-on AF with either of the Flexible Spot options, pressing the button assigned to Focus Standard instantly makes the focus

frame active, ready to be moved by pressing the direction buttons. With Flexible Spot, you also can adjust the size of the frame by turning the Control wheel. With Expand Flexible Spot, you can move the frame with the direction buttons or with the Control wheel.

When Center Lock-on AF is in effect, pressing the button assigned to Focus Standard initiates the use of Center Lock-on AF. You then have to press the Center button to lock onto the subject. The Center button is used to lock onto the target even if some other button has been assigned to the Focus Standard option. To cancel the tracking, you have to press the button assigned to Focus Standard.

I find it somewhat confusing to use any button other than the Center button for Focus Standard, because you have to use the Center button to start tracking with Center Lock-on AF, no matter what button is assigned to Focus Standard. However, you may want to try various options to see what works best for you.

In-Camera Guide

If you assign In-Camera Guide to the Custom 1 button (or any other control button), the camera provides a convenient help system for explaining menu options. Once this assignment is made, whenever the camera is displaying a menu screen, including a Function menu or Quick Navi screen, you can press the assigned button to bring up a brief message with guidance or tips about the use of the option that is currently highlighted. For example, if you go to screen 3 of the Custom menu and highlight the Live View Display item, then press the button assigned to In-Camera Guide, the camera displays the message shown in Figure 7-55.

Figure 7-55. In-Camera Guide Screen for Live View Display

If you select a sub-option for a menu item and then press the In-Camera Guide button, the camera will display a different message providing details about that sub-option. For example, Figure 7-56 shows the screen that was displayed when I pressed the assigned button after highlighting the Speed Priority Continuous Shooting option for the Drive Mode item.

Figure 7-56. In-Camera Guide Screen for Speed Priority Continuous Shooting

This help system is quite detailed; for example, it has guidance for different ISO settings such as ISO 100, 160, and 6400, with tips about what shooting conditions might call for a given setting. The system operates with all of the menu systems, including Custom, Playback, Setup, and the others, not just the Shooting menu.

AEL Hold

If you set the Custom 1 button to the AEL (autoexposure lock) Hold option, then, when the camera is in shooting mode, pressing this button will lock exposure at the current setting as metered by the camera, as long as you hold down the button. If the camera is set to Manual exposure mode with ISO set to ISO Auto, pressing the button to activate AEL Hold will lock the ISO setting.

If ISO is set to a specific value in Manual exposure mode, pressing the button assigned to AEL Hold will lock the M.M. (Metered Manual) setting while you hold the button down. The exposure will already be "locked" because you have set it manually, so using the AEL Hold function will just keep the M.M. setting from changing further. (The M.M. setting does not function when ISO is set to Auto.)

When exposure is locked in this way, a large asterisk will appear in the lower right corner of the display and remain there until the AEL button is released.

Here is an example to illustrate the use of the AEL Hold function. You might want to use AEL Hold to make sure your exposure is calibrated for an object that is part of a larger scene, such as a dark painting on a light wall. You could lock exposure while holding the camera close to the painting, then move back to take a picture of the wall with the locked exposure ensuring the painting will be properly exposed.

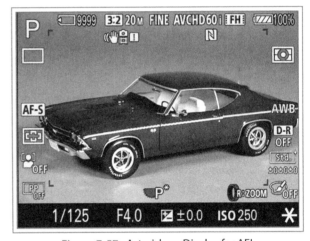

Figure 7-57. Asterisk on Display for AEL

To do this, assuming the camera is in Program mode, hold the camera close to the painting until the metered aperture and shutter speed appear on the screen. Press and hold the AEL button and an asterisk (*) will appear on the screen, as shown in Figure 7-57, indicating that exposure lock is in effect.

Now you can move back (or anywhere else) and take your photograph using the exposure setting that you locked in. Once you have finished using the locked exposure setting, release the AEL button to make the asterisk disappear. The camera is now ready to measure a new exposure reading.

AEL Toggle

If you set the C1 button to the AEL Toggle option, then, in shooting mode, pressing the button will lock exposure just as with AEL Hold. The difference with this setting is that you just press and release the AEL button; the exposure will remain locked until you press the button again to cancel the exposure lock.

Spot AEL Hold

The next option for the C1 button is listed on the menu as AEL Hold with a spot icon before the name. The icon means that, with this setting, when you press the button and hold it, the camera will lock exposure as metered by the spot-metering area in the center of the display, no matter what metering method is currently in effect. This option can be quite useful if you think you will want to switch to spot-metering just for one or two shots. You can press the C1 button to make sure the center of the display covers the area that you want to use for evaluating the exposure, and then take the shot with the exposure adjusted for that spot.

Spot AEL Toggle

The Spot AEL Toggle option is similar to the AEL Toggle option, except that the camera meters only in the spot area in the very center of the display.

AF/MF Control Hold

If you select AF/MF Control Hold for the C1 button's function, pressing the button switches the camera between autofocus and manual focus, but only while you hold down the button. If the camera is set to any autofocus mode, pressing and holding the button will switch the camera into manual focus mode. Releasing it will switch to the autofocus mode that was originally set.

If the camera is set to manual focus mode, pressing and holding the button will switch to single-shot AF mode. In this situation, when you press the button, the camera will also evaluate the focus and lock focus, if possible. With this option, the assigned button can be used for "back button focus," letting you focus the camera without having to half-press the shutter button. Releasing the button will switch back to manual focus mode. If the camera is set to DMF mode, the button will toggle between DMF and manual focus.

This function is useful in situations when it is difficult to use autofocus, such as dark areas, extreme close-ups, or areas where you have to shoot through obstructions such as glass or wire cages. You can switch very quickly into manual focus mode and back again, as conditions warrant.

Also, this capability is helpful if you want to set "zone" focusing, so you can shoot quickly without having to wait for the autofocus mechanism to operate. For example, if you are doing street photography, you can set the camera to single-shot autofocus mode and focus on a subject at about the distance you expect to be shooting from—say, 25 feet (7.6 meters). Then, once focus is locked on that subject, press and hold the button to switch the camera to manual focus mode, and the focus will be locked at that distance in manual focus mode. You can then take shots of subjects at that distance without having to refocus. If you need to set another focus distance, just release the button to go back to autofocus mode and repeat the process.

Finally, it is convenient to be able to quickly get the camera to use autofocus when it is set to manual focus mode. With this function, as noted above, when you press and release the button, the camera will quickly focus using autofocus, and then go back to manual focus mode for any further adjustments you may want to make.

AF/MF Control Toggle

If you select AF/MF Control Toggle for the setting of the C1 button's function, pressing the button switches the camera between autofocus and manual focus. This option works the same as AF/MF Control Hold, except that you do not hold down the control button; you just press it and release it. The switched focus mode then stays in effect until you press the button again. However, when the camera is set to manual focus mode, pressing the assigned button does not cause the camera to evaluate focus. To get that capability, you have to use AF/MF Control Hold, discussed above.

Eye AF

If you assign Eye AF to the C1 button, then, if the camera is set to an autofocus mode, when you press this button the camera will look for human eyes and focus on them if possible. If the camera detects an eye, it will display a small green frame to show that it has focused on the eye, as shown in Figure 7-58. Continue to hold down the assigned button to lock focus on the eye while you press the shutter button to take the picture. The camera does not have to have face detection activated for this option to work, and it functions with both single-shot and continuous autofocus, as well as with direct manual focus (DMF). If there are multiple faces in the scene, move the focus frame over the face you want to focus on before pressing the button assigned to Eye AF; the camera will then use that face for the Eye AF focus.

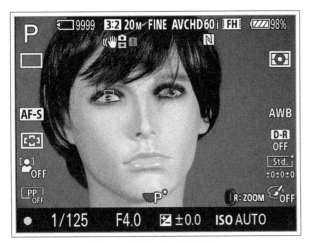

Figure 7-58. Eye AF in Use

Eye AF can be especially useful when depth of field is shallow, such as when the lens is zoomed in to a long focal length or you are shooting a closeup, to make sure the focus is sharpest on the subject's eyes rather than on the nose or some other feature. A portrait generally looks best when the eyes are in sharp focus.

This option also is useful to give you an instant way to focus on a face when you were not expecting to take a portrait. You can just press and hold the assigned button to focus on the nearest eye, which should result in a well-focused portrait. Eye AF is not available when recording movies.

Focus Hold

This next option is assigned by default to the Focus Hold button on the side of the lens, but you can assign it to any one of several buttons. Once you have used the camera's autofocus system to achieve sharp focus, press the button assigned to Focus Hold and hold the button down. As long as the button is held down, the camera will not adjust focus again. So, if you need to adjust the angle of your shot or re-frame the composition, you can then press the shutter button to take the picture without disturbing the original focus setting.

This is not a function you may need often, but it can be useful if you have focused the camera on a particular subject and are waiting for that subject to appear in the frame again. If you hold the focus with the assigned button, that subject will be in focus when it appears again. If you didn't hold focus, the camera might refocus on some other subject when you pressed the shutter button to take the picture. In addition, you can use this feature for a pull-focus effect when recording movies, as discussed in Chapter 5.

Bright Monitoring

This option is intended for a specific situation: when you are using manual focus in dark conditions that make it difficult to evaluate the focus on the LCD screen or in the viewfinder. In that situation, when you press the button assigned to the Bright Monitoring option, the camera changes the display to increase its brightness and sets the Live View Display option to Setting Effect Off, if it was not already set that way. With Setting Effect Off, the display does not darken or brighten to show the effects of exposure settings; instead, it maintains a normal brightness if possible.

If you have the focus mode set to any option other than manual focus, this key assignment will have no effect. It works only with manual focus, and it does not work if either MF Assist or Focus Magnifier is turned on. When you have finished using this feature, press the assigned button again to turn it off.

This setting is designed for use when you can't see well enough to compose your shot on the LCD screen or in the viewfinder, such as when you are trying to make a long exposure outdoors at night or you need to take a portrait in very dim light.

Smart Teleconverter

The next non-menu choice for assignment to a control button is Smart Teleconverter. With this option, when you press the assigned button and release it, the camera enlarges the current image by a factor of 1.4 times and crops the enlarged image to fill the frame. If you press the button again, the magnification increases to 2.0 times. The camera does not do any enhancement of the image; it just crops away some of the pixels in the image, which results in a loss of some resolution.

Some users like this feature because it gives them a quick way to get an enlarged view of the scene—just press a button and you immediately get a 1.4x magnification. Press again for a 2.0x view, and a third time to return to normal size. With the 20-megapixel sensor of the RX10 III, you can afford to lose some resolution if you capture an image with this feature in use. Some people like to be able to compose a shot while looking at a magnified view, and then go back to the normal view to capture it. They may want to have the camera's metering system evaluate the exposure for the enlarged area before capturing the final image. In any event, if you find this feature useful, it is available here and easy to use. It is

not available when Quality is set to Raw. Also note that this feature conflicts with some other features, such as Digital Zoom.

Zoom Assist

I discussed this option in Chapter 4 in connection with the Range of Zoom Assist option on screen 6 of the Shooting menu. As a reminder, when you assign Zoom Assist to a control button, you can press that button when the lens is zoomed in for a telephoto shot. The camera then zooms the lens back out to a wide-angle view, so you can re-orient yourself and locate the subject you want to zoom in on. For example, if you are trying to photograph a bird and have lost track of it in the zoomed-in view, press the Zoom Assist button to pull back to a wide view, locate the bird, then release the button to zoom back in on the bird.

Deactivate Monitor

This is the next non-menu option for the C1 button (or any other assignable button). (Remember that I'm skipping over settings that are just duplicates of menu options, such as Focus Magnifier.)

If you assign a button to the Deactivate Monitor option, pressing the button while the camera is in shooting mode will turn off the LCD display, leaving only a single line of information at the bottom of the screen. You might want to use this option if you are in a darkened area and don't want to distract others or attract attention with the brightness of the monitor. This feature can also help you save power if your battery is running down. By pressing the assigned button, you can quickly turn off the monitor temporarily, and recall it just as quickly with the same button. The viewfinder will still operate if it is activated by having your head approach the eye sensor.

If you want to deactivate the monitor on a longer-term basis, you can use the Finder/Monitor option on screen 4 of the Custom menu. If you select Viewfinder (Manual) for that option, then the monitor will be turned off at all times, and will not display even the single line of information that appears when the Deactivate Monitor option is used.

MOVIE

The MOVIE setting does not call up a menu option, and it is not equivalent to the similarly-named Movie option on Screen 8 of the Shooting menu. Instead, when you assign a button to this setting, the button takes on the same role as the camera's red Movie button. This option gives you another way to start and stop the recording of a video. If you set the Movie Button option on screen 6 of the Custom menu to Movie Mode Only, this button will start recording a video only if the Mode dial is set to Movie mode. (The button will act somewhat differently in HFR mode.)

Download Application

When you select Download Application for the Custom Key (Shooting) option for a control button, the camera will display a screen showing the applications that have been downloaded to the camera from Sony's website for camera apps, as discussed in Chapter 9. Scroll through these applications and press the Center button to select the application you want. Then, when you press the assigned button in Shooting mode, the camera will launch the application you selected when you assigned the button to this function.

Not Set

The last option that can be assigned to a control button is called Not Set. If you choose this option, then the button will not be assigned any special function. I cannot think of any reason to use this option, unless you will be using a limited number of settings and don't want to risk activating a different setting by pressing the button accidentally.

Custom Button 2

The next item on the main screen of the Custom Key (Shooting) menu option is Custom button 2. This button can be assigned to any of the same items discussed above for Custom button 1.

Custom Button 3

This button also can be assigned to any of the same functions as the Custom 1 and Custom 2 buttons.

Center Button

You can assign the Center button to any of the same options as for Custom buttons 1, 2, and 3. One of those options is Focus Standard, which I discussed earlier in this section. That option activates the tracking frame for Center Lock-on AF, assuming you have turned on that menu option on screen 6 of the Shooting menu. Second, if Focus Area is set to one of the movable options, such as Flexible Spot, on screen 4 of the Shooting menu, pressing the assigned button activates

the screen for adjusting the location of the spot-focusing bracket.

I find it convenient to assign the Center button to the Focus Standard option, because you have to press the Center button anyway to start tracking a subject using the Center Lock-on AF feature. If you assign a different button to Focus Standard, then you have to use both that button and the Center button to use the feature. Of course, if you don't plan to use Center Lock-on AF, you may want to use the Center button for some other option.

If you assign the Center button to one of the AEL functions (locking exposure by holding or toggling the button), then, if you are using manual focus, you will still be able to use the Center button for changing the magnification on the MF Assist screen without affecting the exposure lock function. To activate or cancel the exposure lock, press the Center button when the shooting screen is in its normal mode (that is, when the MF Assist magnification screen is not displayed).

Left Button

For the Left button, the choices of assignment are the same as for the Custom 1, 2, and 3 buttons, except that several of the choices are not available: Focus Standard, In-Camera Guide, AEL Hold, Spot AEL Hold, AF/MF Control Hold, Eye AF, Focus Hold, and Zoom Assist. So, if you want to set the Left button to lock exposure or to switch between autofocus and manual focus, the button will act only as a toggle, not as one that you have to hold down. Presumably, Sony made this choice because it would be awkward to hold down the Left button while pressing the shutter button. (Eye AF also requires that you hold down the button while pressing the shutter button.)

Right Button

The choices of assignment for the Right button are the same as those for the Left button.

Down Button

The assignment choices for the Down button are the same as those for the Left and Right buttons.

AEL Button

The AEL button can have any function assigned to it from the complete list available for the Custom 1, 2 and 3 buttons. Not surprisingly, by default this button is

assigned to the AEL Hold function, but you can change the assignment to any other on the list.

Focus Hold Button

Finally, the Focus Hold button is assigned by default to the Focus Hold option, but you can assign it to any of the functions listed above for the Custom buttons.

CUSTOM KEY (PLAYBACK)

This next menu option lets you assign four of the camera's control buttons to handle a single function when the camera is in playback mode. The main screen for this option is shown in Figure 7-59.

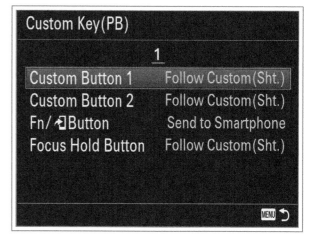

Figure 7-59. Custom Key (Playback) Menu Options Screen

As shown in this illustration, the buttons that can be assigned a function for playback mode are Custom buttons 1 and 2, the Function button, and the Focus Hold button.

The options that can be assigned to these buttons are the following:

- Finder/Monitor Select
- Send to Smartphone
- Download Application
- Application List
- Delete
- Image Index
- Rotate
- Enlarge Image

- Photo Capture
- TC/UB Display Switch
- Follow Custom (Shooting)

Any one of these options can be assigned to any of the buttons listed above, except that the Function button cannot be assigned to the Follow Custom (Shooting) option. With that option, pressing the button in playback mode activates the same option that is assigned to it in shooting mode. The Function button cannot have any option assigned to it in shooting mode; it is permanently assigned to call up the Function menu in shooting mode.

Screen 6 of the Custom menu is shown in Figure 7-60.

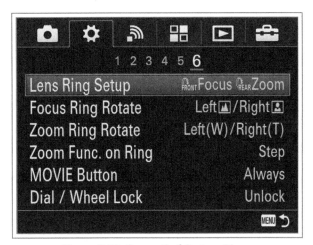

Figure 7-60. Screen 6 of Custom Menu

LENS RING SETUP

This first option on screen 6 of the Custom menu lets you choose which of the camera's two lens rings controls focus, and which controls zoom. This option has two selections, as shown in Figure 7-61.

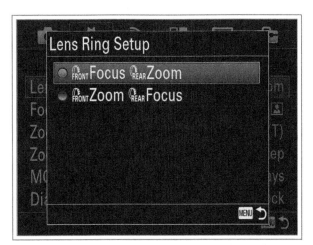

Figure 7-61. Lens Ring Setup Menu Options Screen

With the first option, which is the default setting, the front lens ring controls manual focus, and the rear lens ring controls zoom. If you select the second option, the roles of the two rings are reversed. Your choice for this menu item depends on your personal preference. I generally use the first option. Remember that you can always use the zoom lever to zoom the lens, no matter what setting you use for this menu option.

FOCUS RING ROTATE

This option lets you choose which direction to rotate the lens ring that is assigned to focus. You can set this option according to what feels most natural to you.

ZOOM RING ROTATE

This option lets you choose the direction for rotating the ring assigned to the zoom function.

ZOOM FUNCTION ON RING

This next item on the Custom menu controls the way the lens ring assigned to zoom operates. The three choices are Standard, Quick, and Step, as shown in Figure 7-62.

With Standard, the ring zooms the lens continuously, just as the zoom lever does. That is, as you turn the ring, the lens zooms through all focal lengths that are available. With optical zoom, that means it will zoom from the 24mm wide-angle setting to the 600mm telephoto setting in continuous increments. With Clear Image Zoom and Digital Zoom, the zoom levels increase beyond the 600mm point.

Figure 7-62. Zoom Function on Ring Menu Options Screen

If you choose Quick, the ring still zooms continuously, but at a faster rate. You might choose this option if you

often need to zoom the lens all the way in or all the way out and are not so concerned with setting intermediate focal lengths or making precise adjustments. (There is a similar setting called Fast for the zoom lever, reached through the Zoom Speed option on screen 3 of the Custom menu.)

If you set this option to Step, then the ring zooms the lens only to certain preset values. Those values are 24mm, 28mm, 35mm, 50mm, 70mm, 85mm, 100mm, 135mm, 200mm, 300mm, 400mm, 500mm, and 600mm. When you nudge the ring toward the wide-angle or telephoto side, the zoom will move to the next preset focal length. You should give the ring a quick nudge and then release it; if you keep turning it, it will move past the next value and go on to the one after that.

There are some limitations to note about the step zoom function on the RX10 III. First, the step zoom feature works only for the lens ring assigned to zoom; the zoom lever will always zoom the lens continuously.

Second, the step zoom feature does not work when shooting movies.

Finally, if you turn on Clear Image Zoom or Digital Zoom using the Zoom Setting option on screen 3 of the Custom menu, the step zoom feature will not include specific increments for the zoom range beyond the optical limit of 600mm. Instead, as shown in Figure 7-63, the camera will display an area at the right side of the scale that extends from the 600mm mark to a magnifying glass icon at the far right, showing a general area of extended zoom range.

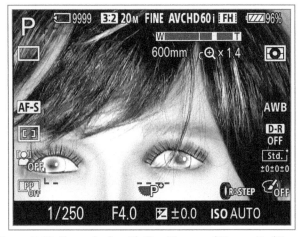

Figure 7-63. Zoom Scale with Step Zoom and Non-optical Zoom

Having the ability to turn on step zoom is a valuable feature in some situations. For example, if you want to set a specific focal length for a shot, using the step zoom feature is an excellent way to make sure you have the lens zoomed to the exact focal length you want. Of course, this feature is of use only if your desired focal length is one of the intermediate values such as 135mm or 200mm. It is easy to set the focal length to 24mm or 600mm using the normal zoom method, because those focal lengths are at the two extremes of the camera's optical zoom range.

You might want to choose a focal length of 35mm, for example, to compare shots from the RX10 III against shots from another camera using that specific focal length for the comparisons. I do not often use the step zoom feature, but it is good to have it available.

MOVIE BUTTON

This option, shown in Figure 7-64, lets you lock out the operation of the Movie button to avoid accidentally starting a video recording. The two choices are Always and Movie Mode Only. If you want to be able to start recording a video at any time without delay, you should leave the Movie Button option set to Always. With this setting, you can start recording a movie by pressing this button, no matter what shooting mode is set on the Mode dial (except HFR, which uses a special procedure and records only high frame rate movies).

Figure 7-64. Movie Button Menu Options Screen

This is a convenient setting, because you can start shooting a video at a moment's notice without having to turn the Mode dial to the Movie position.

As I discussed in Chapter 5 in the section on the Movie button, the main reason to choose the Movie Mode

Only option is if you are afraid you may press the Movie button by mistake.

With the RX10 III, I have never pressed the Movie button by mistake, because the camera is large enough that the button does not come within range of my thumb unless I intend to press it. So, with this camera I leave the menu option set to Always, to avoid missing any video opportunities. But you should consider whether you want to use this option to protect against unwanted footage. Of course, if you have no interest in video recording, you can set this option to Movie Mode Only to avoid unwanted uses of the button.

As discussed earlier, if you assign a control button to have the MOVIE function, which gives that button the same function as the red Movie button, this menu option affects the operation of that button also.

Dial/Wheel Lock

This final option on the Custom menu has two possible settings, Lock and Unlock, as seen in Figure 7-65. If you select Lock, you can lock the functioning of the Control wheel and Control dial. To engage the actual lock, after this menu item is set to Lock, press and hold the Function button for several seconds when the shooting screen is displayed, until a Locked message appears on the screen.

Figure 7-65. Dial/Wheel Lock Menu Options Screen

After that, you will see an icon in the lower right corner of the display indicating that the lock is in effect, as shown in Figure 7-66. Once the lock is in effect, turning the Control wheel or Control dial will not have any effect on the camera's settings.

For example, if the Control wheel has been set to adjust ISO using the Custom Key (Shooting) menu option, turning the dial will not adjust ISO while the lock is in effect. Similarly, when the camera is in Shutter Priority or Manual exposure mode, turning the Control dial will not change the shutter speed, as it normally would.

However, the dial and wheel will still carry out their functions of navigating through menu screens, even with the lock in effect. This option gives you a way to prevent these dials from accidentally moving and changing your settings. If you have made an important adjustment to your settings, you can lock both of these dials so the settings will stay in place. When you are ready to change settings, you can just press and hold the Function button again to remove the lock.

Figure 7-66. Icon Showing Dial/Wheel Lock in Effect

I have not had occasion to use this feature myself, but I can see its value for situations in which you need to keep a setting locked in and want to guard against accidental slipping of the wheel or dial.

Even when the Lock option is turned on, the Function button can be used to call up the Function menu. A quick press of the button will call up that menu, and a longer press-and-hold will lock or unlock the wheel and dial.

Setup Menu

The next menu to be discussed, whose tab is found to the right of the tab for the Playback menu, is the Setup menu. Its first screen is shown in Figure 7-67.

Figure 7-67. Screen 1 of Setup Menu

This six-screen menu contains options that control technical matters such as computer connections, display brightness, audio volume, file numbering, formatting a memory card, and others. I will discuss each menu item below.

MONITOR BRIGHTNESS

When you select this menu option, the camera displays a screen that shows the current setting, as seen in Figure 7-68.

If you press the Center button on that screen, you will see a screen for choosing one of two available settings for controlling the brightness of the LCD display: Manual or Sunny Weather, as shown in Figure 7-69.

Figure 7-68. Monitor Brightness Menu Options Screen

If you choose Manual, the camera displays the screen in Figure 7-70. Using the controls on that screen, you can adjust brightness to one or two units above or below normal.

Figure 7-69. Brightness Setup Options for Monitor

After pressing the Down button or turning the Control wheel to highlight the brightness scale, press the Left or Right button or turn the Control dial to make the adjustment.

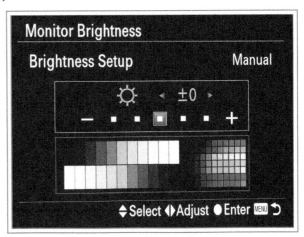

Figure 7-70. Manual Brightness Adjustment Screen for Monitor

If your battery is running low and you don't have a spare, you may want to set the monitor to its minimum brightness to conserve power. Conversely, you can increase brightness if you're finding it difficult to compose the image on the screen.

If you are shooting outdoors in bright conditions, you can choose Sunny Weather, which sets the display to a very bright level. Of course, you can switch to using the viewfinder in bright conditions, but there may be times when you want to hold the camera away from your head as you compose the shot, even in bright sunlight. Or, you may want to play back your images for friends

while outdoors. The Sunny Weather setting drains the camera's battery fairly rapidly, so you should turn it off when it is no longer needed.

The monitor's brightness will be fixed at the zero level when the camera is recording video with File Format set to XAVC S 4K, or with File Format set to XAVC S HD and Record Setting set to either 120p option (100p for PAL systems). Brightness is fixed at the -2 level when Wi-Fi operations are active, to conserve battery power.

VIEWFINDER BRIGHTNESS

This second option on the Setup menu is similar to the Monitor Brightness selection, discussed above, but it has some differences. With this option, you have to be looking into the viewfinder to make adjustments. There is no Sunny Weather setting, because the viewfinder is shaded from the sun and there is no need for a super-bright setting. You can set the brightness to Auto or Manual. If you select Manual, you can make the same adjustments as with the LCD screen. Again, there is not much need for brightness adjustments because the view is always shielded from outside light.

This option has the same restrictions as the previous one with respect to settings for File Format.

FINDER COLOR TEMPERATURE

This option lets you adjust the color temperature of the view through the viewfinder. As with the Viewfinder Brightness setting, you have to look into the viewfinder to make the adjustments. You can use the camera's controls to adjust the color temperature downward by one or two units, which will make the view appear slightly more reddish, or "warmer," or you can adjust upward by one or two units to make it more bluish, or "cooler."

I have not found a reason to take advantage of this adjustment, but, if it is helpful to you, it is easy to use.

GAMMA DISPLAY ASSIST

This option is a specialized one that is intended for use only if you are using a Picture Profile setting that includes the S-Log2 setting for gamma. As I discussed in Chapter 4, S-Log2 is a special setting that enables the camera to record video with an extended dynamic range, so it can record scenes clearly even if there is considerable contrast between shadowed areas and

bright ones. One characteristic of the S-Log2 setting is that the image on the camera's display screen will appear quite dark and low in contrast. In order to take advantage of the high dynamic range available with this setting, the footage needs to be processed with video software that can deal with S-Log2 properly.

Therefore, Sony has provided the Gamma Display Assist setting so you can clearly view a scene being recorded or played back with the S-Log2 gamma setting in effect. When this setting is activated, the images on the camera's display will be boosted in contrast to a level that makes it appear as if a more standard setting was used--specifically, the ITU709(800%) setting.

This menu option has three settings: Off, Auto, and S-Log2, as shown in Figure 7-71.

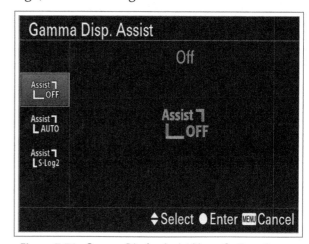

Figure 7-71. Gamma Display Assist Menu Options Screen

If you choose Off, the option is not activated in any case, and video shot with the S-Log2 gamma setting will appear rather dark and low in contrast, as it normally would. If you choose Auto, then the camera will boost the contrast of the display only if the Picture Profile setting in use includes the S-Log2 gamma setting. (The PP7 setting for Picture Profile includes that setting by default, but you can change any Picture Profile setting to include S-Log2, as discussed in Chapter 4.)

If you choose the third setting, called S-Log2, the camera always boosts the contrast of the image on the display, regardless of the Picture Profile setting.

My preference is to leave this option turned off. I do not have difficulty viewing the display when S-Log2 is in use. However, in a situation where you are having a problem viewing the scene on the display screen when using S-Log2, this setting might be useful.

VOLUME SETTINGS

This option lets you set the volume for video playback at a level anywhere from 0 to 15. You can also set this level when a movie is playing by pressing the Down button to get access to the detailed controls, which include a volume setting option. When a movie is displayed on the screen in playback mode before playback starts, pressing the Down button calls up the volume adjustment screen immediately. Pressing that button when a still image is displayed in playback mode also calls up the volume screen, if View Mode on screen 1 of the Playback menu is set to show both videos and still images.

AUDIO SIGNALS

This option lets you choose whether or not to activate the various sounds the RX10 III makes when some operations take place, such as pressing the shutter button or Movie button, using the self-timer, or confirming focus. By default, the sounds are turned on, but it can be helpful to silence them in a quiet area, during a religious ceremony, or when you are doing street photography and want to avoid alerting your subjects that a camera is being used. There is a separate entry for Shutter, so you can leave the shutter sound turned on while silencing sounds such as self-timer and focus beeps if you want.

Screen 2 of the Setup menu is shown in Figure 7-72.

Figure 7-72. Screen 2 of Setup Menu

UPLOAD SETTINGS

This option is the first item on the second screen of the Setup menu as shown in Figure 7-72, but it appears on the menu only when an Eye-Fi card is inserted in the camera. If no Eye-Fi card is present, this menu option

is not dimmed; it just does not display at all, leaving a blank space at the bottom of the menu screen.

As discussed in Chapter 1, an Eye-Fi card includes a transmitter to send images to a computer or other device over a Wi-Fi network. This menu item has only two settings—On and Off. You might want to use the Off setting if you are on an airplane where you may be required to turn off radio transmitters. Or, if you know you will not be using the Eye-Fi uploading capability for a while, you can turn this menu option off to save some battery power.

Of course, the RX10 III has its own built-in Wi-Fi capability, which makes it less likely you will use an Eye-Fi card for the transfer of images.

TILE MENU

If no Eye-Fi card is inserted in the camera, this menu option appears at the top of screen 2 of the Setup menu. If you turn this option on, the camera displays a screen with six tiles representing the various menu systems, as shown in Figure 7-73, when you press the Menu button.

This screen is helpful because it gives you a graphic representation of which menu is which, and lets you choose a menu and get quick access to it. You navigate through the six tiles using the direction buttons, the Control wheel, or the Control dial.

Figure 7-73. Tiled Menu Screen

I prefer to leave this option turned off, because, without it, pressing the Menu button takes me right into the last menu option I was using. From there, I can navigate quickly to any other menu system. But for those who are new to this camera or who like having a

large display to show the menu choices clearly, the Tile Menu option may be worth using.

Mode Dial Guide

This menu item gives you a way to turn on or off the Mode Dial Guide, a graphic display that appears on the camera's screen when you turn the Mode dial to select a shooting mode, as shown in Figure 7-74.

This guide can be helpful when you first get the camera, but it can be annoying if you don't need reminders, and you have to press a button to dismiss the screen. (You can press the Center button or Menu button or press the shutter button halfway; you also can press the Playback button, which puts the camera into playback mode.) I leave this option turned off to speed up my shooting.

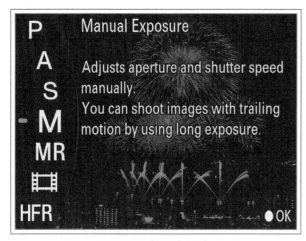
Figure 7-74. Mode Dial Guide in Use

Delete Confirmation

This menu item has two options as shown in Figure 7-75: "Delete" First or "Cancel" First.

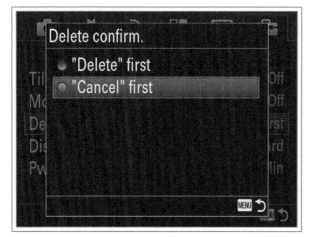
Figure 7-75. Delete Confirmation Menu Options Screen

This option lets you fine-tune the way the menu system operates for deleting images. Whenever you press the Delete button to delete an image or video in playback mode, the camera displays a confirmation screen, as shown in Figure 7-76, with two choices: Delete or Cancel.

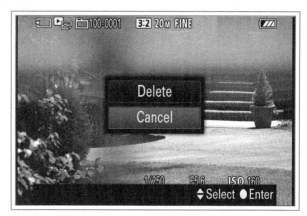
Figure 7-76. Confirmation Screen for Delete Button

One of those choices will be highlighted when the screen appears; you can then just press the Center button to accept that choice and the operation will be done. Of course, you also can use the Control wheel, Control dial, or Up or Down direction button to highlight the other choice before you press the Center button to carry out your choice.

Which option you choose depends on your habits, and how careful you want to be to guard against the accidental deletion of an item. If you like to move quickly in deleting images and videos, choose "Delete" first. Then, as soon as the confirmation screen appears you can press the Center button to carry out the deletion. If you prefer to have some insurance against an accidental deletion, choose "Cancel" first, so that, if you press the Center button too quickly when the confirmation screen appears, you will only cancel the operation, rather than deleting an image.

Unless you use this process often and need to save time, I recommend you leave this menu item set at the "Cancel" First setting to be safe.

Display Quality

This menu item lets you choose Standard or High for the quality of the display. According to Sony, with the High setting the camera displays the live view on the LCD screen or in the viewfinder at a higher resolution

than with the Standard setting, at the expense of additional drain on the battery.

I have tried experiments with these settings, viewing small print from a catalog using both the viewfinder and the LCD display with both Display Quality settings, and I have not found a noticeable difference. There may be situations in which this option has a more obvious impact on the display, but my recommendation is to leave it at Standard to conserve battery life.

POWER SAVE START TIME

This menu option lets you set the amount of time before the camera turns off automatically to save power, when no controls have been operated. The default setting is one minute; with this option you can also choose two, five, or thirty minutes, or ten seconds, as shown in Figure 7-77.

When the camera goes to sleep with this option, you can wake it up by half-pressing the shutter button, or by pressing the Menu button or the Playback button. These presses will place the camera into shooting mode, the menu system, and playback mode, respectively.

You cannot turn the power-saving function off. However, the camera will not power off automatically when you are recording movies, when a slide show is playing, or when the camera is connected to a computer.

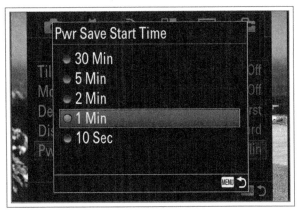

Figure 7-77. Power Save Start Time Menu Options Screen

The setting you use depends on your habits and needs. In my case, I am usually well aware of the camera's status, and I like to use the maximum thirty-minute period for this option so the camera does not power down just when I am about to use it again. I always have extra batteries available and I'm not too concerned if I

have to replace the battery. If you are out in the field and running low on battery power, you might want to choose a shorter time for this option to conserve battery life.

Next, I'll discuss the options on screen 3 of the Setup menu, shown in Figure 7-78.

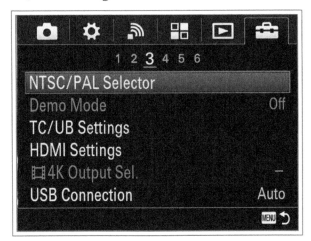

Figure 7-78. Screen 3 of Setup Menu

NTSC/PAL SELECTOR

This menu option controls which television system the camera uses for recording videos—NTSC or PAL. The NTSC system is used in the United States and other parts of North America, as well as Japan, South Korea, and some other countries. The PAL system is used in many parts of Asia, Africa, and Europe.

For purposes of using the RX10 III camera, the difference between the two systems is that the NTSC system uses multiples of 30 for video frame rates (such as 30, 60, or 120 frames per second), while the PAL system generally uses multiples of 25, such as 25, 50, or 100 frames per second. You will see these differences in the options for the Record Setting item on screen 2 of the Shooting menu. If you choose NTSC, the options will be mostly in multiples of 30, although there will be some entries for 24 fps, another NTSC standard. If you choose PAL, the options will be in multiples of 25.

In general, you should use the setting that is standard for the area where you will be using the camera. I live in the United States, so I set the camera to NTSC, where the frame rates are in multiples of 30.

It is important to choose this setting before you start recording files on your memory card. Once you have started using a card under one of these systems, you

cannot change to the other system without re-formatting the card. When you select this menu option, you will see the message shown in Figure 7-79, warning that you will have to re-format the card to continue.

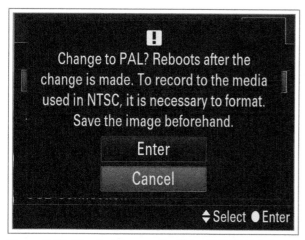

Figure 7-79. Warning Message for Using NTSC/PAL Selector

If you then select Enter and press the Center button, the camera will proceed to format the card for the other video system.

Demo Mode

The Demo Mode menu item automatically plays a movie if the camera has not had any controls operated for about one minute. This feature is designed for use by retail stores, so they can leave the camera turned on with a continuous demonstration on its screen. But you can use it for your own purposes, if you want to create a movie that demonstrates the camera's features for friends, for example, or if you just like the idea of having the camera play a movie when it's not otherwise occupied.

For this feature to be available for selection on the menu screen, as shown in Figure 7-78, the camera has to be plugged into AC power using an AC adapter. Otherwise, this line on the menu will be dimmed.

When Demo Mode is turned on and the camera is in shooting mode, after one minute of inactivity the camera enters Demo Mode. At that point, the camera will automatically play a movie, which you have to provide. It cannot be just any movie. The movie the camera will play in Demo Mode must be recorded in the AVCHD format, it must be protected using the Protect option on the Playback menu, and it must be the oldest AVCHD movie on the memory card. So, if you have a reason to use this option, you may want to use a fresh memory card and record a single AVCHD movie on the card, and then use

the Protect function to protect it. When the movie plays, it plays audio as well as video, and it will keep repeating in a loop. To exit from Demo Mode, you can press the Center button or just turn the camera off.

TC/UB (Time Code/User Bit) Settings

This menu item provides several sub-options that are helpful if you use the RX10 III for advanced video production. For example, because of its ability to shoot 4K video (discussed in Chapter 8), the RX10 III camera can be used as part of a multi-camera setup for shooting a professional production. In such a setup, it can be useful to control whether and how the camera outputs time code, a type of metadata that is used when editing video sequences. The user bit is another form of metadata that also can be used as an organizing aid.

This option is available only if File Format is set to XAVC S 4K, XAVC S HD, or AVCHD; it is not available if you are using the MP4 format. Even when TC/UB Settings is available for selection, all but one of the sub-options are dimmed unless the Mode dial is at the Movie or HFR position. If it is in any other position, you can get access only to the first sub-option, TC/UB Display Setting. For this discussion, I will assume the Mode dial is at the Movie position. (Some options work differently when the Mode dial is at the HFR position.)

I won't discuss the use of time code in great detail in this book, but I will give a brief overview. Time code for video files includes numbers in a format like the following: 02:12:23:19, which stands for hours, minutes, seconds, and frames. In this example, the time code shown would mark the point in the video clip at 2 hours, 12 minutes, 23 seconds, and 19 frames into the next second.

Because video (in the NTSC system) is played back at 30 fps or 24 fps, the number in the final position is based on those values, even if the video is recorded in a format such as XAVC S HD with Record Setting set to 120p 100M. With a Record Setting value of 120p, 60p, 60i, or 30p, the number of frames can be set from 00 to 29. When Record Setting is set to 24p, the number of frames can be set only to 00, 04, 08, 12, 16, or 20. For PAL areas, the numbers of frames can go from 00 to 24, because the video is played back at 25 fps.

When you see a time code like the one in this example, you know what frame of the video is being identified, so you can make an edit at that point or synchronize this

video clip with another video clip, as long as both clips are using the same time code format and had the time code recorded in synchronization.

If you are not going to use your camera for that sort of video production, you can largely ignore this menu option, though it is helpful to know what settings you can control. The sub-options are discussed below.

TC/UB Display Setting

This first option controls what figures display in the lower left corner of the camera's screen during video recording. There are three choices—Counter, TC, or U-Bit, for user bit, as shown in Figure 7-80.

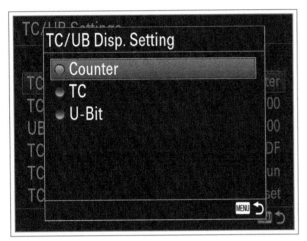

Figure 7-80. TC/UB Display Setting Options Screen

No matter which you choose, the display appears on the screen during recording in all shooting modes and before recording in Movie or HFR mode. The characters are not recorded visibly with the video and will not appear during playback, although they can be used as reference points in appropriate video-editing software.

Figure 7-81. Counter Option in Use on Recording Screen

The first choice, Counter, places a simple display of minutes and seconds of elapsed recording time, as shown in Figure 7-81. This is the default choice, and it is what you probably will want to leave in place for general use. As I noted above, the only reason to use time code (or user bit) is for professional-level video production.

The second choice places time code on the screen, as shown in Figure 7-82.

Figure 7-82. Time Code Option in Use on Recording Screen

You may want to use this setting for professional video production, not just to display on the screen but to output to another device, such as a video recorder, through the camera's HDMI cable, as I will discuss later in this chapter.

The third choice, user bit, lets you set the camera to display a set of four figures in hexadecimal notation, in the format 0B 76 11 F8. This amounts to a string of four numbers, each of which, in hexadecimal notation, can range from 00 (0 in decimal notation) to FF (255 in decimal notation).

In actual practice, I have never used the user bit for video production. Some videographers use this capability to place notes in the video file, using the few available letters (A through F) and the numbers to make notations like C1 for camera 1.

If you don't need to include a customized notation using the user bit option, the RX10 III gives you a way to have the user bit provide a running display of the current time. To do that, go to the last sub-option under TC/UB Settings, UB Time Record, and set it to On. That option sets the user bit to display the current

time in the lower left corner of the display. To make that display appear, you also have to set the TC/UB Display Setting option to U-Bit.

TC Preset

This next option lets you set the initial time code for your video recording. You can set the code anywhere from all zeroes, the default, to 23:59:59:29 for some NTSC formats. As I noted earlier, the final figure can go as high as 29 for most NTSC settings and 20 for the 24p settings. For PAL systems, the highest value is 24.

You might want to use this option if you need to start with a particular time code for a technical reason, in order to synchronize your footage with existing footage or that from another camera. In addition, in some production environments the practice is to set the hours position to a particular value, such as 01, to designate some item, such as the reel number. Unless you have a need to make a setting of that nature, you can leave these values all at zero.

UB Preset

This option lets you set the user bit, as discussed above. Each of the four positions can be set anywhere from 00 to FF, using the hexadecimal system.

TC Format

This option lets you select either DF (drop-frame) or NDF (non-drop-frame) format for the time code, assuming you are using time code and are using the NTSC video system. (Drop-frame time code is not used for PAL video.)

This is a technical setting that you may need to use in order to make sure the time code you use is compatible with that of other cameras and with your editing facilities. Drop-frame time code is used because the NTSC standard of 30 frames per second does not record exactly 30 frames every second. For technical reasons, the actual rate is 29.97 frames per second. To count the frames accurately, video editors use the drop-frame system, which drops a few frames at specified intervals from the counting process, so the actual number of frames is counted accurately.

You can leave this option set to DF if you are using the NTSC system, unless you know of a specific reason to use NDF.

TC Run

This option lets you choose either Rec Run or Free Run for the time code. With Rec Run, the time code increases only while the camera is actually recording. With Free Run, the time code continues to run all the time. Which system to choose is a matter of preference, depending on how you will use the time code for editing. With Rec Run, there should be no gaps in the time code, which can be an advantage. With Free Run, you can set up the time code to match the time of day, which can be useful if you need to find a clip that corresponds to a particular time during the day's video recording.

Free Run time code continues to run even when the camera is powered off. When you turn the camera on again and set it to Movie mode, the current time should be displaying in the lower left corner of the display, assuming you set the initial value for the time code to the current time.

You may have to take some additional steps to get the time code to appear in your editing software. For example, with AVCHD recordings from the RX10 III, if you are using Adobe Premiere Pro CC, you have to copy the entire AVCHD folder to the disk from which you will be importing the video into Premiere, and then use the Media Browser within Premiere to copy the time code.

TC Make

This option is what you use to set the camera to record the time code option you have selected. The two choices are Preset or Regenerate. If you choose Preset, the camera starts recording time code using the value you entered for TC Preset, discussed earlier. If you choose Regenerate, the camera starts the time code recording based on the last value recorded previously.

UB Time Record

This last option, found on the second screen of the TC/UB Settings menu item, lets you choose whether or not to set the user bit option to display and record the time instead of a user bit formula that you set yourself. If you select On for this option and set the TC/UB Display Setting option to U-Bit, the camera will display the current time in the lower left corner of the screen as the video is recorded, as shown in Figure 7-83. The display shows the hour (in the 24-hour format), minute, and second; the last set of digits is left at zeroes. In this case, the time was shortly after 2:53 p.m.

Figure 7-83. User Bit Display of Current Time on Recording Screen

HDMI Settings

The HDMI Settings menu option has six sub-options on its single screen.

HDMI Resolution

The HDMI Resolution option can be set to Auto, 2160p/1080p, 1080p, or 1080i. This setting controls how the camera displays images and videos on an HDTV in playback mode. Ordinarily, the Auto setting will work best; the camera will set itself for the optimum display according to the resolution of the HDTV it is connected to. If you experience difficulties with that connection, you may be able to improve the image on the HDTV's screen by trying one of the other settings. The 2160p/1080p setting is designed for connection to 4K-capable TV sets, which often have a resolution of 3840 x 2160 pixels.

24p/60p Output

This menu option is labeled with a movie-film icon, meaning it is for use when the camera is set to Movie mode. This option has a very specific and limited use. It is applicable only when you have recorded video using one of three Record Setting formats that include the 24p frame rate: 24p 24M, 24p 17m (both using the AVCHD File Format setting), or 24p 50M (using the XAVCS HD File Format setting). It also applies only if you have set the HDMI Resolution item, under HDMI Settings on screen 3 of the Setup menu, to 1080p or 2160p/1080p.

If all of those conditions are met, that means you have some video footage recorded at 24 frames per second. As I will discuss in Chapter 8, that setting is slower than the standard NTSC setting of 30 frames per second,

and produces what some people consider to be a more "cinematic" look for the footage.

When you send your 24p video footage out through an HDMI cable to an HDTV set, you may prefer to send it in a way that looks more like standard TV video, using the 60p setting. That is the function of this menu option. If all of the conditions described above are met, you can select 60p for the 24p/60p Output option, and your 24p footage will be sent out through the HDMI cable to the HDTV in a way that simulates 60p video.

This option also may be of use when you are sending video footage out through the HDMI cable to an external video recorder, if 60p footage is a better option for use by the recorder.

HDMI Information Display

This feature also controls the behavior of the camera when you connect it to an HDTV set or other external device using an optional micro-HDMI cable. However, unlike the HDMI Resolution option discussed above, which controls what happens when the camera is in playback mode, playing your images and videos on an HDTV set, this menu option controls what happens in shooting mode when the HDMI connection is active.

If this menu option is set to On, which is the default setting, then, when the camera is connected to an HDTV or external recorder in shooting mode, the screen of the external device displays exactly what you would see on the camera's display in that mode if the camera were not connected to the device, including icons and figures showing camera settings.

With the On setting, the HDTV acts as a large, external monitor for the RX10 III, and the screen of the RX10 III itself is blank. I use this setting a great deal myself, because this is how I capture screen shots for this book. Once the camera is connected, I can capture all of the information and settings that appear on the shooting screens and menu screens of the camera, with a few exceptions for special settings that are not output through the HDMI port, such as the Zebra stripes.

If this menu option is set to Off, then, when the camera is connected to an HDTV or other external device in shooting mode, the external device's screen displays only the image that is being viewed by the camera, with no shooting information displayed at all. If you press the Display button, nothing will happen on the external

screen; the view will not switch to another display with more information on it. However, at the same time, the camera's screen continues to display all of the shooting information it normally would, including the image and whatever information is chosen by presses of the Display button.

You might use the Off setting when you want to display images from the camera's shooting mode on a large HDTV screen, possibly at a wedding or other gathering, and not have the images cluttered or marred by any shooting information at all. For example, I have seen occasions where a camera is used to focus on an unsuspecting person in the audience, and that person's image suddenly appears on the large screen for everyone to see.

Also, this option is useful for video production when you need to output a "clean" video signal that does not include any shooting information from the camera. That signal can be sent through an HDMI cable to a video recorder for recording to another medium, or for display on a large monitor being viewed by the production team. For example, you can record video directly from the camera to a computer by outputting the clean HDMI signal to a device such as the Intensity Pro by Blackmagic Design. There are similar devices available from companies such as AverMedia, Hauppage, and Elgato. You also can send the clean signal to an external 4K video recorder such as the Atomos Shogun, as I will discuss in Chapter 8.

With the On setting, you can press the Display button to show a screen with very minimal shooting information, but that screen still shows the basic information of aperture, shutter speed, exposure compensation, and ISO value at the very bottom of the screen. If you don't want even that minimal level of information to interfere with the video display, choose the Off setting.

This setting does not change the behavior of the camera for playback of images; its only effect is on the display of information in shooting mode through an HDMI connection.

TC Output

This option works together with the TC/UB Settings option discussed earlier. If you have set up the camera to record time code, you can use this option to have the time code output through the HDMI cable to an external recorder, so the time code will be available in the recorded footage for use in editing. The choices are On or Off.

Rec Control

This next sub-option for HDMI Settings is another one that applies only when recording to an external device by sending a clean signal through the HDMI cable. In this case, the option controls whether the camera sends a start-recording or stop-recording signal through the cable. If you turn this option on, then you can control the external recorder using the camera's controls, if the external recorder is compatible with this camera.

For example, you can connect the Atomos Shogun 4K recorder with an HDMI cable and control the recorder's starting and stopping using the camera's Movie button, if the Rec Control option is turned on. The Rec Control option can be turned on only if the TC Output option, discussed above, also is turned on.

CTRL for HDMI

This final sub-option is of use only when you have connected the camera to an HDTV and you want to control the camera with the TV's remote control, which is possible in some situations. If you want to do that, set this option to On and follow the instructions for the TV and its remote control. This option is intended to be used when you connect the camera to a Sony Bravia model HDTV.

4K OUTPUT SELECT

This next option on the Setup menu is for use only when the camera is connected to a 4K-capable external video recorder, such as the Atomos Shogun. Unless that connection is active, this option will be dimmed and unavailable for selection. Once the connection to the external recorder is made, the following sub-options are available:

Memory Card + HDMI

With this option, the camera will record video to the memory card in the camera and also output the signal to the external recorder through the HDMI cable. This option gives you an immediate backup copy of your footage.

HDMI Only (30p)

With this option, the camera sends a 4K video signal in 30p format to the external recorder but does not record the video to the camera's memory card. This option lets you record 4K video without having a memory card that meets the specifications for that format, and, in fact, it lets you record with no memory card in the camera at all.

If you choose this option or the next one, for 4K/24p video with no card in the camera, the File Format and Record Setting items on the Shooting menu become unavailable, because the recording format has already been selected by choosing this option or the next one.

I tested this option with the RX10 III connected by an HDMI cable to an Atomos Shogun external 4K recorder. The camera sent a clean 4K signal through the HDMI cable and the Shogun recorded the video with no problems. If you turn on the Rec Control menu option on the camera, you can control the operation of the Shogun recorder by pressing the Movie button on the camera to start and stop the recording.

HDMI Only (24p)

This option is the same as the previous one, apart from the use of the 24p frame rate instead of 30p.

USB CONNECTION

This option sets the technical standard that the camera uses for connecting to a computer using the USB cable. This menu item has four choices, as shown in Figure 7-84: Auto, Mass Storage, MTP, which stands for Media Transfer Protocol, and PC Remote.

You ordinarily should select Auto, and the RX10 III should detect which standard is used by the computer you are connecting the camera to. If the camera does not automatically select a standard and start transferring images, you can try one of the other settings to see if it works better than the Auto setting. You may find it necessary to use the MTP option when connecting your camera to the computer to download apps from the playmemoriescameraapps.com site.

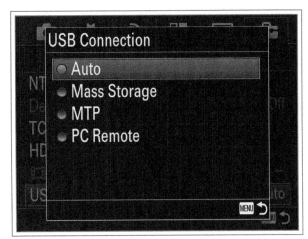

Figure 7-84. USB Connection Menu Options Screen

The fourth setting, PC Remote, adds an important function to the camera. If you select this option, you can then connect the camera to a computer with the camera's USB cable, and control the camera from the computer using Sony's Remote Camera Control software. That software can be downloaded at no charge from http://www.sony.co.jp/imsoft/Win/ for Windows-based computers and from http://www.sony.co.jp/imsoft/Mac/ for Macintosh computers.

Once this software is installed on your computer, set this menu option to PC Remote, connect the camera to the computer with the Sony USB cable, and turn the camera on. Then start the software application. You will see on the computer a window like that in Figure 7-85, showing the various items you can control from the computer.

You will have to turn the camera's Mode dial to select the shooting mode, but you can control quite a few items from the software, depending on what mode is selected. These include Drive Mode, including all settings for continuous shooting, bracketing, and the self-timer; white balance; Picture Effect; Quality; DRO/Auto HDR; Image Size; and Aspect Ratio.

You can set autoexposure lock by clicking on the AEL icon. To control exposure compensation, click on the exposure compensation icon in the black window at the top of the screen, then click on the large plus or minus sign in the gray area below the black window. The same technique works for flash exposure compensation. You also can control ISO by clicking on the ISO reading in the black window and then on the plus or minus sign in the gray control area.

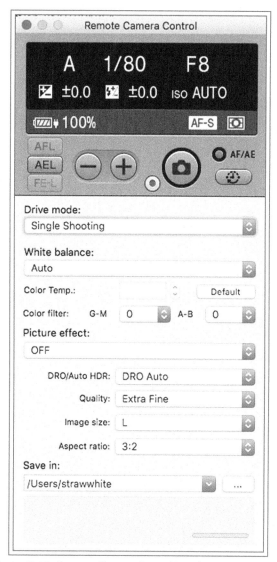

Figure 7-85. Remote Camera Control Window on Computer

When the Mode dial is set to Shutter Priority or Manual exposure, you can control the shutter speed by clicking on the setting in the large black block and then clicking on the plus or minus sign in the gray area. However, when Aperture Priority or Manual exposure mode is selected, you cannot control the aperture from this software; you must use the camera's aperture ring to change that setting. You can click on the button to the left of the AF/AE label in the gray area to simulate a half-press of the shutter button, locking focus and exposure, if autofocus is in effect.

You can click on the red button at the bottom of the gray control area to start or stop a video recording. Click on the camera icon to the right of that button to take a still image. Click and hold down on the camera icon to fire a burst of shots when continuous shooting is selected for Drive Mode.

If you want to use this tethered-shooting capability to save images to your computer, use the Save In . . . dialog box at the bottom of the Remote PC Control window and select a folder; the images captured using this feature will then be stored in that folder.

Finally, if you click on the small button with a timer dial, below the AF/AE button, a new window will open up with options for interval shooting. In that window, you can set the interval between shots to a value from ten seconds to 180 minutes and the number of shots from two to 1000. Using this feature, you can create a time-lapse movie. For example, if you set the camera up on a tripod and aim it at a construction project, taking one picture per minute for 600 minutes, you will end up with 600 images that cover a period of ten hours. If you assemble those images into a movie and play it back at 30 frames per second, the actions for those ten hours will play back in 20 seconds.

If you use this capability for a fairly long sequence, you will probably need to power the camera with the AC adapter or with some other external power source, as discussed in Appendix A.

There is a less cumbersome way to carry out interval shooting or time-lapse photography with the RX10 III. You can do this without connecting the camera to a computer, using the Time-lapse app that is available for download, as discussed in Chapter 9.

Screen 4 of the Setup menu is shown in Figure 7-86.

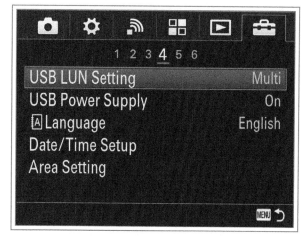

Figure 7-86. Screen 4 of Setup Menu

USB LUN Setting

This first item on screen 4 of the Setup menu is a technical option that should not often be needed.

LUN stands for logical unit number. This item has two possible settings—Multi or Single. Ordinarily, it should be set to Multi, the default. In particular, it should be set to Multi when the RX10 III is connected to a Windows-based computer and you are using Sony's PlayMemories Home software to manage images. If you have a problem with a USB connection to a computer, you can try the Single setting to see if it solves the problem.

USB POWER SUPPLY

The USB Power Supply option, which can be turned either on or off, controls whether or not the camera's battery will be charged or the camera will be powered through the USB cable when the camera is connected by its USB cable to a computer.

If you use the AC adapter provided with the camera or an external USB battery, as discussed in Appendix C, to provide power to the camera, you do not need to have this menu option turned on. When the USB cable is connected to an external power supply, power will be provided to the camera even with this option turned off.

Turning this option on gives you another avenue for keeping the RX10 III's battery charged. The only problem is that if your computer is running on its battery, then that battery will be discharged more rapidly than usual. If you are plugging the camera into a computer that is plugged into a wall power outlet, there should be no problem in using this option.

As I will discuss in Appendix A, in my opinion, you should get an external battery charger and at least one extra battery for the RX10 III because even if you can charge the battery in the camera using the USB cable, you don't have the ability to insert a fully charged battery into the camera when the first battery is exhausted.

I recommend leaving this option at its default setting of On, unless you will be connecting the camera to a battery-powered computer or other device and you don't want to run down the battery on that device.

LANGUAGE

This option gives you the choice of language for information on the camera's display screens. Once you have selected this menu item, as shown in Figure 7-87, scroll through the language choices using the Control

wheel or the direction buttons and press the Center button when your chosen language is highlighted.

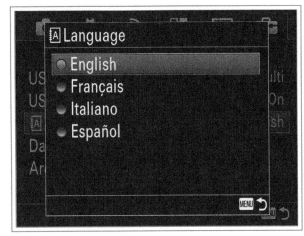
Figure 7-87. Language Selection Screen

DATE/TIME SETUP

I discussed this item in Chapter 1. When the camera is new or has not been used for a long time, it will prompt you to set the date and time and will display this menu option. If you want to call up these settings on your own, you can do so at any time.

When you press the Center button on this menu line, you will see a screen like that in Figure 7-88, which gives you the choice of adjusting Daylight Savings Time (On or Off), Date/Time, or Date Format.

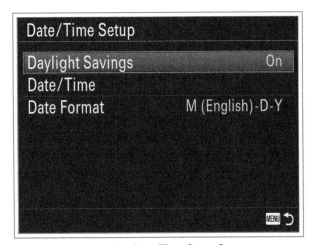
Figure 7-88. Date/Time Setup Screen

To adjust Date/Time, select that option and press the Center button. The camera will display a screen like that shown in Figure 7-89.

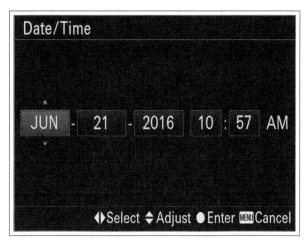

Figure 7-89. Date/Time Settings Screen

Scroll through the options for setting month, day, year, and time by turning the Control wheel or pressing the Left and Right buttons. As you reach each item, adjust its value by using the Up and Down buttons or by turning the Control dial. When all of the settings are correct, press the Center button to confirm them and exit from this screen.

You can also go back to the first menu screen and turn Daylight Savings Time on or off depending on the time of year, and you can choose a date format according to your preference.

Area Setting

The next option on screen 4 of the Setup menu, Area Setting, lets you select your current location so you can adjust the date and time for a different time zone when you are traveling. When you highlight this item and press the Center button, the camera displays the map shown in Figure 7-90.

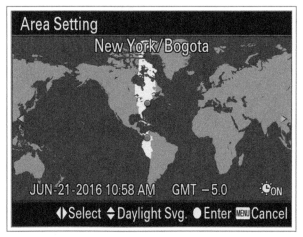

Figure 7-90. Area Setting Map

Turn the Control wheel or press the Left and Right buttons to move the light-colored highlight over the map until it covers the area of your current location, then press the Center button. The date and time will be adjusted for that location until you change the location again using this menu item.

Screen 5 of the Setup menu is shown in Figure 7-91.

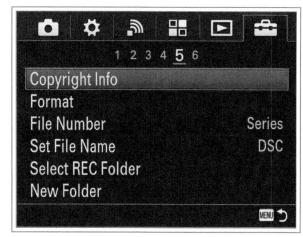

Figure 7-91. Screen 5 of Setup Menu

Copyright Info

This first item on screen 5 of the Setup menu gives you a way to add information about the photographer and copyright holder to the metadata for images taken with the camera.

The first sub-option, Write Copyright Info, determines whether the copyright information entered for this item will be written to still images that you take. If you turn this option on, then the copyright information (names of photographer and copyright holder) will be added to the metadata for any still images captured after the option is turned on. The information will not appear on the images themselves, but can be read by any program that reads EXIF data for images, such as Adobe Bridge.

The second option, Set Photographer, lets you enter the name of the photographer. When you select this option, you will see a screen with a window for entering the name. Press the Center button when the window is highlighted and you will see the data-entry screen. Use that screen to enter any name you want. Use the Control wheel and the Control dial or the direction buttons to move the orange highlight bar to the first block on the left under the name window. When that

block is highlighted, press the Center button to toggle between letters, numbers and symbols. Then move the highlight bar to the block for the letter you want. Move to the up arrow to shift to uppercase letters. Press the Center button repeatedly to choose the letter you want from each group of letters.

For example, to type the letter "e," move the highlight bar to the "def" block and press the Center button quickly two times to select e. After a second or two, the blinking white cursor will move to the right, and you can repeat this process. You can move the cursor forward or back using the left and right arrows at the upper right in the blocks of characters.

When you have finished entering the name, highlight OK and press the Center button to accept the name.

The third option, Set Copyright, lets you set the name of the company or person who holds the copyright for the images to be taken with the camera.

Finally, the Display Copyright Info option lets you see what names are currently entered in the camera for these items.

FORMAT

The next option on the fifth screen—Format—is an extremely important one. This command is used to prepare a new memory card with the appropriate data structure to store images and videos. The Format command also is useful when you want to wipe all the data off a card that has become full or when you have copied a card's images to your computer or other device. Choose this process only when you want or need to completely wipe all of the data from a memory card. When you select the Format option, as shown in Figure 7-92, the camera will warn you that all data currently on the card will be deleted if you proceed.

If you reply by highlighting Enter and pressing the Center button to confirm, the camera will format the card that is in the camera and the result will be a card that is empty and properly formatted to store new images and videos recorded by the camera.

With this procedure, the camera will erase all images, including those that have been protected from accidental erasure with the Protect function on the Playback menu.

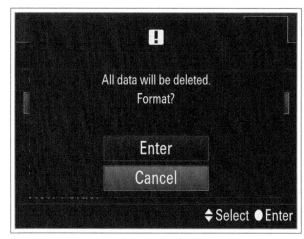

Figure 7-92. Format Confirmation Screen

It's a good idea to periodically save your images and videos to your computer or other device and re-format your memory card to keep it properly set up for recording new images and videos. It's also a good idea to use the Format command on any new memory card when you first insert it into the camera. Even though it likely will work without that procedure, it's best to make sure the card is set up with Sony's own particular method of formatting for the RX10 III.

FILE NUMBER

This option controls the way the camera assigns numbers to your images and videos. There are two choices: Series and Reset, as shown in Figure 7-93.

With Series, the camera continues numbering where it left off, even if you put a new memory card in the camera. For example, if you have 112 images on your first memory card, the last image likely will be numbered 100-0112: 100 for the folder number and 0112 for the image number.

Figure 7-93. File Number Menu Options Screen

If you then switch to a new memory card with no images on it, the first image on that card will be numbered 100-0113 because the numbering scheme continues in the same sequence. If you choose Reset instead, the first image on the new card will be numbered 100-0001 because the camera resets the numbering to the first number.

SET FILE NAME

This menu option lets you specify the first three characters for file names of your images. By default, those characters are DSC, so a typical image might be DSC00150.jpg. You can choose any other characters by using the data-entry screen for this option, shown in Figure 7-94. Those three characters will then appear at the beginning of the file name for any images captured after you change this setting, if the images use the sRGB color space. If the images use the Adobe RGB color space, the camera will add an underscore character before the file name, as shown in Figure 7-94.

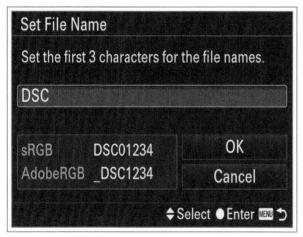

Figure 7-94. Set File Name Menu Options Screen

SELECT REC FOLDER

When you select this item, the camera displays an orange bar with the name of the current folder, as shown in Figure 7-95. You can use the Up and Down buttons or turn the Control wheel to scroll to the name of another folder if one exists, so you can store future images and videos in that folder. It might be worthwhile to use this function if you are taking photos or movies for different purposes during the same outing.

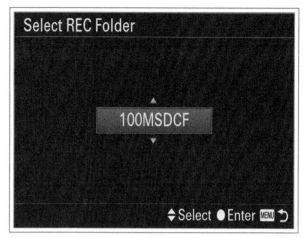

Figure 7-95. Select REC Folder Selection Screen

For example, if you are taking some photos for business and some for pleasure, you can create a new folder for the business-related shots (see the next menu item, below). The camera will then use that folder. Afterward, you can use the Select REC Folder option to select the folder where your personal images are stored and take more personal images that will be stored in that folder.

NEW FOLDER

This menu item lets you create a new folder on your memory card for storing images and videos. Highlight this item on the menu screen and press the Center button; you will then see a message announcing that a new folder has been created, as shown in Figure 7-96.

Figure 7-96. New Folder Creation Confirmation Screen

Creating a new folder can be a good way to organize images and videos from a particular shooting session. If you are going to view and process the files on your computer, it can be useful to have images from different locations arranged in different folders, for example.

The sixth and final screen of the Setup menu is shown in Figure 7-97.

Figure 7-97. Screen 6 of Setup Menu

FOLDER NAME

This menu option gives you a choice of two methods for naming the folders used for storing still images on your memory card, as shown in Figure 7-98: Standard Form or Date Form. The Standard Form option uses the folder number, such as 100, 101, or higher, followed by the letters MSDCF. An example is 100MSDCF. If you choose Date Form, folder names will have the same 100 or higher number followed by the date, in a form such as 10060628 for a folder created on June 28, 2016, using only one digit to designate the year.

Figure 7-98. Folder Name Menu Options Screen

I find the date format confusing and hard to read, and I am used to the MSDCF format. If you use the date format, you will end up having a folder for every date on which you record still images. You may prefer having your image folders organized in that way so you can

quickly locate images from a particular date. I prefer having fewer folders and organizing images on my computer according to my own preferences.

RECOVER IMAGE DATABASE

This menu item activates the Recover Image Database function. If you select this option and press the Center button to confirm it on the next screen, as shown in Figure 7-99, the camera runs a check to test the integrity of the file system on the memory card. I have never used this menu option, but if the camera is having difficulty reading the images on a card, using this option might recover the data.

Figure 7-99. Recover Image Database Message

DISPLAY MEDIA INFO

This next item on the final Setup menu screen gives you another way to see how much storage space is remaining on the memory card that is currently in the camera. When you select Display Media Info and press the Center button, the camera displays a screen like that in Figure 7-100, with information about the number of still images and the hours and minutes of video that can be recorded using the current settings for Image Size, Quality, and video format.

It is nice to have this option available, although the number of images that can be recorded is also displayed on the detailed shooting screen, and the available video recording time appears on the video recording screen once a recording has been started.

Figure 7-100. Display Media Info Screen

Figure 7-101. Screen Showing Current Firmware Version

VERSION

This option tells you the current version of the firmware in your camera. The RX10 III, like other cameras, is programmed at the factory with firmware, which is a set of electronically implanted computer instructions. These instructions control all aspects of the camera's operation, including the menu system, functioning of the controls, and in-camera image processing.

You may want to see what version is installed because the manufacturer may release an updated version of the firmware to fix problems or bugs in the system, provide minor enhancements, or, in some cases, provide major improvements, such as adding new shooting modes or menu options.

To determine the firmware version installed in your camera, highlight this menu option, then press the Center button, and the camera will display the version number, as shown in Figure 7-101. As you can see, my camera currently has Version 1.00 installed.

To see if firmware upgrades have been released, I recommend you visit Sony's support website, whose Internet address is http://esupport.sony.com. Find the link for Drivers and Software, then the link for Cyber-shot Cameras, and then a link to any updated version for the DSC-RX10 III. The site will provide instructions for downloading and installing the new firmware.

SETTING RESET

This final option on the Setup menu is useful when you want to reset some or all of the camera's settings to their original (default, or factory) values. This action can be helpful if you have been experimenting with different settings and you find that something is not working as expected.

When you select this item, the camera displays two choices: Camera Settings Reset and Initialize, as shown in Figure 7-102.

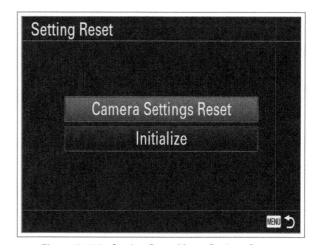

Figure 7-102. Setting Reset Menu Options Screen

If you choose Initialize, the camera resets all major settings to their original values and deletes registered data, such as faces. With Camera Settings Reset, only the values from the Shooting menu are reset.

CHAPTER 8: MOTION PICTURES

The RX10 III is a stellar performer for capturing still images, and it must be considered primarily a camera for stills. But Sony has added a strong set of movie-recording features to this camera. Although a compact camera like this is not one you might think of for professional-level video shooting, it comes with features that would allow you to produce footage for many high-end applications. Before I discuss specific settings you can make for your movies, I'll begin with a brief overview of the process.

Movie-Making Overview

In one sense, the basics of making movies with the RX10 III can be stated in four words: "Push the red button." (That is, the red Movie button to the right of the viewfinder.) In most situations, you can press and release that button while aiming at your subject, and you will get results that are quite usable. You do not need to worry about special settings, particularly if you set the camera to one of the more automatic modes, such as Auto or Scene. (You can record a normal-speed movie with the Mode dial at any position except HFR, as discussed later in this chapter.)

To stop recording, press the red button again. If you prefer not to run the risk of recording unwanted movies by pressing the Movie button accidentally, you can change the button's operation so it activates movie recording only when the camera is in Movie mode, as discussed in Chapter 7.

If you're mainly a still photographer with little interest in movie making, you don't need to read further. Be aware that the red button exists, and if an interesting event starts to happen, you can turn the Mode dial to Auto, press the Movie button, and capture footage to post on YouTube or elsewhere with a minimum of effort. But for those RX10 III users who want to use

this camera's strong motion picture capabilities, there is much more information to discuss.

First, there is a requirement that may decide what memory card you get for your camera. To record movies using the high-quality XAVC S 4K or XAVC S HD format, you have to use an SDHC or SDXC memory card with a speed of at least Class 10 or UHS Speed Class 1. This is not just a recommendation. If you do not use a card with those specifications, the camera will display an error message and will not record video using that format.

If you want to record XAVC S 4K or XAVC S HD video using a Record Setting value of 100M, meaning 100 megabits per second, you have to use an SDHC or SDXC card rated in UHS Speed Class 3. Because all 4K videos recorded with this camera use the XAVC S format, you have to use a card in UHS Speed Class 1 or SD Speed Class 10 for any 4K video, and a card in UHS Speed Class 3 for 4K video using the 100M setting. (As I will discuss later in this chapter, 4K is a designation for video files that have higher resolution than high-definition video.)

I have used the SanDisk Extreme 256 GB SDXC card, shown in Figure 8-1, which is rated in UHS Speed Class 3, for recording the highest-level formats with no problems, but there are other choices available, as discussed in Chapter 1.

Figure 8-1. SanDisk Extreme 256 GB SDXC Card

Of course, if you are not going to use the highest-level formats, you can use a less-powerful card. And, as I'll discuss later in this chapter, you can actually record 4K video with no card at all, if you connect the RX10 III to an external video recorder.

Also, it's important to note that the RX10 III, like most cameras in its class, has built-in limitations that prevent it from recording any sequence longer than about 29 minutes (20 minutes for the MP4 format

using the 1920 x 1080 60p 28M Record Setting option). You can, of course, record multiple sequences adding up to any length, depending on the amount of storage space available on your memory cards.

If you plan on recording a large amount of HD video, you should get a high-capacity and high-speed card. For example, a 16 GB card can hold about 75 minutes of the highest quality of AVCHD video, about 2 hours of lower-quality AVCHD video, or about 75 minutes of the highest quality of MP4 HD video. (I will discuss these video formats later in this chapter.)

Details of Settings for Shooting Movies

As I noted above, the one step that is a necessity for recording a movie with the RX10 III is to press the Movie button. However, there are numerous settings that affect the way the camera records a movie when that button is pressed.

I will discuss four categories of settings: (1) the movie-related selections you make on the Shooting menu; (2) the position of the Mode dial on top of the camera; (3) the other selections you make on the Shooting menu and other menus; and (4) the settings you make with the camera's physical controls.

MOVIE-RELATED SHOOTING MENU OPTIONS

First, I will discuss the movie-related options on the Shooting menu, because those options control the format and several other important settings for the movies you record with the RX10 III. I discussed this menu in Chapter 4, but I did not provide details about all of the movie-oriented options in that chapter.

As noted above, you can press the Movie button to start a normal-speed video recording at any time and in any shooting mode (except for HFR), as long as the Movie Button option on screen 6 of the Custom menu is set to Always. Because of this ability to shoot movies in almost any shooting mode, you can always change the settings for movie recording using the Shooting menu, no matter what shooting mode the camera is set to. I will discuss each item on the Shooting menu that has an effect on your shooting of videos.

At this point, I am going to discuss the Shooting menu options that apply only to movies; later in this chapter, I will discuss the options on this menu and other menus that affect movies as well as still images, such as White Balance, ISO, Creative Style, Picture Effect, and others.

File Format

The first item on screen 2 of the Shooting menu, File Format, gives you a choice of the four available movie recording formats on the RX10 III—XAVC S 4K, XAVC S HD, AVCHD, and MP4, as shown in Figure 8-2.

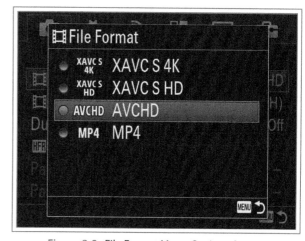

Figure 8-2. File Format Menu Options Screen

This setting determines the format the camera will use to record movies when you press the Movie button. The formats have different characteristics, as discussed below.

XAVC S 4K

The XAVC S format is a consumer version of the XAVC format, developed for use with 4K video recording, sometimes known as Ultra HD. The term "4K" refers to a horizontal resolution of roughly 4,000 pixels, instead of the 1920 pixels in standard HD video. On the RX10 III, video recorded with the 4K format has a pixel count of 3840 x 2160. Because of its high resolution, this option provides excellent quality for your videos. To enjoy the full benefit of the format, you need to view the videos on a TV set that is equipped for 4K viewing. However, even without that type of TV, you can edit 4K videos with appropriate software, such as Adobe Premiere Pro, Sony Vegas Pro, and others. In the editing process, you can downsample the 4K video clips to a standard HD format, such as 1920 x 1080 pixels, and they will have greater quality than videos originally recorded in an HD format.

As noted above, if you use this format, you have to use a memory card rated at least in Speed Class 10 or UHS Speed Class 1. If you use the highest-quality Record Setting option, the card must be rated in UHS Speed Class 3.

However, as I will discuss later in this chapter, you can avoid this restriction if you connect the RX10 III to an external video recorder, such as the Atomos Shogun, using an HDMI cable, and record to the Shogun recorder without recording to the camera's memory card. I'm not suggesting that that system is simple or inexpensive, but it is available if you need to use the RX10 III for 4K video recording without having to use a particular type of memory card.

XAVC S HD

This second option for File Format uses the high-quality XAVC S format, but records using an HD resolution of 1920 x 1080 pixels rather than the higher 4K resolution. This option will give you excellent quality without requiring the use of a 4K-capable TV set. However, it carries with it the same requirement for a high-speed memory card as the 4K format.

AVCHD

If you don't want to purchase the high-speed memory card required for the XAVC S format but you still want very high quality for your movies, you can choose AVCHD. This format, developed jointly by Sony and Panasonic, has become increasingly common in advanced digital cameras. It provides excellent quality, and movies recorded in this format on the RX10 III can be used to create Blu-ray discs.

MP4

If you want to record movies with excellent video quality but in a format that is easier to edit with a computer than the first three options and easy to share on the Internet or by e-mail, you can choose MP4. The MP4 format is compatible with Apple Computer's QuickTime software, and the files can be edited with various software programs, including QuickTime, iMovie, Windows Movie Maker, and many others.

Record Setting

The Record Setting item on the Shooting menu is another quality-related option for recording video. (The accent is on the second syllable of "Record.") The choices for this item are different depending on whether you

choose XAVC S 4K, XAVC S HD, AVCHD, or MP4 for File Format. I will discuss these options assuming you have your camera set for NTSC, the video standard used in the United States, using the NTSC/PAL Selector option on screen 3 of the Setup menu, as discussed in Chapter 7. If your camera is set for PAL, the choices for Record Setting will include numbers such as 50p and 25p instead of 60p, 30p, and 24p.

XAVC S 4K

If you choose XAVC S 4K for File Format, the four options for Record Setting are 30p 100M, 30p 60M, 24p 100M, and 24p 60M, as shown in Figure 8-3.

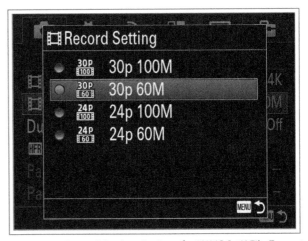

Figure 8-3. Record Setting Options for XAVC S 4K File Format

For these choices, the letter "p" stands for progressive, which means the camera records 30 or 24 full video frames per second. (The other option, used with some AVCHD formats, as discussed below, is designated by the letter "i," standing for interlaced. With those options, such as 60i, the camera records 60 fields, or half-frames, per second, which yields lower quality and fewer possibilities for editing.)

The standard speed for recording video in the United States is 30 frames per second, and using either of the 30p settings will yield excellent quality.

If you select 24p 100M or 24p 60M, your video will be recorded and played back at 24 fps. The 24p rate is considered by some people to be more "cinematic" than the 30p format. This may be because 24 fps is a standard speed for movie cameras that shoot with film. My preference is to use the 30p format, but if you find that 24p suits your purposes better, you have that option with the RX10 III.

The 60M or 100M designation means that these formats record video with a bit rate up to a maximum of 60 or 100 megabits per second, which are very high rates that yield excellent quality. As noted earlier, when you record using the 100M setting, you have to use a memory card rated in UHS Speed Class 3.

My recommendation for this setting is to use 30p 60M unless you have a definite need for the super-high quality of the 30p 100M setting.

XAVC S HD

If you choose XAVC S HD, the five choices for Record Setting are 60p 50M, 30p 50M, 24p 50M, 120p 100M, and 120p 60M, as shown in Figure 8-4. If you use a 60p or 120p option, the camera will record at two or four times the normal speed, and therefore will record two or four times as much video information as with the 30p choice. If you use one of those higher speeds, you will be able to produce a slow-motion version of your footage at very high quality. For example, 60p footage is recorded with twice the number of full frames as 30p footage, so the quality of the video does not suffer if it is played back at one-half speed

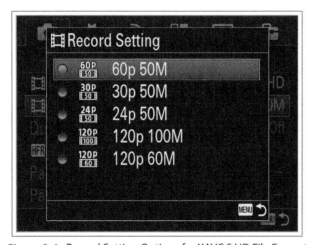

Figure 8-4. Record Setting Options for XAVC S HD File Format

If you think you may want to slow down your footage significantly for playback, you should choose the 60p setting, or, for even slower motion, the 120p setting.

Video taken with the 60p or 120p setting will play back at normal speed in the camera. To play it back in slow motion, you can use a program such as iMovie for the Mac or Movie Maker for Windows. Just set the playback speed to a factor such as 0.5x or 0.25x to play the footage at the slower speed.

The 24p option is not a substantially slower rate than the 60p format or the 120p format, because the video playback rate in the United States is 30 fps, and the 60p and 120p formats are converted to 30 fps for playback in the camera.

All of these options are recorded in full HD, meaning the pixel count for each video frame is 1920 x 1080. The 120p selections (100p for the PAL system) are not available with the Auto and Scene shooting modes. Also, with either of the 120p options, the camera cannot use face detection, DRO/Auto HDR, Monitor Brightness, Viewfinder Brightness, Lock-on AF, or non-optical zoom, while actually recording a video.

Here again, as with the 4K settings, you have to use a memory card rated in UHS Speed Class 3 card if you use the 100M setting, and at least a Speed Class 10 or UHS Speed Class 1 card for the other settings.

AVCHD

If you choose AVCHD for File Format, the five choices for Record Setting are 60i 24M(FX), 60i 17M(FH), 60p 28M(PS), 24p 24M(FX), and 24p 17M(FH), as shown in Figure 8-5. All of these are recorded with a pixel count of 1920 x 1080, which is full HD.

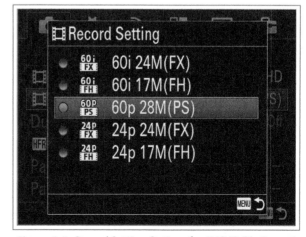

Figure 8-5. Record Setting Options for AVCHD File Format

60i and 60p Video Formats

First, I will discuss the three formats using 60 fields or frames per second. As noted above, the letter "i" or "p" stands for interlaced or progressive. With interlaced video, the camera records 60 fields per second; a field is equal to one-half of a frame, and the two halves are interlaced to form 30 full frames. The video frame rate of 30 frames per second (fps) is the standard video playback rate in the United States.

If the letter is "p," for progressive, the camera records 60 full frames per second, which yields higher quality than interlaced video. The 60 frames are later translated into 30 frames for playback in the camera at the standard rate of 30 fps. However, as with the XAVC S format, if your video-editing software has this capability, you can play back your 60p footage in slow motion at one-half the normal speed and still maintain full HD quality.

The 28M, 24M, or 17M states the maximum "bit rate," or volume, of video information that is recorded—either 28, 24, or 17 megabits per second. The higher-numbered settings provide greater quality at the cost of using more storage capacity on the memory card and requiring greater computer resources to edit.

The final designations, FH, FX, and PS, are proprietary labels used by Sony for these various qualities of video. They have no particular meanings; they are just labels for three levels of video quality—PS is the highest, then FX, and then FH.

Choose 60p 28M if you want the highest quality (including slow-motion capability), 60i 24M for excellent quality, or 60i 17M for excellent quality that takes up fewer resources.

24p Video Formats

As I discussed for XAVC S, above, the 24p formats are available if you want a more "cinematic" look for your footage. (If you set your camera to use the PAL system, it will offer 25p formats instead of 24p.)

MP4

If, instead of XAVC S or AVCHD, you choose MP4 for File Format, you are presented with three choices for Record Setting: 1920 x 1080 60p 28M, 1920 x 1080 30p 16M, and 1280 x 720 30p 6M, as shown in Figure 8-6.

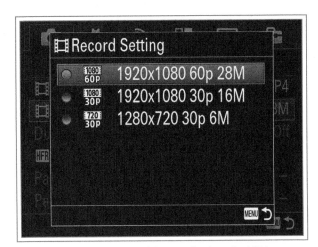

Figure 8-6. Record Setting Options for MP4

The first two settings provide full HD resolution with the same pixel count as XAVC S HD or AVCHD. The third setting, 1280 x 720, has a lower resolution, but is still HD. As you can see from the bit rate values for these settings, 28M, 16M, and 6M, the bit rates are, with one exception, lower than those of the highest-quality AVCHD or XAVC S settings. Therefore, the quality is not as great, but the MP4 formats take up less storage space than AVCHD or XAVC S and, as noted above, are easier to manipulate with a computer and to send by e-mail.

If you choose the MP4 file format, I recommend using the 1920 x 1080 60p 28M option to get maximum quality from this setting, unless you are recording a video of household possessions for an inventory or shooting another subject that does not require high quality. However, you also should recall that because of a 4 GB limitation on file size, the RX10 III can record only 20 minutes of MP4 video at a time in this high-quality HD format. So, if you need to record for a time longer than that in one sequence, you should choose the 1920 x 1080 30p 16M setting, which will still yield excellent quality and record for 29 minutes at a time.

Dual Video Recording

This next menu option, which can be turned either on or off, sets the camera to record an MP4 movie at the same time that it records an XAVC S or AVCHD movie. This feature is like a video version of the Raw & JPEG setting for Quality, for still images. It gives you a video file in a high-quality format for later editing on a computer, along with a lower-quality MP4 version that is easier to manipulate quickly and post to social media sites.

This option is available only when File Format is set to XAVC S 4K, XAVC S HD, or AVCHD. For XAVC S HD

movies, it is available only when Record Setting is set to 30p or 24p; for AVCHD movies, it is available only when Record Setting is set to one of the 60i or 24p formats. It is not available when SteadyShot (Movies) is set to Intelligent Active.

I have not yet found a need to use this setting, but it is available if you want to record a video in one of the high-quality formats and also have a second copy available that is easier to edit or share.

HFR Settings

This menu option lets you set up the camera for super-slow-motion video, which you can record when you turn the Mode dial to the HFR position, for high frame rate shooting. I will discuss these options later in this chapter, in a section on HFR shooting.

Picture Profile

This option, found on screen 5 of the Shooting menu, is applicable for both still images and video recording, though it is really oriented for shooting video. I discussed the details of these settings in Chapter 4. If you want to have the greatest amount of dynamic range available in your video sequences and are willing to go through the effort of color grading your clips with post-processing software, you can choose PP7 for the Picture Profile setting, to take advantage of the S-Log2 setting for gamma curve. Otherwise, choose one of the lower-numbered profiles, or no profile at all. If you want to get involved with parameters such as gamma, black level, detail, and knee, you can create your own profile with the settings you prefer.

If you want to experiment with different Picture Profile settings, you can assign this menu option to one of the control buttons using the Custom Key (Shooting) option on the Custom menu or to the Function menu. You can then call up different Picture Profile settings while recording a video, to see how they affect the recording.

If you use PP7, which includes the S-Log2 gamma setting, you can use the Gamma Display Assist option, discussed in Chapter 7, to increase the apparent contrast of the footage as it is displayed by the camera during recording and playback, so it will be easier to judge composition, exposure, and focus, etc.

Auto Dual Recording

This first option on screen 7 of the Shooting menu lets you set up the camera to capture still images automatically when a video sequence is being recorded. I will discuss this menu item later in this chapter, in a section on shooting stills during movie recording.

High Frame Rate

This final option on screen 7 of the Shooting menu is different from the HFR Settings option on screen 2 of that menu. This High Frame Rate option is available for selection only when the Mode dial is at the HFR position. I will discuss this option in the section on HFR shooting, later in this chapter.

Movie (Exposure Mode)

This menu item, the first option on screen 8 of the Shooting menu, can be selected only when the camera's Mode dial is set to Movie mode, as shown in Figure 8-7. In other shooting modes, this menu option is dimmed and unavailable.

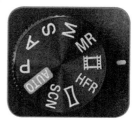

Figure 8-7. Mode Dial Movie

When the camera is in Movie mode, the Movie option lets you select an exposure mode for shooting movies. If you have the Mode Dial Guide option turned on through screen 2 of the Setup menu, you won't need to use the Movie option when you first select the Movie mode. When you turn the Mode dial to the Movie position and then press the Center button, the screen with choices for the Movie item will appear automatically. If the Mode Dial Guide option is not active or if the Mode dial is already set to Movie mode, you get to this screen by selecting Movie from the Shooting menu.

With the Mode dial set to Movie mode, navigate to this menu option and this screen will appear with its four options: Program Auto, Aperture Priority, Shutter Priority, and Manual Exposure, as shown in Figure 8-8. Move through these choices by turning the Control wheel or Control dial, or by pressing the Up and Down buttons.

You also can call up this screen of options by assigning Shoot Mode to the Function menu using the Function Menu Settings option on screen 5 of the Custom menu.

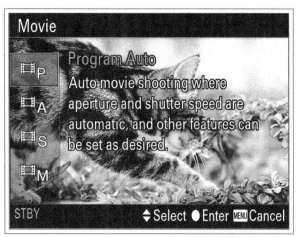

Figure 8-8. Movie Menu Options Screen

If you do that, then, with the Mode dial set to Movie, you can press the Function button to activate the Function menu, scroll to the Shoot Mode item, and select your choice of Movie exposure mode. (The Shoot Mode item will be labeled Movie in the Function menu when the Mode dial is at the Movie position.)

Following are details about the behavior of the RX10 III when shooting movies with each of these settings.

Program Auto

With the Program Auto setting, which is highlighted in Figure 8-8, the RX10 III sets aperture and shutter speed according to its metering, and it uses settings from the Shooting menu that carry over to video recording, including ISO, White Balance, Metering Mode, Face Detection, and DRO.

In this mode, the camera can set the aperture anywhere in its normal range of f/2.4 to f/16.0, and it can use a shutter speed as fast as 1/12800 second. The camera will normally not use a shutter speed slower than 1/25 second, 1/30 second, 1/50 second, 1/60 second, or 1/125 second, depending on the settings for File Format and Record Setting. It can use a slightly slower speed if you turn on the Auto Slow Shutter option, discussed later in this chapter.

Aperture Priority

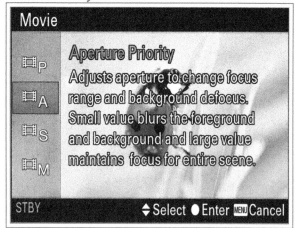

Figure 8-9. Aperture Priority Setting for Movie Exposure Mode

With the Aperture Priority setting, shown in Figure 8-9, you set the aperture, just as in the similar mode for still images, and the camera will set the shutter speed based on its metering. You can set the aperture anywhere from f/2.4 to the most narrow f/16.0, using the aperture ring. As with the Program Auto exposure mode for movies, discussed above, the camera will not use shutter speeds slower than those listed for that mode, unless you turn on the Auto Slow Shutter menu option.

With this setting, you can adjust the aperture during a video recording. This may not be something you need to do often, but it can be useful in some situations. For example, you may be recording at a garden show, and at some point you may want to open the aperture wide to blur the background as you focus on a small plant. Afterward, you may want to close the aperture down to a narrow value to achieve a broad depth of field to keep a large area in focus.

Also, you can use the aperture setting to accomplish a fadeout. For example, in normal indoor conditions, you may start with the aperture set to f/2.4 and ISO set to 640, with Auto Slow Shutter turned off. Press the Movie button to start recording. When you're ready, turn the aperture ring smoothly to the f/16.0 setting. You should get a nice fade to black. In brighter conditions, you may need to reduce ISO to its minimum setting for movies, which is 100.

Whenever you expect that you may adjust the aperture during a video recording, it is a good idea to turn off the aperture clicks using the click switch on the bottom of the lens, as discussed in Chapter 5.

Shutter Priority

With the Shutter Priority mode for movies, shown in Figure 8-10, you set the shutter speed using the Control dial, and the camera will set the aperture.

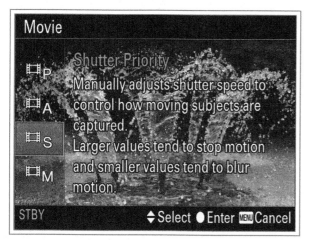

Figure 8-10. Shutter Priority Setting for Movie Exposure Mode

Unlike the situation with the Aperture Priority exposure mode for movies, in which the camera normally will not set the shutter speed slower than 1/25 second (or a higher value for some formats), you are able to set the shutter speed as slow as 1/4 second in this mode in most cases, even if Auto Slow Shutter is turned off. (If Record Setting is set to 120p for XAVC S HD video, the slowest shutter speed available is 1/125 second.) You can select a shutter speed from 1/4 second all the way to the maximum shutter speed for movies, which is 1/12800 second. The camera will use its full range of aperture settings, from f/2.4 to f/16.0.

To expose your video normally at a shutter speed of 1/12800 second or other fast settings, you must have bright lighting, a high ISO setting, or both. Using a fast shutter speed for video can yield a crisper appearance, especially when there is considerable movement, as when shooting sports or other fast-moving events. In addition, having these very fast shutter speeds gives the camera flexibility for achieving a normal exposure when recording video in bright conditions.

With slower shutter speeds, particularly below the normal video speed of 1/30 second (equivalent to 30 fps), footage can become blurry with the appearance of smearing, especially with panning motions. If you are shooting a scene in which you want to have a drifting, dreamy appearance that looks like motion underwater, this option may be appropriate. You will not be able to achieve good lip sync at the slower shutter speeds,

so this technique would not work well for realistic recordings of people talking or singing.

One interesting point is that you can preview this effect on the camera's display even before you press the Movie button to start recording. If you have the shutter speed set to 1/4 second in Movie mode, you will see any action on the screen looking blurry and jerky as if it had already been recorded with this slow shutter speed. (The Live View Display option on screen 3 of the Custom menu is forced to the Setting Effect On option in Movie mode, and you cannot change it.)

With the Shutter Priority exposure mode for movies, you also can achieve a fadeout effect, as with Aperture Priority mode, discussed above. Just turn the Control dial smoothly to increase the shutter speed to its fastest speed of 1/12800 second, and the scene may go black, depending on the lighting conditions. You may need to use a low ISO setting to achieve full darkness.

Manual Exposure

The last setting for the Movie item, shown in Figure 8-11, Manual Exposure mode, gives you more complete control over the exposure of your videos.

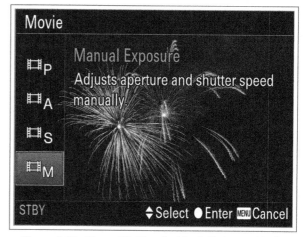

Figure 8-11. Manual Setting for Movie Exposure Mode

As with Manual exposure mode for stills, with this setting you can adjust both the aperture and the shutter speed to achieve your desired effect. With video shooting, you can adjust the aperture from f/2.4 to f/16.0, and you can adjust the shutter speed from 1/12800 second to 1/4 second. (If Record Setting is set to 120p for XAVC S HD video, the slowest shutter speed available is 1/125 second.) Using these settings, you can create effects such as fades to and from black as well as similar fades to and from white.

For example, if you begin a recording in normal indoor lighting using settings of 1/60 second at f/3.2 with ISO set to 800, you can start recording the scene, and, when you want to fade out, start turning the Control dial slowly to the right, increasing the shutter speed smoothly until it reaches 1/12800 second. Depending on how bright the lighting is, the result may be complete blackness. Of course, you can reverse this process to fade in from black.

If you want to fade to white, here is one possible scenario. Suppose you are recording video with shutter speed set to 1/400 second and aperture set to f/2.8 at ISO 6400. When you want to start a fade to white, turn the Control dial smoothly to the left until the shutter speed decreases all the way to 1/4 second. In fairly normal lighting conditions, as in my office as I write this, the result will be a fade to a bright white screen.

There are, of course, other uses for Manual Exposure mode when recording videos, such as shooting "day for night" footage, in which you underexpose the scene by using a fast shutter speed, narrow aperture, low ISO, or all three of those settings, to turn day into night for creative purposes. Also, you might want to use Manual Exposure mode when you are recording a scene in which the lighting may change, but you do not want the exposure to change. In other words, you may want some areas to remain dark and some to be unusually bright, rather than have the camera automatically adjust the exposure. In some cases, having a constant exposure setting can be preferable to having the scene's brightness change as the metering system adjusts the exposure.

Note that you can set ISO to Auto ISO with the Manual Exposure setting. With the Auto ISO setting, you can maintain a constant aperture and shutter speed, but the camera will adjust exposure using the ISO setting to the extent that it can. You might want to use that setup if you need to maintain a narrow aperture to have a broad depth of field.

SteadyShot (Movies)

The second SteadyShot item on screen 8 of the Shooting menu, shown in Figure 8-12, is different from the SteadyShot (Still Images) item above it. (The Movies and Still Images designations are indicated by icons on the menu—a movie film icon for Movies and a mountain/landscape icon for Still Images.)

Figure 8-12. SteadyShot (Movies) Menu Option

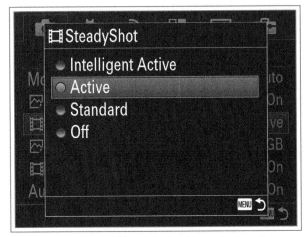

Figure 8-13. SteadyShot (Movies) Menu Options Screen

As shown in Figure 8-13, the SteadyShot (Movies) setting offers four options: Off, Standard, Active, and Intelligent Active, unlike the Still Images version, which is limited to being turned on or off. With the Movies version, if you select Standard, the camera uses the same stabilization system used for shooting stills. If you select Active or Intelligent Active, the camera uses an additional electronic stabilizing system that can compensate for unwanted camera movement to a greater extent.

The Active and Intelligent Active settings are not available when File Format is set to XAVC S 4K or when Record Setting is set to a 120p setting (100p for PAL systems).

With the Active setting, the camera crops out parts of the image at the edges to compensate for the required processing of the image. With Intelligent Active, the camera uses an even stronger stabilizing effect and crops the frame even more heavily.

Figures 8-14 through 8-17 illustrate the cropping that results with the various settings of SteadyShot (Movies), using the same scene in each case. In Figure 8-14, SteadyShot (Movies) was turned off; in Figure 8-15 it was set to Standard; in Figure 8-16 to Active; and in Figure 8-17 to Intelligent Active.

Figure 8-14. SteadyShot (Movies) Off

As you can see, the Standard setting does not crop the frame, but the Active setting crops pixels from all four sides of the frame, and Intelligent Active crops even more pixels from all four sides.

Figure 8-15. SteadyShot (Movies) Standard

I recommend using Standard in most cases to avoid the cropping that comes from using the Active or Intelligent Active setting. If you need to shoot movies when there is a great likelihood of camera movement, though, those two settings can be useful. They can be especially helpful if you need to hand-hold the camera as you walk. If the camera is on a tripod, you should turn SteadyShot (Movies) completely off.

Figure 8-16. SteadyShot (Movies) Active

Figure 8-17. SteadyShot (Movies) Intelligent Active

Auto Slow Shutter

This item on screen 8 of the Shooting menu can be either on or off. When it is turned on and the RX10 III is recording a movie with autoexposure, the camera will automatically use a slower shutter speed than normal if the lighting is too dim to achieve proper exposure otherwise. The details of this option depend on the setting for Record Setting on screen 2 of the Shooting menu. (The File Format setting does not matter; the rules stated here apply for all File Format settings.)

If Record Setting is at a 60p or 60i setting, the camera normally will not use a shutter speed slower than 1/60 second. (In order to record 60 fields or frames per second with good quality, a shutter speed of 1/60 second is needed.) If Auto Slow Shutter is on, the camera can use a shutter speed as slow as 1/30 second.

If Record Setting is at one of the 30p settings, the camera ordinarily will use a shutter speed no slower

than 1/30 second, but it will go down to 1/15 second with Auto Slow Shutter turned on.

If Record Setting is at one of the 24p settings, the camera ordinarily will use a shutter speed no slower than 1/50 second, but it will go down to 1/25 second with Auto Slow Shutter turned on. However, if Record setting is at one of the 120p settings (available only when File Format is set to XAVC S HD), the slowest shutter speed available is 1/125 second, and the Auto Slow Shutter option is not available.

Rather confusingly, the camera will let you turn on Auto Slow Shutter when the Mode dial is set to Movie and the Movie exposure mode is set to Shutter Priority or Manual Exposure. However, the setting you make for shutter speed will stay in place and the Auto Slow Shutter option will have no effect, even when the menu item is turned on. The same situation is true when the Mode dial is set to the Shutter Priority or Manual exposure mode for stills. You can shoot video in those modes while adjusting the shutter speed and you can turn on Auto Slow Shutter, but that setting will have no effect; the shutter speed you set will take priority.

In addition, for the Auto Slow Shutter option to work, ISO must be set to Auto ISO.

The use of an unusually slow shutter speed can produce a slurred or blurry appearance because the shutter speed may not be fast enough to keep up with the motion in the scene. But, if you are recording in a dark area, this option can help you achieve properly exposed footage, so it is worth considering in that situation.

Audio Recording

This last option on screen 8 of the Shooting menu determines whether or not the RX10 III records sound with its movies. If you are certain you won't need the sound recorded by the camera, you can turn this option off. I never turn it off, because you can always turn down the volume of the recorded sound when playing the video, or if you are editing the video on a computer, you can delete the sound and replace it as needed, but you can never recapture the original audio after the fact.

Audio Recording Level

This first option on screen 9 of the Shooting menu is available for selection only when the Mode dial is set to Movie mode. If you record movies by pressing the Movie button in any other shooting mode, the camera

will set the level for recording sound, and you cannot control it. In Movie mode, you can control the recording sound level using this menu option.

When you select this option, the camera displays a screen like that in Figure 8-18, with a scale of values from 0 to 31. While the scale is highlighted by the orange box, use the Control wheel, Control dial, or Left and Right arrows to select your desired value on the scale. If you highlight the Reset block and press the Center button, the level will be reset to the default value of 26.

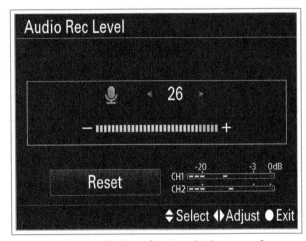

Figure 8-18. Audio Recording Level Adjustment Screen

Once the adjustment is made, press the Center button to exit to the live view. The new setting will be reflected in the behavior of the volume meters on the screen, when those meters are displayed, as shown in Figure 8-19.

Figure 8-19. Audio Meters on Shooting Screen

The meters will be displayed only when the Audio Level Display option is turned on through screen 2 of the Custom menu. If that menu option is turned on, the meters will appear on the screen during video recording in any shooting mode and they also will appear on the

screen before the recording begins when the camera is in Movie mode.

When the screen in Figure 8-19 is shown, the audio level meters will react to sounds you make, so, in Movie mode, you can test the sound level before the recording starts. For example, before you start recording an interview, you can ask your subject to speak normally to test the level. You should try to adjust the level so the green bars never extend all the way to the right sides of the meters; if the bars reach into the red zones, the result is likely to be distorted sound.

No matter what level is set, the camera uses a limiter—an electronic circuit that keeps the volume from getting excessively loud.

The audio recording level meters will operate when you are using the built-in microphone or when using an external microphone, as discussed in Appendix A.

Audio Out Timing

With this option, you can set the timing for the output of audio through headphones, when you are monitoring the sound being recorded for a movie. The possible settings are Live or Lip Sync, as shown in Figure 8-20.

If you choose the default setting of Live, the sound is sent through the headphones jack immediately, with no delay. If you choose the Lip Sync setting, the camera delays the sound by a small amount to account for the delay caused by the camera's processing and display of the video signal.

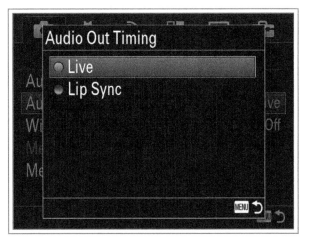

Figure 8-20. Audio Out Timing Menu Options Screen

I have not noticed a significant difference between these two settings. If you ever notice a gap between the sound and video signals as you monitor a recording

using headphones, you can try using the Lip Sync setting to see if that fixes the problem.

This setting should have no effect on how the audio and video are recorded; its purpose is only to let you monitor audio through the headphones in sync with the video.

Wind Noise Reduction

This option, if turned on, activates an electronic filter designed to reduce the volume of sounds in the low frequencies of wind noise. I recommend not activating this feature unless the wind is quite strong, because it limits the sounds that are recorded. With video (or audio) editing software, you can remove sounds in the frequencies that may cause problems for the sound track, but using the camera's built-in wind noise filter may permanently remove or alter some wanted sounds.

Effects of Mode Dial Position on Recording Movies

The second setting that affects video recording with the RX10 III is the position of the Mode dial. As I discussed above, you can shoot normal-speed movies with the dial in any position (if the Movie Button menu option is set that way), and you can get access to many movie-related menu items no matter what position the dial is in. However, as I noted above, the shooting mode does make some difference for your movie options.

First, the position you select on the Mode dial determines whether you can adjust the aperture and/or shutter speed for your movies. If the dial is set to the Auto, Scene, Program, or Sweep Panorama modes, the camera will set both aperture and shutter speed automatically. However, if the dial is set to the Aperture Priority, Shutter Priority, or Manual exposure position, you will be able to adjust the aperture, shutter speed, or both aperture and shutter speed, just as you can when shooting still images. The range of available shutter speeds is different for movies than for still images, but you can make those adjustments at any time.

You also can make those adjustments when the Mode dial is set to the Movie position and you select one of the more advanced exposure modes using the Movie item on screen 8 of the Shooting menu. For example, as discussed earlier in this chapter, if you select Manual Exposure for the Movie item with the Mode dial at the Movie position, you can adjust both aperture and

shutter speed for your movies, in the same way as if the Mode dial were set to the M position. (If you set the Mode dial to the HFR setting, you can shoot high frame rate movies, which will play back as slow-motion movies. I will discuss those options in an HFR section later in this chapter.)

Because of the ability to adjust aperture and shutter speed in the advanced still-shooting modes, you might wonder why you would ever use the Movie position on the dial—why not just set the dial to A, S, or M if you want to adjust aperture and/or shutter speed while recording a movie, or to P if you want the camera to set the aperture and shutter speed automatically?

The answer is that several options or settings are available only when the Mode dial is at the Movie position. For one thing, you will see how the video recording will be framed before you press the Movie button to start recording. If the Mode dial is at one of the still-oriented positions such as Auto, Scene, or one of the PASM modes, the display will show the live view according to the current setting for Aspect Ratio on screen 1 of the Shooting menu. If that setting is 3:2, 4:3, or 1:1, it will not correspond to the framing of the video, which will be recorded in a widescreen format, until you press the Movie button to start recording. (If Aspect Ratio is set to 16:9, the framing will show approximately how the video framing will look before you press the Movie button.)

When the Mode dial is at the Movie position, the camera adjusts the live view to show how the video will look before you press the Movie button, so you will know before you start the recording how to set up the shot to include all of the needed background and foreground elements.

In addition, when the Mode dial is at the Movie position, you can take advantage of the Movie Button menu option, on screen 6 of the Custom menu, to limit normal-speed video recording to that one shooting mode. In this way, you can make it impossible to start a recording accidentally by pressing the Movie button when the Mode dial is set to a still-oriented mode such as Auto, Scene, or one of the PASM modes. If that setting is turned on, you will need to turn the Mode dial to the Movie position in order to record a video.

Moreover, several menu options are not available unless the Mode dial is at the Movie position. In particular,

on screen 3 of the Setup menu, the 4K Output Select option is not available, nor are most of the sub-settings of the TC/UB Settings option. All of these settings can be useful when recording to an external video recorder. In addition, the Marker Display option on screen 1 of the Custom menu can be selected in any shooting mode, but any marker you have selected for display will not appear in still-oriented modes until you actually start recording a video. When the Mode dial is at the Movie position (or the HFR position), you will see the marker on the display before the recording starts, so you can set up your composition ahead of time.

Also, the camera's shooting mode has an effect on what options are available on the Shooting menu and with the control buttons, as discussed in following sections of this chapter. For example, if the Mode dial is set to Auto, Sweep Panorama, or Scene, the Shooting menu options are limited. If the Mode dial is set to Program, Aperture Priority, Shutter Priority, or Manual exposure, the options are greater. This point is important for video shooting because, as discussed below, several important Shooting menu options carry over to movie recording.

If the camera is set to Program mode (P on the Mode dial), you can make several settings that will affect the recording of videos while the Mode dial is in that position. The camera will set the aperture and shutter speed automatically, as it does with still-image shooting. You can use exposure compensation to vary the exposure, but only within the range of plus or minus 2 EV, instead of the 3-EV positive or negative range for still shooting.

If the camera is set to Aperture Priority mode (A on the Mode dial), you will have the same Shooting menu options as in Program mode, and you can also set the aperture; the camera will set the shutter speed automatically, but the range of available shutter speeds will be somewhat different than for still images. That range is also affected by the Record Setting option selected and the setting of the Auto Slow Shutter menu option, as discussed earlier in this chapter.

If the camera is set to Shutter Priority mode (S on the Mode dial), you will have the same Shooting menu options as in Program mode, and you can also set the shutter speed. In this case, you can set the shutter speed anywhere from 1/4 second (the camera's slowest setting for movies) to 1/12800 second (the camera's fastest

setting for movies), regardless of the Record Setting or Auto Slow Shutter settings, with one exception. The one exception is that the slowest setting available is 1/125 second when Record Setting is set to either of the 120p settings (100p for the PAL system), which are available when File Format is set to XAVC S HD.

If the camera is set to Manual exposure mode (M on the Mode dial), you will have the same Shooting menu options as before and you can set both shutter speed and aperture, with the same restrictions for shutter speed settings noted above for Shutter Priority mode.

If the camera is set to Sweep Panorama mode, it will act largely as if it were set to Movie mode with the Program Auto exposure mode selected. If it is set to Scene mode, it will shoot movies as if it were set to Intelligent Auto mode, in which limited menu options are available. It will not recognize any specific scene settings, such as Portrait, Sports Action, or Sunset.

There is a lot of information involved in outlining the differences in the RX10 III's behavior for video recording in different shooting modes, so I am including here a table that lays out the more important differences, for reference.

Table 8-1. Behavior of RX10 III for Video Recording in Various Shooting Modes

Shooting Mode:	Auto	Scene	Panorama	HFR	Movie	M	S	A	P
Adjust Aperture During Video Recording	No	No	No	Yes, before recording, depending on High Frame Rate menu option setting	Yes, depending on Movie menu option setting	Yes	No	Yes	No
Adjust Shutter Speed During Video Recording	No	No	No	Yes, before recording, depending on High Frame Rate menu option	Yes, depending on Movie menu option setting	Yes	Yes	No	No
See Video Framing Before Recording Starts	No	No	No	Yes	Yes	No	No	No	No
Use 4K Output Select	No	No	No	No	Yes	No	No	No	No
Use All TC/UB Settings Options	No	No	No	All except TC Run	Yes	No	No	No	No
See Marker Display Items Before Recording Starts	No	No	No	Yes	Yes	No	No	No	No
Use 120p/100p Record Settings Options	No	No	Yes	No	Yes	Yes	Yes	Yes	Yes
Can record video if Movie Button Menu Option is set to Movie Mode Only	No	No	No	HFR video only	Yes	No	No	No	No

Effects of Other Shooting Menu Settings on Recording Movies

Several other Shooting menu options affect movie recording, beyond options that are applicable only to movies, such as File Format, Record Setting, Auto Slow Shutter, and others discussed earlier in this chapter.

One of the main reasons the shooting mode is important for movies is that, just as with still photography, some menu options are not available in some modes. For example, in an advanced still-shooting mode like Aperture Priority or Program, video recording is affected by the settings for ISO, Metering Mode, White Balance, DRO, Creative Style, Picture Effect, Focus Magnifier, Lock-on AF, and Face

Detection. In some cases, you can adjust these settings while the video is being recorded. You cannot get access to the Shooting menu by pressing the Menu button; you have to use a control button, the Function menu, or the Control wheel to call up the item to adjust. Of course, you have to have that setting assigned to the button, menu, or wheel ahead of time.

For example, you can adjust ISO while recording a video, but only if you have assigned ISO to the Control wheel or one of the control buttons using the Custom Key (Shooting) menu option on screen 5 of the Custom menu, or to the Function menu. Table 8-2 shows which of these settings can be adjusted while a video recording is in progress, when the camera is set to a shooting mode in which that adjustment is possible.

Table 8-2. **Shooting Menu Items that Affect Movies, and Items that Can Be Adjusted During Video Recording**

Shooting Menu Item	Can Adjust During Video Recording
Image Size (Dual Rec)	No
Quality (Dual Rec)	No
File Format	No
Record Setting	No
Dual Video Recording	No
HFR Settings	No
Focus Area	Yes
Exposure Compensation	Yes
ISO	Yes
ISO Auto Min SS	No
Metering Mode	No
White Balance	No
DRO/Auto HDR	No
Creative Style	No
Picture Effect	No
Picture Profile	Yes
Range of Zoom Assist	No
Focus Magnifier	Yes
Center Lock-on AF	Yes
Smile/Face Detection	No
Auto Dual Rec	No
Movie (Shoot Mode)	No
SteadyShot (Movies)	No
Auto Slow Shutter	No
Audio Recording	No
Audio Recording Level	Yes
Audio Out Timing	No
Wind Noise Reduction	No

There are built-in limitations with some of these settings. Exposure compensation can be adjusted to plus or minus 2.0EV only, rather than the 3.0EV range for still images. The ISO range includes Auto ISO and specific values from 100 to 12800, omitting the two lowest settings. Also, you cannot set ISO to Multi Frame Noise Reduction, which would cause the camera to take multiple shots. With Picture Effect, you can use some of the sub-settings, but not all. The settings that are unavailable for movie recording are Soft Focus, HDR Painting, Rich-tone Monochrome, Miniature, Watercolor, and Illustration. (As noted on the table, you cannot get access to the Picture Effect settings during video recording.)

There are some other options on the Shooting menu that have no effect for recording movies. Some of these settings are clearly incompatible with shooting movies, such as Drive Mode, Flash Mode, and Auto Object Framing. Some are less obvious, including AF Illuminator and Scene Selection.

There are two other points to make about using Shooting menu settings for movies. First, you have a great deal of flexibility in choosing settings for your movies, even when the camera is not set to the Movie position on the Mode dial. You can set up the camera with the ISO, Metering Mode, White Balance, Creative Style, Picture Effect (to some extent), or other settings of your choice, and then press the Movie button to record using those settings. In this way, you could, for example, record a black-and-white movie in a dark environment using a high ISO setting. Or, you could record a movie that is monochrome except for a broad selection of red objects, using the Partial Color-Red effect from the Picture Effect option, with the red color expanded using the color axis adjustments of the White Balance setting. (Note that you can't use Creative Style and Picture Effect settings at the same time.)

Second, you have to be careful to check the settings that are in effect for still photos before you press the Movie button. For example, if you have been shooting stills using the Posterization setting from the Picture Effect menu option and then suddenly see an event that you want to record on video, if you press the Movie button, the movie will be recorded using the Posterization effect, making the resulting footage practically impossible to use as a clear record of the events.

Of course, you may notice this problem as you record the video, but it takes time to stop the recording, change the menu setting to turn off the Picture Effect option, and then press the Movie button again, and you may have missed a crucial part of the action by the time you start recording again.

One way to lessen the risk of recording video with unwanted Shooting menu options is to switch the Mode dial to the Auto position before pressing the Movie button. That action will cause the camera to use more automatic settings and will disable the Creative Style and Picture Effect options altogether. (Of course, you have to have the Movie Button item on screen 6 of the Custom menu set to Always for this approach to work.)

Effects of Physical Controls When Recording Movies

The next settings that carry over to some extent from still-shooting to video recording are those set by the physical controls. In this case, as with Shooting menu items, there are differences depending on the position of the Mode dial. I will not try to describe every possible combination of shooting mode and physical control, but I will discuss some settings to be aware of.

First, you can use the focus switch to change focus modes while recording a movie. You can set the switch at any of its four positions: S, C, DMF, or MF. However, the only two modes available for video recording are continuous autofocus and manual focus. If you set the switch to the S, C, or DMF position, the camera will use continuous autofocus. If you set the switch to the MF position, the camera will use manual focus.

Second, you can use the exposure compensation dial while recording movies when the Mode dial is set to the P, A, S, M, Movie, or Sweep Panorama setting. That setting is not available during video recording in the Auto or Scene modes. The range of exposure compensation for movies is plus or minus 2.0 EV, rather than the plus or minus 3.0 EV for still images. If you set exposure compensation to a value greater than 2.0 (plus or minus), the camera will set it back to 2.0 after you press the Movie button to start shooting a movie.

Third, the Function button operates normally. For example, if the Mode dial is set to P for Program mode, then, after you press the Movie button to start recording a movie, you can press the Function button and the Function menu will appear on the screen. This menu will let you control only those items that can be controlled under current conditions, as seen in Figure 8-21.

If you start recording a movie while the Mode dial is set to a mode such as Auto in which most options on the Function Button menu are not available, the RX10 III will display the menu, but few items will be available for selection.

Figure 8-21. Function Menu During Video Recording

Fourth, if you assign the Custom 1, 2, or 3, Center, Left, Right, Down, Focus Hold, or AEL button or the Control wheel to carry out an operation using the Custom Key (Shooting) option on screen 5 of the Custom menu, you can use that button or wheel to perform the operation while recording a movie if the action is compatible with movie recording in the current shooting mode.

For the Control wheel, the only function that can be assigned and controlled during video recording is ISO. Although White Balance, Creative Style, or Picture Effect can be assigned to the wheel and controlled before the recording starts, ISO is the only item that can be controlled by the wheel during the recording.

However, there are numerous options that can be assigned to a control button that will function during video recording, if the current context permits that control. For example, if the Left button is set to control ISO and you are shooting a movie with the Mode dial set to P, pressing the Left button will bring up the ISO menu and you can select a value while the movie is recording. If the Mode dial is set to Auto, though, pressing the button will have no effect during recording, because ISO cannot be adjusted in that shooting mode.

If the Center button is assigned the Focus Standard setting through the Custom Key (Shooting) menu option and Center Lock-on AF is turned on through screen 6 of the Shooting menu, you can press the Center button during video recording to activate tracking focus. Of course, to use tracking focus, you have to have an autofocus mode selected with the focus switch.

If you set the AEL button (or some other button) to the AEL Toggle function, you can press that control while recording a movie to lock the exposure setting. This ability can be useful when recording a movie, when you don't want the exposure to change as you move the camera over different areas of a scene.

Following is a list of functions that can be assigned to one of the control buttons or to the Function menu and that can be controlled during video recording by pressing the assigned button or using that menu:

- Self-timer During Bracketing
- Focus Area
- Exposure Compensation
- ISO
- Picture Profile
- Frame Rate (HFR)
- Auto Dual Recording
- SteadyShot (Still Images)
- Audio Recording Level
- AEL Hold
- AEL Toggle
- Spot AEL Hold
- Spot AEL Toggle
- AF/MF Control Hold
- AF/MF Control Toggle
- Center Lock-on AF
- Focus Hold
- Zoom Assist
- Focus Magnifier
- MOVIE (acting as red Movie button)
- Zebra
- Grid Line
- Marker Display Selection
- Audio Level Display
- Peaking Level
- Peaking Color
- Finder/Monitor Selection
- Gamma Display Assist
- TC/UB Display Switch (switches among counter, time code, and user bit displays)

Some of the items on this list are not useful during video recording, such as Self-timer During Bracketing and SteadyShot (Still Images). However, Sony for some reason has made these items available for use with an assigned button during movie recording, so I have included them on the list.

One more note about physical controls: Program Shift does not function during video recording. If you turn the Control dial while the camera is set to Program mode, the exposure settings will not change while the camera is recording a movie.

High Frame Rate Recording

The RX10 III camera is equipped with an excellent ability to record video at a higher-than-normal frame rate, which results in slow-motion sequences when played back at a normal rate. If you are using the NTSC system, you can record at a rate as high as 960 frames per second (fps); with the PAL system, you can record at up to 1000 fps. With either system, you can create a video sequence to be played back in the camera at up to 40 times slower than normal. Because there are several settings and steps to be taken to use this feature, I will provide a step-by-step guide.

1. Set the Mode dial to HFR, as shown in Figure 8-22.

2. On screen 7 of the Shooting menu, highlight the final option, High Frame Rate, and select one of the available exposure modes, as shown in Figure 8-23—Program Auto, Aperture Priority, Shutter Priority, or Manual Exposure.

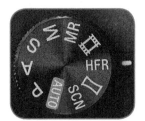

Figure 8-22. Mode Dial HFR

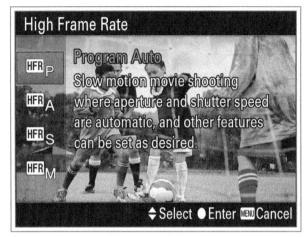

Figure 8-23. High Frame Rate Menu Options Screen

These modes are similar to those for normal-speed movie shooting, discussed earlier in this chapter. Note that the shutter speeds that can be used will depend on the Frame Rate setting you make in Step 6. For example, if you select 480 fps for the Frame Rate, the shutter speed will have to be 1/500 second or faster.

3. Make any control or menu adjustments that are needed. For example, if you selected Aperture Priority for the exposure mode, set the aperture. Set ISO, metering mode, white balance, and any other available settings, if needed. Set the focus mode using the focus switch. Select the zoom amount for the lens and adjust the focus for your subject. None of these items can be adjusted after the screen has been switched to standby mode for HFR shooting.

4. On screen 2 of the Shooting menu, highlight HFR Settings and press the Center button. You will see a screen like that in Figure 8-24.

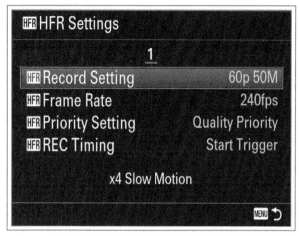

Figure 8-24. HFR Settings Screen

5. On this screen, set Record Setting as you want it. This setting is not related to the Record Setting option on screen 2 of the Shooting menu. This setting sets the frame rate for playback of your slow-motion videos. If your camera is set for the NTSC system, the choices for Record Setting are 60p, 30p, or 24p. The bit rate is set at 50M for each of the three settings. The video will be recorded using the XAVC S HD format. For highest quality of the final video, select 60p. For the greatest amount of slowing down of the final video, select 24p.

6. Go back to the menu options and select Frame Rate. Select either 240 fps, 480 fps, or 960 fps. You can determine how slow the slow-motion footage will be by dividing this number by the Record Setting figure. For example, if Frame Rate is 480 and Record Setting is 30, the final video will be slowed down 16 times when played back in the camera.

7. For Priority Setting, choose Quality Priority or Shoot Time Priority. This setting lets you decide whether it is more important to shoot for a longer time or with higher quality. If you choose Quality Priority, you can record for about two seconds; with Shoot Time Priority, you can record for about four seconds but at considerably lower resolution.

8. For Rec Timing, choose Start Trigger or End Trigger. With Start Trigger, the camera will start the two-second or four-second recording when you press the Movie button, and will record for the next two or four seconds. With End Trigger, it will end the recording when you press the Movie button, and will capture whatever action it was aimed at for the previous two or four seconds. If the action

you are trying to record is predictable, you can use the Start Trigger option. If you need to wait and see which two or four seconds are most worth capturing before you decide, choose End Trigger and push the Movie button quickly after seeing the action you want to record. Press the Menu button to return to the live view.

9. You will see a screen like that in Figure 8-25, with a message indicating to press the Center button to enter Shooting Standby mode. At this point, you can still press the Menu button to adjust menu options if needed. (If you don't see this screen, press the Display button until it appears.)

Figure 8-25. Message: Press Center Button for Shooting Standby

10. When you are ready to start recording, press the Center button. The camera will briefly display a Preparing . . . message, followed by a message saying Starts Recording with MOVIE Button, and then the screen shown in Figure 8-26, with a green STBY label, for Standby, in the lower left corner.

Figure 8-26. Shooting Screen in HFR Standby Mode

11. The camera is now in standby mode, waiting for you to press the Movie button to mark the start or end of the two or four-second sequence. (To adjust settings at this point, press the Center button to exit standby mode and make the settings; press the Center button again to return to standby mode.)

12. If you selected Start Trigger for the recording option, wait until you believe the two or four seconds of action you want to capture is about to start, and press the Movie button just before it starts, if possible. If you selected End Trigger, wait until the two or four seconds of action has just happened, and immediately press the Movie button. In either case, the camera will display a red Recording . . . label near the top of the screen and a red REC label in the lower left corner. It will then show a recording screen. This screen may appear for a fairly long time—much longer than the two or four seconds of action that was captured—depending on the settings used. You can press the Center button to cancel the recording while that screen is displayed.

13. When the live view returns, you can press the Playback button to view your recording. On your memory card, the video will have a file path such as Untitled:PRIVATE:M4ROOT:CLIP:C0114.mp4.

The HFR feature can produce beautiful videos under the right conditions. Because of the very fast recording rate, it is important to have as much light as possible to achieve excellent quality. I recommend using Quality Priority for the Priority Setting option, unless you have a definite need to record for four seconds instead of two seconds. Note that the video quality decreases as the slowdown factor increases, so take that factor into consideration when choosing settings. Finally, note that high frame rate videos are recorded with no sound.

Recording to an External Video Recorder

For recording everyday videos such as clips of vacations or family events, the RX10 III will serve you well. However, Sony also has equipped this camera with options that make it suitable for some aspects of professional video production. Several of these options are designed for use when the camera sends video to an external video recorder. I will not try to discuss all possible scenarios for using the RX10 III with a

recorder, but I will describe the steps I took to record video with the camera connected to an Atomos Shogun 4K recorder, discussed in Appendix A. I will describe the process I used for doing this, with the caveat that there undoubtedly are many other approaches that will work; this happens to be one that worked for me.

First, make sure the Shogun is powered by a battery or power supply and has a formatted storage disk installed. I used a SanDisk Extreme Pro 480 GB solid state drive (SSD). Connect headphones to monitor sound. On the Input menu, enable HDMI and Timecode Trigger. I selected Apple ProRes HQ as the recording format.

Connect the HDMI input port of the Shogun to the HDMI output port of the RX10 III using a micro-HDMI cable. Make sure the camera has an SDHC or SDXC memory card with a speed of UHS Speed Class 3. Then turn on both the camera and the recorder and make the settings on the camera shown in Table 8-3. Set the camera's Mode dial to the Movie position. Set the focus switch to the S, C, or DMF position so the camera will use autofocus, unless for some reason you prefer to use manual focus.

Table 8-3. **Recommended Settings on RX10 III Camera for Recording 4K Video to an Atomos Shogun Recorder**

SHOOTING MENU	
File Format	XAVC S 4K
Record Setting	30p 100M
Dual Video REC	Off
Focus Area	Wide
ISO	ISO Auto
Metering Mode	Multi
White Balance	Auto White Balance
Creative Style	Standard
Picture Effect	Off
Picture Profile	PP1
Center Lock-on AF	Off (Not Available)
Movie	Program Auto
SteadyShot (Movies)	Standard, or Off if camera on tripod
Auto Slow Shutter	Off
Audio Recording	On
Audio Recording Level	26, or as needed
Audio Out Timing	Live
Wind Noise Reduction	Off
CUSTOM MENU	
Zebra	Off unless needed

Grid Line	Off unless needed
Marker Display	Off unless needed
Marker Settings	Off unless needed
Audio Level Display	On
Zoom Speed	Normal
Zoom Setting	Optical Zoom Only
SETUP MENU	
Gamma Display Assist	Off unless using PP7 or S-Log2
NTSC/PAL Selector	NTSC (in U.S., etc.)
TC/UB Settings	
TC/UB Display Setting	TC
TC Preset	00:00:00:00
UB Preset	00 00 00 00
TC Format	DF
TC Run	Rec Run
TC Make	Preset
UB Time Rec	Off
HDMI Settings	
HDMI Resolution	Auto
24p/60p Output	60p
HDMI Info Display	Off (Not Available)
TC Output	On
REC Control	On
4K Output Select	Memory Card + HDMI

Some of the above settings are optional or unnecessary and some, such as white balance and metering mode, can be changed according to your preferences. The important ones are File Format, Record Setting, the TC/UB settings, and the HDMI settings.

Once the connections and settings are made, press the Movie button on the RX10 III. The screen on the Shogun recorder should indicate that the recording has begun. Use the controls on the camera to zoom or adjust settings as needed. When you are ready to stop the recording, press the Movie button again, and the recorder should stop.

I also tried a modified version of these settings with no memory card in the camera, setting 4K Output Select on the Setup menu to HDMI Only (30p). The Shogun recorded the video as expected and the resulting file imported readily into Adobe Premiere Pro CC for viewing and editing.

Shooting Still Images During Video Recording

The RX10 III can shoot still images while recording a video sequence, with some limitations. You cannot capture stills when File Format on screen 2 of the Shooting menu is set to the XAVC S 4K format. If File Format is set to XAVC S HD, you have to have Record Setting set to the 60p, 30p, or 24p setting. You can use any Record Setting values for AVCHD or MP4 videos. The camera can be set to any shooting mode, except HFR. If the camera is set to Movie mode, you can capture still images during video recording, but you cannot capture still images when the camera is not recording video. If you press the shutter button when the camera is not recording, you will see an error message.

Also, certain menu settings are incompatible with this feature. For example, if Picture Profile is turned on through screen 5 of the Shooting menu, you cannot capture still images during movie recording.

To control the size and quality of the still images you capture, use the Image Size (Dual Recording) and Quality (Dual Recording) items on screen 1 of the Shooting menu. The choices for size are L:17M, M:7.5M, or S:4.2M. The choices for quality are Extra Fine, Fine, or Standard. The images will be captured in the widescreen format of the video (aspect ratio of 16:9). There is no option for capturing Raw images during video shooting.

Assuming you have the Mode dial set to a compatible shooting mode and File Format and Record Setting set to compatible values, with no other conflicting settings in place, once the movie is recording, just press the shutter release button at any time to capture a still image. The camera will display a green CAPTURE message at the top of the screen. There is no limit on the number of still images you can capture in this way, other than the space available on the memory card. You cannot use the camera's built-in flash when shooting still images during video recording.

There is another option to be aware of for shooting still images during video recording—the Auto Dual Recording feature, found on screen 7 of the Shooting menu. I discussed the details of this setting in Chapter 4. When you turn this option on, the camera is programmed to capture still images during video recording when it detects what it determines to be an "impressive" composition including people. As I noted in Chapter 4, I do not often use this feature, but it might be useful if you were to have a camera set on a tripod, unattended, at a gathering and wanted to have some interesting stills captured while the video was being recorded. This option has the same limitations as shooting stills by pressing the shutter button. You can still press the shutter button to capture images when this option is activated.

Finally, there is one other way to capture still images in connection with video recording—by using the Photo Capture feature, as discussed in Chapter 6. For example, if you record video using the XAVC S 4K format, the video clips will have the high resolution of 4K video, giving you the option to save a still frame that is of high enough quality to stand on its own. If you use an exposure mode that lets you set the shutter speed, you can choose a fast shutter speed to stop action, and use this technique as a type of super burst shooting. Figure 6-35 in Chapter 6 is an example using this approach.

Summary of Options for Recording Movies

As I have discussed, there is some complication in trying to explain all of the relationships among the controls and settings of the RX10 III for recording movies. To simplify matters, I will provide a summary of options for recording movies with the RX10 III.

To record a video clip with standard settings, set the Mode dial to the Auto or Scene position and press the Movie button. The camera will adjust exposure automatically, and you can use either continuous autofocus (set for video recording using the S, C, or DMF setting for the focus switch) or manual focus (MF setting). In those shooting modes, you cannot adjust many shooting options, such as ISO, White Balance, DRO, Creative Style, or Picture Effect. You can use options such as Center Lock-on AF, Face Detection, and SteadyShot (Movies). You can choose File Format and Record Setting options to control the video quality.

For more control over video shooting, set the Mode dial to the P, A, S, or M position. Then you can control several additional Shooting menu options, including ISO, White Balance, Metering Mode, Creative Style, and Picture Effect, among others. You can choose continuous

autofocus or manual focus in the same way as for the more automatic shooting modes. You can adjust aperture, shutter speed, or both, or let the camera set them, depending on which shooting mode you select.

For maximum control over movie recording, set the Mode dial to the movie film icon for Movie mode. Then select an option for the movie exposure mode from the Movie item on screen 8 of the Shooting menu. To control aperture, choose Aperture Priority; to control shutter speed, choose Shutter Priority; to control both aperture and shutter speed, choose Manual Exposure. Other options can be selected from the Shooting menu.

Control buttons and dials operate during movie recording if the context permits, as discussed earlier. If you want a set of functions tailored for video recording, use the list in Table 8-4 to start, and adjust it for your own needs:

Table 8-4. **Suggested Control Assignments for Movie Recording**

Control	Function
Control wheel	ISO
Custom button 1	AF/MF Control Toggle
Custom button 2	Picture Profile
Custom button 3	Zoom Assist
Center button	Focus Standard
Left button	Zebra
Right button	Focus Magnifier
Down button	Focus Area
AEL button	AEL Toggle
Focus Hold button	Focus Hold

To record good, standard video footage at a moment's notice without having to remember a lot of settings, I recommend that you set up one of the seven registers of the Memory Recall shooting mode with a solid set of movie-recording settings. Table 8-5 lists one group of settings to consider. (Settings not listed here can be set however you like.) The Record Setting option and the Picture Profile setting in this table make some other settings unavailable, as noted in the table. If you want to use those settings, turn Picture Profile off and use a different option for Record Setting. I am assuming the Mode dial is at the Movie position and the focus switch is at the S, C, or DMF position, so the camera will use autofocus.

Table 8-5. **Suggested Shooting Menu Settings for Recording Movies in Movie Mode**

File Format	AVCHD
Record Setting	60p 28M (PS)
Dual Video Recording	Off (not available)
Focus Area	Wide
ISO	ISO Auto
Metering Mode	Multi
White Balance	Auto White Balance
DRO/Auto HDR	Off (not available)
Creative Style	Standard (not available)
Picture Effect	Off (not available)
Picture Profile	PP1
Center Lock-on AF	On
Smile/Face Detection	Off
Movie	Program Auto
SteadyShot (Movies)	Standard (Off if using tripod)
Auto Slow Shutter	Off
Audio Recording	On
Audio Recording Level	26 or as needed
Audio Out Timing	Live
Wind Noise Reduction	Off unless needed

Other Settings and Controls for Movies

There are several other points to be made about recording and playing back videos that don't concern the Shooting menu or the major physical controls. Here are brief notes about these issues.

The step zoom function is not available for video recording, even if the Zoom Function on Ring option is set to Step on screen 6 of the Custom menu. The zoom operates continuously for movies. The Zoom Assist feature does operate, however, if Zoom Assist is assigned to a control button.

The Display button operates normally to change the information that is viewed during video recording. The screens that are displayed are controlled by the Display Button option on screen 2 of the Custom menu. However, the For Viewfinder screen does not appear for video shooting, even if it was selected through that menu option.

In playback mode, the Display button operates normally for movies. The screen with space for a

histogram will display, but the spaces for histogram and other information will be blank.

The MF Assist option on screen 1 of the Custom menu does not operate for video recording, so the camera will not magnify the display when you turn the lens ring to adjust manual focus. However, you can assign the Focus Magnifier function to one of the control buttons and use that capability to enlarge the screen when using manual focus. After you press the assigned control button to put the orange frame on the display, press the Center button to enlarge the area within the frame to 4.0 times normal. (This is less than the 5.3x enlargement factor for still shooting.) Then turn the lens ring to adjust the focus. Half-press the shutter button to dismiss the Focus Magnifier frame.

The Setting Effect Off choice for the Live View Display option on screen 3 of the Custom menu does not function for video recording; the Setting Effect On choice is locked in. So, for example, if you are shooting movies in Movie mode using Manual Exposure for the Movie setting and you have the aperture and shutter speed set for strong underexposure, you cannot adjust this option to make the display more visible.

Movie Playback

As with still images, you can transfer movies to a computer for editing and playback or play them back in the camera, either on the camera's display or on a TV connected to the camera.

If you want to play your movies in the camera, there is one basic aspect of the RX10 III you need to be mindful of. As I discussed in Chapter 6, the View Mode option on screen 1 of the Playback menu controls what images or videos you will see in playback mode. If you don't see the video you are looking for, check to make sure this menu option is set to display all files from a certain date (Date View), Folder View (MP4), AVCHD View, XAVC S HD View, or XAVC S 4K View.

Once you have selected the proper mode to view your video, navigate to that file by pressing the direction buttons or turning the Control wheel or Control dial. Once the first frame of the selected video is displayed on the screen, you will see a playback triangle inside a circle, as shown in Figure 8-27. In the lower right corner of the screen will be a Play prompt with a white circle

icon indicating that you can press the Center button to play the video. (If you don't see that prompt, press the Display button one or more times until it appears.)

After you press the Center button to start playback, you will see more icons at the bottom of the screen, as shown in Figure 8-28. From the left, these icons indicate: Rewind/Fast Forward; Pause; Open Control Panel; and Exit. From this screen, you can press the Left or Right button repeatedly to play the movie rapidly forward or backward; multiple presses increase the speed up to four times.

Figure 8-27. Movie Ready for Playback

Figure 8-28. Initial Set of Playback Controls

One icon indicates you can press the Down button to open the Control Panel. While the video is playing, press the Down button, and you will see a new line of controls at the bottom of the screen, as shown in Figure 8-29. When the movie is playing, these icons indicate, from left to right: Previous Movie; Fast Reverse; Pause; Fast Forward; Next Movie; Motion Shot; Photo Capture; Volume; and Close Control Panel. When the movie is paused, the icons change, as seen in Figure 8-30. Those icons indicate, from left to right: Previous Frame; Reverse Slow; Normal Playback; Forward Slow; Next Frame; Motion Shot; Photo Capture; Volume; and Close Control Panel.

Figure 8-29. More Detailed Set of Movie Playback Controls

Figure 8-30. Detailed Playback Icons with Movie Paused

In either case, move through the icons with the Left and Right buttons, and press the Center button to select the function for that icon.

When a movie is playing, you can fast-forward or fast-reverse through a video at increasing speeds by turning the Control wheel or Control dial right or left or by pressing the Right or Left button.

MOTION SHOT FEATURE

The icon on the movie playback control panel that is a series of shrinking circles represents the Motion Shot feature. With this option, you can slow down the playback of a movie and display a motion sequence as a series of multiple exposures on the camera's screen, or on a TV screen if you have the camera connected to one.

This feature works only with AVCHD and MP4 movies, not with movies recorded in either of the two XAVC S formats. To use the feature, let the movie play up to the point where you want to start the effect. For example, suppose you recorded some children playing basketball. You could play the movie up to the point where a child shoots the ball toward the basket. At that point, or just before it, use the Right button to scroll to the Motion

Shot icon, highlight it, and press the Center button to select it.

The camera will then play back the video as a series of multiple exposures tracing the path of the object in motion. For example, Figure 8-31 shows how the camera processed a video sequence of a basketball shot.

Figure 8-31. Motion Shot Example

If the images of the moving object overlap too closely on your first attempt, you can make an adjustment using the Motion Interval Adjustment option. On the video control panel, once you have selected the Motion Shot icon, the line of icons will change. The Motion Shot icon will change to an icon for exiting the Motion Shot mode, which looks like a smaller version of the Motion Shot icon.

The icon to the right of that one, which looks like a set of rectangular frames, lets you adjust the interval between the images. Select that icon and adjust the scale to a lower number to place the images closer together and to a higher number to place them farther apart. You also can adjust the interval using the Motion Interval Adjustment option on screen 2 of the Playback menu.

You cannot save the results of your work with the Motion Shot feature unless you connect the camera to a video capture device using an HDMI cable, as I did for Figure 8-31. I view this feature as an interesting novelty that lets you examine the path of an object in motion in some detail. It might be helpful for checking your golf swing or for adding interest to a video demonstration.

If you like the general idea of the Motion Shot feature, you can purchase an application (app) called Motion Shot from the Sony website, http://www.playmemoriescameraapps.com. That app lets you save

the composite image that shows the motion trail. I will discuss the use of in-camera apps in Chapter 9.

Editing Movies

The RX10 III camera cannot edit movies in the camera. (At least, not with the options that come with the camera. It may be that an application will be developed for in-camera movie editing in the future.) If you want to do any editing, you will have to do it with a computer. For Windows, you can use software such as Windows Movie Maker. If you are using a Mac, you can use iMovie or any other movie editing software that can deal with MP4 and AVCHD files, and with XAVC S files, if you record movies using that format. I use Adobe Premiere Pro CC on my Mac, and it handles all three of these file types very well.

You also can use the PlayMemories Home software that comes with the RX10 III. To install PlayMemories Home on your computer, you need to download the software from the internet. For Windows-based computers, go to http://www.sony.co.jp/imsoft/Win/. For Macintosh computers, go to http://www.sony.co.jp/imsoft/Mac/. This software is updated with new features periodically, so be sure to keep checking the website for updates.

One issue you may encounter when first starting to edit movie files from the RX10 III is finding the files. When you insert a memory card into a card reader, the still images are easy to find; on my computer, the SD card shows up as No Name or Untitled; then, beneath that level, there is a folder called DCIM; inside it are folders with names such as 100MSDCF, which contain the still images. (If you use the Folder Name option on screen 6 of the Setup menu to select Date Form, the folder names will be based on dates the images were taken; an example is 10060617 for images taken on June 17, 2016.)

The movie files are a bit trickier to find. The XAVC S 4K and XAVC S HD files that you need to find and import into your software for editing have the .mp4 extension, but they are not the same as the more ordinary .mp4 files. Here is the path to a sample XAVC S file: Untitled\Private\M4ROOT\CLIP\C0007.MP4.

Here is the path to an AVCHD movie file: Untitled\Private\AVCHD\BDMV\Stream\0006.MTS. These files can be difficult to find on a Macintosh, because the Finder may not immediately show the contents of the AVCHD folder. You may have to right-click on the AVCHD item in the Finder and select Show Package Contents in order to view the BDMV folder. You may have to repeat that process to see the contents of the BDMV folder.

Here is the path to an ordinary MP4 movie file: Untitled\MP_ROOT\100ANV01\MAH00180.MP4.

You can avoid the complications of finding the movie files on a memory card by connecting the camera to your computer using the USB cable. With most video-editing software, the camera should be detected and the software should import the movie files automatically, ready for you to edit them.

Also, with the RX10 III, you can transfer your files to your computer using the Wi-Fi capabilities that are built into the camera, as discussed in Chapter 9.

CHAPTER 9: USING WI-FI AND OTHER TOPICS

The RX10 III has the ability to connect to computers, smartphones, and tablets using a Wi-Fi network. As noted in Chapter 1, you can transfer images and videos wirelessly using an Eye-Fi card or other memory card with Wi-Fi connectivity, but having Wi-Fi circuitry built into the camera gives you features that are not available with a card. Also, with some devices, the RX10 III can use NFC (near field communication) technology to establish a Wi-Fi connection without going through all the steps that are ordinarily required. In this section, I will describe these features and give examples of how you can use them.

First, here is one note to remember when using any of the camera's Wi-Fi features: The Wi-Fi menu has an option called Airplane Mode at the bottom of its first screen. If that option is turned on, no Wi-Fi features will work. Make sure that menu setting is turned off when using the Wi-Fi options.

Sending Images to a Computer

Although you can edit and print images and edit videos to some extent using a smartphone or tablet, the easiest way to work with them is to transfer them to a computer. The traditional ways to do this are to connect the camera to the computer with the camera's USB cable or to use a memory card reader. However, there are two methods you can use to transfer your images and videos to a computer over a wireless network, eliminating the need to use a USB connection or a card reader.

First, as discussed in Chapter 1, you can use an Eye-Fi card or a similar memory card with the capability of transfering your files wirelessly to the computer. This

system works well, but it requires the purchase and use of this special type of memory card.

The other approach for wireless transfer is to use the Wi-Fi capability built into the RX10 III. Once you have the camera and computer set up to communicate over a wireless network, you can use the Send to Computer menu option to transfer images and videos from the camera's memory card over that network, regardless of what type of memory card is installed. Here are the steps to set up the camera and computer:

1. Install the appropriate Sony software on the computer. For Windows-based computers, the software is PlayMemories Home, available for download at http://www.sony.co.jp/imsoft/Win/.

–or–

 For Macintosh computers, install Wireless Auto Import, available for download at http://www.sony.co.jp/imsoft/Mac/.

2. Run the software you downloaded in Step 1. Follow the program's prompts to connect the camera to the computer using the camera's USB cable, and select the option to designate this computer to receive images from the camera. You may have to set USB Connection on Screen 3 of the Setup menu to Auto or Mass Storage. This step needs to be done only once, unless you later switch to a different computer. Then disconnect the USB cable.

3. Make sure the camera is within range of a wireless access point, also known as a Wi-Fi router. Normally, this will be a private, secured network at your home or office.

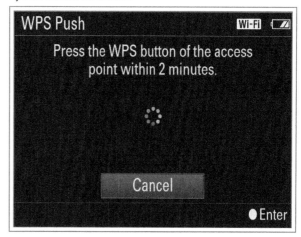

Figure 9-1. WPS Push Menu Screen

4. If the router has a button labeled WPS (Wi-Fi–protected setup), use the button to connect the camera to the network. Select the WPS Push option on the second screen of the Wi-Fi menu, and the camera will display the screen in Figure 9-1.

5. Within two minutes, press the WPS button on the router. Figure 9-2 shows an example of that sort of button.

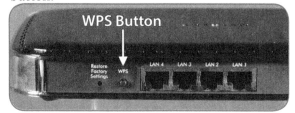

Figure 9-2. WPS Button on Router

6. If the setup is successful, the camera will display a message saying the access point has been registered. Proceed to Step 10.

–or–

If the router does not have a WPS button, or if pushing the button does not work, go to Step 7.

7. Locate the name of the network and its password. (This information may be on a label on the router.)

8. Select the Access Point Settings option on the second screen of the Wi-Fi menu, as shown in Figure 9-3.

Figure 9-3. Access Point Settings Option Highlighted on Menu

9. If the name of your network appears on the camera's screen, as shown in Figure 9-4, select that network and enter its password, as shown in Figure 9-5. The camera will display a virtual keyboard to let you enter the necessary characters.

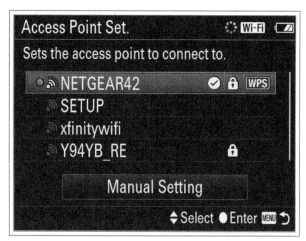

Figure 9-4. Network ID on Camera's Screen

Figure 9-5. Screen to Enter Network Password

–or–

If the access point does not appear on the camera's screen, enter its SSID (network ID), using the Manual Setting option on the menu screen, as shown in Figure 9-6, and then enter the network's password, as shown in Figure 9-5.

Figure 9-6. Manual Setting Highlighted on Menu Screen

10. On the Wi-Fi menu select Send to Computer, as shown in Figure 9-7.

Figure 9-7. Send to Computer Highlighted on Menu Screen

11. The camera will display a screen like that in Figure 9-8, reporting the name of the computer it is connecting to.

Figure 9-8. Screen Showing Camera Connecting to Computer

12. The computer will display an Importing dialog box. The images and videos will be uploaded to a folder on your computer. You can designate that folder using the software installed in Step 1. On my Macintosh, the default folder is the Pictures folder; the computer places the images and videos in a sub-folder bearing the date of the transfer.

The camera will only transfer images and videos that have not previously been transferred wirelessly to the computer, but there is no way to select which items will be transferred. The transfer may take a very long time, especially if the transfer includes AVCHD and XAVC S videos. In fact, Sony does not recommend transferring XAVC S videos using the Send to Computer option. I

ran a test using two brief videos, one recorded with the XAVC S HD format and one with the XAVC S 4K format. The camera did manage to send both files to my computer, but it took several minutes to transmit each video, each of which was less than 60 seconds in length.

I have not found this option to be as useful as transferring images and videos using a card reader or a USB cable, because of the time it takes for the transfer. However, if you have only a few items to transfer, it can be convenient to have this option available.

Sending Images to a Smartphone

If you don't need to print your images or do heavy editing, you may want to transfer them to a smartphone or tablet so you can send them to social networks, display them on the larger screen of your tablet, or otherwise share and enjoy them.

You can transfer images and MP4 videos (not XAVC S or AVCHD videos) wirelessly from the RX10 III to a smartphone or tablet that uses the iOS (iPhone and iPad) or Android operating system. These systems have different capabilities. With iOS, you have to use the camera's menu system to connect. With many Android devices, you can use NFC technology, which establishes a Wi-Fi connection automatically when the camera is touched against the smartphone or tablet.

Here are the steps for connecting using the menu system, using an iPhone as an illustration:

1. Install Sony's PlayMemories Mobile app on the phone; it can be downloaded from the App Store for the iPhone or from Google Play for Android devices.

2. Put the camera into playback mode and select an image or MP4 video to be transferred to the phone.

3. On the Wi-Fi menu, select Send to Smartphone, and from that option choose Select on This Device, as shown in Figure 9-9. On the next screen, you can choose to transfer This Image, All Still Images (or All Movie (MP4)) on Date, or Multiple Images.

4. On the next screen, as shown in Figure 9-10, the camera will display the SSID (name) of the Wi-Fi network it is generating.

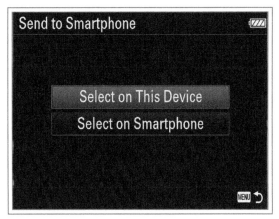

Figure 9-9. Screen to Select Items for Transfer to Smartphone

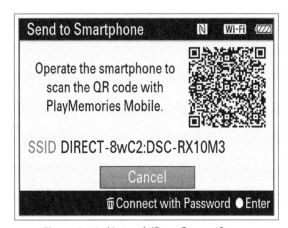

Figure 9-10. Network ID on Camera Screen

Figure 9-11. Camera's Network Selected on iPhone Screen

Figure 9-12. Icon for PlayMemories Mobile App on iPhone

5. On the phone, go to the Settings app, select Wi-Fi, and select the network displayed on the camera's screen, as shown in Figure 9-11. The first time you connect to that network, you will have to scan the QR code on the camera's screen with the phone, in the PlayMemories app. Or, if you prefer, you can press the C3/Delete button to go to a screen that displays the network password, which you can enter in the phone. After that initial connection, you can connect to that network without entering the password.

6. The camera will then display a message saying "Connecting." At this point, start the PlayMemories Mobile app, shown by the arrow in Figure 9-12 on the iPhone, unless it was already started so you could scan the QR code from the camera's screen.

7. The phone will display a message saying it is copying the images or videos from the camera, and will confirm the copying with a screen like that in Figure 9-13. The images or videos will appear in the Camera Roll area on an iPhone.

If you prefer, you can initiate the Send to Smartphone process by pressing the Function button when the camera is in playback mode, assuming that button is assigned to that operation. (The Function button is assigned to Send to Smartphone by default, but that operation can be assigned to a different button using the Custom Key (Playback) option on screen 5 of the Custom menu.)

Figure 9-13. Confirm Copying Screen on iPhone

Connecting with NFC

If you are using an Android device with NFC, the steps for connecting that device to the RX10 III are easier. I tested the procedure using a Samsung Galaxy S6 phone, but the same process should work with many Android devices that have NFC included. Here are the steps:

1. On the Android device, go to the Google Play Store and find and install the PlayMemories Mobile app, as shown in Figure 9-14.

Figure 9-14. PlayMemories Mobile App on Samsung Phone

2. On the Android device, go to the Settings app, and choose NFC and Payment. On the next screen, make sure the settings for NFC are turned on, as shown in Figure 9-15.

Figure 9-15. NFC Activated on Android Phone

3. Put the RX10 III into playback mode and display an image you want to send to the Android device.

4. Find the NFC icon on the right side of the camera, which looks like a fancy "N," as shown in Figure 9-16.

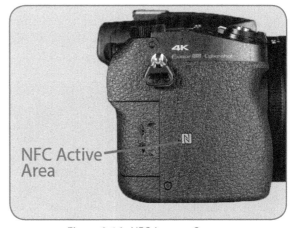

Figure 9-16. NFC Area on Camera

5. While both devices are active, touch the N on the camera to the NFC area on the Android device. (On the Galaxy S6, this area is on the back near the Samsung label, as shown in Figure 9-17.) Be sure the two areas touch; you cannot have the two NFC

spots separated by more than about a millimeter, if that.

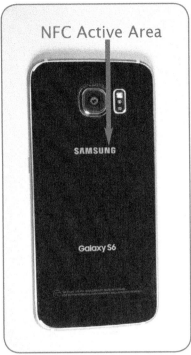

Figure 9-17. NFC Area on Galaxy S6 Phone

6. Hold the devices together, and within a few seconds you may hear a sound, depending on settings, and the camera will transfer the image to the Android device; you should see a message on the camera as the connection is established, as in Figure 9-18. You may have to select an option on the phone such as Connect to Camera to complete the operation. However, if you wait a few seconds, the camera and phone should complete the connection and transfer the image without any further action on your part.

Figure 9-18. Message on Camera as Connection is Established

7. The image will appear in the Gallery app on the Android device.

8. If you want to transfer multiple images, select that option from the camera's menu before touching the camera to the Android device to start the transfer.

By default, when you transfer images to a smartphone or tablet, the maximum image size will be 2 MP. If the image originally was larger than that, it will be reduced to that size. You can change this setting to send the images at their original size or at the smaller VGA size. To do that on your device, find the settings for the PlayMemories Mobile app. On an iPhone, go to Settings, then scroll to find PlayMemories Mobile. On an Android device, open PlayMemories Mobile, then tap the Settings icon. If the images were taken with Raw quality, they will be converted to JPEG format before being transferred to the smartphone or tablet, even if the device is set for transfer at the original size.

Using a Smartphone or Tablet as a Remote Control

You can use a smartphone or tablet as a remote control to operate the RX10 III from a distance of up to about 33 feet (10 meters), as long as the devices are in sight of each other. Here are the steps to do this with an iPhone:

1. Go to the camera's Application menu, marked by an icon with white and black blocks. Highlight the first item, Application List. Press the Center button to display the list of applications, or apps, currently loaded into the camera.

2. Use the direction buttons or the Control wheel or Control dial to highlight the app called Smart Remote Embedded, as shown in Figure 9-19.

 (If you have downloaded an updated version of this app, it may be called Smart Remote Control instead of Smart Remote Embedded.)

3. Start the app by pressing the Center button, and the camera will display a screen with the identification information for its own Wi-Fi network, along with a QR code for scanning and a message saying to press the C3/Delete button to use a password, as shown in Figure 9-20.

Figure 9-19. Smart Remote Embedded App on Camera

4. On the phone, you can open the PlayMemories Mobile app and choose Scan QR Code of the Camera, or you can go to the Wi-Fi tab of the Settings app and select the network ID displayed by the camera, as shown earlier in Figure 9-11. If this is the first time you are making this connection, you will have to enter the network password on the phone; you will not have to enter the password for future connections unless the network ID is changed. You may be prompted on the phone to install a profile. If so, follow the prompts.

Figure 9-20. Camera's Display of its Network ID

5. Set up the camera on a tripod or just place it where you want it, aiming at your intended subject.

6. Open the PlayMemories Mobile app on the iPhone, if it is not already open.

7. The camera will display a screen like that shown in Figure 9-21, with an icon in the upper left corner showing that the camera can now be controlled from the phone.

8. The phone will display a screen like that in Figure 9-22, showing the view from the camera's lens and several control icons.

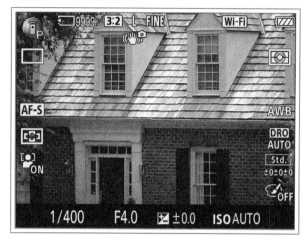

Figure 9-21. Camera Display when Remote Control App Running

Figure 9-22. iPhone Display for Remote Control App

9. Using these controls, you can zoom the lens and control exposure compensation. You can press the wrench-and-screwdriver icon to get access to settings for the self-timer, image review, save options, and a few other items, as shown in Figure 9-23. If you turn on Mirror Mode, the camera reverses its display of the scene, to make it easier to take a self-portrait. You also can adjust several options using the camera's controls. For example, you can use the Mode dial to change the shooting mode and you can use the Menu button to get

access to a special menu for the app, which includes options such as Image Size, Aspect Ratio, Creative Style, and others.

Figure 9-23. Settings for Remote Control App on iPhone

10. To record a movie from the phone, you have to turn the camera's Mode dial to the Movie mode position and select an exposure mode, at which point the camera icon on the iPhone app will change to a red button for starting a video recording. If you download the updated Smart Remote Control version of the app, you can focus by touching the screen with your finger. You also can use the settings panel to turn on the Touch Shutter function, which lets you trigger the shutter as the focus is set, when you touch the phone's screen with your finger. The updated app also has additional controls for exposure.

11. By default, images saved to the phone will be resized down to 2 MP unless they already were that small or smaller. Movies will be saved only to the camera; they cannot be displayed on the phone.

12. When you have set up the shot as you want it, press the camera icon on the iPhone app to take the picture or the red icon to start the video recording.

13. If you are using an Android device with NFC capability, you should be able to connect to the camera by touching the device to the camera, as discussed above in connection with transferring

images. To do this, you may first have to register the Smart Remote Embedded (or Smart Remote Control) app using the One-touch (NFC) menu option on screen 1 of the camera's Wi-Fi menu.

14. Once the connection has been made, you can separate the devices to the standard remote-control distance of up to about 33 feet (10 meters). If you have difficulty making an NFC connection, start the PlayMemories Mobile App on the Android device before touching the camera to that device. The camera can then be controlled using the PlayMemories Mobile app on the Android device, as noted in the numbered steps above.

The features of the remote control app are likely to change as Sony updates this and other apps; you can download updated versions at www. playmemoriescameraapps.com.

You can use the remote-control setup if you want to place your camera on a tripod in an area where birds or other wildlife may appear, so you can control the camera from a distance without disturbing the animals. (The wireless remote will work through glass if you are indoors behind a window.)

Also, you can try pole aerial photography, which involves attaching the camera to a painter's pole or other pole about 10 to 16 feet (3 to 5 meters) long, as shown in Figure 9-24, to get shots from a vantage point that would otherwise not be possible.

Figure 9-24. Camera Attached to Pole

I took the image shown in Figure 9-25 using this pole (see polepixie.com), which allowed me to get a shot from several feet outside of a second-story door to the outside. I would have no way of making this shot ordinarily. With this system, I could see exactly where

the camera was being aimed. It was difficult holding the pole steady while using the iPhone, but if you have another person to help, this setup can be useful for higher-angle photos of properties being sold, viewing above crowds, and other applications. Being able to control the camera remotely also might be useful in other situations in which you want to have the camera set up unattended, such as when you want to capture images in a classroom or other group setting without calling attention to the camera.

Figure 9-25. Image Taken from Pole with Remote Control App

Wi-Fi Menu

I have discussed some of the items on the Wi-Fi menu, whose first screen is shown in Figure 9-26, but there are several other options to discuss.

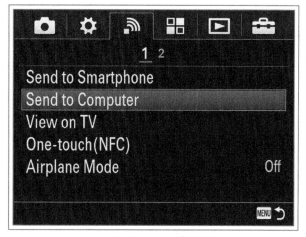

Figure 9-26. Screen 1 of Wi-Fi Menu

Following is information about each of the items on this menu.

SEND TO SMARTPHONE

This first Wi-Fi menu option lets you transfer images or MP4 videos to a smartphone or tablet. I discussed the steps for using this option earlier in this chapter. You also can press the Function button (or other button assigned to this option) when the camera is in playback mode, to carry out this action.

SEND TO COMPUTER

This next option lets you send your images and movies directly from the RX10 III to your computer via a Wi-Fi network. I discussed the steps for this process earlier in this chapter.

VIEW ON TV

This option sets up the RX10 III to transmit still images (not movies) wirelessly to a Wi-Fi–enabled TV, such as a Sony Bravia TV. The procedure will vary with the TV set you are using. Once the connection is established, you can browse through the images using the controls on the camera or the remote control of the TV if the TV is compatible with this setup.

This is a useful option once it is working properly, but I have found it difficult to set up. In the past, with other Sony cameras, I was able to connect to a device called WD TV Live, by Western Digital. I also downloaded a program called Serviio from http://serviio.org and configured this system to work as a DLNA streaming media server on my network. (DLNA stands for Digital Living Network Alliance; see www.dlna.org.)

With the RX10 III camera, I was able to connect to a Samsung HDTV with built-in networking. I selected an option on the TV for connecting to a mobile device. The TV prompted me to connect that device to the same network the TV was on. I used the WPS Push menu option to connect the camera to that network. Then, when I selected View on TV on the RX10 III, it displayed the screen seen in Figure 9-27 as it connected to the Samsung TV. The TV displayed a message asking me to confirm that the new device should be allowed to connect to the TV. I used the TV's remote control to say yes.

After that connection was established, the camera sent still images to the TV through the wireless network. The camera showed the screen in Figure 9-28, with a few control icons at the bottom.

Once this screen appeared, I pressed the Center button to pause the transmission, and pressed the Down button to display the screen shown in Figure 9-29 with additional options, including 4K display mode, found under the Playback Image Size option.

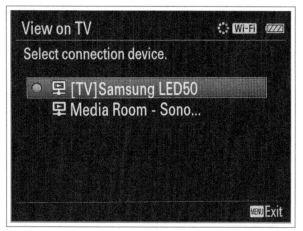

Figure 9-27. Camera Display for Discovery of TV Device

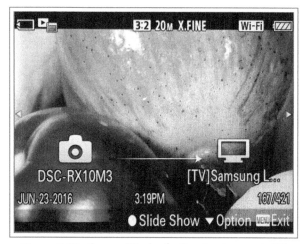

Figure 9-28. Camera Display for Sending Images to TV

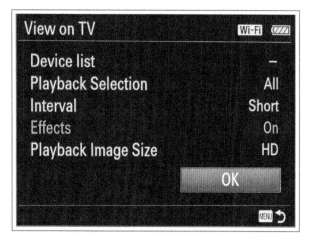

Figure 9-29. Additional Options for View on TV Menu Item

If you have a "smart" TV or are familiar with setting up a DLNA server, this option may be great for you.

Otherwise, I recommend that you view your images on a TV using an HDMI cable, a USB flash drive, or some other direct connection.

ONE-TOUCH (NFC)

The RX10 III has built-in near field communication (NFC) functionality, which means it can establish a wireless connection just by touching a smartphone or tablet that also has NFC built in. As of this writing, many Android phones and tablets have this feature, but Apple devices, such as iPhones and iPads, do not.

To use the NFC feature to start a camera app, the app first needs to be registered using this menu item. Then, with the smartphone or tablet turned on and the camera in shooting mode, touch the N mark on the right side of the camera to the NFC area on the smartphone or tablet. (It may not be marked.) The two devices should immediately start to establish a connection, and the application you registered using this menu option should launch. For example, you might want to register the Smart Remote Control application or another application that you have downloaded from Sony's site.

You don't have to use this menu option before using the camera to connect to a phone or tablet to transfer images. Also, the Smart Remote Embedded app is registered with this option by default from the factory, so you may not need to use this menu option at all unless you download additional apps for the camera.

AIRPLANE MODE

This option is a quick way to disable all of the camera's functions related to Wi-Fi, including Eye-Fi card activity and the camera's own internal Wi-Fi network. As indicated by its name, this option is useful when you are on an airplane and you are required to disable electronic devices. In addition, this setting can save battery power, so it may be worthwhile to activate it when you are on an outing with the camera and you won't need to use any Wi-Fi capabilities for a period of time.

If you try to use any of the camera's Wi-Fi functions such as Send to Smartphone or Send to Computer and notice that the menu options are dimmed, it may be because this option is turned on. Turn it off and the Wi-Fi options should be available again.

The second and final screen of the Wi-Fi menu is shown in Figure 9-30.

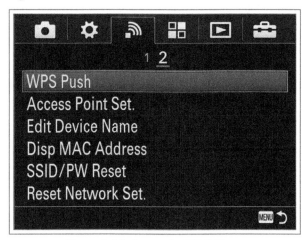

Figure 9-30. Screen 2 of Wi-Fi Menu

WPS Push

The WPS Push option gives you an easy way to set up your camera to connect to a computer over a Wi-Fi network. Ordinarily, to connect to a wireless network, you have to use the Access Point Settings option and then enter the network password into the camera to establish the connection. The WPS Push option gives you a shortcut if the wireless access point or wireless router you are connecting to has a WPS button. That option, if it is present, is likely to be a small button on the back or top of the router, and it is likely to have the WPS label next to it or on it. For example, one router I connect to has the button shown earlier in Figure 9-2.

If the router has a WPS button, you will not have to make any manual settings or enter a password. All you have to do is select the WPS Push menu option on the RX10 III, and then within two minutes after that, press the WPS button on the router. If the operation is successful, the camera's display screen will show that the connection has been established, as seen in Figure 9-31.

Once that connection has been made, you will be able to connect your camera to a computer on that network to transfer images using the Send to Computer option.

If the connection does not succeed using WPS Push, you will need to use the Access Point Settings option, the next item on screen 2 of the Wi-Fi menu.

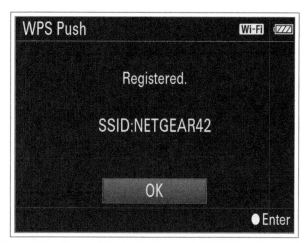

Figure 9-31. Camera Display for Successful WPS Push Connection

Access Point Settings

This option is for connecting the camera to a router if WPS Push, discussed above, is not available or does not work. I discussed the use of this option earlier in this chapter, in connection with sending images and videos to a computer wirelessly.

Edit Device Name

This next option, shown in Figure 9-32, lets you change the name of your camera as it is displayed on the network. The default name is DSC-RX10M3, and I have found no reason to change it, especially because doing so would require me to use the camera's laborious data-entry system.

Figure 9-32. Edit Device Name Menu Screen

This option could be useful, though, if you are in an environment where other RX10 III cameras are present and you need to distinguish one camera from another by using different names.

DISPLAY MAC ADDRESS

This menu option causes the camera to display a screen like that in Figure 9-33, which shows your camera's MAC address. MAC stands for media access control.

The MAC address is a string of characters that identifies a physical device that can connect to a network. In some cases, a router can be configured to reject or accept devices with specified MAC addresses. If you are having difficulty connecting your camera to your Wi-Fi router using the options discussed above, you can try configuring your router to recognize the MAC address of your camera, as reported by this menu item. I have not had to use this option, but it is good to have it available in case it is needed.

Figure 9-33. Display MAC Address Screen

SSID/PW RESET

When you connect your RX10 III to a smartphone or tablet, either to transfer images or to control the camera remotely with the other device, the camera generates its own Wi-Fi network internally. With this option, whose main screen is shown in Figure 9-34, you can force the camera to change the SSID (name) and password of its own wireless network.

You might want to do this if, for example, you have attended a conference where you allowed other people to connect their smartphones to your camera, and now you want to reset the camera's network ID so they will no longer have access to the camera's network.

Figure 9-34. SSID/PW Reset Confirmation Screen

RESET NETWORK SETTINGS

This final item on the Wi-Fi menu lets you reset all of the camera's Wi-Fi network settings, not just the SSID and password. This option is useful if you are having problems and need to get a fresh start with the wireless functions, if you are switching to a new wireless network where you use the camera, or if you are selling the camera and want to erase these settings.

Applications and Application Menu

The one menu system I have not yet discussed in any detail is the Application menu, represented by an icon with white and black blocks, to the right of the Wi-Fi menu's icon. This menu system opens the door to expansion of the RX10 III's features through applications, or apps, that you can download from a Sony website. I will give a brief introduction to this capability, though there undoubtedly will be ongoing changes to the website and the available options as time goes by.

The apps available from Sony are similar to apps for smartphones and tablets. Each camera app provides a separate function or set of functions, and is represented by a name and an icon. The apps are found on the RX10 III by going to the Application menu and selecting the first item, Application List, shown in Figure 9-35.

When you highlight that item and press the Center button, you will see a screen like that in Figure 9-36, with icons for all apps currently loaded into the camera. If you highlight any of those icons and press the Center button, you will activate that app.

Figure 9-35. Application List Item Highlighted on Menu

Figure 9-36. Camera App Icons on Application Menu

Although it is likely that the set of initial apps will change over time, when my camera was new it came with just one actual camera app installed—Smart Remote Embedded, which lets you use a smartphone or tablet to control the camera. The camera included two other apps that involve downloading and management of camera apps. Sony has updated the Smart Remote Embedded app to add new features in a version called Smart Remote Control, and I expect the app will be updated further in the future.

Besides the app that came pre-installed, Sony has, as of this writing, made available several other apps, some free and some for prices up to $9.99. These apps include My Best Portrait (free); Photo Retouch (free); Star Trail ($9.99); Motion Shot ($4.99); Smooth Reflection ($4.99); Time-Lapse ($9.99); Multiple Exposure ($4.99); Light Painting ($4.99); Stop Motion+ ($4.99); and Picture Effect+ (free), among others. You can read about these apps at Sony's site, mentioned in the next paragraph. Some of them, like Motion Shot and Picture

Effect+, add enhancements to features that already exist in the camera, and others, like Multiple Exposure, add new features.

In order to install and use any of these apps, you first have to go to Sony's site at www.playmemoriescameraapps.com and create an account. Then you can obtain information about the apps and download them by connecting your camera to the computer using the camera's USB cable. You may have to set USB Connection to MTP on screen 3 of the Setup menu to get these steps accomplished.

Once the account is set up and you have your camera registered with a Wi-Fi access point, you can also download an app directly to your camera. The camera has about 100 MB of capacity to install apps, and each of the ones I have downloaded so far has used about 6 MB, so you may be able to have about 15 apps installed altogether. To manage installed apps and view how much storage space has been used, you use the administrative app called Application Management, whose icon is shown in Figure 9-36.

To purchase an app directly from the camera, use the PlayMemories Camera Apps icon, also shown in Figure 9-36. With this method, you need to connect the camera to a wireless network and then sign in to the site with your username and password.

That can be a laborious process using the on-screen keyboard, but the system does work effectively for downloading apps if you are not able to use a computer for that purpose.

Once you have installed an app and activated it by selecting its icon, press the Center button and follow the on-screen instructions to use it. If you press the camera's Menu button while the app is running, the camera may display a special menu with options that apply while that app is in use. For example, when the Smart Remote Embedded app is running, if you press the Menu button you will see one of the five menu screens for that app, as shown in Figure 9-37.

The other four menu screens for this app display more camera options that can be controlled when the app is in use, such as Flash Mode, Focus Area, ISO, Picture Effect, and the like. In other cases, an app may just use icons to let you choose various functions. If you expect to use in-camera apps often, you can assign the

Application List menu item to the C1, C2, C3, Center, Left, Right, Down, Focus Hold, or AEL button so it can be called up quickly.

The second line of the Application menu, Introduction, provides some general information about applications.

Figure 9-37. Menu Screen for Smart Remote Embedded App

Other Topics

USING THE SUPERZOOM TELEPHOTO LENS

One of the distinctive features of the Sony RX10 III camera is the unusually long telephoto range of its built-in lens. This camera has a relatively large image sensor for a compact model, and most cameras with such a large sensor do not have a lens with such a long maximum focal length. In this section, I will provide some advice about taking advantage of the reach of the lens.

One of the most useful steps you can take is to use a solid tripod or other support when shooting at long focal lengths such as 600mm. If you can't use a tripod, use a monopod, fence post, or other steady support. You might be able to sit on a bench with the camera in your lap and tilt up the LCD monitor so the camera can sit firmly against your legs. Also, when using a tripod, it is a good idea to use the self-timer so the camera will not be moved when you press the shutter button to capture an image. You also can use a smartphone to trigger the camera remotely, as discussed in Chapter 9, or a remote control device to trigger it, as discussed in Appendix A.

If you cannot put the camera on a solid support, you can place the neck strap around your neck and hold the camera tightly against the strap to anchor it. Turn on the SteadyShot (Stills) option on screen 8 of the Shooting menu. Follow this rule of thumb for shutter

speed when using a long zoom lens: Use a shutter speed whose denominator is greater than the current focal length. For example, if you are shooting with the lens zoomed in to 600mm, use a shutter speed faster than 1/600 second, which would mean 1/640 second or faster. To do this, you would need to use Shutter Priority or Manual exposure mode, or, with Program or Aperture Priority mode, you would need to go to the ISO Auto Minimum Shutter Speed option on screen 4 of the Shooting menu and set it to 1000, for 1/1000 second.

Second, be aware of the ways in which using a long focal length can affect your images. For example, when the lens is zoomed in, distant objects can be compressed into a single plane, making it look as if they are all about the same distance from the camera. An example is shown in Figure 9-38.

Figure 9-38. Example of Compression Effect from Long Focal Length

Also, using a long focal length can be a good way to isolate a person or other subject in a crowd, as seen in Figure 9-39, where I captured an image of one person who was standing near a group of others.

Figure 9-39. Example of Isolating Subject with Long Focal Length

And, the depth of field can be very shallow when using a long focal length, especially for objects relatively close to the lens. Therefore, you can use a long focal length to blur the background and isolate the subject, as seen in Figure 9-40.

Figure 9-40. Example of Blurred Background from Long Focal Length

Third, remember the features discussed earlier in this book that can help you use the RX10 III's lens to its full advantage. For example, you can assign the Zoom Assist feature to a control button using the Custom Key (Shooting) option on screen 5 of the Custom menu. Then you can press that button when the lens is zoomed in to cause it to pull back to a wide view, helping you see the overall scene before zooming in on your subject again. Also, you can use the step zoom feature, with which the lens zooms only to specific focal lengths, such as 100mm, 200mm, and others. To do that, go to the Zoom Function on Ring item on screen 6 of the Custom menu and select Step. And, you can select which of the two lens rings controls zoom, and select the direction in which the ring rotates, using the Lens Ring Setup and Zoom Ring Rotate items on that same menu screen. You can adjust the speed with which the zoom lever zooms the lens, using the Zoom Speed item on screen 3 of the Custom menu.

Also, take advantage of focusing aids when shooting difficult subjects with a long focal length. Figure 9-41 is an image of the moon that I took with the RX10 III's lens zoomed to its full optical focal length of 600mm. I set the camera to Manual exposure mode with settings of 1/200 second, f/9.0, and ISO 200. I used manual focus. At first I used the MF Assist option, so I could fine-tune the focus with an enlarged view of the moon's craters. After some experimenting, I found I got better results using the Peaking Level function at High, and Peaking

Color set to red. When focus was sharp, I saw a bright, red outline on the outer edge of the moon, which made focusing much easier than relying on the normal manual focus mechanism, even with MF Assist activated.

Figure 9-41. Moon, 1/200 Second, f/9.0, ISO 200

I set the self-timer to ten seconds to minimize camera shake. I set Quality to Raw & JPEG so I would have a Raw image to give extra latitude in case the exposure seemed incorrect. I used a low ISO setting to keep the quality high. Because of the large sensor and relatively high resolution of the RX10 III, this image can be enlarged to a fair degree without deteriorating.

Finally, be aware of the advantages of using continuous shooting to increase the chances of getting one or more usable images when shooting under challenging conditions, such as using a long focal length.

Figure 9-42 is a shot of a duck, taken with the RX10 III at a zoom length of 477mm. Because the actions of birds are so unpredictable, I used burst shooting to get a variety of actions.

Figure 9-42. Telephoto Image Taken with Burst Shooting

STREET PHOTOGRAPHY

The RX10 III is well suited for street photography—that is, shooting candid pictures in public settings, often without the subject being aware of your activity. Its 24mm wide-angle lens takes in a broad field of view, so you can shoot from the hip without framing the image carefully on the screen. You can tilt up the LCD screen and look down at it to frame your shot, which can hide your actions. The f/2.4 lens lets in plenty of light, and it performs well at high ISO settings, so you can use a fast shutter speed to avoid motion blur. You can silence the camera by turning off its beeps and shutter sounds.

The settings you use depend in part on your style of shooting, One technique that some photographers use is to shoot in Raw, and then use post-processing software such as Photoshop or Lightroom to convert their images to black and white, along with any other effects they are looking for, such as extra grain to achieve a gritty look. (Of course, you don't have to produce your street photography in black and white, but that is a common practice.)

If you decide to shoot using Raw quality, you can't take advantage of the image-altering settings of the Picture Effect menu option. You can, however, use the Creative Style option on the Shooting menu. (You may have to use Sony's Image Data Converter software for the Creative Style setting to be effective.) You might want to try using the Black and White setting; you can tweak it further by increasing contrast and sharpening if you want. Also, try turning on continuous shooting, so you'll get several images to choose from for each shutter press.

You also can experiment with exposure settings. I recommend you shoot in Shutter Priority mode at a fairly fast shutter speed, 1/100 second or faster, to stop action on the street and to avoid blur from camera movement. You can set ISO to Auto, or use a high ISO setting, in the range of 800 or so, if you don't mind some noise.

Or, you can set the image type to JPEG at Large size and Extra Fine quality to take advantage of the camera's image-processing capabilities. To get the gritty "street" look, try using the High Contrast Monochrome setting of the Picture Effect item on the Shooting menu, with ISO set in the range of 800 or above, to include some grain in the image while boosting sensitivity enough to stop action with a fast shutter speed.

For Figure 9-43, though, I was shooting with the Sports Action setting of Scene mode when this woman appeared nearby, walking her dog. I didn't have time to change settings, so I grabbed this shot. It was just about time for sunset, and the camera used an ISO setting of 2000 with a shutter speed of 1/125 second, which stopped the action and avoided motion blur. The burst shooting, which is standard for the Sports Action option, gave me a choice of several images.

Figure 9-43. Street Photography Example

Another possibility is to take advantage of the camera's ability to shoot 4K video. You can shoot video using an exposure mode such as Shutter Priority that lets you use a fast shutter speed to avoid motion blur, and record a street scene for several seconds, or even a minute or more. You can then use video-editing software or the camera's Photo Capture feature to extract a single frame. Because of the high resolution of 4K video, the quality is likely to be quite acceptable. I used that technique for Figure 6-34, discussed in Chapter 6 in connection with Photo Capture.

INFRARED PHOTOGRAPHY

The RX10 III is capable of taking infrared photographs if you attach a 72mm infrared filter to the lens. I use a Hoya R72 infrared filter, for infrared photography. (The R72 designation is for the infrared capability, meaning the filter blocks light up to a wavelength of 72 nanometers; the 72mm size is the size for filters used by the RX10 III.) Figure 9-44 shows that filter attached to the camera.

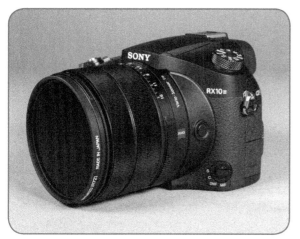

Figure 9-44. Hoya R72 Infrared Filter on RX10 III Camera

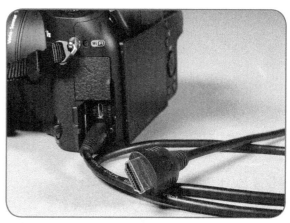

Figure 9-46. Micro-HDMI Cable Connected to Camera

I set a custom white balance while aiming at bright green grass or leaves with the filter in place, and then use a long exposure in Manual exposure mode, often as long as 15 seconds. Figure 9-45 is an example taken using the R72 filter. I used a shutter speed of 6 seconds at f/2.5 with ISO set to 200.

Figure 9-45. Infrared Image

CONNECTING TO A TELEVISION SET

The RX10 III can play back its still images and videos on an external television set, as long as the TV has an HDMI input jack. The camera does not come with any audio-video cable as standard equipment, so you have to purchase your own cable, with a micro-HDMI connector at the camera end and a standard HDMI connector at the TV end. These cables are available through online retailers and electronics stores.

To connect the cable to the camera, you need to open the flap marked Multi/HDMI on the left side of the camera and plug the micro-HDMI connector into the lower port underneath that flap, as shown in Figure 9-46.

Then connect the large connector at the other end of the cable to an HDMI input port on an HDTV set.

Once you have connected the camera to the set, the camera not only can play back images and videos; it also can record. When the RX10 III is hooked up to a TV while in recording mode, you can see on the TV screen the live image being seen by the camera. In that way, you can use the TV as a large monitor to help you compose your photographs and videos.

You also can use this port and cable to output a "clean" video signal to another device, such as a video recorder. To do that, you have to turn off the HDMI Information Display option under the HDMI Settings item on screen 3 of the Setup menu, as discussed in Chapters 7 and 8.

As noted earlier in this chapter, the RX10 III also has an option on the Wi-Fi menu called View on TV, which lets you view your images on a Wi-Fi–enabled TV. As I discussed in that chapter, I have found this option to be difficult to use effectively. Unless you are familiar with setting up the special type of network that is needed for this sort of connection, I recommend that you stick to using an HDMI cable for the connection.

APPENDIX A: ACCESSORIES

When people buy a camera, especially a fairly expensive model like the Sony RX10 III, they often ask what accessories they should buy for it. I will discuss several options, sticking mostly with items I have used personally.

Cases

You don't have to get a case for your RX10 III, but I always use one when I'm going out for a photo session, so I can carry along filters, extra batteries, and other items. I will discuss a few of the many possible choices.

The Sony case designed for the RX10 III, model number LCJ-RXJ, is shown in Figure A-1. I tried this case first because I always like to try the "official" option. It has the appearance of black leather, though it is made of 100% polyester. It does a good job of holding and protecting the camera, but has no room for accessories apart from a small interior pocket to hold an extra memory card, and does not have a particularly attractive appearance, in my opinion.

Figure A-1. Sony Case, LCJ-RXJ

The RX10 III will not fit in the case with the lens hood attached normally, but the camera will fit if you put the lens hood on in the reverse direction. Then, of course, you would need to remove the lens hood and put it back on in the correct orientation before taking any shots.

I also like the VanGoddy Laurel case, shown closed in Figure A-2 and open in Figure A-3. This case can just fit the camera if the lens hood is reversed, and the case is convenient to carry by its handle.

Figure A-2. VanGoddy Laurel Case, Closed

The Crumpler 6 Million Dollar Home Bag, model number MD6002-X01P60, shown closed in Figure A-4 and open in Figure A-5, with its large flap in front, has more than enough room for the camera and items such as external flash units, batteries, filters, and other items for a day trip.

Figure A-3. VanGoddy Laurel Case, Open

Figure A-4. Crumpler Case, Closed

Figure A-5. Crumpler Case, Open

Finally, the case that I probably use most often is the Lowepro Inverse 100 AW, shown in Figures A-6 and A-7. This case easily holds the RX10 III camera, and has additional storage space for batteries, chargers, filters and other items.

Figure A-6. Lowepro Inverse 100 AW Case, Top View

It also has straps on the bottom for carrying a tripod, as shown in Figure A-7, and it has two expandable mesh pockets on the sides that can hold small water bottles.

Figure A-7. Lowepro Inverse 100 AW Case, Side View

Batteries and Chargers

These are items I recommend you purchase when you get the camera or soon afterward. I use the camera heavily, and I find it runs through batteries fairly quickly. You can't use disposable batteries, so if you're out taking pictures and the battery dies, you're out of luck unless you have a spare battery, or you can plug the camera's charging cable into a power outlet or USB port. You can get a spare Sony battery, model number NP-FW50, for about $60 as I write this. It won't do you a great deal of good by itself, though, because the battery is designed to be charged in the camera.

There is an easy solution to this problem. You can find generic replacement batteries, as well as chargers to charge the batteries outside the camera, inexpensively from eBay, B&H Photo, and elsewhere. Figure A-8 shows a Vivitar external charger and replacement battery, which have worked well with the RX10 III. As I write this, you can purchase this charger with two batteries for about $28.

Figure A-8. Vivitar Charger and Replacement Battery

AC Adapters and Other Power Sources

Another option for powering the RX10 III is an AC adapter. For example, Sony sells Model No. AC-PW20 as an optional accessory. As you can see in Figure A-9, this item is quite cumbersome.

Figure A-9. Sony AC Adapter, Model No. AC-PW20

It consists of a power brick with a separate cord that plugs into an AC outlet, and a smaller cord that terminates in a block shaped like the camera's battery. That block is inserted into the camera, and the cord is routed through a small flap in the battery compartment door. You have to pull that flap out to leave room for the cord, so the door can be closed and latched. All this accessory does is power the camera. It does not recharge the battery, because the battery has to be removed from the camera in order to use this setup.

As I discussed in Chapter 1, the battery charger that comes with the camera, model no. AC-UUD12 in the United States, can be used as an AC adapter as well as a battery charger. If you plug the camera's USB cable into that charger and into the camera's Multi port, and then plug the charger into an electrical outlet, the camera will be powered by the charger when the camera is powered on, as long as there is a battery in the camera. If you turn the camera off, the charger will charge the battery inside the camera. However, you cannot use the supplied charger to power the camera if you are using the Multi port for some other purpose, such as uploading images and videos to a computer, or if you have connected a wired remote control to the camera. In those situations, the optional AC adapter would be quite useful.

Another device that is useful for providing power for the RX10 III is the Anker 40-watt desktop USB charger, shown in Figure A-10, which has 5 slots for charging devices such as smartphones and tablets. I use it to charge my iPhone and iPad, and it does a good job of

charging the Sony battery inside the RX10 III camera at the same time, or powering the camera when I am using it near my desk. You also can use this device to charge the G-Cord USB battery, discussed below.

Figure A-10. Anker 40-Watt Desktop USB Charger

Of course, it is usually not convenient to have the camera plugged into an external power source, unless you are just uploading images and videos to a computer, or taking shots in a studio. If you want to power the camera from an external source when you are in the field, you can get a good-quality USB power source and connect it to the camera, either for charging the camera's battery or for powering the camera. Figure A-11 shows the G-Cord 10000 mAh Boutique Mobile Power Supply.

This device has two standard-sized USB ports. You can plug the camera's USB cable into one of those ports and connect the other end to the camera to provide a long-lasting source of power, or to charge the camera's battery. You can charge the power supply through its own micro-USB port, using any compatible AC adapter. In fact, you can use the RX10 III's own AC adapter to recharge the G-Cord device. The G-Cord device is not very large and weighs about 220 grams (8 ounces).

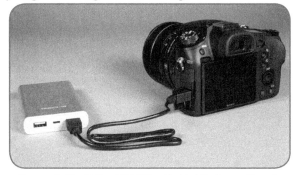

Figure A-11. G-Cord 10000 mAh Mobile Power Supply

Add-On Filters and Lenses

One positive feature of the RX10 III is that its lens is threaded to accept filters and other screw-on accessories. With many other compact cameras, you need a separate adapter to attach filters. With the RX10 III, you can use any filter with a 72mm thread.

There are various filters you might consider using. A neutral density (ND) filter reduces the amount of light entering the lens. Using such a filter is useful on a bright day when you need to use a slow shutter speed to smooth out the appearance of a waterfall or a wide aperture to allow blurring of the background. You might want to consider using a polarizing filter to cut down on haze and to darken skies for landscape photos. As I discussed in Chapter 9, you can use an infrared filter such as the Hoya R72 to take infrared photographs.

Figure A-12. Infrared Filter Attached to Lens of RX10 III

You also can use close-up lenses to enhance the camera's macro shooting. I do not recommend using accessory lenses such as teleconverters and wide-angle conversion lenses, because the RX10 III is not designed to withstand the weight of such an item on the end of its lens, especially when zooming.

Remote Controls

In several situations, it is useful to control the camera remotely. For example, when you are using slow shutter speeds, holding the shutter open with the BULB setting, or doing closeup photography, any camera motion during the exposure is likely to blur the image. If you control the camera remotely, you lessen the risk of blurred images from moving the camera as you press the shutter button. Remote control also is helpful when you need to be located away from the camera, as for taking self-portraits or images of wildlife, or using the camera on a pole, as discussed in Chapter 9.

As I discussed in Chapter 9, the RX10 III has a built-in Wi-Fi capability for connecting a computer, smartphone, or tablet to the camera wirelessly. Besides using that feature to transfer images from the camera to the other device, you can use a smartphone or tablet as a wireless remote control. However, it can be tricky to establish and maintain the connection between the camera and the phone or tablet.

Fortunately, Sony offers several remote controls that are compatible with the RX10 III camera. Sony's model number RM-VPR1 is shown in Figure A-13.

Figure A-13. Sony Remote Control, Model No. RM-VPR1

You connect this device to the Multi port on the left side of the camera. With this remote, you can turn the camera on and off, use the autofocus system, zoom the lens in and out, take a still image, lock the shutter down for a long exposure, and start and stop video recording.

This remote comes with two cables—one for cameras with a Remote terminal and one for cameras like the RX10 III, which has the Multi terminal. Take the cable that has identical connectors at each end, and plug the end with the smaller plastic housing into the camera. Plug the other end of the cable, which has a larger housing, into the remote. You also can attach the included clip to the underside of the remote, if you want to clip the remote to a tripod or other support.

You can half-press the remote's shutter button to cause the autofocus system to operate (if the camera is in an autofocus mode), and press the button fully to take a still picture. You can press the shutter button down and then slide it back toward the other controls to lock it in place. This locking is useful when you are taking continuous shots using the Drive Mode settings, or when you want to hold the shutter open using the BULB setting in Manual exposure mode. Press the shutter button back up in its original direction to release it.

The red button labeled Start/Stop is similar to the Movie button on the RX10 III camera. Press it once to start recording a movie and press it again to stop the recording.

The power button on the side of the remote control can also be used with the RX10 III, although it does not duplicate the functions of the camera's own power switch. You have to have the camera's power switch in the On position for the remote to work, and it cannot turn the camera completely off; it can only place it into power-saving mode or wake it up.

A more sophisticated remote, Sony model number RMT-VP1K, is shown in Figure A-14.

Figure A-14. Sony Remote Control, Model No. RMT-VP1K

This remote comes with an infrared receiver with a cable that plugs into the camera's Multi port. The receiver, shaped like a small cylinder, has a foot for attaching to the camera's flash shoe.

The remote control itself is similar to the wired remote discussed earlier, RM-VPR1, though there are some differences. You can press the shutter button, and you can lock it down for BULB shooting. You can zoom the lens and start and stop a video recording. The remote also has a slide switch labeled TC Reset on the left side. You can operate that switch to reset the camera's time code to zero. With the camera's Mode dial at the Movie position, just press the TC Reset switch on the remote, and the time code displayed in the lower left corner of the display will be reset to the zero point. The way to accomplish this reset in the camera is to go to the TC Preset option under TC/UB Settings on screen 3 of the Setup menu. With TC Preset highlighted, press the

Center button to bring up the screen showing the values of the current time code. While that screen is displayed, press the C3/Delete button, and the time code will be reset. It is considerably easier to just press the TC Reset button on the remote if you need to reset the time code.

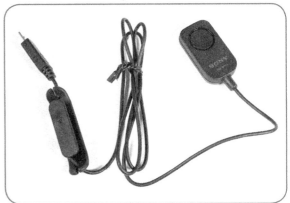

Figure A-15. Sony Remote Control, Model No. RM-SPR1

Figure A-15 shows another option, Sony model number RM-SPR1. This device is a very simple wired remote that also connects to the Multi port. It has only one large button, which acts as a remote shutter button. You can press it halfway to evaluate focus and exposure, press it all the way to take a still image, or hold it down to fire a burst of shots if Drive Mode is set for continuous shooting. You cannot use this remote to record a movie or carry out any other functions.

Cable Release

There is one more type of external control to discuss—the traditional, mechanical cable release. Although, as noted above, you can operate the RX10 III using a Sony remote control or a smartphone, Sony also has designed this camera with a shutter button that is threaded to accept an old-fashioned cable release. This inexpensive device, an example of which is shown in Figure A-16, screws into the camera's shutter button.

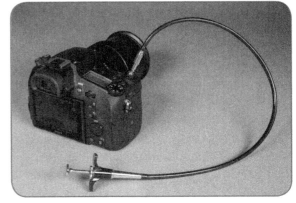

Figure A-16. Cable Released Attached to RX10 III

You can press the plunger at the other end of the cable to trigger the shutter, and you can lock the cable to keep the shutter pressed until you unlock it. This device is useful for general shooting when you don't want to risk causing motion blur by pressing the shutter button with your hand. It is especially useful for exposures using the BULB setting, when you have to hold the shutter closed for many seconds.

External Flash Units

The RX10 III is equipped with Sony's special Multi Interface Shoe, where you can attach an external flash unit, among other items.

The most obvious choice for using external flash is to use one of the units offered by Sony. The smallest Sony flash for use with the RX10 III is model number HVL-F20M, shown in Figure A-17.

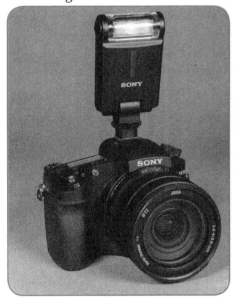

Figure A-17. Sony Flash, Model No. HVL-F20M

This unit is very small and fits with the camera nicely. It has a guide number of up to 20 at f/2.8 and ISO 800, meaning it can reach up to 20 meters (66 feet) with those settings; it has a shorter range at higher apertures and with lower ISO values. It has a Bounce switch, which rotates the flash head upward by 75 degrees to let you bounce the flash off a ceiling or high wall.

The F20M is capable of acting as the trigger unit for Sony's wireless flash control system. As discussed in Chapter 4, the RX10 III's built-in flash unit does not provide that function. So, if you want to fire other flash units remotely using Sony's system, the F20M is the least

expensive option for that purpose. Note, though, that the F20M cannot be fired remotely using that system; it can act as the master unit, but not as a slave unit.

The next step up with Sony's external flash options is a considerably larger unit, the HVL-F32M, shown in Figure A-18.

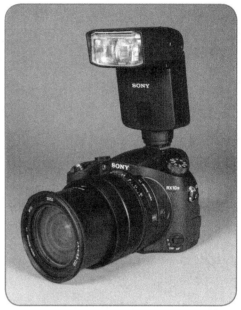

Figure A-18. Sony Flash, Model No. HVL-F32M

This powerful flash can act as either the trigger unit or a remote unit with Sony's wireless flash system. The next model, HVL-F43M, shown in Figure A-19, also can assume either role for wireless flash and includes a video light that can provide continuous illumination.

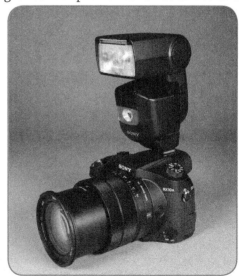

Figure A-19. Sony Flash, Model No. HVL-F43M

Or, you can opt for the largest unit, the Sony HVL-F60M, not shown here, which also can perform both wireless functions.

Another option is to use an older Sony flash that was not designed for the Multi Interface Shoe. In that case, you need Sony's shoe adapter, model number ADP-MAA, so the flash will work automatically with the RX10 III.

There also are several non-Sony flash units that work with the hot shoe of the DSC-RX10 III and fire whenever the camera's shutter button is pressed. However, with these units, there is no communication with the flash unit through the camera's accessory shoe. Therefore, you have to set both the camera and the flash to their manual modes and determine the exposure through trial and error or by measuring the light with a meter.

I have tested several non-Sony units that fire reliably from the accessory shoe of the RX10 III, including the Yongnuo YN560-III and the LumoPro LP180.

If you are not using the built-in flash or a Sony external flash, you probably will want to set the camera's white balance to its Flash setting, because the Auto White Balance setting will not take account of the use of flash unless the flash communicates with the camera.

Here is one other issue you need to be aware of when using a non-Sony external flash unit. When you set the camera to Manual exposure mode, the camera's display screen is likely to be black or very dark because the Manual exposure settings would result in a dark image if you were not using flash, and the camera will not "know" about the effects of the non-Sony flash. Therefore, it may be difficult to compose the shot.

The RX10 III has a menu option that deals with this type of situation—the Live View Display option on screen 3 of the Custom menu. If you select the Setting Effect Off option for that menu item, then, when you use Manual exposure mode, the camera's display will not show the dark image that would result from the shot without flash; instead, the display will show the image with normal brightness (if there is enough ambient light), so you can compose the shot with a clear view of the scene in front of the camera.

Another way to deal with external flash is to use a radio flash trigger system, such as model number NPT04, by CowboyStudio.

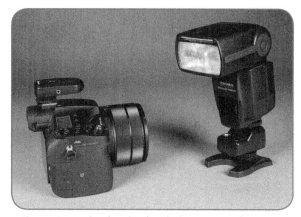

Figure A-20. CowboyStudio Flash Trigger with RX10 III

As seen in Figure A-20, I mounted the transmitter in the camera's accessory shoe and attached the receiver to the Yongnuo YN560-III, an external flash unit discussed above, which I placed on a small stand. I set the transmitter and receiver to the same channel, and I turned on the power of the receiver. (The transmitter does not have a power switch, but it has a battery that needs replacement about once a year.) Then, with the camera and flash set to their Manual modes and the camera's flash mode set to Fill-flash, when I pressed the shutter button, the external flash fired.

With this system, you can use any flash unit that is compatible with the receiver. I have found that you need to use a flash that has a Manual mode, like the Yongnuo unit. External flash units that have only automatic (TTL) exposure systems do not work, in my experience.

I also tested another radio transmitter, the Hensel Strobe Wizard Plus, which I use for triggering monolight flash units for photography with a DSLR. It worked well in the accessory shoe of the RX10 III, triggering the monolights perfectly.

Figure A-21. Softbox with Yongnuo YN560-III Flash

You may want to consider one other accessory for use with any external flash unit—a softbox, like the one shown in Figure A-21. A softbox is an enclosure that surrounds a flash unit and diffuses the light through a white, translucent surface, enlarging the area that lights up the subject. The effect of using a softbox is to soften the light because the larger the light source, the less harsh the light will be, with softer shadows. This softbox is a Photoflex LiteDome XS, whose enclosure is about 12 by 16 inches (30 by 40 cm). For Figure A-22, I placed the softbox on a light stand over a Yongnuo flash unit and took the image seen in Figure A-22.

Figure A-22. Image Taken with Flash in Softbox

Sony Video Light

Another item that can be useful for supplemental lighting, especially for recording video, is the Sony HVL-LBPC video light, shown in Figure A-23. This compact unit fits nicely in the Multi Interface Shoe of the RX10 III camera and communicates with the camera through that shoe. As I discussed in Chapter 7, the Video Light Mode option on screen 5 of the Custom menu selects the way in which the light interacts with the camera, if the light's power switch is placed at the Auto position. If you don't need automatic control of the light, you just turn it on or off using its power switch. I put together a short video demonstration at https://youtu.be/CS52xDldvLw.

This light is quite bright and versatile, with its condenser lens, diffuser, and barn doors. However, at $550.00, it is quite expensive, and it does not come with a battery. You have to use an expensive Sony battery, which cost me about $170.00. (Watch out for counterfeit batteries, which look genuine but do not

work in this light.) If you use your camera for mobile video shooting, this light may be an excellent accessory, if you don't mind the expense.

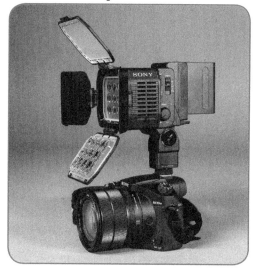

Figure A-23. Sony HVL-LBPC Light with RX10 III

External LCD Monitor

There is another accessory to consider for viewing live and recorded images with the RX10 III. The Sony Clip-On LCD Monitor, model number CLM-FHD5, is an add-on unit with a 5-inch (12-cm) screen. This small monitor, shown in Figure A-24, comes with a foot that attaches securely to the accessory shoe of the RX10 III.

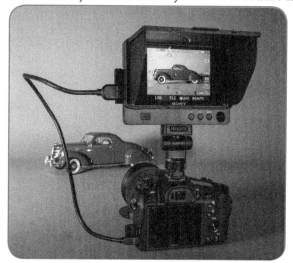

Figure A-24. Sony LCD Monitor, Model No. CLM-FHD5

The unit includes a short HDMI cable that ends in a micro-HDMI plug at the camera end, for connecting to the HDMI port of the camera.

This monitor works well with the RX10 III. It adds visibility for viewing the shooting screen and for

playing back images and videos. The screen can rotate 180 degrees, so you can view the scene from the front of the camera for self-portraits. It also can tilt up or down for viewing from high or low angles. The monitor has numerous controls for settings such as Peaking, brightness, and contrast, and it has a special display mode for boosting the contrast when you are using the S-Log2 gamma curve, whose use produces dark footage that is hard to see before it has been processed with a computer. This unit costs about $700 at the time of this writing, plus the cost of a battery, but if you need the extra screen size or versatility, it is worth looking into.

External Microphones

With the inclusion of the Multi Interface accessory shoe, the DSC-RX10 III can use a Sony microphone that gets its power from that shoe. One relatively inexpensive microphone that connects through the camera's special interface shoe is Sony's model number ECM-XYST1M, shown in Figure A-25.

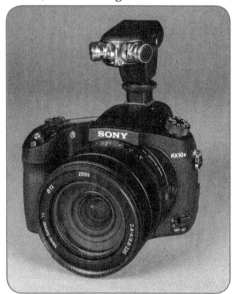

Figure A-25. Sony Microphone, Model No. ECM-XYST1M

This compact device has two microphone units that can be kept together or separated by 120 degrees, as shown here, to pick up sounds from different directions.

I did some informal testing to see if I could hear a difference in sound quality with this microphone installed as opposed to using the built-in microphone. I noticed an increased amount of lower frequency sound and some added sensitivity. If you are recording a concert or other musical event, the external microphone might enhance the quality of the audio, but

for everyday use, I find the sound quality with the built-in microphone to be fine.

Another option, which provides wireless capability, is Sony's Bluetooth microphone, model number ECM-W1M, shown in Figure A-26.

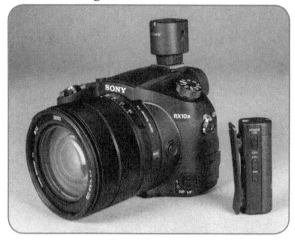

Figure A-26. Sony Microphone, Model No. ECM-W1M

With this unit, you attach a small receiver to the camera's Multi Interface Shoe as shown here. You then can clip the separate microphone to a shirt pocket or any other location, and the camera will pick up sounds from the microphone from any distance within a range of about 300 feet or 100 meters.

Sony also offers a more expensive and sophisticated option for using external microphones—the XLR-K2M adapter kit, shown in Figure A-27. The kit connects to the camera's Multi Interface Shoe and provides inputs for two professional-quality XLR microphones. That type of microphone provides balanced input, resulting in lower noise and cleaner sound.

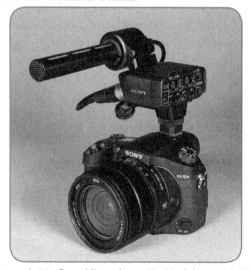

Figure A-27. Sony Microphone Kit, Model No. XLR-K2M

The kit includes a single Sony shotgun microphone with an XLR connection and an adapter for attaching the kit to the camera, as well as a connector for another microphone and controls for both inputs.

You may not want to spend $600.00 to add this capability to a compact camera, but, given the RX10 III's excellent video features, it could be a worthwhile expense if you use the camera heavily for video production.

You also can use any of a multitude of other external microphones with the RX10 III, as long as the microphone has a cable that terminates in a standard 3.5mm stereo plug. One example from Sony is a shotgun mic, model number ECM-CG50. You also can use third-party mics, such as the Rode VideoMic Pro, or various models from Shure or Audio-Technica.

External Video Recorder

In Chapter 8, I discussed how to take advantage of the RX10 III's video features to output its 4K video signal via the HDMI port to an external video recorder. Using this system, you can record 4K video without having to obtain an especially fast memory card for the camera; you can record with no memory card in the camera at all.

The recorder I used for this process is the Atomos Shogun, a capable device though expensive, at about $1,500 as of the time of this writing. The Shogun can be mounted on top of the camera as shown in Figure A-28, where I used a Vello Multi-Function Ball Head; the Shogun has tripod sockets on its top and bottom edges.

The combination of RX10 III and Shogun performed very well in producing high-quality 4K video files. The menu system is easy to work with and the recorder produces high-quality files. At the highest quality, the files can be extremely large (more than 220 GB in one of my tests), so be prepared with a strong computer capability for editing. There are other 4K video recorders that might work as well, such as the Odyssey7 series of recorders from Convergent Design or devices from Blackmagic Design, as well as less expensive models from Atomos, though I have not tested any of those.

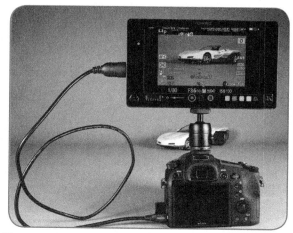

Figure A-28. Atomos Shogun Recorder Mounted on RX10 III

Tripods

Finally, an item I have found to be an excellent choice for traveling with the Sony RX10 III camera is the Manfrotto BeFree tripod, seen in Figure A-29.

Figure A-29. Manfrotto BeFree Tripod - Aluminum

This tripod, model MKBFRA4-BH, includes a versatile head, reduces to about 20 inches (50 cm) long just by collapsing the legs, and to about 16 inches (40 cm) if you fold the legs backward. It weighs about 3 pounds 5 ounces (1.5 kg). There also is a carbon fiber model, MKBFRC4-BH, shown in Figure A30, which is more expensive but lighter and also very sturdy.

Figure A-30. Manfrotto BeFree Tripod - Carbon Fiber

APPENDIX B: QUICK TIPS

This section includes tips and facts that might be useful as reminders. My goal is to give you small bits of information that might help you in certain situations or that might not be obvious to everyone. I have tried to include points you might not remember from day to day, especially if you don't use the RX10 III constantly.

Use continuous shooting settings. Consider turning continuous shooting on as a matter of routine, unless you are running out of storage space or battery power, or have a reason not to use it. Even with portraits, you may get the perfect expression on your subject's face with the fourth or fifth shot. Call up Drive Mode, scroll to Continuous Shooting, and select it. Continuous shooting is not available when the camera is set to the Sweep Panorama mode or any Scene mode setting other than Sports Action. It also is incompatible with the last six Picture Effect settings, Multi Frame Noise Reduction, Smile Shutter, and Auto HDR. You can shoot more rapidly if you use the Speed Priority setting, but the camera will not adjust its focus after the first shot.

Use shortcuts. You can speed up access to many settings by placing them on the Function menu for recall with a press of the Function button. You can assign your most-used settings to the Control wheel or a control button using the Custom Key (Shooting) option on screen 5 of the Custom menu. Speed through the Shooting menu by using the Control wheel to move rapidly through the items on each screen, and use the Right and Left buttons or the Control dial to move through the menu system a full screen at a time. In shooting mode, use the Control dial to change scene types in Scene mode and to change panorama direction in Sweep Panorama mode.

Use the Memory Recall shooting mode. MR position on the Mode dial gives you a powerful way to customize the RX10 III by storing seven groups of settings. You also can use it for more specific purposes. One thing I

like to do is have one slot set up to remove all "special" settings, such as Creative Style, Picture Effect, and Drive Mode, so I can quickly set up the camera to take a shot with no surprises.

Use the extra settings for white balance and Creative Style. When you set white balance, even with the Auto White Balance setting, you can press the Right button to use the amber-blue and green-magenta axes to further adjust the color of your shots. This setting is not obvious on the menu screen, but it gives you a useful tool to alter color settings. Just remember to undo any color shift when you no longer need it. Also, you can press the Right button or turn the Control dial after selecting a Creative Style option and then adjust the contrast, saturation, and sharpness settings. (Saturation is not adjustable for the Black and White or Sepia setting.)

Play your movies in iTunes, and on iPods, iPhones, and iPads. If you set the RX10 III to record movies using the MP4 format, the files are compatible with Apple's QuickTime and iTunes software. You can use iTunes to copy your MP4 files to a device such as an iPad. Open a window on your computer to display the icon for a movie file (using Windows Explorer or Macintosh Finder), then open iTunes on the same computer and drag the .mp4 file from the Explorer or Finder window to the panel for the Library in iTunes. You can then play the movie from iTunes. To play it on an iPod, iPhone, or iPad, select the video in iTunes, then select File on the iTunes menu, then from that menu item select Create New Version, and then choose Create iPod or iPhone version, or iPad or AppleTV version, as appropriate. After you sync iTunes with your device, the converted movie will play on that device. (If you have trouble locating the .mp4 files on your computer, see the last part of Chapter 8.)

Use the lens hood. Sony includes a lens hood with the RX10 III. It's a good idea to attach it to the lens when

shooting outdoors, especially when the sun is bright, to protect against glare.

Diffuse your flash. If the built-in flash produces light that's too harsh for macro or other shots, use translucent plastic pieces from milk jugs or broken ping-pong balls as homemade diffusers. Position the plastic between the flash and the subject. When using Fill-flash outdoors, try using the Flash Compensation setting on screen 3 of the Shooting menu to reduce the intensity of the flash by -2/3 EV.

Use the self-timer to avoid camera shake. The self-timer is not just for group portraits; you can use the two-second or five-second self-timer whenever you use a slow shutter speed and need to avoid camera shake. It also is useful for macro photography. Don't forget that you can set the self-timer to take multiple shots, which can increase your chances of getting more great images.

Be aware of conflicting settings. There are times when a feature will not operate because a conflicting setting is in place. One excellent feature of the RX10 III is that it often will explain the conflict when you try to select the feature. For example, if you have Picture Effect turned on and then try to select Creative Style, when you press the Center button to select it, the RX10 III will display an error message about the conflict. There are many such conflicts; an important one to remember is that you cannot take still images when the Mode dial is set to Movie mode, except during video recording.

Use Flexible Spot for the Focus Area setting. With this option, you can move the focus frame around the display and change its size. To use the feature most efficiently, set the Center button or one of the other control buttons to Focus Standard in the Custom Key (Shooting) menu option. Then, just press the assigned button in shooting mode to make the focus frame movable.

Be aware of functions available only by assigning a button. The RX10 III has several features that do not appear on any menu and that can be used only if you use the Custom Key (Shooting) menu option on screen 5 of the Custom menu to assign them to a button. These include AEL Hold or Toggle; AF/MF Control Hold or Toggle; Eye AF; Smart Teleconverter; Zoom Assist; Focus Hold; and Deactivate Monitor.

Take advantage of two shooting modes that are hidden in menus. The Superior Auto shooting mode is not on the Mode dial; to set it you have to set the Mode dial to Intelligent Auto mode, then use the Auto Mode menu option to select Superior Auto, which adds the capability of taking bursts of shots to create composite images with improved quality. To get to the Multi Frame Noise Reduction setting, which involves bursts of shots to reduce noise, you have to use the ISO menu option. With MFNR, you normally would want to set the ISO level to a high value or Auto, but you also can use that option with a low ISO value to get higher image quality from the composite image.

Use DMF for focusing. Set the focus switch to DMF for direct manual focus. Then you can use autofocus, but still turn the focusing ring for further adjustments with manual focus. If you have MF Assist turned on to enlarge the manual focus image, you have to half-press the shutter button to get the enlargement when DMF is in effect. If you turn the focus switch to DMF when recording video, the camera will use continuous autofocus.

Use Auto ISO in Manual exposure mode. Not all cameras allow this. With this setting, you can set aperture and shutter speed as you want for a particular effect, and let the camera adjust the exposure by setting the ISO automatically.

Try time-lapse photography. With time-lapse photography, a camera takes a series of still images at regular intervals, several seconds, minutes, or even hours apart, to record a slow-moving event such as the rising or setting of the moon or sun or the opening of a flower. The images are played back at a much faster rate to show the whole event unfolding quickly. You can purchase the Time-lapse app from Sony through playmemoriescameraapps.com for $9.99 as of this writing. This app includes several preset options for capturing sunsets, night scenes, miniatures, and other traditional time-lapse subjects. You also can use the interval-shooting feature of the Remote Camera Control software when the RX10 III is connected to a computer.

Use the self-timer for bracketed exposures. To do this, use the Bracket Settings option on screen 3 of the Shooting menu and select the first sub-option, Self-timer During Bracket.

Use the camera's automatic HDR option. To do this, go to screen 5 of the Shooting menu, select DRO/Auto HDR, then HDR. You cannot use certain other settings with HDR, including Raw for Quality, Picture Effect, or Picture Profile.

Use the Picture Profile feature to full advantage. If you are serious about getting the maximum benefit from the Picture Profile feature, especially PP7 with its use of the S-Log2 gamma curve setting, you need to use color-grading software. A good software package can take advantage of the profiles and bring out the colors, contrast, and other aspects of your video files in the way you intend. One powerful program is DaVinci Resolve 12.5, which is available in a free version as well as a professional one. See https://www.blackmagicdesign.com/products/davinciresolve.

Use tethered shooting. Go to the USB Connection option on screen 3 of the Setup menu and choose the PC Remote setting. Then use the camera's USB cable to connect the camera to a computer that has Sony's Remote Camera Control software installed. Using the icons in the window that appears on the computer, you can control several settings on the camera and save images directly to a directory on the computer.

Appendix C: Resources for Further Information

Books

There are many excellent books about general subjects in photography. I will list a few especially useful books that I consulted while writing this guide.

C. George, Mastering Digital Flash Photography (Lark Books, 2008)

C. Harnischmacher, Closeup Shooting (Rocky Nook, 2007)

H. Horenstein, Digital Photography: A Basic Manual (Little, Brown, 2011)

H. Kamps, The Rules of Photography and When to Break Them (Focal Press, 2012)

J. Paduano, The Art of Infrared Photography (4th ed., Amherst Media, 1998)

Websites and Videos

Since websites come and go and change their addresses, it's impossible to compile a list of sites that discuss the RX10 III that will be accurate far into the future. I will include below a list of some of the sites or links I have found useful, with the caveat that some of them may not be accessible by the time you read this.

Digital Photography Review

Listed below is the current web address for the "Sony Cyber-shot Talk" forum within the dpreview.com site. Dpreview.com is one of the most established and authoritative sites for reviews, discussion forums, technical information, and other resources concerning digital cameras.

http://www.dpreview.com/forums/1009

Reviews and Demonstrations of the RX10 III

The links below lead to reviews or previews of the RX10 III by dpreview.com, photographyblog.com, and others, as well as some YouTube videos with useful demonstrations.

http://www.dpreview.com/reviews/all-about-that-lens-sony-cyber-shot-rx10-iii-review

http://www.imaging-resource.com/PRODS/sony-rx10-iii/sony-rx10-iiiA.HTM

http://www.imaging-resource.com/PRODS/sony-rx10-iii/sony-rx10-iiiA.HTM#shooting

http://www.digitaltrends.com/photography/sony-rx10-iii-hands-on/

http://www.stevehuffphoto.com/2016/03/30/hands-on-sony-rx1r-iii-some-samples-thoughts/

https://www.engadget.com/2016/04/02/sony-rx10-iii-hands-on-sample-photos/

http://www.dpmag.com/cameras/mirrorless/sony-rx10-iii/

https://www.cinema5d.com/sony-rx10-iii-review-real-world-video-samples-first-impressions/

White Knight Press

My own site, White Knight Press, provides updates about this book and other books, offers support for download of PDFs and eBooks, and provides a way for readers or potential readers to contact me with questions or comments.

http://www.whiteknightpress.com

The Official Sony Site

The United States arm of Sony provides resources on its website, including the downloadable version of the user's manual for the RX10 III and other technical information.

http://esupport.sony.com

http://helpguide.sony.net/dsc/1410/v1/en/print.pdf

https://esupport.sony.com/US/p/model-home.pl?mdl=DSCRX100M3&LOC=3#/manualsTab

The next link is to a guide for using the Picture Profile feature with the RX10 III:

http://helpguide.sony.net/di/pp/v1/en/index.html

The link below is to the operating instructions for the PlayMemories Mobile app for Android and iOS:

http://support.d-imaging.sony.co.jp/www/disoft/int/playmemories-mobile/en/operation/index.html

The link below leads to the site for downloading camera apps for the RX10 III:

https://www.playmemoriescameraapps.com/portal/

The link below provides information about compatibility of various Sony microphones with Sony camera models.

http://www.sony.net/Products/diacc/compatibilities/microphone/

Other Resources

The first two links below are to a two-part tutorial on the use of the S-Log2 gamma setting on the Sony A7s camera, which includes a lot of helpful information that is applicable to the use of that setting with the RX10 III:

http://www.xdcam-user.com/2014/08/exposing-and-using-slog2-on-the-sony-a7s-part-one-gamma-and-exposure/

http://www.xdcam-user.com/2014/10/using-s-log2-from-the-a7s-in-post-production/

This next link is to a fairly detailed video seminar by video expert Philip Bloom discussing video settings for

the Sony A7S camera, much of which is useful for the RX10 III.

https://youtu.be/zeX-eZXaRtw

The link below is to more information from Philip Bloom, including very interesting insights about the video features of the RX10 III.

http://philipbloom.net/blog/rxroadtests/

The link below is to a video that gives general tips about movie settings on the Sony Alpha A7S camera, which has many settings similar to those of the RX10 III.

https://blog.sony.com/2014/10/a7s-movie-setting-tips-for-the-filmmakers-out-there/

The next link gives some helpful discussion of using picture profiles on the Sony FS-700 video camera. Much of the discussion, which explains terms such as gamma, black level, and knee, is applicable to the RX10 III.

http://videogearsandiego.blogspot.com/2013/12/using-picture-profiles-on-sony-fs-700.html

The link below is a YouTube video that gives one person's approach to grading S-Log2 video from the Sony A7S camera using DaVinci Resolve software.

https://youtu.be/WPRiGXF5JKQ

This next link provides some technical information about the S-Log 2 gamma curve:

http://blog.abelcine.com/2013/01/18/sonys-s-log2-and-dynamic-range-percentages/

If you're interested in using the Atomos Shogun external video recorder, the video in the link below gives a helpful introduction to using that recorder with the Sony A7S and the Panasonic GH4. A lot of this discussion is helpful for users of the RX10 III.

http://nofilmschool.com/2014/12/helpful-crash-course-using-atomos-shogun-4k-recorder-gh4-a7s

This next link has a video with tips on settings for shooting video with the Sony A7S:

http://www.4kshooters.net/2014/10/13/some-useful-sony-a7s-movie-settings-tips-and-tricks/

The link below provides more information about the settings that can be adjusted for Picture Profiles:

http://www.xdcam-user.com/picture-profile-guide/

The next link is to an article with some tests and observations on the video features of the RX10 II camera, which are useful for the RX10 III.

http://www.4kshooters.net/2015/08/24/sony-rx10-ii-first-impressions-super-slow-mo-s-log2/

Finally, the last link below is to a site that has excellent tutorials on many photographic topics.

http://www.cambridgeincolour.com

Index

CPSIA information can be obtained
at www.ICGtesting.com
Printed in the USA
BVOW05s1925240817
492854BV00013B/78/P